Superhero Comics

BLOOMSBURY COMICS STUDIES

Covering major genres, creators and themes, the *Bloomsbury Comics Studies* series are accessible, authoritative and comprehensive introductions to key topics in Comics Studies. Providing historical overviews, guides to key texts and important critical approaches, books in the series include annotated guides to further reading and online resources, discussion questions and glossaries of key terms to help students and fans navigate the diverse world of comic books today.

Series Editor
Derek Parker Royal

Forthcoming Titles
Children's and Young Adult Comics, Gwen Tarbox
Webcomics, Sean Kleefeld
Autobiographical Comics, Andrew J. Kunka

Superhero Comics

Chris Gavaler

Bloomsbury Academic
An imprint of Bloomsbury Publishing Plc

B L O O M S B U R Y

LONDON • OXFORD • NEW YORK • NEW DELHI • SYDNEY

Bloomsbury Academic

An imprint of Bloomsbury Publishing Plc

50 Bedford Square	1385 Broadway
London	New York
WC1B 3DP	NY 10018
UK	USA

www.bloomsbury.com

BLOOMSBURY and the Diana logo are trademarks of Bloomsbury Publishing Plc

First published 2018

British Library Cataloguing-in-Publication Data

A catalogue record for this book is available from the British Library.

ISBN:	HB:	978-1-4742-2635-6
	PB:	978-1-4742-2634-9
	ePDF:	978-1-4742-2637-0
	ePub:	978-1-4742-2636-3

Library of Congress Cataloging-in-Publication Data

A catalog record for this book is available from the Library of Congress.

Series: Bloomsbury Comics Studies

Cover design by Eleanor Rose
Cover image © John Royle

Typeset by Fakenham Prepress Solutions, Fakenham, Norfolk NR21 8NN
Printed and bound in Great Britain

To find out more about our authors and books visit www.bloomsbury.com. Here you will find extracts, author interviews, details of forthcoming events and the option to sign up for our newsletters.

To Cameron and Madeleine

CONTENTS

Series Editor's Preface xi
Acknowledgments xii

1 Introduction 1

2 **Historical Overview, Part 1: Pre-Comic Origins**
I The Mythic Superhero 15

 The superhero with a thousand masks 16
 Minimally counter-intuitive fairy tales for grown-ups 19
 Brutal fairy tales and epic violence 24
 Children's great men fables 28
 Mythical myths 32

II The Imperial Superhero 33

 The British superhero 35
 American supermen 39
 Imperial expansion 43
 New frontiers 46

III The Wellborn Superhero 49

 On the origin of supermen: 1883–1905 51
 Experiments in hero hybridization: 1893–1928 59
 Acts of sterilization: 1929–39 68

IV The Vigilante Superhero 77

Vigilante hero 81
Superman 87
Superhero 92

3 Historical Overview, Part 2: Pre-Code and First Code Origins

I The Fascist Superhero 101

Champion of the oppressed 106
Eager to strike back 113
Heroic doings 117

II The MAD Superhero 125

Crisis: 1961–2 128
Turning point: 1962–3 135
Aftermath 140

4 Social and Cultural Impact

I The Black Superhero 155

Pre-Code era, 1934–54 156
First Code era, 1954–71 160
Second Code era, 1971–89 165
Third Code era, 1989–2000 173
Fourth Code and Post-Code eras, 2001 to present 176

II The Gendered Superhero 179

Super binaries 179
Super queer 191

5 Critical Uses

I The Visual Superhero 205

1. Layout rhetoric 205
2. Framing rhetoric 215

3. Juxtapositional closure 222
4. Page sentencing 225
5. Image-texts 227
6. Representational abstraction 230
7. Visualizing *Elektra* 241

6 **Key Texts**
I The Authorial Superhero 273
 Pre-Code era, 1934–54 274
 First Code era, 1954–71 276
 Second Code era, 1971–89 278
 Third Code era, 1989–2000 281
 Fourth Code era, 2001–11 283
 Post-Code era, 2011 to present 285

Glossary 289
Resources 293
Works Cited 297
Index 321

SERIES EDITOR'S PREFACE

The *Bloomsbury Comics Studies Series* reflects both the increasing use of comics within the university classroom and the emergence of the medium as a respected narrative and artistic form. It is a unique line of texts, one that has yet to be addressed within the publishing community. While there is no shortage of scholarly studies devoted to comics and graphic novels, most assume a specialized audience with an often-rarefied rhetoric. While such texts may advance the scholarly discourse, they nonetheless run the risk of alienating students and representing problematic distinctions between "popular" and "literary." The current series is intended as a more democratic approach to comics studies. It reflects the need for more programmatic classroom textbooks devoted to the medium, studies that are not only accessible to general readers, but whose depth of knowledge will resonate with specialists in the field. As such, each volume within the *Bloomsbury Comics Studies Series* will serve as a comprehensive introduction to a specific theme, genre, author, or key text.

While the organizational arrangement among the various volumes may differ slightly, each of the books within the series is structured to include an historical overview of its subject matter, a survey of its key texts, a discussion of the topic's social and cultural impact, recommendations for critical and classroom uses, a list of resources for further study, and a glossary reflecting the text's specific focus. In all, the *Bloomsbury Comics Studies Series* is intended as an exploratory bridge between specialist and student. Its content is informed by the growing body of comics scholarship available, and its presentation is both pragmatic and interdisciplinary. The goal of this series, as ideal as it may be, is to satisfy the needs of novices and experts alike, in addition to the many fans and aficionados upon whom the medium popularly rests.

Derek Parker Royal

ACKNOWLEDGMENTS

Like its sibling, *On the Origin of Superheroes: From the Big Bang to* Action Comics *No. 1* (University of Iowa Press, 2015), this book began when I was asked to teach an honors seminar course called "Superheroes" at Washington and Lee University in 2008. Many of the ideas expressed here began with that first class of students and the half-dozen classes which followed. I also owe thanks for the feedback and suggestions of Carolyn Cocca, Madeleine Gavaler, Sean Guynes, Suzanne Kean, and Lesley Wheeler, as well as to the members of the COMIXSCHOLARS-Listserve, Noah Berlatsky and the Hooded Utilitarian reading community, and numerous conference panel participants, journal editors, and peer reviewers. Versions of Chapters 2.II, 2.III, 2.IV and 3.I were originally published in *PS: Political Science & Politics* 47 (1) (2014), *Journal of American Culture* 37 (2) (2014), *Journal of Graphic Novels and Comics* 4 (2) (2013), and *Journal of Graphic Novels and Comics* 7 (1) (2016). A portion of Chapter 4.I appeared in *ImageTexT* 7 (4) (2015), and portions of other chapters appeared at HoodedUtilitarian.com and my own site, thepatronsaintofsuperheroes.com. Thanks also to Peter Coogan, Derek Royal, and David Avital for making this book possible, and to Washington and Lee University for their generous support, including providing summer Lenfest grants. Finally, thank you to Cameron, Madeleine, and Lesley for the never-ending superhero conversation that is our household, and to John Gavaler for giving me *The Defenders* #15 (September 1974), my first superhero comic.

1

Introduction

What is a superhero comic? Any answer has to combine two categories: genre and medium. A superhero comic is a superhero story told in a graphic narrative. Superhero is the content; comics the form. Each requires its own definition, and there is a great deal of scholarly debate about both.

Peter Coogan, in *Superhero: The Secret Origin of a Genre*, offers one of the most recent and thorough definitions for the superhero character type:

> A heroic character with a selfless, pro-social mission; with superpowers—extraordinary abilities, advanced technology, or highly developed physical, mental, or mystical skills; who has a superhero identity embodied in a codename and iconic costume, which typically express his biography, character, powers, or origin (transformation from ordinary person to superhero); and who is generically distinct, i.e. can be distinguished from characters of related genres (fantasy, science fiction, detective, etc.) by a preponderance of generic conventions. Often super-heroes have dual identities, the ordinary one of which is usually a closely guarded secret. (2006: 30)

Many earlier definitions include dual identity as a defining feature, which suggests that the character type can and has evolved. In 1938, Jerry Siegel and Joe Shuster's Superman wears an iconic costume and closely guards his identity. In 1962, Stan Lee and Jack Kirby's Fantastic Four have codenames but no dual identities (and, briefly,

no costumes). In 2001, Brian Michael Bendis and Michael Gaydos' *Jessica Jones* has no codename, no costume, no dual identity, and, since she works as a professional private detective, no selfless mission. She is only superpowered—the opposite of Batman, who in all of his incarnations possesses all of the traditional qualities but superpowers. Since Jessica Jones and Batman are both understood to be superheroes, the character type appears to have no requisite qualities. Instead, individual characters may be defined by a range of possible traits, including association with other superheroes in a superhero comic.

In terms of character traits, the hero type predates comics by decades and even centuries (Gavaler 2015), but if genre is defined as a tradition of direct influence, all post-1938 superheroes evolved from Siegel and Shuster's first thirteen-page Superman episode in *Action Comics* #1. Simon J. Evnine clarifies the difference. The first approach considers genres as "regions of conceptual space," and to be in a region a work only has to have "certain features," regardless of where or when the work was created (2015: 2, 8). The second approach considers genres as "historical particulars," and to belong to that sort of genre a work has to be "read and interpreted in the light of previous works" and so understood in terms of "lineage" and "influence" (4, 16, 20). According to the first definition, sauropods and giraffes would both belong to the genre of long-necked animals, but, because their necks are the result of convergent evolution and not ancestry, sauropods and giraffes do not belong in the same genre according to the second tradition-based definition. Both approaches are useful—though the second is largely contained by the first, which emphasizes inclusiveness and so expansiveness. By looking at the superhero genre as a shifting set of formal features, it is difficult to exclude a range of pre-comics characters, including the Shadow, Zorro, the Scarlet Pimpernel, Spring-Heeled Jack, and the Count of Monte Cristo. This study is focused primarily on the second definition, the tradition of superheroes in superhero comics, and so will look at pre-comics characters to the extent that they maintain a defining influence on their comics descendants.

Finally, in a legal sense, a superhero is a character owned by either DC or Marvel, because the two companies have maintained a jointly owned registered trademark on the word "superhero" since 1979, preventing anyone else from using the word in a

publication title or advertisement. In 2016, however, Marvel and DC withdrew their two-and-a-half-year lawsuit against author Graham Jules whose self-published book is titled *Business Zero to Superhero*, suggesting that the companies may no longer be able to defend the trademark (Quinn 2016). Regardless, the history of the superhero comics genre is largely a history of DC and Marvel, the only two comics companies in continuous publication since the late 1930s.

The term "comic" is equally complex. Scott McCloud in his 1993 *Understanding Comics* offers what remains the most pervasive definition: "Juxtaposed pictorial and other images in deliberate sequence, intended to convey information and/or produce an aesthetic response in the viewer" (1994: 9). Will Eisner's earlier and more concise "sequential art" remains popular, too. McCloud critiques Eisner's definition for being too broad, while a range of scholars have critiqued McCloud's on similar grounds, before offering alternate definitions, which have then also been critiqued, leading Roy T. Cook to conclude that it is "unlikely that a precise definition of 'comic,' or even an account of substantial necessary or sufficient conditions for being a comic, will be forthcoming" (2011: 294). Using Ervine's first approach, it is difficult to isolate the "certain features" that make a comic a comic while also distinguishing comics from illustrated novels, animated films, paintings in an art gallery, or anything else intuitively understood as not a comic. While failing to exclude sufficiently, the same formal definitions may also fail to include such things as one-panel comic strips which traditionally—and so using Ervine's second approach—are understood to be comics. Abstract comics, because they include no traditional stories or often even representational objects, present further challenges, since most definitions attempt to explain how a sequence of images is unified by narrative. Even the most basic unit "image" is ambiguous—especially if panels and gutters are understood as conventions and not requisite features. A "comic book" originally described a pulp-paper magazine of newspaper comic strip reprints, i.e., a book of comics, but it is now used synonymously with graphic narratives, which include graphic novels, graphic memoirs, and graphic journalism. "Comics" began as a synonym for "funnies" or "funny papers," the humorous strips published in newspapers. Stan Lee has argued that, "because it doesn't mean funny book," comic book should be written "as

one word ... then it's a generic term meaning a comicbook" (Fegter 2012). Since Lee's preference has not been adopted, this book is a study of superhero comic books.

Despite these complexities, the vast majority of superhero comics fall into the more easily defined centers of both content and form. For the most part, superhero comics can be called sequential art about characters who have superhero traits. Most are published in comic books before reprinted in graphic novel format—though superhero comics also include works first published as comics strips, in both daily and Sunday formats, and works designed and published first as graphic novels. Webcomics, whether later published in book format or not, join the category, too.

Terminology aside, the content of comic books—their words and pictures—are the product of complex and often overlapping creative processes. Although Will Eisner's 1940s' Sunday newspaper section, *The Spirit*, is one of several significant exceptions, superhero comics have been typically created by multiple authors, with production divided into five semi-autonomous roles. A writer may conceive a story idea, plot the events, plan the image content and sequence of panels typically through a written script, and/or compose the words that appear in caption boxes and word and thought balloons after the pages have been drawn. These various writing roles may involve more than one individual. A penciler sketches the pages, typically based on a writer's script or plot summary. A superhero comic usually has only one penciler. The penciled artwork is sometimes also referred to as "layouts" or "breakdowns." An inker finishes the pages by penning over the penciler's work. More than one inker may be involved in a single issue, and a penciler may also ink their own pencils. An inker is sometimes referred to as a "finisher" or, less often, an "embellisher." A colorist designs or co-designs color or gray tones and adds them to the inked pages, sometimes with multiple assistants. A letterer draws the scripted words (but usually not sound effects) inside balloons and boxes.

Although rarely credited, a penciler also often co-writes by making encapsulation and layout decisions, and sometimes creating content based on the credited writer's story summary. During the 1950s, *Marvelman* writer Mick Anglo wrote no scripts, but "would instead suggest a basic plot outline to an artist, giving him a specific

number of pages to fit the idea into. Once the art was complete, Mick would then write in the actual wording for the letterer" ("Miracleman Alias Marvelman" 1985). Stan Lee followed the same process in the 1960s, dubbing it the Marvel Method. Jack Kirby and Steve Ditko would also conceive and pencil stories independently, leaving margin notes for Lee to expand into dialogue and narration. It is unclear whether Lee produced general story ideas as a writer or as an editor. Contemporary Marvel editors Axel Alonso and Sana Amanat initiated the projects that would become *Truth: Red, White & Black* and *Ms. Marvel*, suggesting that Lee's role as writer was exclusively the creation of text after pages were drawn. Job applicants seeking writing positions in the 1960s were hired based on their ability to fill in four pages of empty balloons and caption boxes from *Fantastic Four Annual #2*, further suggesting that pencilers were often the primary "writers."

Even when working from full scripts, pencilers may exert a great deal of creative control. According to 1990s' *Deathlok* writer Dwayne McDuffie, penciler Denys Cowan "felt free to alter my panel breakdowns and shot descriptions whenever he had a better idea" (2002: 28). Neil Gaiman encouraged Andy Kubert to alter his 2003 scripts: "Feel free to ignore my suggestions if you can see a better way of doing it. (You are the artist.)" (Gaiman and Kubert 2009). Brian Michael Bendis continues the attitude: "with every script, I write a note to my collaborator that says: 'I write full script. But see it as a guide. You take us where we need to go any way you see fit. I tried to write something specifically for you. If you agree with my choices, fine. If not, you do what you have to do'" (Bendis 2014: 56). Will Eisner, however, describes an artist's freedom in far more negative terms, likening the replacement of a writer's scripted dialogue with visual pantomime as "the total castration of his words" (2008: 133). While Bendis considers writer and artist relationships to be "as intimate as dating" (2014: 80), penciler and inker relationships are equally complex. Inker Eric Shanower was notorious for adding details to layouts, while Vince Colletta was equally notorious for eliminating them. John Byrne even voiced homophobic complaints about Bob Layton's inking of his work:

> I actually feel physically ill when I look at Bob's stuff. [...] It's like everything is greasy and slimy. [...] all his men are queer.

They have these bouffant hairdos and heavy eye make-up and an upper lip with a little shadow in the corner which to me says lipstick. [...] I remember my father looking at [...] the finished inks [...] and my father said, "Well this guy's queer." No, he didn't look queer in the pencils, Dad. (Ikowitz 1980)

When John Byrne inked Steve Ditko's pencils in the 1980s, their styles clashed, too, creating Byrne-detailed figures arranged in signature Ditko poses.

Unless the penciler is instead painting in a color medium—Alex Ross, for example, prefers gouache watercolors—color is added to comic pages last. Before Photoshop, this was accomplished during the printing process by overlaying color-separation boards and screening ink by percentages in Ben-Day dot patterns. The colorist would select color combinations for each discrete shape, and multiple assistants would cut the shapes from each board. Color decisions might also be indicated by the writer in a script or by the penciler in the margins of the layout. With exceptions that include Lynn Varley's coloring of *300* in 1998 and Matt Hollingsworth's coloring of *Wytches* in 2016, colorists' contributions are usually considered of secondary importance. John Higgins, for example, does not appear on the cover of *Watchmen* with Alan Moore and Dave Gibbons. Because the artists' boards remain black and white, colors can also be altered with each publication. Alan Moore and Garry Leach's first chapters of *Marvelman* originally appeared in black and white in *Warrior* magazine in 1982; the retitled *Miracleman* #1 was reprinted in color in 1985 by Eclipse Comics; and Marvel Comics reprinted them again in 2014 with a new color design by Steve Oliff. Because all three *Marvelman/Miracleman* are each a comic, they reveal that—unlike a traditional painting which may be copied and mass distributed—a comic is its multiple copies. The artboards for a comic book may be considered works of art, too, but the artboards are not the comic book produced from them. A comic book has no single original.

The three versions of *Miracleman*, plus Anglo's original *Marvelman*, were each published in what has been traditionally termed a different "Age." In July 1934, Max Gaines and Eastern Color Printing published *Famous Funnies*, the first comic strip reprint omnibus in what would become the standard comic book format and so the start point for what has been traditionally

termed the "Golden Age" of comics. The first use of the term is attributed to science-fiction author Richard A. Lupoff from his article "Re-Birth," in the first issue of the fanzine *Comics Art* in 1961 (Schelly 2010: 74), and DC was using the term by 1966: "Watch for the return of Golden Age villains and villainesses you love to hate in the latest new/old Wonder Woman!" (Marston et al. 2007: 87). The start point for the Golden Age of superhero comics is usually considered June 1938, the cover date of *Action Comics* #1—even though the cover date was an indication to sellers to remove copies from newsstands on June 1 and so not the publication or release date, which for a monthly series is typically a month earlier, so May 1. But since *Action Comics* was not necessarily the first comic book to feature a superhero, May 1938 is not necessarily the start point of the superhero comics genre either. Beginning March 1937, Sven Elven's detective "Cosmo, the Phantom of Disguise" was a monthly feature in all fifteen issues of *Detective Comics*, preceding *Action Comics*. The year 1937 also saw Watt Dell Lovett's "The Astounding Adventures of Olga Messmer, the Girl with the X-Ray Eyes" in *Spicy Mystery Stories* and Will Eisner and S. M. Iger's "Sheena: Queen of the Jungle" in the British magazine *Wags*. George E. Brenner's The Clock, an imitation of Frank L. Packard's 1914 pulp hero the Gray Seal, premiered in *Funny Picture Stories* #1 (November 1936). Lee Falk's *The Phantom*, first published February 17, 1936, and *Mandrake the Magician*, on June 11, 1934, are also both contenders for first comic strip superhero.

Based on formal traits, some, none, or all of these comics characters may be considered superheroes. But approaching genre as a tradition of direct influence and lineage, there is a sense in which the Golden Age of superhero comics begins not with any of Superman's immediate predecessors or even Superman himself, but with his first overt imitation. Seeing the success of *Action Comics*, publisher Victor Fox hired Will Eisner to create Wonderman for *Wonder Comics* #1 (May 1939), prompting Harry Donenfeld—the owner of several comics companies that would collectively become DC Comics—to sue for copyright infringement. Though Circuit Judge Augustus Hand's opinion rejected "the old argument that various attributes of 'Superman' find prototypes or analogues among the heroes of literature and mythology" (qtd in Payne 2006), once DC published imitations itself, the superhero comics

genre was underway. Adding a unitard, cape, and chest icon to a standard pulp-magazine mystery man, Bob Kane and Bill Finger's "Bat-Man" premiered in *Detective Comics* #27, with the same cover date as *Wonder Comics* #1. Before the end of the 1939, comic book superheroes included: Arrow, Crimson Avenger, the Sub-Mariner, the Flame, the Sandman, Bozo the Iron Man, Hooded Justice, Blue Beetle, Amazing Man, the Human Torch, the Angel, Ultra-Man, and Doll Man. Soon there would be over two hundred.

The Golden Age has no defining endpoint, and is sometimes said to be followed either by an undefined interregnum or by the Atomic Age, both of which end with the onset of the Silver Age, traditionally marked by the appearance of the revised Flash in DC's *Showcase* #4 (October 1956). According to Michael Uslan, the term originates from a 1966 fan letter in *Justice League of America* and replaced Jerry Bails' "Second Heroic Age" designation (Casey 2009: 79). The Silver Age division is arbitrary even within superhero comics since it applies only to DC Comics, which was already publishing nine superhero titles in 1956 featuring Superman, Batman, and Wonder Woman, the new character Batwoman appeared three months earlier and Martian Manhunter a year earlier. The success of the new Flash title, however, eventually led to DC's 1959 Green Lantern in *Showcase* #22 and the Justice League of America in the 1960 *Brave and the Bold* #28, which in turn influenced Charlton Comics and Marvel Comics. Though initiated by DC, the Silver Age is most defined by the early 1960s superhero comics of Stan Lee, Jack Kirby, and Steve Ditko published by Martin Goodman's newly rechristened Marvel Comics, known as Atlas in the 1950s, and Timely in the 1940s. From 1961–4 the company introduced the Fantastic Four, the Hulk, Spider-Man, Thor, Iron Man, the Avengers, the X-Men, Doctor Strange, and Daredevil.

Though less defined, the division between the Silver Age and the Bronze Age is understood largely as a tonal shift, as reflected by Dennis O'Neil's relatively realistic scripting of *Green Lantern Co-Starring Green Arrow* beginning in 1970 and by the death of Gwen Stacy in *Amazing Spider-Man* #121 (July 1973). Jack Kirby also left Marvel in 1970, and Steve Ditko in 1966, allowing new artists Neal Adams and Jim Steranko to redefine the dominant style. The creative changes may also be understood as a response to a significant market slump, similar to the slump that endangered

comics in the mid-1950s and led to the resurgence of the superhero genre. The Bronze Age is most often said to end when DC's 1985 *Crisis on Infinite Earths* restructured the multiverse it unintentionally created with the 1956 Flash, while the 1986 publications of Frank Miller's *Batman: The Dark Knight Returns* and Alan Moore and Dave Gibbons' *Watchmen* mark a further creative shift to what is variously referred to as the Dark, Iron, Copper, or Modern Age, which extends to the present or is divided, in the 1990s, into the Modern or New Age or, at the turn of the century, into the New or Millennial Age.

The Ages' system is largely a product of the comics collectors' market, with the annual *Overstreet Comic Book Price Guide*, in its 46th edition as of 2016, maintaining its popularity. It has been criticized for multiple flaws, including the arbitrariness of the metallurgic names and their descending value, leading Ben Woo to conclude that the "schema has outlived its usefulness" (2008: 277). Other schema have been suggested. Nat Gertler, for example, divides superhero history into four "Generations," each with its own characteristics, and Randy Duncan and Matthew Smith suggest eight Eras, each named by a defining abstraction: Invention, Proliferation, Diversification, Retrenchment, Connection, Independence, Ambition, and Reiteration (2009: 232–3, 24–5). Paul Lopes, viewing the mid-1980s as the birth of the autonomous author, instead divides the history in half, labeling the 1930s to the mid-1980s the "Industrial Age," and the mid-1980s to the present the "Heroic Age," a term introduced by Bails in the 1960s, though Lopes refers instead to Pierre Bourdieu's analysis of nineteenth-century French literature (2009: xiii).

While the mid-1980s is a significant turning point for creator rights and auteur analysis, Lopes' division and naming are not self-evident or intrinsic, a flaw of most retroactive schema. In contrast to the ambiguity and competing interpretations of the various Ages, the Comics Code provides a means for dividing superhero comics into six objectively named and defined pre-existing historical periods. The Code was created and managed by comic book publishers through the CMAA, the Comics Magazine Association of America, in an immediate response to the 1954 Senate subcommittee hearings on the role of comic books in juvenile delinquency. The pre-Code era runs from 1934, with the format-defining publication of *Famous Funnies*, to October 1954. Since the Code's

guidelines were revised twice, the first Code era spans October 1954 to January 1971, and the second February 1971 to spring 1989. The second and final revision marks the start of the third Code era with less restrictive guidelines than those of 1954–89, as demanded by CMAA members during the 1980s. Marvel moved the Code stamp to its back covers during the third era, before replacing it with its own rating system in 2001, marking the first time since its creation that the Comics Code Authority did not oversee a majority of the market. The fourth Code era therefore runs from 1989 to 2000. DC stopped printing the Code stamp on their covers with their 2011 company-wide reboot, and Archie, the sole remaining member of the CMAA, followed the same year— formally marking the start of the current, post-Code era.

Unlike the Ages, the Code eras are self-defining and, because they originate from within the industry during the periods they describe, are intrinsic to that history and so not retroactively imposed. Mapping the two historical systems overtop each other, the pre-Code era and the Golden Age with all but the last two years of the interregnum correspond. The first Code era begins two years prior to the Silver Age, ending with the second Code era in 1971, also a common start point for the Bronze Age. The second Code then extends four years into the Dark/Iron/Copper/Modern Age before establishing clear divisions with the third Code era in 1989, the fourth in 2001, and the current post-Code era in 2011. Because the Golden Age describes the superhero character types' foundational period, this study will retain the term when referring to those original tropes and formula.

The history of superhero comics may also be outlined financially and demographically. Comics sold for ten cents during their first three decades, rising to twelve cents in 1962. Prices reached forty cents in the 1970s, a dollar before the end of the 1980s, roughly two dollars by the turn of the twentieth century, and four dollars during the second decade. Since a dime in 1934 converts to $1.78 in 2016 U.S. currency, the change reflects more than inflation. Paper quality increased too, with most companies switching from pulp to more expensive glossy grades in the 1990s. But while prices increased, overall sales decreased. During World War II, popular titles sold over a million copies per month. That market peak dropped dramatically in the mid-1950s, with Marvel selling around 230,000 copies per monthly title in the late 1960s (Costello

2009: 21). After a 1970s' slump, comics shifted from newsstands to specialty shops in the 1980s, producing a market bubble in the early 1990s, with collectors purchasing multiple copies of single issues and companies printing variant cover editions to extend the trend. *X-Men* #1 reached a record 8.1 million copies in 1991, but the bubble burst in 1993. Marvel filed for bankruptcy protection in 1996, before emerging under new ownership in 1998. The highest-selling comic of 2000, *Uncanny X-Men* #381, reached only 119,300 copies. The market has since improved. Marvel and DC's top superhero issues in 2015, *Secret Wars* #1 and *Dark Knight III* #1, sold around a half million copies each, but both titles dropped to 234,017 and 158,188 for issues #2, while the lowest-selling superhero titles fell under 29,000 (Miller 2016). The *Washington Post* reported that June 2016 "was the industry's best-selling month since December 1997," part of a five-year trend of rising sales and evidence of the "resurgence of comic books" (Andrews 2016). Marvel and DC have also maintained their dominance, averging together 68 percent of the retail market share over the last decade, with Marvel fluctuating between 33–46 percent and DC between 26–34 percent ("Industry Statistics").

In terms of demographics, the original comics market was defined by white twelve-year-old male readers. Marvel began to attract college readers in the 1960s, but the market did not fully shift to twenty-year-olds until the early 1990s, reaching an average age of twenty-five before the end of the decade (Gaslin 2001). ComiXology, which reached 200 million downloads in 2013, found their average customer to be between twenty-seven and thirty-six and male (Kraft 2013). Female readership, however, was rising, and the comics market appeared to reach gender balance for the first time in the mid-teens. Since the primary North American comics distributor does not release demographic information, no definitive gender or ethnic statistics are available. Other indicators, however—the gender breakdown of Facebook "likes," for instance—indicate a comics market in continuing transition toward female and non-white readers, which, according to Travis M. Andrews, may also account for the rise in sales of recent years (2016).

This study follows superhero comics through all of these changes. The chapters are both historic and thematic and are organized chronologically based on start points with each extending into the

post-Code era. The Historical Overview section is divided into two parts. The first addresses superhero topics that precede comics. Chapter 2.I examines the claim that comic-book superheroes are mythic and so continuations of ancient tradition. Chapter 2.II begins in the nineteenth century to examine the continuing influence of colonialism and imperialism on the later comics genre. Chapter 2.III also begins in the nineteenth century and examines the role of the eugenics movement in defining the character type of the superman that comics superheroes both express and contradict. Chapter 2.IV studies romanticized vigilantism popularized by the 1920s' Ku Klux Klan (KKK), an organization that comics both imitated and rejected. The second part of the Historical Overview covers the pre-Code and first Code eras. Chapter 3.I is an analysis of the role of fascism in the creation of the superhero genre; Chapter 3.II examines the role of Cold War nuclear fears in the early 1960s' rebirth of superheroes. The Cultural and Social Impact section looks at how superhero comics have both reflected and reinforced changes in cultural attitudes, with African-American characters and creators in Chapter 4.I, and female and LGBTQ characters in Chapter 4.II. Critical Uses introduces a range of tools for analyzing comics visually, followed by an annotated list of key works defined by authorship in Chapter 5.I and the Works Cited list in the Resources section.

2

Historical Overview, Part 1: Pre-Comic Origins

I

The Mythic Superhero

"For generations of readers," writes Sean Howe, "Marvel comics was the great mythology of the modern world" and its creators like living "Homers and Hesoids" (2012: 6). Chris Mackie draws similar parallels between the Homeric heroes Achilles and Odysseus and DC's Superman and Batman (2007). Richard Reynolds, one of the earliest superhero comics scholars, notes "a tendency for comics creators to legitimize their offspring by stressing their resemblance to legendary heroes or gods," including, in the case of Siegel and Shuster, "the myth of Samson, Hercules and so on" (1992: 51). For Lee and Kirby's Thor, Reynolds suggests that the adaptation of Norse mythology "fitted so neatly into the format of the superhero comic" in part because after Superman "writers and artists had been working with such models consciously or half-consciously in mind" (1992: 57).

The notion that superhero comics are contemporary versions of ancient mythology and folklore is common but difficult to substantiate. If true, the popularity of the genre transcends culture and history by drawing from traits rooted in human psychology. This chapter assesses that claim by examining the superhero character type and narratives formulas in relation to four "universal" topics: monomyths, memory processing, appeals of violence, and children's cognitive and moral developmental levels.

The superhero with a thousand masks

Of the nearly 5,000 characters listed in Jess Nevins' *Encyclopedia of Golden Age Superheroes*, the vast majority were introduced before 1949, the year Joseph Campbell published *The Hero with a Thousand Faces*. Campbell's study introduced his concept of the monomyth, a eighteen-step narrative formula that he applied across societies and time periods worldwide. Vladimir Propp published a similar thirty-one-step analysis, *Morphology of the Folktale*, in 1928, but it was not translated to English until 1958.

Propp, Campbell, and other structuralist and formalist scholars studied anonymously authored cultural tales and categorized their character and plot similarities to suggest universal patterns, some akin to Carl Jung's collective unconsciousness. When Hollywood executive Christopher Vogler summarized *The Hero with a Thousand Faces* as a guide for screenwriters, he called it "one of the most influential books of the 20th century," noting that "The myth can be used to tell the simplest comic book story or the most sophisticated drama" (Vogler 1985). George Lucas famously credited Campbell's influence on *Star Wars*. Campbell's examples include Greek, Roman, Egyptian, Mesopotamian, Indian, Norse, and Inuit sources. He did not, however, relate his analysis to the hero character type most popular while he was developing his formula in the 1940s: the comic book superhero.

Campbell published his study shortly after DC terminated Jerry Siegel and Joe Shuster, ending their ten-year contract on *Action Comics*. Superman, meanwhile, had expanded to newspapers, radio, film, and TV, producing a legion of similarly superhuman imitations. While Campbell's approach to comparative mythology is flawed by inattention to differences between disparate tales and cultures, it shares its mid-century, American context with the superhero genre and so suggests one culturally-specific explanation for the character type's popularity. What appealed to Campbell apparently appealed to other twentieth-century U.S. readers, too.

Campbell summarized his monomyth's essential elements:

A hero ventures forth from the world of common day into a region of supernatural wonder: fabulous forces are there encountered and a decisive victory is won: the hero comes back

from this mysterious adventure with the power to bestow boons on his fellow man. (2004: 28)

The description encapsulates superhero origin stories. Will Eisner condensed the same elements into the first panel of *Wonder Comics* #1 (May 1939), when a blond-haired American vacationing in Asia receives supernatural powers from a turbaned Tibetan:

> So, Fred Carson, wear this ring as a symbol of the Herculean powers with which you are endowed—as long as you wear it, you will be the strongest human on Earth—you will be impervious—and now in the name of humanity and justice, go forth into the world! (1939: 1)

Wonderman premiered the same month as *Action Comics* #12 and *Detective Comics* #27, which introduced Bob Kane and Bill Finger's "Bat-Man." Both characters were the first direct imitations of Siegel and Shuster's industry-transforming Superman. While Superman was influenced by decades of pulp, film, and penny dreadful predecessors, the medium-specific tradition of the comic book superhero begins in 1939 with the expansion of a single character into a repeated character type.

Like Wonderman's, Batman's origin story, retroactively inserted six months later in *Detective Comics* #33, is a monomyth variant—though a darker one. Bruce and his parents are "walking home from a movie" when they encounter the dark forces of the criminal underworld. After the "terror and shock" of the murders, a "curious and strange scene takes place," in which Bruce vows to his parents' spirits to avenge their deaths and so becomes "a creature of the night" himself (Kane et al. 2006: 62–3). Finger places the formative event in an inexact past, "some twelve years ago," suggesting the ahistoricity of many myths and folktales, while also grounding the ongoing consequences in a contemporary moment. Superheroes pass between Campbell's "two worlds, the divine and the human" regularly (Campbell 2004: 201). While Krypton is the original comic book region of supernatural wonder, giving Superman the power to bestow boons on humanity, Clark Kent is the ongoing embodiment of the world of the common day. Structurally the Krypton past is only preamble, establishing one of the most significant elements of Campbell's heroic journey: personal transformation.

Myths and folktales are complete stories that end in closure, but superhero comics are typically episodic and endlessly incomplete. The monomyth as applied to comics' form then is not limited to a character's origin nor necessarily expandable to an accumulative series. The superhero monomyth is a single adventure—and, in fact, each and every single adventure. The early twelve-page *Action Comics* episodes begin with Clark, who abandons his common day persona to encounter some force which he decisively defeats, before returning to live among humans as Clark again, his boon-bestowing powers at the ready.

If Campbell is correct, and the appeal of the myths he studied is grounded in the cyclic pattern of common heroes transforming through a descent into the fantastical, superhero comics enacted that script monthly. Every time Bill Parker and C. C. Beck's little Billy Batson, for example, accepts a call to action and shouts "Shazam!" he receives the aid of his wizard mentor and crosses a supernatural threshold, causing Billy to vanishes and be reborn as Captain Marvel. Campbell writes:

> The hero, instead of conquering or conciliating the power of the threshold, is swallowed into the unknown and would appear to have died. ... This popular motif gives emphasis to the lesson that the passage of the threshold is a form of self-annihilation ... instead of passing outward, beyond the confines of the visible world, the hero goes inward, to be born again. (2004: 83–4)

After the trials of physical combat end in victory, Captain Marvel returns to the mundane world by transforming back into Billy Batson. Campbell describes the act as a trial itself:

> The first problem of the returning hero is to accept as real, after an experience of the soul-satisfying vision of fulfillment, the passing joys and sorrows, banalities and noisy obscenities of life. Why re-enter such a world? Why attempt to make plausible, or even interesting, to men and women consumed with passion, the experience of transcendental bliss? As dreams that were momentous by night may seem simply silly in the light of day, so the poet and the prophet can discover themselves playing the idiot before a jury of sober eyes. (2004: 202–4)

Siegel and Shuster solved Campbell's dilemma by presenting Clark Kent as the hero's banal disguise, allowing him to play an idiot to Lois Lane and the mundane temptations she represents. As Jules Feiffer concludes, Clark "is Superman's opinion of the rest of us, a pointed caricature of what we ... were really like" (2003: 13). Superman's adoption of the caricature also reflects Campbell's final monomythic stages, allowing him to remain in the never-ending moment by mastering both of his worlds:

> Freedom to pass back and forth across the world division, from the perspective of the apparitions of time to that of the causal deep and back—not contaminating the principles of the one with those of the other, yet permitting the mind to know the one by virtue of the other—is the talent of the master. (2004: 212–13)

Viewed within the monomythic scope of each episode, the Clark of the opening scene is fundamentally different from the Clark of the ending scene. If a reader had never heard of Superman, she would see a human transform into super-being and then relinquish that soul-satisfying fulfilment in order to appear human again. Other superheroes enact the same cyclic transformations every time they don a costume. Though Campbell's monomyth can be applied only tentatively to the diverse array of world mythologies, it may find its most defining embodiment in the comics produced at its same cultural moment.

Minimally counter-intuitive fairy tales for grown-ups

A half-century after Joseph Campbell published *The Hero with a Thousand Faces*, the study of "cross-cultural regularities" in folktales and mythologies had shifted to cognitive psychology and the search for "a set of conceptual mechanisms that is pan-cultural" and "essentially inevitable given innately specified cognitive biases" (Barrett and Nyhof 2001: 70). Members of different cultures produce similar stories not because they share a collective unconscious, but because they share similar brains.

Instead of mapping monomythic plot formulas, studies over the last two decades have focused on defining what kinds of ideas are most easily remembered and therefore more likely to be retold. Intuitive ones, ideas that meet our expectations about reality, are harder to remember than ones that violate them. Counter-intuitive ideas require more attention to mentally process and so make a longer lasting impression. Or they do up to a point. Too many counter-intuitive elements and remembering becomes harder again. So, as Justin L. Barrett and Melanie A. Nyhof conclude, a being who "will never die of natural causes and cannot be killed" is easier to recall than a being who "requires nourishment and external sources of energy in order to survive" and also easier to recall than a being who "can never die, has wings, is made of steel, experiences time backwards, lives underwater, and speaks Russian" (2001: 95, 96, 93).

In 1994, Pascal Boyer named the conceptual sweet spot the "minimal counterintuitive" or MCI, and a range of research has refined the definition. Ara Norenzayan and his co-authors found that Brothers Grimm tales with two to three counter-intuitive elements received more hits on Google web searches than Grimm tales with one or none and tales with more than three (2006). Barrett looked at seventy-three folktales and found the majority, 79.2 percent, included either one or two counter-intuitive elements (2009). Joseph Stubbersfield and Jamshid Tehrani's study of the contemporary "Bloody Mary" urban legend found that Internet versions averaged between two and two and a half MCI elements (2013). Lauren O. Gonce and her co-authors also found that context matters, since counter-intuitive items presented on a list fair worse than intuitive ones ("singing bird" is easier to memorize than "flowering car") (2006), and M. Afzal Upal defines that relevant context in terms of story coherence, showing that study participants recall a MCI element only if it makes sense of the events surrounding it (2011).

Like Campbell's monomyth, minimal counter-intuitiveness also describes superheroes. According to Hal Blythe and Charlie Sweet, the prototypical character has inhuman powers, but those "powers are limited" and the individual is "human," striking the optimal MCI balance (1983: 182). Stan Lee summarized Marvel's formula in a 1970 radio interview even more precisely: "these are like 'fairy tales' for grown-ups, but they were to be completely realistic except

for one element of a super power which the superhero possessed, that we would ask our reader to swallow somehow" (McLaughlin 2007: 21). Other comics' superheroes tend to violate only one real-world expectation too: Flash moves inhumanly fast; Hawkgirl has wings; Plastic Man's body is malleable. When a character has more than one counter-intuitive quality, those qualities tend to derive from a single, unifying concept. The bald-headed Professor X has the mental powers of telekinesis and telepathy. The Wasp shrinks to the size of a wasp, flies like a wasp, and stings like a wasp. Spider-Man has the proportional strength of a spider, climbs walls by adhering to vertical surfaces like a spider, and even has "spider senses"—an unrelated ability made to conform to the MCI conceit by adding "spider" as an adjective. When a superhero violates MCI, it is most often through narrative evolution rather than original concept. Although Superman can fly, shoot lasers from his eyes, and even travel backward in time, Siegel and Shuster's original had only advanced muscles. Similarly, Wolverine had no mutant healing powers when introduced in 1974, and Lee and Kirby didn't add force fields to Invisible Girl's abilities until *Fantastic Four* #22. Finally, while one character possessing multiple superpowers violates MCI, a team of superhumans does not. An immortal, winged, steel, time-reversing, water-breathing Russian-speaker is maximally counter-intuitive, but a comic book that includes Superman, Angel, Colossus (who also speaks Russian), Merlin, and Aquaman might merely be "bizarre" (a category Barrett and Nyof distinguish from MCI).

Not only does the superhero character type demonstrate MCI, so does the overall world and story contexts. Although superheroes violate a range of natural laws, Joseph Witek still defines superhero stories as naturalistic because the

> depicted worlds are like our own, or like our own world would be if specific elements, such as magic or superpowers, were to be added or removed. However cursory the attempts to support its truth claim might be, that claim supplies the metaphysical structure underlying the visual and narrative strategies of the conventional tradition of comics. (2012: 32)

The cohesive nature of superhero stories would also place them in Upal's "Coherent-Counterintuitive" category because the

MCI superpower "is causally relevant because it could allow a reader to make sense of the events to follow" (2011: 33). A traditional superhero story does not simply include a character with a superpower, but features the superpower as the means for resolving the central conflict. Comics writer Dennis O'Neil argues:

> A writer fails the genre when a story depicts superheroes who are weak or do not use their powers. What makes a character interesting (both superheroes and other types of characters) is what he does to solve problems. You give him a knotty situation, and he gets out of it. Well, by definition, *superheroes use extraordinary physical means* ... [we] respond to exhibitions of power. *That is what a superhero is.* (2013: 130–1; emphasis in the original)

MCI then defines the superhero character, the superhero world, and the superhero plot.

Although MCI was coined to explain religious concepts, subsequent studies suggest that superheroes in particular demonstrate MCI and so benefit more than other MCI-character types and narratives. For one of Barrett and Nyhoff's 2001 experiments, participants read a story about an inter-galactic ambassador visiting a museum on the planet Ralyks. The museum featured eighteen exhibits, six with MCI qualities:

> a being that can see [or] hear things no matter where they are. For example, it could make out the letters on a page in a book hundreds of miles away and the line of sight is complete obstructed. (2001: 95)

> a species that will never die of natural causes and cannot be killed. No matter what physical damage is inflicted it will survive and repair itself. (2001: 95)

> a being about the size of a young human that is impossible to move by any means. (2001: 95)

> a being that is able to pass through solid objects. Being the size of an adult human, it can pass directly through solid objects. (2001: 96)

a being that can be completely in more than one place at a time. All of it can be in two or all four different corners at the same time. (2001: 96)

a being that can remember an unlimited number of events or pieces of information. For example, it could tell you in precise detail, everything thing it had witnessed in the past, and if you read it a list of 10 billion words, it would remember them all flawlessly. (2001: 96)

All six beings duplicate abilities and characters found in superhero comics: Superman's supervision; Wolverine's mutant healing; the Blob's immovable force; Kitty Pryde's and Vision's intangibility; Multiple Man's duplication; and the Watcher's omniscience. Barrett and Nyhof also bookend their article with references to the contemporary folklore of the part-goat Chivo Man because "a part-animal, part-human creature violates one of our expectations for animals while maintaining rich inferential potential based on pan-cultural category-level knowledge" (2001: 94). Part-animal, part-human characters are also one of the most common naming tropes in superhero comics.

The "Aesop-like fables" created for Upal's study also reproduce superhero tropes. Of the six MCI qualities contained in the three "Coherent-Counterintuitive" stories, five duplicated superheroes: a "steel-man," a "wing-man," an "invisible man," an "all-seeing woman," and a "man who could fly and loved helping others" (2011: 46–7). The "Incoherent–Counterintuitive" examples contained only one superhero trope, which appeared in two stories: a woman and then a man both "made of iron." Upal replaced the previous tropes with non-superhero variants: "a man who had feet instead of hands," a "villager who could bend spoons with his eyes," and "a woman from a neighboring village who had ten heads" (2011: 47–8). Because the coherent and the superheroic coincide, and because the incoherent and the non-superheroic coincide, Upal's experiment texts further suggest the intrinsic nature of superhero powers as cohesion-producing story elements.

The fact that both Upal's and Barrett and Nyhof's studies reproduced superhero character types also makes the researchers unknowing participants in a larger cultural study. The museum beings and Aesop-like characters could be examples of convergent

evolution—meaning their authors duplicated Superman's x-ray vision and the X-Men mutant Colossus' steel flesh independent of direct influence—or the authors absorbed superhero characters and characteristics unconsciously and reproduced them unknowingly. Either way, the experiment texts taken as cultural artifacts reveal superheroes as especially fit cultural competitors—due perhaps to their pan-cultural appeal.

Brutal fairy tales and epic violence

If superheroes, as O'Neil says, problem solve through extraordinary physical means, then in monomythic terms, the plots of superhero comics are dominated by Campbell's middle, trial stage of initiatory conquests: "Dragons have now to be slain and surprising barriers passed—again, again, and again" (2004: 100). Because their MCI qualities are overwhelmingly physical (strength, agility, invulnerability, flight, etc.) and/or weapon-oriented (arrows, hammer, throwing shield, lasers, etc.), superheroes problem solve through violence—a quality long present in hero narratives. Roger B. Rollin, linking superhero comics to *Beowulf* and *The Faerie Queene*, notes the underlying logic that validates violence: "crises call for lions. And whether they take place in epics or in pop romance, crises usually require violent solutions. Violence indeed seems to be the reality of their worlds, and it is in violent situations that the heroes are defined" (2013: 93).

Determining the average amount of combat depicted in superhero comics would require exhaustive quantitative analysis, but two examples are suggestive. Beginning with *Detective Comics* #33 (January 1940) and continuing with *Batman* #1 (Spring 1940), DC regularized Batman episode lengths to a norm of twelve to thirteen pages. Of those first seven episodes, combat occurs on an average of seven pages—or roughly half of each episode. Beginning with *Amazing Spider-Man* #3 (July 1963), Marvel regularized Spider-Man's episodes to a 1960s norm of an issue-length twenty-one or twenty-two pages. Averaging issues #3–9, combat occurs on eleven pages—or again roughly half of each episode. Tallying individual panels would yield a lower average since combat does not always dominate an entire page, but analyzing the same issues in terms of

Neil Cohn's narrative grammar (as discussed in Chapter 5.I), the majority of visual sentences are predicated on physical combat. As with monomyths and MCI narratives, Dolf Zillman argues that the "attraction of superviolent entertainment is evident cross culturally" and so "not limited to audiences in the Western world, but universal" (1998: 180). The nature of that appeal, however, is ambiguous, prompting Vasileios-Pavlos Kountouriotis to ask "why we bombard our children with brutal fairy tales" (2008: 6). We may also ask why we and our children enjoy them. One of the most common explanations is arousal: humans seek stimulating sensations because they are intrinsically rewarding, and fictional violence is stimulating, especially when it is novel within an audience's otherwise non-violent environment. According to excitation transfer theory, the arousal caused by violent depictions continues after the violent incident and intensifies subsequent experiences—most likely relief. In the superhero formula, violence is followed by positive plot outcomes, making the experience of those outcomes more gratifying. Excitation transfer also aligns with disposition theory, which evaluates violence according to perceived retribution. An audience enjoys violence to the degree that it is seen as a justified reprisal against immoral behavior—another near constant in superhero comics. Laurence Ashworth and his colleagues go further by separating violence from domination, arguing that portrayals of the "successful suppression of another" are innately appealing—provided that the suppression is both meaningful and socially acceptable, as it is when a superhero dominates a powerful and threatening supervillain (2010: 123).

Other media studies challenge the notion that fictional violence affects enjoyment at all. Glenn G. Sparks and his co-authors deleted ten minutes of the 1993 film *The Fugitive* to create a non-violent version and assigned a set of college students to watch each; the two versions received roughly identical scores for quality and enjoyment (2005). Andrew J. Weaver led a similar study with an edited children's cartoon and found that elementary school children reported liking the violent and non-violent versions to the same degree (2011). Citing George Gerbner, Sparks sees the ubiquity of violent narratives not as a result of violence having universal appeal, but because violence is merely a "universal language," one with "global marketability" since it requires no translation (2005: 22, 21).

The claim might explain the overseas success of contemporary superhero films, but not the centuries-long success of violent epics such as *The Iliad*. If superhero comics draw from ancient myth, they are not mini-odysseys but rather mini-Trojan wars. Since 1939, Superman has waged "his never-ceasing war on injustices" (Siegel and Shuster 2006: 112), and Bruce Wayne has spent his life "warring on all criminals" (Kane et al. 2006: 63). Their initial battles against a human criminal class expand to wider conflicts against fellow superhumans in which superheroes, ostensibly motivated to protect society, appear to relish combat itself. When first facing the Joker, Batman declares: "It seems I've at last met a foe that can give a good fight!" (Kane et al. 2006: 147), and Spider-Man laments two decades later: "It's almost too easy! I've run out of enemies who can give me any real opposition! I'm too powerful for any foe! I almost wish for an opponent who'd give me a run for my money!" (Lee and Ditko 2009: 66). Comics often fulfill this wish by pitting superhero against superhero, a trope Alan Moore parodies in *Watchmen* when an interviewer asks Ozymandias about the Comedian:

> NOVA: [...] I heard that he beat you in combat, back when you were just starting out ...
>
> VEIDT: Yes, well, that was a case of mistaken identity and general misunderstanding. For some reason it happens a lot when costumed crime-fighters meet for the first time. (*Laughter*) (Moore and Gibbons 1987: Ch. 11; 32)

Mark Waid and Alex Ross extend the theme to its logical extremes in their1996 *Kingdom Come*, which is filled not with "heroes," but rather,

> their children and grandchildren. [...] progeny of the past, inspired by the legends of those who came before ... if not the morals. They no longer fight for the right. They fight simply to fight, their only foes each other. The superhumans boast they've all but eliminated the super-villains of yesteryear. Small comfort. They move freely through the streets...through the world. They are challenged ... but unopposed. They are, after all ... our protectors. (2008: 22–3)

Ross expresses the warriors' joy of combat through the near-photorealistic grin of a downed superhuman and the maudlin tears of a human child fleeing falling rubble. According to Douglas Wolk, "Ross's painted upgrades of standard superhero-comics imagery are stiff and glossy" and "suffer from a commitment to looking 'just like the real thing'" (2007: 122). Whether Ross's style is "misguidedly 'realistic'" or not, his photo-like yet somehow still-bloodless renderings reveal the core contradiction of superhero comics: the simultaneous celebration and avoidance of violence.

While superheroes may evoke ancient epic traditions, their paradoxical approach to violence may place them in a more specific sub-category, what Edward Adams terms the "liberal epic": "a revivified heroic tradition" that glorifies "war and violence in the cause of liberty" (2011: 22). Adams identifies

> two distinctive features of all liberal epics: first, an apologetic strategy for justifying this war as a worthy exception to a general rule [...]; second, a concerted effort to limit or sanitize the public's access to graphic representations of the liberating soldier-heroes' acts of violence and domination—an effort, moreover, that has foregrounded a concern not to shock. (2011: 5)

Although too recent to be termed "universal," the liberal epic is both multi-national and centuries-long, beginning with the French archbishop Fénelon's Homer-inspired yet war-critical *The Adventures of Telemachus* in 1699 and Alexander Pope's *The Iliad of Homer* (1715). Where Homer presents combat in graphic and arguably glorifying detail, Adams argues that Pope's "concision in translating Homer's violence," "his implicit omission of the nonpoetic material reality of Homer's battle scenes," and his preference for "more distanced and generalizing heroic couplets" and "poetic verbal analogy" "betrays his fundamental objection to epic" (2011: 75).

The superhero genre shares both the objection to and the extended focus on violence. Where liberal epic employs poetic diction to obscure its subject matter, comics achieve similar effects through visual devices. To stop a "blood thirsty aviator" in *Action Comics* #2 (July 1938), Superman leaps in front of a plane; Shuster draws the plane plummeting out of the frame, but instead of its impact and the death of the pilot, the next panel features another

character who "witnessed the crash" (Siegel and Shuster 2006: 28). Batman kills his first adversary on the third page of his first adventure, sending a "burly criminal flying" from the roof a two-story house (Kane et al. 2006: 6). Bob Kane does not draw the presumably fatal impact but does include the criminal's barely discernable body on the sidewalk two panels later.

Though most superhero violence is non-lethal, even the broken noses and bloodied lips that would result from real-world punches often go undepicted. The 1966 *Batman* TV series parodied the comic book norm of sanitized violence by replacing live-action punches with cut-away shots of drawn sound effects such as "POW!!" and "BOFF!!" The stylization literally blocks its own content. Despite the TV parody, superheroes comics maintained the approach. In *Green Lantern Co-Starring Green Arrow* #77 (June 1970), Neal Adams draws soldiers charging across a mine field and then in the next panel entirely obscures their bodies with a bloodless "BLAM" below the caption, "Some die immediately" (O'Neil and Adams 2012: 43). For *Wolverine* #4 (December 1982), Frank Miller depicts the death of a Japanese crime lord through framing and closure effects. In the penultimate panel of the combat sequence, Wolverine's claws are sheathed and his fist hovers in front of the warrior's face; the final panel frames Wolverine's face, partially cropped arm, and the letters "SNIKT," the signature sound effect of his extending claws. Miller does not draw the claws piercing the enemy's head (Claremont and Miller 2009: 95).

Like the liberal epics of Dryden, Byron, Scott, Hayden, and Churchill, which according to Adams "implicitly admit to a deep human pleasure to dominating others—a delight at the surface of Homer—and address the need to control that pleasure" (2011: 12), superhero comics began as an oxymoronic genre of sanitized hyperviolence, pleasing readers by avoiding direct representations of its most central subject matter.

Children's great men fables

Edward Adams also observes an improbable shift in Victorian literature in which "war epic becomes largely a province of childhood and a pleasure reserved for children—or for adults relaxing

into a juvenile mood" (2011: 49). Superhero comics share the same audience—or they did for their first half-century. Sanitized violence dominated the genre from its inception in 1938 through the mid-1980s when the Comics Code increasingly lost its control over the industry. Once Kent Williams painted Wolverine's claws punching through the eyeballs of a random thug in the non-Code-approved *Havok & Wolverine: Meltdown*, the genre could no longer be defined entirely by its pubescent audience (Simpson et al. 1988: #3; 6).

Superhero comics, however, did achieve their defining success in the juvenile market, and the character type may be especially adapted to adolescent readers. In addition to drawing from ancient mythology for their "Shazam" acronym (Solomon, Hercules, Atlas, Zeus, Achilles, Mercury), Captain Marvel creators Bill Parker and C. C. Beck reflected their intended audience through their leading character's alter ego, twelve-year-old Billy Batson in *Whiz Comics* #2 (February 1940). Since puberty typically occurs for girls between the ages of ten and fourteen, and for boys between twelve and sixteen, Parker selected an especially representative age. Every time Billy transforms into the hypermasculine superhero, he enacts a pre-pubescent wish-fulfilment. The puberty metaphor, never far below the surface text, extends across the genre's decades of publications. Stan Lee and Steve Ditko developed it further in 1962 by featuring a teenaged superhero as a title character. After being bitten by a radioactive spider, Peter Parker declares: "What's happening to me? I feel—different! As though my entire body is charged with some sort of fantastic energy!" (Lee and Ditko 2009: 3). Spider-Man's readers may have experienced their bodies' transformations too.

Developmental psychology also provides additional parallels. David Elkind introduced the concept of adolescent egocentrism, a developmental stage that includes the "imaginary audience" and the "personal fable," a belief in one's invulnerability, omnipotence, and uniqueness—traits that describe most superheroes (1967). One textbook makes the analogy explicit:

> Spider-Man and the Fantastic Four, stand aside! Because of the personal fable, many adolescents become action heroes, at least in their own minds. If the imaginary audience puts adolescents on stage, the personal fable justifies being there. [...] It

also includes the common adolescent belief that one is all but invulnerable, like Superman or Wonder Woman. (Rathus 2014: Ch. 15; 8)

Fredric Wertham described a similar "Superman complex," reporting to the 1954 Senate Subcommittee Juvenile Delinquency that comics "arouse in children phantasies of sadistic joy in seeing other people punished over and over again while you yourself remain immune" (U.S. Congress). Wertham argued that the complex was harmful to children's ethical development, but a 2006 study found that the fable's omnipotence correlated with self-worth and effective coping; uniqueness with depression and suicide; and invulnerability with both negative and positive adaptational outcomes (Aalsma 2006: 488). Whatever its developmental effects, the personal fable could also increase reader identification with the superhero character type, providing a further explanation for the popularity of the genre with its original age group.

Lawrence Kohlberg's theory of moral development provides another explanation. Kohlberg outlined six stages, placing twelve-year-olds at the intersection of three. Most children leave stage four by the age of twelve, expanding interpersonal relationships to the rigid upholding of social laws that characterizes stage four conventionality (1981). Twelve is also the earliest age that stage five reasoning appears—though Kohlberg estimates that less than a quarter of adults achieve it or a stage six level of post-conventionality. Superheroes, however, do. As a character type, the superhero evaluates morality independently of governments and legal systems, relying instead on personal judgment based on universal principles. Superman, observes Reynolds, displays "moral loyalty to the state, though not necessarily the letter of its laws" and is willing "to act clandestinely and even illegally" to achieve it (1992: 15–16).

Superheroes are independent moral agents, devoted to a higher good which they alone can define. This is also the general definition of "hero" that coalesced in the first half of the nineteenth century. German philosopher Georg Wilhelm Friedrich Hegel praises "heroes" such as Alexander the Great, Julius Caesar, and Napoleon as

thinkers with insight into what is needed and timely. They see the very truth of their age and their world, the next genus, so to

speak, which is already formed in the womb of time. It is theirs to know this new universal, the necessary next stage of their world, to make it their own aim and put all their energy into it. The world-historical persons, the heroes of their age, must therefore be recognized as its seers – their words and deeds are the best of the age. (Hegel 1953)

Hegel's 1820s' lectures on the philosophy of history were published in 1837, six years after his death, and four years before Scottish writer Thomas Carlyle's *On Heroes, Hero-Worship, and The Heroic in History*, in which Carlyle proposed his "Great Men" theory:

Find in any country the Ablest Man that exists there; raise him to the supreme place, and loyally reverence him: you have a perfect government for that country; no ballot-box, parliamentary eloquence, voting, constitution-building, or other machinery whatsoever can improve it a whit. It is in the perfect state; an ideal country. (1841)

Ralph Waldo Emerson echoed it in his *Representative Men*:

Mankind have in all ages attached themselves to a few persons who either by the quality of that idea they embodied or by the largeness of their reception were entitled to the position of leaders and law-givers. [...] The great, or such as hold of nature and transcend fashions by their fidelity to universal ideas, are saviors from these federal errors, and defend us from our contemporaries. (1844)

Hegel, Carlyle, and Emerson also share assumptions that Adams links to the popularity of the epic: "that wars were the most important of historical events; and that individuals possessed the agency to determine their outcomes" (2011: 34). Beginning in the early nineteenth century, that tradition shifted to juvenile fiction, as authors such as Carlyle and Tennyson rescued "modern faith in heroes by self-consciously appealing to primitive, childish beliefs" (2011: 52). The great man of epic history began its transformation into children's adventure hero in 1844, when French novelist Alexander Dumas described the titular hero of *The Count of Monte*

Cristo as one of a new breed who "by the force of their adventurous genius" is "above the laws of society" (339). Siegel and Shuster drew on the same hero type a century later, transforming so-called great men into the comics genre of superheroes.

Mythical myths

It is impossible to determine why any specific myth or folk tale emerged from its particular cultural context and then survived as an artifact transported through many later contexts, but, as Rollin observes, "Western values have persisted remarkably down through the ages to even the present time through a variety of literary forms and through diverse media" including superhero comics (2013: 98). While superheroes evoke such diverse legends as Achilles, Sampson, and Thor without necessarily reproducing the qualities that made those earlier characters legends, by drawing on contemporary understanding of those characters and their narratives, superheroes reveal a range of commonalities. If superhero comics can be said to achieve a level of universal myth, that myth can be summarized according to the specifically twentieth century, U.S. appeal that first produced it:

> An adolescent-focused micro-epic depicting individual transformation from the ordinary to the morally and minimally counterintuitively extraordinary through violence rendered in a paradoxically violence-obscuring style.

Moving past claims of universality, the next chapter will add one additional formal quality to the comics character, one inherited not from ancient mythology but nineteenth-century colonialism.

II

The Imperial Superhero

Shortly after Jerry Siegel and Joe Shuster's Superman propelled *Action Comics* into an industry-transforming hit in 1938, rival publisher Victor Fox hired Will Eisner to imitate the character. Eisner responded with Wonderman, whom Circuit Judge Augustus Hand declared a copyright infringement: "The only real difference between them is that 'Superman' wears a blue uniform and 'Wonderman' a red one" (Payne 2006). Hand did not comment on the differences between the characters' origins. While Superman is the lone survivor of the planet Krypton, Wonderman is a blond American given a magic ring by a turbaned lama while vacationing in Tibet. Hand considered the difference irrelevant. Both locations serve as a fantastical source for fantastical powers, and once those powers are bestowed, each vanishes from its narrative. But unlike Krypton, Eisner's Tibet is derived from a real-world counterpart. While his imaginary lama was handing out magical treasure, real Tibetans were embroiled in diplomatic disputes with China over national autonomy as a conflict between successive regents was building internally—issues that have no meaning in the world of Wonderman. Eisner's "Tibet" is an orientalist construct, a pulp stereotype inherited and reproduced from a range of writers well before Siegel and Shuster.

Superheroes like Wonderman divide the world into an imperial binary, the relationship articulated by Albert Memmi in his analysis of the colonized as "an alter ego of the colonizer" (1957: 86). There is no American Wonderman without the imaginary "Tibet." "The function of stereotypes," asserts Ania Loomba in her

discussion of the ways in which colonialism reshapes knowledge, "is to perpetuate an artificial sense of difference between 'self' and 'other'" (2005: 55), and that other, writes Robert Young, is "only knowable through a necessarily false representation" (1995: 5). Superhero narratives, as a sub-genre of juvenile fantasy adventure literature, are especially conducive to such imperial representations and divisions. The character type often originates from a perceived "fundamental ontological distinction between the West and the rest of the world," a distinction described by Edward Said in which "'the Orient,' Africa, India, Australia are places dominated by Europe, although populated by different species" (1993: 108). "Empire," Elleke Boehmer similarly observes, signifies "far realms of possibility, fantasy, and wish-fulfillment where identities and fortunes might be transformed" (2005: 26). Eisner's "meek radio engineer" can suddenly find himself "the strongest human on Earth" (1939: 1), a transformation that mirrors empire's claim as a rightfully dominating power over global possessions.

The superhero's imperial roots were established long before the comic book incarnations of the character type. The superhero, as first embodied in England in the Victorian penny dreadful *Spring-Heel'd Jack*, originates as a reflection of English nineteenth-century colonialism. Through adaptations by Edgar Rice Burroughs and other American authors, the superhero evolves into a reflection of U.S. imperialism in the early twentieth century. While personifying empire authority in both the British and American periods, the early superhero owes his origin, powers and plot to colonial peripheries. Drawing from this merged frontier, the superhero absorbs elements of the racial Other, disturbing but not overthrowing the imperial binary as a dual-identity character who employs otherness to maintain the empire's status quo. When Siegel and Shuster created Superman, these tropes were already ubiquitous and then were quickly reproduced in the comic book formula by imitators. After the superhero character type faded from comics in the late 1940s, the genre reemerged in the early 1960s, with its imperial underpinnings intact, but no longer illuminated by their formative context. Contemporary superhero comics remain haunted by that imperial past.

The British superhero

Summarizing the postcolonial critique of nineteenth-century British literature, Ania Loomba declares "no work of fiction written during that period, no matter how inward-looking, esoteric or apolitical it announces itself to be, can remain uninflected by colonial cadences" (2005: 73). The claim applies particularly to the body of literature that produced the pre-comics superhero. Emerging as a sub-genre of juvenile literature, the character type is an amalgamated product of several pre-existing and overlapping genres—juvenile fantasy, adventure, science fiction, detective fiction—each with its own nineteenth-century colonialist ties.

Daphne Kutzer laments how scholars too often ignore children's texts and their role in forming a "national allegory," texts which from the late nineteenth century to early World War II "encourage child readers to accept the values of imperialism" (2000: xiii). Jo-Ann Wallace identifies "the rise of nineteenth-century colonial imperialism" with "the emergence of ... a 'golden age' of English children's literature," a genre of "primarily ... fantasy literature" (1994: 172), with the term "imperialism" coming into popular use during this fantasy age's middle decade of the 1890s (Eperjesi 2005: 7). Edward Said also cites "fantasy" as a primary example of "generically determined writing" that produces and shares orientalism's "cumulative and corporate identity" (1978: 202). Fantasy is especially conducive to imperialist projections, as Elleke Boehmer emphasizes "the way in which the West perceived the East as taking the form of its own fantasies" (2005: 43). When defining "colonial literature," Boehmer offers H. Rider Haggard's 1885 lost world fantasy adventure *King Solomon's Mines* as her representative example of a novel "reflecting a colonial ethos" and "the quest beyond the frontiers of civilization" as a defining motif of all colonial literature (2). Jeffrey Richards views adventure literature as "not just a mirror of the age but an active agency" that energized and validated "the myth of empire as a vehicle for excitement, adventure and wish-fulfillment through action" (1989: 2–3). John Rieder similarly observes how "the Victorian vogue for adventure fiction in general seems to ride the rising tide of imperial expansion," while "the period of the most fervid imperialist expansion in the late nineteenth century is also the

crucial period for the emergence of" science fiction (2008: 4, 2–3).
Patricia Kerkslake reads science fiction as an exploration of "the
notion of power formed within the construct of empire, especially
when interrogated by the general theories of postcoloniality"
(2007: 3). Caroline Reitz applies a parallel approach to detective
fiction, reading the figure of the detective "as a representative of
the British Empire" who rose in popularity as Victorian national
identity shifted "from suspicion of to identification with the
imperial project" (2004: xiii). Dudley Jones and Tony Watkins
critique not only the adventure story for its associations "with
colonizing pioneers and ethno-centric notions of racial superiority"
(2000: 13), but the multi-genre figure of the hero whose "notions
of exemplary value ... influenced children's literature through
the nineteenth century and well into the twentieth" and whose
"moral virtues ... were always articulated through the ideological
frameworks of gender, imperialism, and national identity" (4). By
combining these genres, the superhero is a depository and melding
point for a multitude of imperial tropes and attitudes.

The earliest known manifestation is Spring-Heeled Jack who,
paralleling Britain's expansion from an empire of chartered entre-
preneurs to one of direct governance, appeared in "at least a dozen
plays, penny dreadfuls, story paper serials, and dime novel stories"
(Nevins 2005: 821). Inspired by sensational newspaper accounts of
a demonic assailant, John Thomas Haines brought the character to
stage in 1840, followed by Alfred Coates's 1866 penny dreadful.
Alfred S. Burrage reimagined the character for two serials, the
first also in 1886. John Springhall lists Spring-Heeled Jack among
several highly popular penny dreadful characters (1994: 571), part
of what Sheila Egoff identifies as a "brand of fantasy" that grew
because boys "had little else to read in the adventure line after
they had read *Robinson Crusoe*" (1980: 414). "In format, illus-
tration, content, and popularity," writes Egoff, such serial stories
in boys' sensational magazines "were matched only by the rise and
influence of the comic book in the mid-twentieth century" (413).
Peter Coogan acknowledges the character as the first "to fulfill the
core definitional elements of the superhero" (2006: 177), and Jess
Nevins declares him "the source of the 20th century concept of the
dual identity costumed hero" (2005: 822).

It is striking then how deeply Spring-Heeled Jack is immersed in
colonial narratives. In Alfred Burrage's first treatment, Jack's father

is "a younger son" who "as was frequently the case in those days
... had been sent out to India to see what he could do for himself"
(1885: n.p.). "[F]ortunes could be made in India by any who had
fair connection, plenty of pluck, and plenty of industry," and so
Jack's father "managed to shake the 'pagado tree' to a pretty fair
extent," resulting in his ownership of "plantation after plantation
in the Presidencies." After his death, the family's lawyer plots with
Jack's cousin to cheat Jack of his inheritance, including "the Indian
plantations." The outlying colonial possessions both initiate the
plot and provide its fantastical solution. Jack explains:

> I had for a tutor an old Moonshee, who had formerly been
> connected with a troop of conjurers ... this Moonshee taught
> me the mechanism of a boot which ... enabled him to spring
> fifteen or twenty feet in the air, and from thirty to forty feet in
> a horizontal direction.

With the aid of this "magical boot" which "savoured strongly of
sorcery," Jack robs his enemies until his inheritance is restored. The
old Moonshee (or *munshi*, an Urdu term for a writer which became
synonymous with clerks and secretaries during British rule) is the
first incarnation of Wonderman's turbaned Tibetan, both variants
of the magical mentor type transposed to a colonial setting. In both
cases, a Westerner takes an Asian's fantastical object to gain power
at the metropolitan center of the empire, or metropole. Although
narratively a hero, "Jack, who had been brought up under the
shadow of the East India Company, had not many scruples as to
the course of life he had resolved to adopt. To him pillage and
robbery seemed to be the right of the well-born."

As one of the first dual-identity heroes, Jack also imports a
secondary persona that is not only contrastingly alien to his primary
self but magical and demonic. As Richard Reynolds observes of the
comic's superhero character type: "His costume marks him out as
a proponent of change and exoticism," but because of his split
self he "is both the exotic and the agent of order which brings the
exotic to book" (1992: 83). Robert Young similarly notes how
many nineteenth-century novels "are concerned with meeting and
incorporating the culture of the other" and so "often fantasize
crossing into it, though rarely so completely as when Dr Jekyll
transforms himself into Mr Hyde" (1995: 3). So complete a binary

transformation, while rare in other genres, is one of the defining
tropes of the comic's superhero, where a Jekyll-controlled Hyde
defines what Marc Singer identifies as "the generic ideology of the
superhero" in which "exotic outsiders ... work to preserve" the
status quo (2002: 110).

Jack's relationship to the racial Other expresses itself beyond
his Indian-powered and devil-inspired disguise. Due to his colonial
childhood, Jack is no longer simply European: "'I am not yet sixteen,
but, thanks to my Oriental birth, I look more like twenty.'" He
has been altered by living away from his empire's center. Jack has
absorbed an element of the alien, a dramatization of how imperial
culture is inevitably altered by the cultures it dominates. Looking
at recent conventions in science fiction, Kerslake proposes that
"extreme travel must render the traveler into a different form" as
"a component of Othering" (2007: 17). If "the place of departure
is the traveler's cultural 'centre,'" Kerslakes asks "how far a person
must now proceed before he or she reaches the indefinable edge
of a nebulous periphery" or, more simply, "At what point do we
become Other?" (18). The figure of the superhero embodies this
question.

Spring-Heeled Jack also established the trope of the non-European
mentor of a European protagonist, one more widely popularized by
Kipling's *Kim* (1901), a novel Said classifies with works of Conan
Doyle and Haggard in "the genre of adventure-imperialism"
(1993: 155). Kipling depicts "a guru from Tibet" who needs an
English boy in order to achieve his life quest, and Kim in turn
treats him "precisely as he would have investigated a new building
or a strange festival in Lahore city. The lama was his trove, and
he purposed to take possession" (Kipling 1998: 6, 13). While no
superhero, Kim does, in Said's analysis, possesses a "remarkable
gift for disguise" and fulfills "a wish-fantasy of someone who
would like to think that everything is possible, that one can go
anywhere and be anything," a "going native" fantasy permissible
only "on the rock-like foundations of European power" (1993:
158, 160, 161).

Spring-Heeled Jack emerged during England's expansion as
an imperial power and, after numerous Victorian publications,
vanished during the British Empire's transition from traditional
colonies to self-governing but British-dominated settler nations.
Australia gained dominion status in 1901, followed by Canada,

Newfoundland, and New Zealand in 1907. Anxiety over this transition can be seen in Baroness Orczy's 1905 *The Scarlet Pimpernel*—the most cited of early superhero texts—in which the plot-driving periphery contracts to France and the threat of a newly independent, democratic mob. Similarly, when Burrage reinvented Spring-Heeled Jack for his 1904 serial, he removed the character from his Indian origins and recast him in relationship to the Napoleonic wars. The post-Victorian serial was discontinued before it reached narrative closure (Nevins 2005: 824).

Martin Green argues that "Britain after 1918 stopped enjoying adventure stories" because such narratives "become less relevant and attractive to a society which has ceased to expand and has begun to repent its former imperialism" (1984: 4). In contrast, the United States continued as "a world ruler," making the adventure story "a peculiarly American form" (4–5). The British Empire and the British superhero halted together, but the narrative type and its colonialist underpinnings were adopted by American authors as the United States pursued its own imperial ambitions.

American supermen

In 1893, Frederick Jackson Turner proposed that American history "has been in a large degree the history of the colonization of the Great West" (1920: 1). In 1898, the United States fought its last battle with native tribes and took possession of the Philippines, Puerto Rico, and Guam. To expand its naval capabilities, it instigated the 1903 secession of Panama from Columbia and the construction of the Panama Canal. When *All-Story* serialized Edgar Rice Burroughs' first novel, *Under the Moons of Mars* in 1912, the canal was still two years from completion, but the U.S. was already a global power.

Burroughs' pulp hero, John Carter, personifies American imperialism. Coogan identifies him as "the first wholly positive [science fiction] superman and the model for science-fiction heroes of the next few decades" (2006: 135). Carter is also one of the first characters in twentieth century literature with superhuman strength, one who Eric Mein likens to "Superman in a world without kryptonite" (2006: 43). This "strange metamorphosis"

(19) is the direct product of what Fred G. See terms Carter's "imperial adventure" (1984: 59). A "soldier of fortune," the former Captain of the Confederate Army begins his narrative "determined to work [his] way to the southwest and attempt to retrieve [his] fallen fortunes in a search for gold" (Burroughs 1983: vi). His prospecting and resulting battle with a band of Apaches triggers his magical, death-like leap to the planet Mars, where he becomes a fantastical embodiment of Memmi's colonizer. Though he "lands just by chance," it does not "take him long to discover the advantages of his new situation," and though "repelled by its climate, ill at ease in the midst of its strangely dressed crowds, lonely for his native country," he accepts "these nuisances and this discomfort in exchange for the advantages of the colony" (Memmi 1957: 4).

Like Spring-Heeled Jack, Carter is altered by his travels, but Burroughs emphasizes the role of the colonial frontier by making the transformation dependent on the foreign environment. Carter's powers are a product of "the lesser gravitation and lower air pressure on Mars" so that "a very earthly and at the same time superhuman leap" carries him "fully thirty feet into the air and landed [him] a hundred feet" away, doubling the reach of Spring-Heeled Jack's Moonshee boot (Burroughs 1983: 21, 23–4). Memmi's colonizer also wishes for "the disappearance of the usurped" (1957: 52), a fantasy that Burroughs supplies by making Mars a planet of ruins. The fact that the cities of Barsoom—the quasi-Oriental-sounding name Burroughs coins for the planet— are "deserted metropolises of an ancient Martian civilization" establishes Carter's right of exploitation (50). Mars' cultural stasis exemplifies the "anthropological fantasy" that Rieder identifies at "the intersection of colonialism and science fiction" (2008: 32, 30). "Although we know that these people exist here and now," explains Rieder, "we also consider them to exist in the past" (32). Burroughs' Barsoom actualizes this impossible, colonialist mindset. Sharon DeGraw describes "Burroughs' choice of an interplanetary setting" as evidence of a "specifically American bias"; "While the United States was a colonial and imperial power, like its Old World predecessors," argues DeGraw, "Americans ... chose to ignore their own imperial attitudes and activities or interpret them in a more benevolent light than that of other European peoples" (2007: 28).

Burroughs follows similar strategies in *Tarzan of the Apes*, published by *All-Story* eight months after *Under the Moons of*

Mars and a core source for later superhero creators. Like Barsoom, Burroughs' West British Africa is a colony arrested not only in the ancient past, but, as Rieder describes anthropological fantasy, specifically "our own past" (2008: 32). Africa is a "primeval world" "wrapped in Cimmerian darkness" that "our ancestors of the din and distant past faced" (Burroughs 1999: 17, 160, 19). Tarzan's father wonders if it is even "the same primeval forests" unaltered after "Hundreds of thousands of years" (19). Although Jane's father is searching for "an unthinkably ancient civilization, the remains of which lay buried somewhere in the Congo valley" (167), Burroughs populates his lost world with a species of "anthropoid ape," "the most fearsome of those awe-inspiring progenitors of man" (24, 32). Although they use language and play drums, the anthropoids are most "closely allied to the gorilla," and so are a living yet somehow unchanging evolutionary link (24). Their religion is the same practiced by "our fierce, hairy forebears ... of the long dead past" (60). Such a frozen culture reflects what Said identifies as the "central argument" of orientalism, "the myth of the arrested development of the Semites" that justifies colonial enterprises (1978: 307).

Jeff Berglund emphasizes that *Tarzan of the Apes* was set "during the height of British imperialism and during the escalation of the United States' own empire-building" and so works to "re-establish the authority of imperial power" (1999: 79). The British–American imperial link is further evidenced in Burroughs' acknowledgment of Kipling's 1894 *The Jungle Book* as one of his primary influences, only with mythic Africa substituted for colonial India (Lupoff 2005: 157). Burroughs also evokes the "British Colonial Office" as the grounding for his tale's authenticity and as the motivation that initiates its plot (1). Tarzan's father is "commissioned to make a peculiarly delicate investigation of conditions in a British West African Colony," resulting in his family being marooned and the infant Lord Greystoke adopted by an ape mother (2, 39). The first humans Tarzan encounters are a victimized tribe of cannibals whose "cruel savagery" is worsened by "the poignant memory of still crueler barbarities practiced upon them and theirs by the whiter officers of that arch hypocrite, Leopold II of Belgium, because of whose atrocities they had fled the Congo Free State" (200–1). Although the reference suggests a critique of colonialism, Burroughs is evoking a single regime condemned by

other colonial powers in implied contrast to their own practices. Leopold II ruled Belgium from 1865 to his death in 1909, the year Burroughs sends the Porters to Africa. He is infamous for founding the Congo Free State as a private colony in 1885—three years before the Greystokes sail to Africa—and for the exceptionally brutal treatment of its inhabitants. After the deaths of millions, the international community forced him to relinquish control of the colony in 1908. Conan Doyle published *The Crime of the Congo* the following year, dubbing Leopold and his followers' crime "the greatest which has ever been known in human annals" (1909: iii), the attitude also adopted by Burroughs.

Rather than repudiating colonialism, Doyle and Burroughs urge the U.S. to greater imperial action. While Doyle views the U.S. as a colonial partner, Burroughs imagines his country as an heir meant to revitalize England's softening empire. When Doyle calls for America and Britain to aid "their wards" in the Congo (iv), Burroughs responds with a colonial narrative that champions the transformative powers of the colonial periphery to counteract the dissipation of the British metropole. Although Tarzan's aristocratic mother "does [her] best to be a brave primeval woman," she is rendered insane by her new environment and dies under the delusion that she never left London (19). Tarzan's father is duty bound to the "interest of vested authority," and his circumstances render him "unaccustomed [to] labor" (8, 27). Only Tarzan, born "frail and delicate" but "nursed at the breast of Kala, the great ape," can grow to "physical perfection" (37, 34, 128). Though Burroughs ridicules the British aristocracy and has Jane declare that she could never marry "a titled foreigner," he also declares that the "aristocratic scion of an old English house" has "the blood of the best," in need only of a frontier wilderness to turn him into a "demi-god" and deserving ruler (165, 40, 50, 110).

Eric Cheyfitz declares Tarzan "a new American superhero," and his desire to transform himself to suit his future bride articulates "the deepest desires of U.S. foreign policy toward the Third World" since Teddy Roosevelt (1991: 4, 3). Paralleling Tarzan's allegorical meaning for U.S. imperialism, the character is one of the most influential in the superhero genre. Burroughs declares Tarzan a "superman," one who "transcends our trained athletes and 'strong men' as they surpass a day old babe" (226, 228). Tarzan, writes Berglund, is an "American Adam," the quintessentially "self-made

man" of American mythology (1999: 101, 100). Like Spring-Heeled Jack, Tarzan retains his otherness after leaving the colonies, but rather than sailing to England to reclaim his lost estates from his own usurping cousin, Tarzan follows Jane to Baltimore and Wisconsin in the hopes of marriage. With that union, and its turning away from England, England's imperial project is figuratively transferred to the U.S.

Imperial expansion

New American supermen proliferated after Burroughs, appropriating superpowers from a range of non-Western locations, including Africa, Antarctica, Central America, Middle East, Asia, and Australia.

Hugo Danner, the "super-child" and "invulnerable man" of Phillip Wylie's 1930 *Gladiator*, is "like a man made out of iron" who runs "like an express train" and "move[s] in flying bounds" (Wylie 2004: 18, 51, 46). Siegel reviewed the novel for his high school newspaper in 1932—the same year he claimed to have created Superman—and the resemblance between the two characters was so strong that Wylie threatened a lawsuit (Jones 2004: 82, 110, 80). Although Danner's powers result from an in utero injection, his displays of strength trigger Native American identification: Professors mistake his play fort of boulders as the work of a "lost race of Indian engineers" (54); a fellow student asks, "You aren't an Indian, are you?" when Danner carries a large trunk without tiring (68); during the Great War, he becomes an "Indian scout" and single-handedly kills thousands of Germans (191). Although a "Scotch Presbyterian for twenty generations," the transformed Danner is linked instead to the colonized past of his birthplace, Indian Creek, Colorado. After a life of relentless frustration, Danner joins an expedition to a lost Mayan city where he experiences "a sense of recognition" and "home-coming" (321, 322).

Gladiator is followed by a range of 1930s' mystery men. Walter Gibson's Shadow, the most popular pulp and radio mystery man of the thirties, "went to India, to Egypt, to China ... to learn the old mysteries that modern science has not yet rediscovered, the natural

magic" (Gibson and Bierstadt 1937). When Harry Earnshaw and Raymond Morgan created *Chandu the Magician* for radio and film, they sent their secret agent to India to gain supernatural powers from yogis. Lee Falk's Mandrake the Magician, another Tibetan-powered American, is accompanied by Lothar, an African prince dressed in a Tarzan-copied leopard skin plus a Turkish fez. Falk's Phantom gains his dual identity in the fictional Asian country of Bengalla—which Falk later transposes to Africa, literalizing the interchangeability. Even Lars Anderson's softporn superheroine the Domino Lady was "thrilling in a Far Eastern trip" when the transformative news of her father's murder turns her into a costumed avenger (2004: 21). In each case the colonial periphery is redirected for the good of the metropole. As Said observes of the early twentieth century, "now the Orient must be made to perform, its power must be enlisted on the side of 'our' values, civilization, interests, goals" (1978: 208).

Lester Dent's 1933 Doc Savage reflects a specifically American brand of imperialism when he travels to "the Valley of the Vanished" to find a "lost clan of ancient Mayans" believed extinct since Spanish colonization (2008: 38, 17). Already part-other from his abilities and his ambiguously bronze skin, Savage refuses marriage with a princess and returns to the metropole with a gift of Mayan gold to finance his do-gooding missions. In this rendering of the colonial dynamic, colonized subjects, while still providing the narrative's foundation, are kept willingly hidden in a static preserve seemingly unrelated to any actual Indians within the borders of a contemporary United States. Unlike late nineteenth-century British colonialism, early twentieth-century American imperialism evolved from a myth of the frontier as a free and unpopulated periphery, requiring the colonized Other to vanish. Where *Spring-Heel'd Jack* refers openly to abusive colonial practices, American superhero narratives avoid acknowledgment of empire, representing what John Carlos Rowe identifies as the nation's "contradictory self-conceptions" in which "Americans' interpretations of themselves as people are shaped by a powerful imperial desire and a profound anti-colonial temper" (2000: 3).

When Siegel and Shuster entered the comic book industry in the mid-1930s, the tropes of imperial superheroism were already ubiquitous. Superman takes his origin from the lost world motif, a science-fiction variation on the fantasy genre introduced

by H. Rider Haggard in 1885, one of several narratives of "triumphalism" which, "far from casting doubt on the imperial undertaking," argues Said, "serve to confirm and celebrate its success" because heroes "find what they're looking for, adventurers return home safe and wealthier" (1993: 187). The lost world motif also produced the most immediate source of 1930s Oriental exoticism, Shangri-La, the magical Himalayan city of the 1933 James Hilton novel and 1937 Frank Capra film *Lost Horizon*. It features a semi-immortal High Lama who recruits a European American to be his heir and rule the secret mountain paradise—a source point for Wonderman and other comic book superheroes.

After the frontier of Krypton was destroyed and its lone survivor adopted Tarzan-like for the benefit of Metropolis, imperial supermen inundated newsstands. Having discontinued Wonderman and his Tibetan powers after DC's injunction, *Wonder Comics* #2 (June 1939) features another Will Eisner creation, Yarko the Great, with his orientalist inspiration foregrounded in the hero's amulet-crested turban. Donald Markstein documents Yarko as one of a dozen Mandrake-inspired comic book magicians to appear between 1938 and 1941; nine of the characters wear Chandu-copied turbans, one a fez, and three are assisted by Asian servants. Another half dozen comic book superheroes of the same period also receive orientalist origins for their powers, three involving Tibet. Egypt contributes its own subset of characters, with archeologist superheroes traveling the periphery from the Middle East to Central America.

William Marston and Harry Peter's Wonder Woman and Bill Everett's Sub-Mariner, an Amazon princess from an island hidden in former colonial waters and an Atlantean prince from an underwater homeland encroached on by land-dwellers, respectively, further incorporate imperial origins into some of the most popular pre-Code superheroes. For Captain Marvel, C. C. Beck and Bill Parker created the wizard Shazam, whose acronymic name begins with the Middle Eastern Solomon. In his first year, Batman faces eastern European vampires, fez-wearing henchmen, and a band of fake Hindus seeking "an ancient Hindu idol, Kila, the God of Destruction" (Kane et al. 2006: 87). Even the *Arabian Nights*—"shorthand for magic and the exotic" since the mid-nineteenth century (Boehmer 2005: 43)—is recycled in Bill Finger and Martin Nodell's Green Lantern. The simplified visual and narrative formulas of children's comic books were a fertile

outlet for the larger culture's unexamined biases. "It is as if," writes Said, "... a bin called 'Oriental' existed into which all the authoritative, anonymous, and traditional Western attitudes to the East were dumped unthinkingly" (1978: 102).

New frontiers

Superheroes' popularity declined with World War II, largely vanishing by the early 1950s. When the genre resurged a decade later, it was in a neocolonial context that disguised, but did not erase its imperial roots. When DC reintroduced Green Lantern in 1959, John Broome and Gil Kane superficially transposed the character's *Arabian Nights*' antecedents to outer space through the trope of a dying alien who, like so many orientalist predecessors, gives superpowers to a white hero. The revised Lantern also received an Inuit sidekick, but the genre's colonial frontier shifted to Earth's upper atmosphere with Joe Gill and Steve Ditko's 1960 Captain Atom, a rocket technician who acquires his powers after accidentally launched and atomized in an explosion. Ditko soon moved from Charlton to Marvel Comics, where he, Stan Lee and Jack Kirby, the most celebrated creators of the 1960s, further distanced superheroes from their nineteenth-century roots.

Adventurers still returned from far realms of possibility with identities triumphantly transformed, but where earlier American imperial tales relied on the myth of a free and unpopulated periphery, outer space actualized the colonial wish for the disappearance of the usurped. Superman's Krypton and Wonderman's Tibet are interchangeable in their imperial implications, but the Fantastic Four visit a frontier free of racial Others. Cosmic rays bestow superpowers without the exploitation of a culture beyond the metropole. Jeffrey Kripal discusses the fantasy and superhero genres' need for "a Somewhere Else, an Other" that is "distant or foreign to Europe," such as Tibet which by the late nineteenth century had "taken central stage, primarily through British colonialism" (2011: 31, 41). Beginning with Superman, however, Kripal observes a shift from mysticism to science fiction, "from the mytheme of Orientation to Alienation" (73), and then in the 1960s

to the mytheme of Radiation as "a kind of spiritual power or mystical energy" (125).

Because the source of a hero's powers is relocated inside the metropole, the new trope revised the imperial binary and so the formerly transformative frontier faded. The origin tales of the Hulk, Spider-Man, Ant-Man, Wasp, Daredevil, and the X-Men require no travel outside the United States. For Thor, the hero's alter ego is only "vacationing in Europe" (Lee et al. 2011: 115), and although captured in South Vietnam and aided by Don Heck's stereotypically drawn Professor Yinsen, Tony Stark uses the magic of his own American technology to transform himself. This movement away from frontier narratives paralleled the larger global shift away from formal colonialism in the 1950s and 1960s. Seventeen former French, British, and Belgian colonies emerged as independent nations in 1960 alone, most in Africa. When Lee and Kirby did venture into that former periphery in 1966, the fictional and never colonized nation of Wakanda maintains control of its magical technology instead of giving it to a white visitor, producing comic books' first African superhero, Black Panther.

Despite such changes, imperialism continued both within U.S. foreign policy and the superhero narratives that reflected it. While advocating decolonization, the United States expanded its neocolonial control of emerging nations, relying on economic exploitation rather than military occupation. Former orientalist tropes of the penny dreadfuls and pulps continued in comics too. The 1961 Doctor Droom, Stan Lee and Jack Kirby's first Marvel superhero, gains his powers from a Tibetan lama. Kirby even gives Droom stereotypically slanted eyes and a Fu Manchu moustache as the lama explains: "I have transformed you! I have given you an appearance suitable to your new role!" (Lee et al. 2011: 40). Lee reused the imperial origin story for the villain Doctor Doom in 1961 and then Doctor Strange in 1963, sending another American to Tibet to return with magical powers and an Asian servant, as did Peter Morisi for Charlton Comics' 1966 Thunderbolt—a Tibetan origin to be reproduced yet again by Alan Moore and Dave Gibbons for the Thunderbolt-based Ozymandias in *Watchmen*. Joe Gill and Frank McLaughlin's Charlston Comics character Judomaster debuted in 1965. Arnold Drake and Carmine Infantino created Deadman for DC in 1967; the character is turned into a superhero by a Hindu god who resides in a mystical Tibetan city

called Nanda Parbat—a variation on the actual Nanga Parbat mountain in the Pakistan portion of the Himalayas. Dennis O'Neil and Neal Adams introduced Ra's al Ghul and his League of Assassins to *Batman* in 1971. Beginning in 1974, the Roy Thomas and Gil Kane Iron Fist travels to another mystical Asian city where he gains superpowers and returns to the United States to become a superhero. Like the nation of Wakanda, the city of K'un-L'un is a fictional location, but one derived from such a thinly disguised real-world counterpart—the Kunlun Mountains form the northern edge of the Tibetan Plateau—that the mytheme of Orientation is defining.

If the critiques in Said's *Orientalism* filtered into comics, they lessened but did not eradicate superheroes' original Orientation. Expanding on Frank Miller's 1985 *Batman: Year One*, the twenty-first-century Batman of Christopher Nolan's 2005 *Batman Begins* travels to the Himalayas to learn his skills from a martial arts mentor and future adversary; Nolan's Joker in *The Dark Knight* (2008) is likened to a Burmese anarchist, figuring Batman as the embodiment of imperial order. Tibet also appears in the recent superhero films *Chronicle* (2012), *Iron Man 3* (2012), *X-Men: Days of Future Past* (2014), *Doctor Strange* (2016), and the TV shows *Arrow* (2014–15), *Agents of S.H.I.E.L.D.* (2014–15), and *Iron Fist* (2017). "How does Orientalism transmit or reproduce itself from one epoch to another?" asks Said (1978: 15). In the case of superheroes, it is through the unexamined repetition of fossilized conventions that encode the colonialist attitudes that helped to create the original character type and continue to define it in relation to imperial practices.

Looking beyond overt orientalist allusions, Claire Pitkethly recognizes the imperial binary as a defining trait still in the contemporary character type. The superhero, she writes, "straddles the boundary of a duality or opposition" and so "incorporates a paradox or contradiction, and it is the dynamic tension that results from this split that makes him or her a *super*human" (2013: 25, 28). The next chapter will explore this split further by examining the superhero hybridity that developed as racial anxiety shifted from colonialism to eugenics.

III

The Wellborn Superhero

The dual-identity hero—millionaire playboy by day, crime-fighting do-gooder by night—is one of the most enduring staples of American comic books, most famously embodied by Bob Kane and Bill Finger's 1939 Batman. The hybrid figure, however, originates decades earlier and encompasses a multi-generic, transatlantic array of texts unified by the central trope of controlled, individual transformation employed for social good. Early literature of the dual-identity hero spans not only comic books but plays, silent film, radio, popular novels, and pulp fiction magazines, in an expanse of genres that, in addition to superhero narratives, includes adventure, western, crime, science fiction, and romance. While these characters have no single point of origin and influence, the superhero's duality evolved within cultures that exhibited a larger preoccupation with superhuman transformation.

The contemporary comic book superhero character type is, in part, an inheritance from the British and American eugenics movements of the early twentieth-century. "[R]egardless of the literary form in which it is presented," write Lois A. Cuddy and Claire M. Roche in *Evolution and Eugenics in American Literature and Culture, 1880–1940*, "the Darwinian way of seeing the world and human life had taken root," and science "empowered upper-class, educated, white men to enjoy the only thing they could believe with absolute certainty: their own pre-eminence in a world of constant change" (2003: 47). While Bruce Wayne continues to embody that pre-eminently upper-class white man championing the status quo, the generative context of the original, privileged,

dual-identity heroes is mostly lost in contemporary renderings of the character type.

Evolution, devoid of the protective hand of Providence, presented two assaults to late nineteenth- and early twentieth-century social structures: degenerates from below and degeneration from within. "Superman" was the solution to both. Although the name is most associated with the comic book character, superman was the central term of eugenics introduced by George Bernard Shaw in 1903 (with only a tangential reference to Nietzsche). The hybrid figure of the dual-identity hero also expanded at this cultural moment when many eugenicists were popularizing Gregor Mendel's principles of hybridization. Beginning with Baroness Orczy's *The Scarlet Pimpernel*, supermen of aristocratic birth rescue the ruling class by metaphorically blending their identities with the objects of their fear. Refiguring gothic tragedies of inter-breeding into narratives of triumph, the dual-identity hero—part wellborn, part criminal commoner—absorbs the threat of the unfit, while simultaneously improving the wellborn by purging the upper class of its degenerative parasitism. By transforming the idle rich into noble adventurers, eugenic hero narratives safeguard their class' inheritance as rightful rulers. Where selective breeding promised the eventual biological transformation of the ruling class into a ruling race of supermen, fantastical supermen of genre litera-tures popular before comic books delivered the eugenic future in a single bound.

As the most influential dual-identity superman, Orczy's Scarlet Pimpernel established hybridity as a paradoxically reactionary trait for the wellborn hybrids to follow in the emergent genre. As eugenics widened its cultural hold, hero hybridization expanded, particularly into pulp fiction, manifesting a range of iconic characters that include Tarzan, the Gray Seal, and Zorro. When eugenics declined in the late 1920s, the hero formula mirrored that change too. As the superman found its ultimate expression in Nazism, a race of artificially evolved superhumans shifted from societal goal to societal threat. While still maintaining cultural fascination with the figure of the superman, 1930s' pulp fiction subverted the marriage plot to isolate superhuman heroes and thwart narratives of reproduction. In their final comic book incar-nations, supermen abandoned eugenics to defend the egalitarian principles the movement had opposed.

THE WELLBORN SUPERHERO 51

Early comic book creators were not directly responding to eugenics, but the pseudo-science provided the name and the cultural foundation for their new genre. *Action Comics* was not the superman's first embodiments but its last. Where the imperial binary discussed in the previous chapter distanced the racial Other along a colonial periphery, eugenics figures the racial Other as the degenerate threatening the metropole from within. This chapter's analysis of the wellborn, dual-identity hero in another of its original contexts reconstructs the superhero genre's evolutionary foundation and reveals eugenics' enduring presence in the comics tradition.

On the origin of supermen: 1883–1905

Articulating resistance to eugenics in 1928, Waldemare Kaempffert wrote in the *New York Times* that selective breeding "would establish an artificial aristocracy, which, like all aristocracies, would seek to perpetuate itself" and, therefore, "[s]pecimens of humanity that fail to meet the aristocratic standards [would] become 'weeds'" (1928: 72). The objection, while common in the 1930s, had been eugenics' primary rationale: humanity needed to be weeded.

Social philosopher Sir Francis Galton, cousin of Charles Darwin, coined "eugenics" in 1883, the year Friedrich Nietzsche published *Also Spake Zarathustra*. The term is a translation of "wellborn" into Latin. After researching the alumni records of Oxford and Cambridge, Galton argued for the inherited intellectual superiority of English families such as his own and theorized that the human race could be improved through the selective breeding of their bloodlines. Nietzsche, responding to a similar evolutionary impulse, coined "Ubermensch" to name one such race of intentionally evolved humans.

The superman's eugenic and literary incarnations were conceived to battle the same threat. Analyzing "the shock Charles Darwin caused with his theory of evolution," Andreas Reichstein concludes that "the Batman myth" and its Jekyll–Hyde duality "exemplify the fear Darwinism generated" in the last decades of the nineteenth century (1998: 346). H. G. Wells imagined humanity replaced by

the "Coming Beast," "some now humble creature" that "Nature
is, in unsuspected obscurity, equipping ... with wider possibilities
of appetite, endurance, or destruction, to rise in the fullness of time
and sweep *homo* away" (2000: 12).
 In addition to battling other species, Victorians feared that
human evolution could reverse. E. Ray Lankester in his 1880
Degeneration: A Chapter of Darwinism dismisses the "tacit
assumption of universal progress" as "unreasoning optimism,"
reminding readers that "the white races of Europe ... are subject
to the general laws of evolution, and are as likely to degenerate as
to progress" (1880: 59–60). "Possibly," Lankester warns, "we are
all drifting, tending to the condition of intellectual Barnacles" (60).
In addition to "criminals, prostitutes, anarchists, and pronounced
lunatics," argues Max Simon Nordau in 1895, degeneration
could manifest even within the most wellborn. By broadening
his definition to encompass any "contempt for traditional values
of custom and morality," Nordau includes the example of "a
king who sells his sovereign rights for a big cheque" (1895: 6).
Bloodlines could be insulated, but the wellborn themselves might
be the source of the crisis. "Any new set of conditions occurring to
an animal which render its food and safety very easily attained,"
writes Lankester, "seem to lead as a rule to Degeneration" (1880:
33). He likens the phenomenon to how "an active healthy man
sometimes degenerates when he becomes suddenly possessed of a
fortune" or how "Rome degenerated when possessed of the riches
of the ancient world" (33). The problem is wealth and the "habit of
parasitism" it produces: "Let the parasitic life once be secured, and
away go legs, jaws, and eyes; the active highly-gifted crab, insect,
or annelid may become a mere sac, absorbing nourishment and
laying eggs" (33). Degeneration therefore threatened the wellborn
on two fronts: infection from below and decay from within.
Eugenics' superman defended against both.
 Advocates such as Shaw applauded the botanically engineered
"changes from the crab apple to the pippin" and called for an appli-
cation to human reproduction (1928: 182). Mendel's seminal study
in plant hybridization, while independent of Darwinism, supplied
eugenicists a scientific foundation. Originally published in 1865,
six years after *On the Origin of Species*, Mendel's "Experiments
on Plant Hybridization" was first translated into English in 1901.
Though not all eugenicists agreed on the application of Mendel's

ideas, his essay become one of the international movement's most influential texts. Applying his "transformation experiments" to the study of metabolic disease in 1902, British physician Archibald Garrod revealed the possibility that a range of human traits could be hereditary and therefore manipulated; like Mendel, eugenicists sought "the transformation of one species into another by artificial means" (Mendel 1865: 39, 36). Projects expanded simultaneously on both sides of the Atlantic, disseminating Mendel's ideas to the broader cultures. In 1903, the American Breeders' Association formed to promote wide-scale selective breeding and eliminate such degenerate traits as feeblemindedness, promiscuity, criminality, insanity, and poverty. In 1904, Galton founded the School of Eugenics at University College in London, and the Carnegie Institute funded the creation of the Station for Experimental Evolution and the Eugenics Record Office in Cold Spring Harbor, Long Island.

George Bernard Shaw and Baroness Emma Orczy wrote at this critical moment when the varied field of eugenics was transitioning from theory to application. *Man and Superman* was published in 1903, the year that *The Scarlet Pimpernel* premiered at Nottingham's Theatre Royal. Two years later, *Man and Superman* premiered at the Royal Court Theatre in London, as Orczy's newly published novel, *The Scarlet Pimpernel*, reached bookstands. Tamsen Wolff, in *Mendel's Theatre*, identifies Shaw as "an ardent eugenicist," one who attended Galton's lectures and communicated with Karl Pearson, "the leading disciple of Galton," while writing *Man and Superman* (2009: 41–2). "Shaw," writes Keum-Hee Jang, "accepted Galton's eugenic religion as a supplement to conventional religion," arguing that "Shaw's view of social change cannot be explained in isolation from his thought on evolution and eugenic debate in the Victorian context" (2007: 232). While his ideas are distinct from Galton's and Pearson's, and his belief in a life force is opposed to Darwin's natural selection, Shaw brought eugenic theories of heredity into the literary mainstream.

Less biographical information is available on Orczy, but she did experience personally the fears that eugenics embodied, that the wellborn would lose their birthright to expanding lower classes. The Baroness was an aristocrat in the Austrian–Hungarian Empire; she had lost her family estate and inheritance during a peasant revolt. Her family was forced to flee its homeland, eventually

residing in England, where Orczy began her writing career with a
hero who assumes an alias to rescue fellow aristocrats from French
revolutionaries. Her first novel is today one of the most influential
texts for the superhero genre, and she is often cited as the origi-
nator of the dual-identity hero. Gary Hoppenstand traces Orczy's
influence from "Johnston McCulley's Zorro to D.C. Comics'
Superman and Batman" (2000: xviii). Danny Fingeroth agrees: in
"the realm of heroic and superheroic disguises, we should probably
begin with Baroness Orczy's *Scarlet Pimpernel* mythology" (2004:
48). Although it is impossible to prove a direct causal influence
between Mendelian eugenics and her dual-identity adventure tale,
Orczy imagined similar solutions to similar fears at the same
cultural moment.

Where Orczy looks backward to a historical revolution to
express contemporary social anxiety, Shaw applies the rhetoric
of revolution directly to Edwardian England. John (Jack) Tanner,
the protagonist of *Man and Superman*, pens "The Revolutionist's
Handbook and Pocket Companion," which Shaw included in the
play's publication. Although wellborn, Tanner voices only mild
sympathy for France's guillotine victims, "those unlucky ladies
and gentlemen, useless and mischievous as many of them were,"
and likens them to America's own useless millionaire class (Shaw
1928: 205). His agenda is a eugenic revolution. Both *The Scarlet
Pimpernel* and "The Revolutionist's Handbook" figure hybridi-
zation as the tool for improving and so ultimately protecting
the aristocracy by the controlled crossbreeding of nobility with
common stock. The shared aim of the two works and Mendelian
eugenics is not interbred equality through the merging of classes,
but rather an extension of pre-existing social divides by producing
a hardier species of noble.

Like so many eugenicists, Orczy, through her hero Sir Percy
Blakeney, and Shaw, through his "Handbook" narrator John
(Jack) Tanner, conflate biology and culture and so indiscriminately
apply Mendel's principles to the production of any trait. "If two
plants which differ constantly in one or several characters be
crossed," Mendel explains, "each pair of differentiating characters
... unite in the hybrid to form a new character" (1865: 4). "Thus,"
declares Shaw's Tanner, "the son of a robust, cheerful, eupeptic
British country squire, with the tastes and ranges of his class, and
of a clever, imaginative, intellectual, highly civilized Jewess, might

be very superior to both his parents" (1928: 187). Orczy selects
the same differentiating characteristics for her fictional mates. Her
Sir Percy is robust: "Tall, above average, even for an Englishmen,
broad-shouldered and massively built" (2000: 42); and cheerful
with a "perpetual inane laugh" and "good-humoured" air (46,
82). His "plebeian" wife, Marguerite, is considered "the cleverest
woman in Europe" (34). Tanner acknowledges that such repro-
ductive pairings in which "two complementary persons may supply
one another's deficiencies" do not make "congenial marriages,"
and, therefore, "good results may be obtained from parents
who would be extremely unsuitable companions" (186–7).Orczy
demonstrates the same assertion with Percy and Marguerite's
estranged marriage: "she took no pains to disguise that good-
natured contempt which she evidently felt for him," and he, in
turn, "has the most complete contempt for his wife" (45, 55).

Despite marital incompatibility, Tanner argues that such combi-
nations—"a countess to a navvy or of a duke to a charwoman"
(186)—will eventually produce a hybrid class of supermen.
Tanner cannot, however, define the new species except as some
"sort of goodlooking philosopher-athlete, with a handsome healthy
woman for a mate," which he declares "a great advance on the
popular demand for a perfect gentleman and a perfect lady"
(182). The ruling class, replaced by democracy, serves no societal
function. Tanner identities himself as a "Member of the Idle Rich
Class," and its flaw is at best "Uselessness," at worst parasitism,
Lankester's term for the cause of biological degeneration reapplied
to social order (177, 241). While he conceives of the superman
as superior in multiple characteristics, Tanner's primary breeding
goal is the elimination of his class' central flaw. "No elaboration of
physical or moral accomplishment," he insists, "can atone for the
sin of parasitism" (237).

Orczy's Sir Percy is an embodiment of the parasitically useless
gentleman. A "descendant of a long line of English gentlemen,"
Percy "has more money than any half-dozen men put together, he
is hand and glove with royalty" (56, 80). He has also inherited
more than wealth: "all the Blakeneys for generations had been
notoriously dull, and ... his mother had died an imbecile" (45).
She was, in fact, "hopelessly insane," suffering a "terrible malady
which in those days was looked upon as hopelessly incurable and
nothing short of a curse of God upon the entire family" (44). This

noble but tainted bloodline resulted in a "hopelessly stupid" son, a "nonentity" with no "spiritual attainments" and "the air of a lazy, bored aristocrat indifferent to matters of honor and justice" (45, 82, 45). He is, thus, the degenerated wellborn prophesized by Lankester two decades earlier.

Despite aristocratic uselessness, however, both *The Scarlet Pimpernel* and *Man and Superman* present democracy as a failed solution, expressing a greater fear of lower-class degenerates destroying civilization. Handing "the country over to riff-raff," asserts Tanner, "is national suicide, since riff-raff can neither govern nor will let anyone else govern except the highest bidder of bread and circuses." Orczy's omniscient narrator declares a crowd of French revolutionists "savage creatures," "human only in name" (1). Her villain, who "despised all social inequalities," is "blindly enthusiastic for the revolutionary cause" (93). Tanner acknowledges England's similarly egalitarian ideals, but concludes that nostalgia for the former order remains: "every Englishman loves and desires a pedigree" (223). Tanner answers that desire by reasserting the lost social structure in a new guise: "The overthrow of the aristocrat has created the necessity for the Superman" (223). Orczy depicts the same overthrow—the guillotine claims "all that France had boasted ... of ancient names, and pure blood," "descendants of the great men who ... had made the glory of France" (1)—in order to establish the necessity of her wellborn, aristocracy-saving hero.

Where Shaw's Tanner describes the eventual "weeding out of the human race" (186), Orczy extends the plant metaphor to her contemporaneously transformed hero. Through dual identity, Orczy achieves the goal that Shaw and other eugenicists project onto a distant future. Rather than spending generations to produce a biological superman through hereditary means, her narrative transforms its wellborn instantaneously. Wedding Marguerite to the degenerated Percy, Orczy produces a figurative offspring, the Scarlet Pimpernel, a hybrid who is both "the best and bravest man in all the world," and yet also a "humble English wayside flower" (31). Percy the "inane fop" (60)—a kind of hot house plant—is crossed with hardy weeds, resulting in a new species uniquely capable of "the noble task he has set himself to do" (31). As a master-of-disguise, the Scarlet Pimpernel is a metaphorical cross between Percy and commoners so poisonous enemies fear

approaching them. To a French border guard, he assumes the appearance of a "horrible hag" carrying "the small-pox" (7). Where Tanner theorizes crossing a noble with a Jewess, Percy merges identities with "an elderly Jew"; Chauvelin, "who had all the Frenchman's prejudice against the despised race, motioned to the fellow to keep at a respectful distance," before "turning away with disgust from the loathsome specimen of humanity" (213, 214).

Orczy's noble–common hybridization, however, does not produce a species that dilutes or equalizes its inherited qualities. Mendel proposes that "hybrids, as a rule, are not exactly intermediate between the parental species" (7), but something new. Similarly, Orczy's hybridized character traits are literally superhuman and manifest only after the resolution of the mystery plot collapses Percy and the Pimpernel into a single character. When speaking about his estranged marriage, Percy's formerly "slow, affected" voice "shook with an intensity of passion, which he was making superhuman efforts to keep in check" (198, 35). As the Pimpernel, he has "superhuman cunning" and "almost superhuman strength of will," and "the man's muscles seemed made of steel, and his energy was almost supernatural" (199, 206, 264).

Orczy's adventure fantasy achieves through non-biological means Tanner's call for the biologically bred superman. As the Pimpernel, Percy has absorbed his wife's differentiating characteristics—cleverness, imagination, intellect—while remaining robust and cheerful. Orczy has also metaphorically bred out her hero's lesser traits. Mendel explains that "those characters which are transmitted entire ... in the hybridization ... are termed the *dominant*, and those which become latent in the process *recessive*" because they "disappear in the hybrids" (1865: 7). *The Scarlet Pimpernel* treats aristocratic uselessness as a recessive trait. Thus, any "imbecile" qualities that Percy inherited from his "half-crazy mother" disappear in the hybrid Pimpernel, purging him of his "foppish manners" (45, 127, 46). In the process, the character subverts "the curse of God" and assumes a godly role himself, what Tanner demands of all eugenicists: "Man must take in hand all the work that he used to shirk with an idle prayer" (181).

Both *The Scarlet Pimpernel* and "The Revolutionist's Handbook" figure such god-like, evolutionary work as actions designed to benefit a larger society. Orczy frames the estranged marriage as

an admonitory tale—"Thus human beings judge of one another, with but little reason, and no charity" (128)—so the reconciliation may become a model against destructive prejudices. Tanner frames his handbook as the solution to a national threat, and his socialist disdain of property suggests an egalitarian agenda. Both works, however, reinforce class divides. Despite his cross-class breeding treatise, Tanner ends *Man and Superman* by marrying a fellow member of his Idle Rich. While the Scarlet Pimpernel is praised by the working-class staff of The Fisherman's Rest, he saves only fellow aristocrats, yet he does so "for the sake of humanity" (68), echoing a central conceit of eugenics.

Both works, in fact, further expand social divides. Tanner's example of selective breeding pairs a squire father and a Jewish mother, and so the offspring would take its father's name. The commoner mother provides traits for the aristocracy, while her class receives nothing. Not only does the plebian Marguerite marry gentility with no benefit to her former proletariat class, her own character ultimately suffers as a result of the eugenic pairing. Though the primary agent in the first half of the novel, she "could do nothing but follow" in the second half (233). Orczy applies the phrase "the cleverest woman in Europe" to her eight times before the revelation of her husband's secret, but only once afterward in order to contrast her transformation: "the elegant and fashionable Lady Blakeney, who had dazzled London society with her beauty, her wit and her extravagances, presented a very pathetic picture of tired-out, suffering womanhood" (249). She is a husk of her former character, passive and comparatively dimwitted. Her intelligence— once her differentiating characteristic—is transferred entirely to her husband. Orczy's adventure plot first establishes an ideal eugenic paring and then skips the multi-generational breeding process to dramatize eugenics' ultimate goal: the strengthening and eventual transformation of the upper class through the weakening and eventual elimination of the lower classes.

Orczy also applies the transformation beyond the microcosm of the Blackeney marriage. The Pimpernel's "Secret Orchard" includes other "good-looking, well-born and well-bred Englishmen" (52, 28). Tanner questions the usefulness of the "Idle Rich Class," and Orczy answers: "The idle, rich man wanted some aim in life—he and the few young bucks he enrolled" (156). A member of the League of the Scarlet Pimpernel insists that their motives are

stereotypically shallow, declaring England "a nation of sportsmen, and just now it is the fashion to pull the hare from the teeth of the hound ... Tally-ho!—and away we go!" (32). Sport in the service of fashion echoes the "inanities" of the foppish Sir Percy (128), but Marguerite recognizes a superior motive in their mission: "the sheer love of the fellow-men" (67). *The Scarlet Pimpernel* transforms shallow sportsmen into noble adventurers, and as the first dual-identity superman, Orczy's hero establishes the prototype for the league of wellborn hybrids to follow in the emergent genre.

Experiments in hero hybridization: 1893–1928

"Hybridity," writes Annie E. Coombes and Avtar Brah in *Hybridity and its Discontents*, "has become a key concept in cultural criticism, post-colonial studies, in debates about cultural contestation and appropriation, and in relation to the concept of the border and the ideal of the cosmopolitan"; the term as applied to human beings echoes nineteenth-century scientific racism and "signals the threat of 'contamination' to those who espouse an essentialist notion of pure and authentic origins," which also "lends the term a potentially transgressive power" (2000: 1). As a postcolonial concept, hybridity resists imperialism by promoting the agency and creative adaptability of the colonized. At the turn of the twentieth century, however, the rhetoric of hybridity reinforced colonial hierarchies. People of mixed race were seen as evidence that the combining of lower and higher subjects produces sub-human offspring. Where late Victorian gothic tales reflect this colonial assumption, early twentieth-century genre authors refigure hybridity as superhumanly powerful. Postcolonial narratives would later employ that power against imperial oppressors, but adventure writers hybridized their heroes in the service of the ruling class.

The rise of Mendelian eugenics in the first decade of the twentieth century parallels the birth of multiple hybrid heroes in popular culture. Owen Wister formulated the western vigilante in *The Virginian*, published in 1902. In addition to assuming the godlike role of moral arbiter, the frontiersman, like the super-human Percy–Pimpernel, combines himself with the forces he

combats. Richard Slotkin defines the western genre as a narrative
of hybridization that requires borders to be crossed by a hero

> whose character is so mixed that he ... can operate effectively on
> both sides of the line. Through this transgression of the borders,
> through combat with the dark elements on the other side,
> the heroes reveal the meaning of the frontier line (that is, the
> distinctions of value it symbolizes) even as they break it down.
> In the process they evoke the elements in themselves (or in their
> society) that correspond to the "dark"; and by destroying the
> dark elements and colonizing the border, they purge darkness
> from themselves and the world. (1998: 351–2)

The western formula both fears and romanticizes border-crossing,
expressing the same colonial anxiety that fueled eugenics.

The pseudo-scientific defense against inferior bloodlines rose
as both Europe's and the U.S.'s colonial expansions ended, and
opportunities for immigration increased. In 1896, three years after
Frederick Jackson Turner declared the American frontier closed,
former Bureau of the Census Director Frances Amasa Walker cited
"the complete exhaustion of the free public lands of the United
States" in his warnings against the immigration of "foul and
loathsome" eastern Europeans: "They have none of the inherited
instincts and tendencies which made it comparatively easy to deal
with the immigration of the olden time. They are beaten men from
beaten races; representing the worst failures in the struggle for
existence" (1896). Fear of the previously distant Other moved to
the metropole, transforming the Other into the degenerate. Where
scientific racism justified imperialism abroad by constructing a
hierarchy of races, eugenics expanded the hierarchy to ethnicity
and class at home.

To defeat the animal-like degenerate, the hybrid hero must
combine himself with it. Reichstein observes the frontiersman's
border-transgressing qualities in the later dual-identity hero
Batman, who blurs "the line between man and beast ... He is
Bat-Man, a mixture of man and beast, of good and evil" (1998:
346). Reichstein identifies the use of "an animal as a means of
showing the dual side of man's nature" as "a prominent motif
in the 'decadent Gothic' novels" of the late Victorian period,
including H. G. Well's *The Island of Dr. Moreau* and Robert

Louis Stevenson's *The Strange Case of Dr. Jekyll and Mr. Hyde* (346). Though a later advocate, Wells began his career skeptical of eugenics, and Moreau's half-men are laboratory-produced degenerates, organisms that fall below their human ancestors in the biological hierarchy. Jekyll and Hyde are a similarly failed hybrid unable to blend into a single, Jekyll-dominated entity. Hyde—a violent, lustful, physically stunted, animal-like, urban-dwelling criminal—is Victorian literature's ultimate degenerate. The Mendelian models of heroism that emerge after the turn of the century correct these tragic fantasies into anxiety-assuaging triumphs by enlisting Well's Coming Beast in the service of the ruling class. To stifle Hyde's threat, adventure narratives bond degenerate criminality to an aristocratic master.

The gentleman-thief, another dual-identity character type influential to the later comic book superhero, also emerges at this moment of eugenics' rise and further reflects its anxieties. Like the frontiersman, however, the gentleman-thief falls short of the superman's generative hybridity. E. W. Hornung introduced the figure in 1898 with A. J. Raffles, a cricket-playing society man by day and amateur cracksman by night. He premiered on American stages as *The Scarlet Pimpernel* was first performed in England. Jacob Smith analyzes how Raffles opposes the more threatening figure of the "working-class criminal type," quoting 1903 reviewers who described Raffles as an "artist" and "epicure," in contrast to a "mere thief" or "low-browed malefactor." "The rhetoric of artistry, with crimes committed as an amateur aesthetic diversion," explains Smith, "defused the fact that the protagonist was a criminal" (2011: 39). Moreover, Raffles is not idly rich and so avoids Lankester's biological "habit of parasitism." By helping himself, Raffles helps society against both the degenerate from below and degeneration from above.

Imitators replaced Raffles' anti-hero purity with Robin Hood do-goodery, but still tempered their gentleman-thieves with aristocratic self-interest. R. Austin Freeman and John Jones Pitcairn's 1902 Romney Pringle robs only from criminals; O. Henry's 1903 Jimmy Valentine employs safe-cracking skills to rescue a child from a bank vault; and Arnold Bennett's 1904 Cecil Thorold commits crimes to punish worse criminals. Thorold, already wealthy, is not motivated by money or philanthropy; he desires entertainment. He is, as Bennett's subtitle asserts, *A Millionaire in Search of Joy*, and he begins his self-motivated quest the year millionaire Andrew

Carnegie began funding eugenics research with the goal of creating real-life supermen.

Despite the successful grafting of criminality onto a dominant aristocrat, gentleman-thief hybridization falls short of the superman. Aesthetic diversions maintain but do not raise the wellborn. In Shaw's analysis, the character type remains literally in hell, because "Hell, in short, is a place where you have nothing to do but amuse yourself" (1928: 97), whereas the heaven of *Man and Superman* is for those striving to progress. The gentleman-thief escapes his ennui, but the hybrid superman of the Scarlet Pimpernel—a species of gentleman-thief stealing nobility from democratic degenerates—devotes his League to a new sport and then transforms that sport into a noble enterprise, saving himself by saving others. The frontiersman safeguards the perimeter, the gentleman-thief prevents internal degeneration, but only the superman has evolved into something new.

As early twentieth-century adventure literature produced these post-gothic experiments in heroism, eugenics continued its own expansion. In 1906, millionaire John Harvey Kellogg founded the Race Betterment Foundation to sponsor conferences at its Michigan sanitarium. With the support of future President Woodrow Wilson, Indiana passed the first eugenics sterilization law the following year. In 1911, the American Breeder's Association published its first Preliminary Report, advocating prevention of unfit breeding through immigration restrictions, racial segregation, anti-interracial marriage laws, sterilization, and so-called "euthanasia" through the use of gas chambers. The First International Eugenics Congress discussed similar legislation at the University of London the following year; future British Prime Minister Winston Churchill later served as the Congress's vice-president.

The year 1912 also marks the movement of the superman into pulp fiction, evidence of eugenics' expanding cultural base. As discussed in Chapter 2.II, Edgar Rice Burroughs—following the success of his first pulp hero, John Carter, a "gentleman of the highest type" (1983: v)—introduced his second serial novel, *Tarzan of the Apes*, two months after the Eugenics Congress convened. Sharon DeGraw observes in Burroughs many "biases associated with the eugenics movement in the United States" (2007: 11), and biographer John Taliaferro describes him as a man "obsessed with his own genealogy" and "extremely proud of his nearly pure

Anglo-Saxon lineage," while endorsing the eugenic "extermination of all 'moral imbeciles' and their relatives" (1999: 19). Burroughs, like Orczy, employs adventure literature to portray an accelerated version of that process.

While eugenicists could only promote the laborious, multi-generational system of selective breeding in the hopes of biologically transforming the wellborn into supermen in some far-off future, Burroughs' literary path to the superman ennobles noble blood within a single specimen. Tarzan—"White-Skin" in ape language (1999: 39)—is a variation on Orczy's triumphant, rather than Stevenson's failed, dual-identity model; he is both "the aristocratic scion of an old English house" and "King of the Apes (228). His duality accomplishes the same transformative purpose as Orczy's Percy. Because he has been raised in the laboratory of the jungle, he is "unmarred by dissipation, or brutal or degrading passions," and is free of the habits of parasitism displayed by his London cousin who dips "his finger-ends into a silver bowl of scented water" (80, 79). The degenerating attributes of the aristocracy are purged, allowing his full genetic potential to flourish.

The result is a new breed, what another character declares a literal "superman," Shaw's term now evident in wide use (226). The hybrid "Monsieur Tarzan," a French-speaking "polished gentleman," manipulates dinnerware "exquisitely" before going "naked into the jungle, armed only with a jack knife, to kill" a lion (247, 248). When the smitten Jane Porter declares Tarzan a "gentleman," Burroughs redefines the term in the way that Galton translates "wellborn" into "eugenics." The transformed Greystoke is an improved species of gentleman, one who, like Sir Percy, has earned the right to be paired with a eugenically appropriate commoner, in this case the intelligent daughter of an American professor (165). That union occurs only after the gothic fear of Moreau's degenerate animal-men, that Tarzan is "a cross between an ape and a man," is erased and his aristocratic lineage thus proven (254).

Burroughs also inadvertently showcases the flawed understanding of genetics that defined eugenics. In the chapter "Heredity," the young Lord Greystoke is not only "endowed by inheritance with more than ordinary reasoning power," but he knows how to bow in a courtly manner, "the hall-mark of his aristocratic birth, the natural outcropping of many generations of fine breeding, an

hereditary instinct of graciousness which a lifetime of uncouth and savage training and environment could not eradicate" (58, 191). Like so many eugenicists, Burroughs cannot differentiate between hereditary and environmental influences. Though less scientific than scientific breeding, his use of Tarzan's environment as a method of biological transformation is equally absurd. The jungle is a fantastically transformative narrative element, possible only within fiction, which condenses the long-term breeding process to achieve instantly the biological goal eugenics advocates could otherwise only forecast.

Months after *Tarzan of the Apes* completed its serial run in *All-Story* magazine, the U.S. government, motivated by the fear of the miscegenation that Burroughs and the earlier gothic authors express, segregated black-and-white employees. Kellogg's Race Betterment Foundation hosted its First National Conference the following year. By 1914, Galton's eugenics curricula had spread to forty-four universities, including Harvard, Columbia, Cornell, and Brown. George William Hunter's high-school biology textbook, *A Civic Biology Presented in Problems,* describes families of degenerates as social parasites, concluding that if "such people were lower animals, we would probably kill them off to prevent them from spreading" (1914: 263). Eugenic theories had thus become conventional knowledge.

The teens also mark an expansion point for superman hybridization in popular literature. Frank L. Packard's *The Adventures of Jimmie Dale* applies Orczy's model to the contemporary urban setting of the gentleman-thief. In his first 1914 story, Packard introduces a commoner strain to American nobility, the aristocratic St. James Club, "an acknowledged leader" of "New York's fashionable and ultra-exclusive clubs"; while membership "guaranteed a man to be innately a gentleman ... there were many members who were not wealthy ... men of every walk of life" (2005: 4). The "cosmopolitan" club echoes the surface egalitarianism of Marguerite's "exclusive" Paris salon, but Harvard graduate Jimmie Dale, with "the grace and ease of power in his poise," received his membership by bloodline via his wealthy father (9). The "innate gentlemen" that is "the 'hall mark' of the St. James" remains a traditional wellborn, now fortified by commoner strains of "authors" and "artists" (4).

As the "Prince of Crooks," Jimmie also bonds nobility to criminality as the masked Gray Seal, suppressing criminality by

dominating its field: "he was the king-pin of them all" (23). He adventures in a "business section of rather inferior class, catering to the poor, foreign element" and, as another master-of-disguise, combines himself with the degenerate Larry the Bat, an opium-addicted "denizen of the underworld" (28). Jimmie also assumes a version of Percy's foppish disguise by speaking "languidly" and claiming motives of "Pure selfishness" (20, 35). The idle rich continue to appear useless, but the initiated reader knows their secretly noble attributes. Like Raffles, "the art of the thing was in his blood" which, like the League of the Scarlet Pimpernel, he pursues to satisfy his "adventurous spirit" (6, 11).

In the process of nullifying both elements of degeneration, Packard's hybridization transforms another wellborn into the superman. Though the hero's "crookedness" begins with Raffles-eque self-amusement, it gains "a leading string to guide it into channels worthy of his genius" (11). Just as Marguerite refigures the League's sport into humanitarianism, a female black-mailer forces Jimmie to aid others, thereby mixing "pure deviltry" with altruism and raising the Gray Seal to a "Philanthropic Crook" (5, 21). Moreover, Jimmie gains an awareness of his own superiority through adventuring: "there came a mighty sense of kingship upon him, as though all the world were at his feet, and virility, and great glad strength above all other men's" (294). The blackmailer selects worthy working-class characters for his aid, but ultimately the Gray Seal benefits himself and another member of his own class, the blackmailer, a French aristocrat deprived of her inheritance. Like Jimmie, she leads a life of crime-fighting disguise, but once he restores her name and fortune, both abandon their mission. Their working-class identities, having served to ennoble another example of Shaw's "perfect gentleman and a perfect lady," are discarded (182). Packard's first novella ends in their romantic union, providing a transformed "goodlooking philosopher-athlete, with a handsome healthy woman for a mate" and so optimum conditions for future offspring (Shaw 1928: 182).

While Packard was publishing his short stories, eugenics deepened its cultural hold. The Second National Conference on Race Betterment met in 1915, and Madison Grant's *The Passing of the Great Race* reached the best-seller list the following year. Grant's call for the sterilization of defectives, weaklings, and ultimately worthless race types was praised by former President

Theodore Roosevelt, and Adolf Hitler would later refer to the book
as his Bible. Also in 1916, Stanford University psychologist Lewis
M. Terman introduced I.Q. testing to identify and segregate defec-
tives from the gene pool. Margaret Sanger published the first issue
of *Birth Control Review* in 1917, the year Packard collected his
first dozen Gray Seal stories; Sanger declared superman the aim of
birth control through the prevention of reproduction by the unfit.

Germany's Socialist German Workers' Party formed in 1920,
the year the wellborn, dual-identity hero reached a new cultural
height with Douglas Fairbanks' *The Mark of Zorro*, evidence
of eugenics' influence on both sides of the Atlantic. The film
adapted Johnston McCulley's *The Curse of Capistrano*, serialized
in *All-Story Weekly* a year earlier. The film's opening subtitles liken
Zorro to "a Cromwell," one of Shaw's examples of a spontaneous
superman. McCulley also reproduces Orczy's hero formula: Don
Diego, "a fair youth of excellent blood" but also a "dandy" with
a "languid grasp," combines identities with a "common fellow,"
a "highwayman," and so redefines himself and "*caballero*" as the
animal-man "Senor Zorro," literally Mister Fox (1998: 7, 194,
37, 4, 18, 3).

Although Zorro is a self-proclaimed "friend of the oppressed,"
McCulley likens the lowly Indians his hero saves to "rats," and
Don Diego addresses them as "scum!" (247, 136). His plot centers
instead on securing a wife of "the best blood" to produce an
"offspring to inherit and preserve [his father's] illustrious name" or
face disinheritance (16, 161, 53, 176). Like the Scarlet Pimpernel,
Tarzan, and the Gray Seal, Zorro is the means for Don Diego to
transform from a parasitic aristocrat into a superman worthy of
reproduction. His dual identity is not simply a strategy of disguise;
his costume triggers a fantastical biological change:

> The moment I donned the cloak and mask, the Don Diego part
> of me fell away. My body straightened, new blood seemed to
> course through my veins, my voice grew strong and firm, fire
> came to me! and the moment I removed the cloak and mask I
> was the languid Don Diego again. (264)

The mask is another variant on Dr. Jekyll's serum, but one
that allows the aristocrat to maintain his class superiority. The
novel concludes with his "endeavor to establish a golden mean,"

replacing degenerate criminality and degenerative uselessness with hybrid virility; in order to suit his future wife, the new Don Diego "shall drop the old languid ways and change gradually into the man you would have me" (265). Once again, an adventure author collapses the extensive process of selective breeding into a single character, allowing a wellborn to become a superman by fathering himself.

Like the Scarlet Pimpernel, Zorro also transforms his fellow wellborns into true nobles. "Be men, not drunken fashion plates!" he orders; "Live up to your noble names and your blue bloods" and "make some use of your lives!" (167, 168). After enlisting "the young men of all the noble families" into a "new league" with "adventure a plenty," Zorro "fears it was a lark with them," but the caballeros learn "their strength and power" and overthrow the corrupt government (257, 129, 168, 252, 258). "Thus," writes Nadia Lie, "McCulley's Zorro revives the old idea of nobility," ideals that have suffered from Lankester's degeneration (2001: 491). Reflecting Galton's definition of eugenics, Zorro improves the pre-existing "inborn qualities of a race" and develops "them to the utmost advantage." Despite his stated oppression-fighting mission, Zorro is a revolutionary only in Shaw's sense, a wellborn fighting for wellborns. He is a noble bandit, a hero type who, Eric Hobsbawm explains, "seeks to establish or to re-establish justice or 'the old ways,' that is to say, fair dealing in a society of oppression … He does not seek to establish a society of freedom and equality" (1981: 55). Having strengthened his class, Don Diego unmasks and marries, fulfilling his obligation to maintain his now fully noble bloodline.

In the decade that Fairbanks presented Zorro and the figure of the wellborn superman to an international audience, eugenics also reached its high point. The Second International Congress, featuring Alexander Graham Bell and future President Herbert Hoover, met in New York in 1921. President Coolidge signed the Johnson–Reed Immigration Act into law, drastically reducing immigration of non-Anglo Saxons. Coolidge argued: "America must be kept American. Biological laws show … that Nordics deteriorate when mixed with other races" (Kevles 1985: 97). In 1924, Virginia joined twenty-eight states in barring marriage between whites and non-whites, and broke new legislative ground with the Virginia Sterilization Act. Hitler published *Mein Kampf*

the following year, reiterating gothic fears of degeneration through the mixing of low and high blood. The U.S. Supreme Court agreed in 1927, ruling eight-to-one in favor of Virginia's sterilization law; Oliver Wendell Holmes declared the majority opinion: "It is better for all the world [that] ... society can prevent those who are manifestly unfit from continuing their kind" (White 1993: 406). The Rockefeller Foundation funded the construction of the Kaiser Wilhelm Institute of Anthropology, Human Genetics, and Eugenics in Berlin the same year. Eugenics curricula had spread to 376 universities globally.

The final growth of eugenics parallels the expansion of the wellborn, dual-identity hero in popular culture. Over a dozen variations appear during the second and third decades of the twentieth century, including Johnston McCulley's Thunderbolt (1920), the Man in Purple (1921), and the Crimson Clown (1926); Herman Landon's Gray Phantom (1917) and the Picaroon (1921); Russell Thorndike's Doctor Syn (1915); Charles W. Tyler's Blue Jean Billy Race (1918); Edgar Wallace's Four Square Jane (1919); Eustace H. Ball's Scarlet Fox (1923); Erle Stanley Gardner's Phantom Crook (1925); Graham Montague Jeffries' Blackshirt (1925); Paul Ellsworth Triem's John Doe (1928); and Leslie Charteris' The Saint (1928) (Nevins). The character type expanded into film with Edward José and George B. Seitz' *The Iron Claw* (1916), Grace Cunard and Francis Ford's *The Purple Mask* (1916), and Louis Feuillade's *Judex* (1917); and into light opera with Sigmund Romberg, Oscar Hammerstein II and Otto Harbach's *The Desert Song* (1926). The superman's popular culture incarnations reached fruition as the eugenic movements that inspired and defined them achieved social and political dominance.

Acts of sterilization: 1929–39

"After Mendel discovered his famous principles of heredity," writes Waldemare Kaempffert in 1932, "we seemed to be in a fair way of achieving the superman"; however, when "the hereditary characteristics called genes were discovered much of this cocksureness was shaken" (1932). Beginning with Frederick Griffith's 1928 breakthrough experiments, the study of heredity shifted away

from eugenics. The Rockefeller Foundation withdrew funding in favor of better scientifically grounded projects that would develop into the field of molecular biology. Kaempffert lauds Lancelot Hogben's 1932 *Genetic Principles in Medicine and Social Science* and its rejection of selective breeding on scientific grounds: "The eugenicists, who usually know nothing of genetics, would do well to peruse Dr. Hogben's book" (1932).

The Nazi Party, however, claimed a majority in Germany's government in 1932, and the Third International Congress of Eugenics recommended the sterilization of 14 million Americans with low IQ scores. The following year Hitler's cabinet enacted the Law for the Prevention of Offspring with Hereditary Diseases in Future Generations, requiring physicians to report to Heredity Health Courts individuals meeting standards for sterilization. In 1935, South Carolina became the thirty-first and last state to pass a sterilization law. Though well entrenched, American eugenics was in decline; a Carnegie Institute review panel concluded that the Eugenics Record Office lacked scientific merit and recommended halting all eugenics funding.

The allure of the superman, however, remained. As selective breeding grew unpopular, the *New York Times* and the *Washington Post* reported a range of alternate means for attaining a goal no longer limited to the wellborn. Rather than "pick out a few superior children and make supermen of them alone," explained Rockefeller Institute researcher Dr. Alexis Carrel, "we would improve all of mankind" ("Everybody Has Telepathic Power" 1935). New, egalitarian possibilities included hormones, glandular stimulation, chemistry, vaccines, nutrition, diet, and even the transplantation of ape glands into children, literalizing Moreau's gothic animal-men. In contrast to "the Hitler program of race purification," Carrel refigured mixed breeding as a new ideal: "It may be that crossing civilizations as we do in America produces the best minds" (1935).

Popular culture incarnations of the superman mirrored the shift in social attitude. Where Orczy, Burroughs, Packard, and McCulley end their heroes' narratives with marriage plot closure, beginning in the late 1920s, authors deny that closure and the subsequent reproduction it implies. New superhuman protagonists face death, isolation, and celibacy, all forms of narrative sterilization to subvert the threat of a singular superman expanding into a race. Reversing the evolutionary anxiety that created eugenics

and its heroes, the superman became Well's Coming Beat, the species that could battle against humanity for survival.

When Jack Williamson and Miles J. Breuer apply Burroughs' Tarzan pseudo-environmental hybridization model to science fiction in their 1929 "The Girl from Mars," they imagine the offspring of a superior race of aliens raised by the comparative savages of the U.S. After Mars "was destroyed by atomic energy released by intelligent entities," embryonic capsules sent "to perpetuate their race on another world" land in New Jersey, and the widower narrator incubates his adoptive daughter, Pandorina (1998: 7, 10). Like Lord Greystoke, the wellborn Pandorina is set apart by her "white skin" and "astonishing aptitude that must have been her inheritance from a higher civilization" (6, 11). The authors provide her with a eugenically appropriate mate—her "tall and slender, blond, and cleanly made" adoptive brother (12)—but when the wedding approaches, Williamson and Breuer prevent consummation with the arrival of a "haughty and aggressive" Martian male who woos Pandorina himself (15). Though also raised by humans, "the striking and powerful figure with his mighty, muscular limbs" is set "apart from ordinary men" by a "strange, malign spirit," and he recognizes Pandorina by her "pallor of skin, color of hair, and luster of eye," all physical racial attributes unaffected by upbringing (15). The mating rivalry intensifies with a second Martian suitor who has mastered "the science of warfare," further evidence of the wellborns' social threat (20). When Pandorina's human fiancé wins her back, he is met with "fiendish, inhuman rage" from the "ultrahumundane man," who murders him (21). These supermen, rather than aiding humanity through noble adventure or genetic mingling, seek only to perpetuate their own destructive species. When the two males war for Pandorina, her adoptive father lures them onto an artillery range where all three are destroyed. Although Pandorina's death is conveniently accidental—"I had quite forgotten her. God knows that I meant her no harm! But then it was too late" (25)—the God-evoking father eliminates not only the threat of alien purebloods displacing humanity, but also the possibility of future hybrids. No superman, whether a Martian "ultramundane man" or a crossed offspring, survives.

Like Williamson and Breuer, Philip Wylie offers a version of failed superhuman reproduction in his 1930 *Gladiator*. Wylie reveals both the shift away from selective breeding and the continued

interest in the figure of the superman through means unrelated to social class. A "professor of biology" who "lectured vaguely" on "the law discovered by Mendel" believes instead that "chemistry controls human destiny" and "vaccinate[s]" his pregnant wife to "produce a super-child," what he imagines will be "the first of a new and glorious race" (2004: 3, 5, 18, 26). Instead, his son, Hugo, becomes a lone superman, alienated from society and unable to aid it or himself. He is not wellborn in either a eugenic or class sense, and where a dual identity-hero ennobles through humanitarian adventure, Hugo exhausts a list of heroic pursuits, all of which fail.

Hugo's single friend, Shayne, is a reiteration of Shaw's idle gentleman; he has "too much money," considers his family "useless," and is "bored with the routine of his existence" and "weary of the world to which he had been privileged" (170, 171, 168, 173). His degeneration is infectious, making the ecstasy that Hugo felt after enlisting show "signs of decline" after a night of debauchery (173). Where dual-identity heroism would save such a wellborn, Shayne enters the war with Hugo and quickly dies in combat. Hugo attempts to ennoble him posthumously by "invent[ing] brave stories for his friend" and "tripl[ing] his accomplishments" (207). Like Zorro's father, Shayne's parents, who had "disinherited" him, "feel that at last" their son had come "into the Shayne blood and heritage," fulfilling his wellborn potential (206). That fulfillment, however, is a lie, and Wylie further taints the family with unrepentant war profiteering, reversing the primary doctrine of eugenics by rejecting upper class superiority.

Wylie also thwarts his superman's search for a eugenic mate. Hugo develops relationships with a half-dozen women, but, like his heroic pursuits, each pairing fails. Where the figure of the superman previously attracted mates, he now repels them. At the sight of his strength, Hugo's last lover "screamed and drew back," shouting "Don't touch me!" (276). Percy, Tarzan, Don Diego, and Dale secure wives by displaying their superhuman qualities, but Hugo loses his because he "isn't human" (276). Since Hugo suspects he is "sterile," Wylie further prevents hybrid offspring, leaving Hugo to consider reproduction by other means (62). A scientist suggests that he use his father's serum and create "a thousand of you," the "new Titans!" (327). To decide who should be selected for transformation, Wylie evokes for the first time Galton's theories: "Eugenic offspring ... the children of the best parents" (327). As a

result, God in the form of "a bolt of lightning" from a cloud "like a huge hand" destroys Hugo and the formula, reasserting the role of Providence that mankind usurped in the quest for the superman (331, 330). Like the trustees of the Carnegie and Rockefeller Foundations, popular authors had rejected eugenics.

The wellborn, dual-identity hero, however, does not fade with the failed pseudo-science that inspired it. Beginning with the *Shadow Magazine* in 1931, the character type expands further into pulp literature. Writers continue to reject eugenics by undermining marriage plots and eliminating the prospect of reproduction. Where Orczy introduces dual identity as a device for romantic closure, Walter Gibson disrupts the trope by eliminating half of his hero's character. When "[t]all, well-bred" Lamont Cranston appears to be the man behind the Shadow's cloak, Gibson reveals that the millionaire is only another of a potentially endless array of disguises, allowing no Marguerite to solve the mystery and unify both characters in marriage (Tinsley 2007: 73). Similarly, Lester Dent's 1933 Doc Savage assumes no secondary identity. Although labeled a wellborn "superman" like Tarzan, Savage receives no financial inheritance upon his father's death and refuses to perpetuate the family bloodline: "There won't be any women in Doc's life" (2008: 35, 67). Norvell Page, while not dooming his wellborn hero to celibacy, locks the Spider and his fiancé in perpetual courtship: "It was part of the compact between them, the oath they had sworn when [he] had lost his fight against their love and told her the truth of his harried existence, and the fact that they could never marry while work remained for the *Spider!*" (2007: 39). Even Lars Anderson's overtly sexualized Domino Lady receives no romantic closure: "Devoting her life to a campaign of reprisal against the ruthless killers of her father, the amorous little adventurous had denied herself the love she craved with all her heart" (2004: 76). Despite its original mate-transforming function, the dual-identity mission now explicitly excludes marriage. To be a post-eugenic superman is to be isolated and therefore unproductive.

Jerry Siegel corresponded with Jack Williamson, reviewed Orczy's and Wylie's novels in his high-school newspaper, read Tarzan comic strips in his daily newspaper, and watched the film adaptation of *The Scarlet Pimpernel* (Jones 2004: 35, 65, 78, 116). There is no evidence that the twenty-year-old Siegel was aware of and directly responding to the history of eugenics, but when he conceived

the most famous popular culture superman, his new hybrid hero reflected those influences. Like his predecessors who found fantastical means to condense selective breeding into an instantaneous product, Siegel brings Superman to Earth not from an alien planet, but rather from Earth's literal eugenic future. In Siegel's earliest 1934 scripts, Superman is "a child whose physical structure was millions of years advanced from" humans because he was a child of Earth "in its last days"; as "Giant cataclysms were shaking the reeling planet, destroying mankind," "the last man on earth" "placed his infant babe within a small time-machine ... launching it" to "the primitive year, 1935, A. D." (Trexler 2006). Siegel later changed planets but retained eugenics through "Krypton, a distant planet so far advanced in evolution that it bears a civilization of Supermen—beings which represent the human race at its ultimate peak of human perfection" (13). In both, Siegel irrevocably divides his wellborn hero from his genetically superior roots, and, because no superhuman mates survive, there is no threat of a superman race overwhelming humanity. Siegel also prevents hybrid offspring by reversing Orczy's dual-identity trope. His Lois Lane is no Marguerite-like sleuth, and the hero's opposing identities thwart rather than aid romantic closure. Clark hopelessly pursues Lois who "can barely bear looking at him, after having been in the arms of a REAL HE MAN" like Superman, but the aloof Superman puts her off: "But when will I see you again!" she asks; "Who knows? Perhaps tomorrow—perhaps never!" (Siegel and Shuster 2006: 68, 27). The love triangle grew so ingrained that when Siegel tried to break it in 1940, his DC editors rejected his script (Jones 2004: 183). The post-eugenics superman must remain solitary.

One of the comic book Superman's first imitations, Bob Kane and Bill Finger's Batman—introduced the year Germany invaded Poland—is ironically atavistic. The dual-identity hero is a literary throwback, a pulp degenerate regressing to an earlier formula: a wellborn millionaire bonds himself with an animal to battle criminal degenerates preying on his fellow millionaires. Finger and Kane also reproduce the performance of idleness that had once signified the now forgotten threat of degeneration: "young socialite" Bruce Wayne "must lead a boring life," and "seems disinterested in everything" (Kane et al. 2006: 4, 9). Together Superman and Batman defined the early comic book genre, extending the tropes of eugenics decades past the movement's end and well into

the twenty-first century. Though no longer distinguishing the trait as necessary for the contemporary character type, Coogan ends his definition by noting: "Often superheroes have dual identities, the ordinary one of which is usually a closely guarded secret" (2006: 30).

All superheroes are arguably descendants of eugenics, but Marvel overtly acknowledged the movement and its connection to its characters through Robert Morales and Kyle Baker's 2003 limited series *Truth: Red, White & Black*. After detailing the history of the movement, a retired U.S. military officer explains to Steve Rogers that Captain America is its direct product:

> A century ago, the world's ruling classes weren't very happy about how quickly the poor—the unwashed, ethnic, working poor, immigrants, what have you—were breeding. So a lot of money started to funnel toward ideas of keeping their numbers down. And for many at the top that also meant keeping their bloodlines—Home Europeaus—pure.
>
> Before World War I, eugenicists from around the world—primarily the Brits, the Germans, and us—routinely met to effect racial hygiene policy. The U.S. and British governments took the lead in the sterilizations of ... ah ... undesirables, for instance—while Germans like Hitler looked on enviously because they lost the Great War and didn't have the resources.
>
> Once he took power, Hitler sent the good doctors Reinstein and Koch to meet with privately-funded eugenicists here in the States to introduce their revolutionary medical techniques.
>
> As a result of those meeting, Rogers, Project Super Soldier was born. (Morales and Baker 2004: 4–5)

Similarly, Garth Ennis in his anti-superhero series *The Boys* premises the existence of all superheroes on the work of Nazi Germany. An agent tasked with controlling superheroes explains "Compound V": "this is why supes ARE supes. Some Jerry come up with it in the thirties, started trials on people" (Ennis and Robertson 2008).

While eugenicists in Germany and the U.S. never created such supermen, the history of their attempts is preserved in the DNA of the comic book character type. The next chapter explores another central trait that developed in the same early twentieth-century

context. Where the colonialism of Chapter 2.II established the superhero's imperial binary, and eugenics extended that binary from race to class divisions, the superhero trope of vigilantism in Chapter 2.IV grows from the same anti-democratic impulse that defined the eugenic superman.

IV

The Vigilante Superhero

When innocent people are brutalized, villains go unpunished, and corrupt police fail to act, a hero must rise to save the country he loves. His secret identity hidden behind a mask, the Grand Dragon leads his team of loyal companions in a battle to restore law and order.

This plot structure is familiar to anyone with a passing awareness of superhero formulas, but the specific hero, the Grand Dragon, is unknown except to readers of Thomas Dixon, Jr.'s once best-selling novel, *The Clansman: An Historical Romance of the Ku Klux Klan*. Dixon, while claiming to have taken no "liberty with any essential historical fact" (2005: 7), recounts a version of the post-Civil War period in which the heroic Klan rescues the victimized South from the villainy of "Negro" rule. Although Dixon is "relatively unknown today," and "no longer deserving of respectful prominence in the history of American popular culture," biographer Anthony Slide likens him to John Grisham as an author who once commanded a major American audience (2004: 3, 5, 7). Dixon's 1905 novel became the source for D. W. Griffith's more enduring but equally racist adaptation, *The Birth of a Nation*, a film so influential that it incited the reformation of the Ku Klux Klan (KKK) with its 1915 release. Although both Dixon and Griffith's white supremacist rewriting of history is now reviled, their masked vigilantes entered the American consciousness as admired figures, and the Klansmen's characteristics—as introduced by Dixon, adapted by Griffith, and also emulated by actual KKK members across the U.S.—shaped comic book superheroes.

Working in a different medium more than three decades after Dixon, Siegel and Shuster, two young urban Jewish men of immigrant parents, were anything but sympathetic to Klan ideology. But by the mid-1930s, KKK hero tropes had been absorbed into popular culture, distanced from their white supremacist roots, and reproduced as generic formula in pulp adventure fiction. Ben Cameron, a.k.a the Grand Dragon, represents the earliest twentieth-century incarnation of an American vigilante hero who assumes a costumed alias to hide his identity while waging his war for good—the formula adopted by Siegel and Shuster.

Dixon did not invent the figure of the costumed superhero, but the character type—as traced from *The Clansman* through *The Birth of a Nation* and the second Klan to pulp fiction and early comic books—was popularized by Dixon's vision. This chapter first places *The Clansman* into literary context by comparing the Grand Dragon to the proto-superhero character type so popular at the turn of the century and by tracing the evolution of the secret identity trope that developed in fiction after *The Birth of a Nation*. Because the influence on the genre also occurred through real world vigilantism, a brief history of the 1915–44 KKK clarifies the cultural context from which Superman and other superheroes emerged and also how the new characters were shaped by both the fictional Klans of Dixon and Griffith and the actual Klan they, in turn, inspired. The superhero, despite the character's evolution into a champion of the oppressed, partly originated from an oppressive, racist impulse in American culture, and the formula codifies an ethics of vigilante extremism that still contradicts the superhero's purported social mission.

Numerous writers have drawn likenesses between superheroes and the KKK. After noting the criminal need for disguised identities, specifically referencing "the Ku Klux Klan and its hooded cross burners," Danny Fingeroth observes how the "idea of disguise" is "a staple, indeed one of the very definitions of the superhero mythos" (2004: 48–9); however, Fingeroth only superficially links superheroes with the Klan in a list of disguised identities that includes graffiti artists and crank callers. Bradford W. Wright observes that some of the very first critiques of superheroes recognized their vigilantism and how their violence was portrayed as supposedly essential to society (2001: 28). "The lawful processes of police and courts have disappeared," objects James Frank Vlamos,

in a 1941 *American Mercury* editorial, and "only the heroism of the superhero keeps us from being annihilated"; the superhero "is a law unto himself" (414). When Hal Blythe and Charlie Sweet analyzed comic book narrative structures forty years later, they came to the same conclusion: the initiating "menace is so powerful it is more than the victim, the authorities or society can handle. The Commissioner Gordons of the world, realizing their impotence in the face of the overwhelming threat, summon the superhero" (1983: 182). Accordingly, the "reader does not care how often the superhero transgresses man's petty laws, for the hero operates under a higher law that always has the ultimate good of society at its center" (185). Mike S. Dubose examines comic book vigilantism in relation to Reagan-era political conservatism, concluding that "true heroship did not occur without defining oneself as an entity separate from the powers that be and transcending traditional notions of law, order, and justice" (2007: 916). Dubose limits his discussion to the 1980s, but his description applies equally to the Dixon-era Klan and to the superhero in most of its evolving incarnations.

After observing that "the superhero is a kind of criminal—a vigilante," Geoff Klock concludes that:

> masked crime fighters differ from the Ku Klux Klan only in that they are usually afforded socially acceptable status on a large scale. As masked men who take the law into their own hands the superhero comes dangerously close to some of the great evils in American history. (2002: 39)

The difference that Klock asserts, however, is historically inaccurate. The KKK was, in fact, afforded socially acceptable status on a very large scale. It operated on the same principle that Blythe and Sweet articulate for the superhero: overstepping lawful processes to combat perceived menaces for the supposed good of society. As a result, the Klan rose to national popularity in the early 1920s, receiving the same favorable status that Klock attributes to the later, fictional character type. Sean McCann cites an example of a pro-Klan short story published in *Black Mask* magazine in 1923 in which members rescue a kidnapping victim and are lauded by a sheriff for their mission "to do good—even with violence" (McCann 1997: 685). Historian Richard K. Tucker details the similarly positive reaction the Klan received nationwide:

Mainline Protestant ministers often praised the Klan from their pulpits. Reformers welcomed it to vice-ridden communities to "clean up" things. Prohibitionists and the Anti-Saloon League supported it as a force against the Demon Rum. Most of all, millions saw it as a protection against the Pope of Rome, who, they believed, was threatening to "take over America." (1991: 2)

Vice-ridden communities and plots to conquer America became and remain central motifs of superhero narratives, and the superhero's ability to act outside of the law, superseding an impotent government's police powers, is one of the character type's most defining qualities. The other primary traits—mission, secret identity, masked costume, and self-defining emblem—are also elements portrayed by Dixon and inherited by the superhero via Griffith and the 1914–44 KKK.

The second Klan was critically different from both the Reconstruction-era organization and the Klan that rallied against the civil rights movement of the 1960s. Whereas the post-Civil War and post-World War II groups directed their actions primarily against African-Americans, the second Klan—while still virulently racist and violent—represented a wider range of prejudices and political agendas embodied in the eugenics movement detailed in Chapter 2.III. "These Klansmen," writes Jesse Walker, "were more likely to flog you for bootlegging or breaking your marriage vows than for being black or Jewish" (2005). Identified with traditional, rural morality, the second Klan embodied a cross-section of American middle-class racial and ethnic anxiety, focused primarily against a perception of urban crime, corruption and expanding immigrant populations. Both national and nationalistic, the organization was defined by a Victorian nostalgia for pre-modernist, authoritarian order that reached far beyond the vision of its Southern, Reconstruction-era namesake. The new, larger and eugenics-fueled Klan imagined that it "fought to restore the values of an earlier America" (Grant 2001: 14).

Although the Klan, when directly portrayed, is invariably an organization of villains, the superhero still operates from the same reactionary, paternalistic ethics of vigilantism. The superhero does not simply save the world—he restores a moral, nationalistic status quo by superseding the powers of a democratic government incapable of combating or often even recognizing alien threats.

Even when superheroes are depicted as battling for liberal, anti-discriminatory values, the mass appeal of the character is found in its ability to reduce complex social anxieties into terms of absolute good and evil. Whatever the specific story content, the formula remains centered on romanticized vigilantism, still one of the most defining traits of contemporary superhero comics.

Vigilante hero

The year 1902 is a cornerstone for literary portrayals of American vigilantism, in which American authors began mythologizing the recent past in terms of redemptive violence. Owen Wister's *The Virginian*, a foundational text of the western, introduces the figure of the cowboy hero administering vigilante justice on a lawless frontier. To explain the necessity of lynching horse thieves, a character explains:

> when your ordinary citizen ... sees that he has placed justice in a dead hand, he must take justice back into his own hands ... so far from being a *defiance* of the law, it is an *assertion* of it—the fundamental assertion of self governing men, upon whom our whole social fabric is based (Wister 1989: 274).

Joel Chandler Harris published *Gabriel Tolliver: A Story of Reconstruction* the same year, and Dixon *The Leopard's Spots: A Romance of the White Man's Burden—1865–1900*, applying similar vigilante principles to an unlawfully occupied South. Written in response to a stage production of Harriet Beecher Stowe's *Uncle Tom's Cabin*, Dixon's novel includes a twenty-page sequence in which the Klan springs "up like magic ... almost simultaneously in every Southern state produced by the same terrible conditions" of Reconstruction (1902: 151).

Lawrence and Jewett in *The Myth of the American Superhero* identify *The Virginian* as the first of "the most crucial formations" of the American monomyth in which selfless heroes "rescue an impotent and terrorized community" through "superheroic redemptive violence" (2002: 11, 5). Since Dixon and Wister published simultaneously, Dixon did not derive his vision of

vigilantism from Wister's frontier justice. Lawrence and Jewett also name *The Birth of a Nation* as the second crucial formation, establishing Dixon's centrality in the establishment of the hero formula. *The Leopard's Spots* sold 100,000 copies before the end of 1902 and eventually nearly one million (Joel Williamson 1984: 158), allowing Dixon to expand on his subject in his second best-selling novel, *The Clansman*, which exceeded one million copies within months of its publication (Grant 2001: 190).

After Wister the western would grow in stature and cultural influence, but during the first decade of the century, the genre was limited to dime novels, a literary form below Dixon's aspirations. However, Dixon's literary style, as appraised by Williamson, did descend "almost to dime novel story-telling, unashamedly melodramatic, undisciplined, and oppressively didactic" (140). His writing process also resembled a dime novelist's: he drafted the 130,000-word *Leopard's Spots* in sixty days, and submitted it unrevised to an editor friend at Doubleday who immediately published it (158).

The dime novel also offers the clearest example of an American vigilante hero type that precedes Dixon, and which also influenced later comic-book superheroes. The avenger detective, explains Gary Hoppenstand, "exemplifies the American heroic tradition as it is perceived at specific historical moments in American culture" (1982: 4). Its dime novel incarnation emerged in the early 1880s, dwindling by the 1920s. Nick Carter, its exemplar, began publication in 1886, received a single-character magazine in 1891, and was discontinued in 1915. The avenger detective represents the period's closest equivalent to a superhero, and it is the literary context in which Dixon introduced his Klan narratives. Dixon's heroes, however, stand apart from the avenger detective model and introduce qualities central to the later superhero that are otherwise absent from the heroic tradition.

In his second treatment of the Klan, Dixon replaces his Major Dameron, "the Chief of the Ku Klux Klan" in *The Leopard's Spots* (1902: 169), with the more expansively portrayed Ben Cameron, a character who partially resembles the dime novel avenger detective. In Hoppenstand's analysis, the character type is foremost a vigilante, a criterion the leader of the KKK fully exemplifies. As a decorated Confederate officer who single-handedly charged an entrenchment "as if he were leading a million men to victory" (12), Cameron possesses ample strength, training, determination

and courage. He also has wealth ("a blue-blood" temporarily impoverished by Reconstruction [164]), possess a sanctuary (his secret "meeting-place" for his Klan is a "cave" [235]), is nationalistic (he swears to "protect and defend the Constitution of the United States" [236]), and commands an army of 1,250 Klansmen (252), a version of the avenger detective's "dedicated group of assistants" (Hoppenstand 1982: 4). Dixon omits any depiction of lynchings and nooses, so his Klan has no iconic weaponry, but *The Clansman* does introduce the "Fiery Cross" used to summon and organize members (240), a symbol and practice invented by Dixon and not derived from the Reconstruction-era organization (Newton and Newton 1991: 165). Hoppenstand also describes the avenger detective as "moral" (he doesn't drink, smoke, or womanize), "superhuman" relative to the skills displayed by other characters, and not only a defender of "the culture that he served" but a representative of "the best that culture had to offer" (4), all of which describe Dixon's hero.

Hoppenstand does not list the character type's most overt characteristic, presumably because it is embodied in his designation: the avenger detective investigates crime, and though he is more focused on action than are classical detectives like Sherlock Holmes, detection is central to his narratives. Likewise, Dixon portrays Ben Cameron as a skilled detective. When "he could find no trace of the crime he had suspected" in a victim's house, he "searched the yard carefully" until he found "the barefoot tracks of a negro" which he carefully analyzes:

The white man was never born who could make the track. The enormous heel projected backward, and the hollow of the instep where the dirt would scarcely be touched by an Aryan was the deep wide mark of the African flat foot. He carefully measured it, brought from an outhouse a box, and fastened it over the spot. (229)

Though the racial analysis is absurd, Dixon intends to establish Cameron as an insightful sleuth. *The Clansman*, although purportedly historical fiction, also resembles the proto-superhero tradition of the occult detective. During the investigation of the rapist Gus, Cameron's father employs two "scientific experiment[s]" of fantastical nature: "The doctor's eyes flashed with a mystical

light" after he "drew from its case a powerful microscope of French make"; "the fire-etched record of this crime can yet be traced" by revealing the image of the criminal left on the retinas of a dead woman's eyes, an "experiment" which apparently "has been made successfully in France" (237, 231). Soon afterward, Dr. Cameron, appearing "like an ancient alchemist" in "weird surroundings," places Gus "into complete hypnosis," forcing him to "describe and rehearse the crime itself," including a periodic "fiendish laugh" (237).

Despite these correspondences, Dixon's Klansmen stand apart from his literary context. Though Hoppenstand identifies the dime novel avenger detective as a vigilante, Nick Carter functions as an arm of the government. Carter receives a trusted police inspector "at home ... as he would have received no other man in the whole city of New York; in his own proper person" (*Nick Carter* 1891); by 1907, Carter's government liaison was upgraded to the President of the United States, who requests his services in terms of a "contract" and a "commission" (*Great Spy System* 1907). Furthermore, neither the dime novel avenger detective nor the occult detective formulas include some of the superhero's most distinguishing features. Cameron, like Superman, is not a master of disguise because *The Clansmen* and the superhero narratives that followed transform "disguise" into an alternate, consistent, and single heroic identity. Nick Carter assumes multiple identities—his cover illustration includes a row of dissimilar faces and the caption: "Nick Carter in various disguises" (1891)—but he has no Ben Cameron/Grand Dragon or Clark Kent/Superman double identity nor the accompanying alias and representative costume required to maintain it.

As mentioned in Chapter 2.III, Hoppenstand attributes the "invention of a hero who employs a dual identity" to Baroness Orczy in *The Scarlet Pimpernel*, another historical novel published the same year as *The Clansman* (2000: xviii). Bypassing Dixon's contribution is striking because, unlike the Grand Dragon, the Scarlet Pimpernel has no costume or bodily incarnation. Instead of transforming into the hero persona, his alter ego, Sir Percy, vanishes into multiple, anonymous disguises that keep the hero hidden and usually out of scene. Superheroes bear much greater resemblance to Dixon's Klansmen: costumed heroes with overt, physical, and always recognizable presences. Dixon portrays his

Night Hawks as carefully concealing their identities, carrying with them costumed disguises that "were easily folded within a blanket and kept under the saddle in a crowd without discovery" (233). He emphasizes the efficiency of the physical transformation that takes place "in the woods," the nineteenth-century equivalent of Clark Kent's phone booth: "It required less than two minutes to remove the saddles, place the disguises, and remount" (233). In contrast, the Scarlet Pimpernel, like other avenger detectives, is a master of multiple disguises with no single, representative costumed persona.

With Griffith's film adaptation, Dixon's character type—a vigilante hero with a costumed alias—shifted from its Reconstruction era to a contemporary U.S. setting. The Clansman, retitled by Dixon to The Birth of a Nation, was an immediate critical and box office success leading to a nationwide KKK revival. The Klan portrayed in Dixon's novels was historical; no Klan had existed in the United States since the1870s. Eight months after the film's Los Angeles premiere in January 1915, and following the film's Thanksgiving showing in Atlanta, the second Klan was founded at a rally at a Confederate memorial. The inaugural roster included elderly members of the original Reconstruction-era Klan and the recently formed vigilante organization Knights of Mary Phagan. The latter had kidnapped Leo Frank, a Jewish factory owner sentenced to life imprisonment for the murder of his employee Mary Phagan, from a Georgia prison and lynched him that summer.

Although Dixon's attitudes toward the Klan are complex—both The Leopard's Spots and The Traitor, the final installment of his Reconstruction trilogy, ultimately reject the legitimacy of the post-1870 organization—those complexities are largely absent from The Clansman and are entirely lost in Griffith's adaptation. Despite the record-breaking success of The Birth of a Nation, by the 1920s Dixon's literary popularity, and so his direct cultural influence, had ended. According to Williamson, his "extravagant romanticism" alienated him from literary readers and his "extremism in race relations" made him "an embarrassment to a South that had passed over into an age of genteel racism" (1984: 141). Dixon's fifteenth novel in 1921 essentially marked the end of his publishing career, and Slide notes that in 1925 Publishers Weekly did not include any of his works when documenting the best-selling fiction of the first quarter of the century (2004: 5). Dixon's more permanent cultural impact, however, was felt through the organization recreated

in the image of his fictional characters. By the early twenties, national KKK membership reached five million. Klansmen were no longer primarily literary or cinematic entities. Living Night Hawks donned masks and costumes and assumed actual aliases to preserve real-life secret identities. They often acted outside of state and federal laws to carry out what they considered to be a moral and nationalistic mission. Their powers were manifest in their numbers and the political and social influence they wielded.

In fiction, the KKK's rise coincided with the ebbing of the dime novel avenger detective. Between the lynching of Leo Frank and his murderers' induction into the new Klan, Nick Carter vanished from newsstands as Street and Smith (future publisher of *The Shadow* and *Doc Savage*) changed their bi-monthly *Nick Carter Weekly* to *Detective Story Magazine*. The character type was replaced by a new and expanding wave of secret identity vigilante heroes, a manifestation of the period's Klan-driven zeitgeist. While *The Birth of a Nation* was showing in theaters across the country, Dixon's publisher introduced another proto-superhero historical novel, Russell Thorndike's *Doctor Syn: A Tale of the Romney Marsh*: the doctor, a former pirate turned vicar, dons a scarecrow disguise and leads a band of smugglers against an abusive central government. Like Ben Cameron's ghostly Night Hawks, his riders "were fantastically dressed in black, and wore queer tall hats ... only seen in ghost books" (1915: 58). This new breed of hero next appeared in film as the Laughing Mask in the Edward José and George B. Seitz serial *The Iron Claw* (1916). Although pursued by police who mistakenly wish to "land that masked criminal in the cell where he belongs" (Stringer 1916), the hero "acted in a double role," appearing both as himself and as the Laughing Mask. Like the Grand Dragon and the Scarecrow, he organizes "a secret order of Laughing Masks" to help him (Stringer 1916a).

In the decade following *The Birth of a Nation*, the new hero type proliferated in multiple media (as discussed in Chapter 2.III), and the 1930s, beginning with the market-transforming introduction of The Shadow, first on radio, and then in the first single-character magazine since Nick Carter expanded the presence of the costumed hero exponentially, making masked vigilantism a pop culture norm. "In these formulas," writes Hoppenstand, "traditional law enforcement agencies were unable to deal with crime; thus the pulp hero adopted vigilantism to deal with the

problem" (1983: 144). As the Klan declined in the 1930s, its fictional stand-ins continued its authoritarian mission, imposing moral order on urban chaos. These Klan-influenced characters are all second generation descendants of Dixon's Klansmen and direct predecessors of the comic book superheroes about to emerge. The image of the Night Hawk featured on *Birth of a Nation* posters included a cape billowing from his back, an element of the superhero costume not seen again until Joe Shuster's Superman cover of *Action Comics* #1.

Superman

According to Stan Lee, "Superman was the first of all costumed comic book heroes and, even today, his image is probably the first that comes to mind when thinking of the phrase 'super hero'" (2009: 5). The claim is disputable, but Michael Chabon summarizes general opinion: "There were costumed crime-fighters before Superman (the Phantom, Zorro), but only as there were quartets before the Beatles. Superman invented and exhausted his genre in a single bound" (65). Richard Reynolds examines Superman's original *Action Comics* appearance as a "first step towards a definition of the superhero" (1992: 12). Though "the wholly new genre" was created "out of a very diverse set of materials," "much that would become central," asserts Reynolds, "is established in these 13 pages" (10, 12). While Dixon does not provide all of these materials, he is a primary contributor.

Ben Cameron, a prototype of the costumed vigilante hero distinct from the dime novel avenger detective, shares a majority of qualities that Reynolds claims were uniquely clustered in Superman. Most centrally, Superman possesses a secret identity, the trope evolved from the nineteenth-century hero tradition of the master of disguise portrayed by Dixon and subsequently manifested by the actual KKK. Like the Klan, the original Superman is explicitly a vigilante, working against the government to achieve a greater good. Reynolds notes that Superman helps those "victimized by a blind though well-intentioned state" in his first adventure by breaking into a governor's home to save a wrongly convicted woman from execution (14). The governor, paradoxically, declares

afterward: "Thank Heaven he's apparently on the side of law and order!" (Siegel and Shuster 2006: 7), the same claim that Dixon makes for the Klan in *The Leopard's Spots*, dubbing the organization "a Law and Order League" in their first appearance (1902: 151). Where Superman opposes the state's failed judicial process, Cameron battles state-sponsored "negro Leagues" of armed freedmen policing the occupied South (2005: 183). Though under the influence of a villain, the Union government is misguided rather than evil, as evidenced by its acceptance of the Klan's eventual victory, ending "The Reign of Terror" of Reconstruction (139). Both characters share the same aim: self-defined and self-imposed justice.

Reynolds also analyzes the vigilante theme on a nationalistic level, describing "Superman's ability (and willingness) to act clandestinely and even illegally if he believes national interests are at stake" (1992: 15); yet he is "capable of considerable patriotism and moral loyalty to the state, though not necessarily the letter of its laws" (16). This is also the position of the Klan. Gillespie and Hall observe how Dixon's "warriors rac[e] to the rescue of aged parents, small children, virtuous women, and, symbolically, the nation as a whole" (2006: 8). Not only is Ben Cameron's Klan "an institution of ... Patriotism ... patriotic in purpose," but he and his followers pledge themselves "To aid and assist in the execution of all Constitutional laws" (2005: 236), implying that the laws of Reconstruction are both unconstitutional and unpatriotic. Dixon's nationalistic vigilante is fighting for his own definition of truth, justice and the American way.

Cameron also partly prefigures Reynolds' "superpowered" criterion; his "extraordinary nature" is "contrasted with the ordinariness of his surroundings" (1992: 16), a continuation of the "superhuman" qualities that Hoppenstand identifies in the dime novel avenger detective (1982: 4). Unlike average white citizens and the Klan's African-American adversaries, Cameron and his followers display almost supernatural powers: their "ghostlike shadowy columns" rode "through the ten townships of the country and successfully disarmed every negro before day without the loss of a life" (252). As "Commander-in-Chief of the State" (235), Cameron also stands significantly above his followers, and he and his father are the most elite echelon of Southern aristocracy: "the hereditary leaders of these people. They

alone would have the audacity to fling this crime into the teeth of the world and threaten worse" (244). Cameron, however, is not superpowered in the manner of Superman, and he also does not suit Reynolds' "lost parents" and "man-god" categories (1992: 12). The only parental loss that Cameron suffers is metaphorical. He and his Southern aristocracy have been robbed of their Aryan "birthright" and "racial destiny" (126, 215). Siegel's Superman— because he inherited Cameron's structural traits but not his white supremacist agenda—has no link to his lost lineage nor any desire to re-establish it.

Beyond Dixon's literary influence, the transition from the 1930s incarnation of the pulp avenger detective to the superhero was shaped more directly by the real Klan—though now in a reverse manner, through the organization's loss of popularity. The Klan, the closest equivalent to real world superheroes, weakened by the late 1920s with the Great Depression and the rise of the ultimate Aryan superpower, Nazi Germany. Dixon, always ambivalent about the second Klan, openly criticized the organization, declaring them "unprincipled marauders" and "a menace to American democracy" (Slide 2004: 16). In 1936, while Siegel and Shuster were conceiving and revising Superman, nine members of Detroit's Black Legion—a splinter group of the Ohio Klan—were convicted of the kidnapping and murder of Charles Poole, an alleged wife-beater targeted by the organization. Black Legion founder William Shepard, according to historian Peter H. Amann, revitalized Klan-style vigilantism with new rites, higher secrecy, and new costumes: "You have to have mystery in a fraternal thing to keep it up," explained Shepard; "the folks eat it up" (Amann 1983: 496). Black Legion members wore black hoods, pirate hats, and robes with a cross-and-bones emblem on the chest—outfits resembling a comic book superhero costume. *Exciting Comics'* Black Terror would later feature the same chest emblem. Despite Shepard's passion for "crime fighting," Amann writes that in "real life, the activities ... were neither glamorous nor likely to reduce crime" (500). After the murder of Charles Poole, *The Detroit News* concluded: "Hooey may look like romance and adventure in the moonlight, but it always looks like hooey when you bring it out in the daylight." The trial shattered the Black Legion's "romantic air" and turned public sentiment against the organization and vigilantism in general. In 1937, despite the Senate's most recent

filibuster, a George Gallup poll found that 72 percent of Americans supported anti-lynching legislation (Thomas-Lester 2005).

So while the superhero incorporated tropes introduced by Dixon and literalized by real-world Klansmen, the genre also emerged from a culture that was turning against the Klan. As a paradoxical result, superheroes are vigilantes who battle, among other evils, vigilantism. Lars Anderson's Domino Lady was the first masked vigilante to battle the Klan, specifically the Black Legion, a "feared organization" of "black-hooded devils" on a "campaign of torture and death," in the unlikely pages of *Saucy Romantic Adventures* in October 1936 (2004: 68, 61); the issue was on newsstands when a Detroit jury convicted nine Black Legion members of murder on September 29. *The Shadow* radio episode "The White Legion" aired in March 1938, three months before *Action Comics* #1 reached newsstands. The White Legion, self-styled "avengers of injustice," begin the episode with a lynching, but by the end the Shadow has exposed their leader as a criminal ("The White Legion" 1938). When Siegel and Shuster expanded Superman's first adventure for *Superman* #1 in 1939, they added a new opening sequence in which a mob attacks a jail in an attempt to lynch a suspected murderer. The rope is over a tree branch and the noose around the innocent man's neck when Superman intervenes: "This prisoner's fate will be decided in a court of justice.—Return to your homes!" (Siegel and Shuster 2006: 198). The mob refuses, and so the first punch Superman throws in his career is against a Klan-style vigilante.

Siegel also evokes the Black Legion when Clark Kent hears of a "wife-beating" a few pages later (8), but in this case Superman is replacing the vigilante organization as a non-lethal but equally non-legal alternative. By the time the ineffectual police arrive, the would-be Charles Poole has fainted in the face of Superman's threat to give him "a lesson you'll never forget!" (9), making Superman as much a vigilante as a vigilante-fighter. DC would later transform Siegel and Shuster's character into a law-abiding champion of the status quo, but his formula would remain largely outside of government-regulated law enforcement. He is anti-Klan, yet, as Marshall McLuhan observes in his 1951 analysis, Superman also makes no "appeal to process of law. Justice is represented as an affair of personal strength alone" and "violent solutions" (2004: 105). Gershon Legman makes the same appraisal of

the overall genre in 1949, the year DC fired Siegel and Shuster, concluding that:

the Superman formula is essentially lynching ... Legal process is completely discounted and contemptuously by-passed. No trial is necessary, no stupid policeman hog all the fun ... Superman glorifies the 'right' of the individual to take the law into his own hands. (2004: 117–18)

Legman includes an "abbreviated" list of seventy-five comic book characters—"the black mask constant among all their copyrightable peculiarities" (118)—all of whom share this fundamental vigilante trait with the Klan. Legman's assertion, however, is rhetorical rather than historical; by 1949, the direct relationship between the superhero and the Klaln was lost.

The link was obscured in part by the change in political attitude represented by superheroes. While the Klan vilified immigrants from southern and western Europe and as threats to white Anglo Saxon Protestants, Superman in his third *Action Comics* appearance reverses the prejudice by rescuing mining victim "Stanislaw Kober," an apparent first generation Slavic immigrant exploited by mine owner "Thornton Blakely" (Siegel and Shuster 2006: 35). Making Superman the ultimate (and arguably Jewish) immigrant, Siegel appropriated his hero's name from the eugenics movement but undermined the movement's goals in the process.

As the superhero industry united against Nazi Germany, the ultimate embodiment of the Klan's eugenic agenda, Klan membership continued to plummet until the organization disbanded in 1944 at the peak of pre-Code superheroes. When Samuel Green, a.k.a "Imperial Wizard," formed a third Klan, Superman's radio incarnation battled him directly. Beginning in June 1946, two months after Thomas Dixon's death, a sequence of episodes titled "Clan of the Fiery Cross" revealed insider knowledge of the new organization's secret codes and rituals supplied to the show's writers by undercover journalist Stetson Kennedy. Since the organization was now a fringe group, well outside of the American mainstream, Superman had already won. Fictional superheroes had replaced real-world vigilantes. And yet, the unattributed motifs of *The Clansman* were preserved in the newly evolved hero formula.

At its core, the superhero still resembled the Grand Dragon, but stripped of its white supremacist elements.

Superhero

Nearly eighty years have passed since *Action Comics* #1, but the superhero preserves a majority of its original qualities, and so Dixon's contributions are still embedded in the character type. Coogan's twenty-first-century definition emphasizes the hero's mission, powers, and identity-expressing name, costume and emblem, all of which Ben Cameron still embodies. While Siegel and Shuster introduce Superman as a "Champion of the oppressed ... who had sworn to devote his existence to helping those in need!" (2006: 4), the Grand Dragon, and his followers, declare a nearly identical purpose decades earlier:

> To protect the weak, the innocent, and the defenseless from indignities, wrongs and outrages of the lawless, the violent, and the brutal; to relieve the injured and the oppressed: to succour the suffering and unfortunate, and especially the widows and the orphans of Confederate Soldiers. (Dixon 2005: 236)

When Batman swore in November 1939 to avenge his parents' death by "warring on all criminals" (Kane et al. 2006: 63), Coogan's selfless, pro-social mission became ingrained in the comic book character formula. He asserts that it is not unique to the superhero, since Superman's mission does not "differ materially from the missions of the dime novel or pulp and radio heroes of the late 19th and early 20th centuries" (2006: 31), but he does distinguish superheroes from heroes without generalized missions: "Superheroes actively seek to protect their communities by preventing harm to all people and by seeking to right wrongs committed by criminals and other villains" (2006: 254). The Klan's self-proclaimed purpose is the earliest incarnation of this superhero mission statement.

Coogan's emphasis on emblematic costumes and codenames further emphasizes the formula's debt to Dixon. Although Coogan presents the secret identity as typical but optional, the central,

identity-representing nature of the costume and codename is derived from the unique qualities of Ben Cameron's costumed alias. The iconic element, continues Coogan, "most clearly marks the superhero as different from his predecessors" since characters "like the Scarlet Pimpernel and Zorro ... do not firmly externalize their alter ego's inner character or biography" (32). Michael Chabon makes a similar observation, noting how the superhero costume "functions as a kind of magic screen onto which the repressed narrative may be projected," often "hinted at with a kind of enigmatic, dream-like obviousness right on the hero's chest" (2008: 68–9). Superman most famously embodies this trait, but Dixon's fictional Klansmen predate him by thirty-three years. Their costumes externalize their racial lineage and so their core motive. Dixon likens the costumed Night Hawks to "the Knights of the Middle Ages" riding "on their Holy Crusades," and on "each man's breast was a scarlet circle within which shone a white cross" (2005: 233); the Grand Dragon wears "two yellow circles with red crosses interlapping" (235). This is the first appearance of an iconic emblem on a hero's chest, a motif not repeated in fiction until Joe Shuster framed an "S" on Superman's shirt in 1938. When Bob Kane adopted a chest emblem for Batman in 1939, the motif became standard for the genre, but it is missing from all other superhero predecessors including the otherwise prototypical Zorro, the Shadow, and the Phantom. The Grand Dragon's chest emblem evokes "olden times when the Chieftain of our people summoned the clan on an errand of life and death" with "the Fiery Cross ... the ancient symbol of an unconquered race of men" (240). Though the Grand Dragon and his men express no inner character-ization through their individual codenames, their costumes' iconic imagery is embedded in their organization's name. "Ku Klux Klan" originates from "kuklos," the Greek word for "circle" (Newton and Newton 1991: vii), so the Klan is a "circle" in the sense of a band or brotherhood and is represented by the lineage-laden circle of their emblem.

Griffith's *The Birth of a Nation* reveals an even stronger influence on the superhero costume and its relation to the superhero origin formula. After seeing his homeland under Negro rule, Ben Cameron sits alone, "[i]n agony of soul over the degradation and ruin of his people." A group of children appear as if in answer; two white children place a white sheet over their heads, and

the black children are terrified by the ghostly sight: "The inspiration." Cameron stands, now ready to act: "The result. The Ku Klux Klan." In the next frame sit three mounted Klansmen in full costume. Bill Finger and Bob Kane, when creating Batman's origin, echo Griffith's narrative structure. After witnessing the murder of his parents and vowing to avenge their deaths by warring on all criminals, Bruce Wayne sits alone contemplating a disguise: "Criminals are a superstitious cowardly lot. So my disguise must be able to strike terror into their hearts. I must be a creature of the night, black, terrible." Like Cameron, Wayne's needs are answered by a seemingly chance appearance—"As if in answer a huge bat flies in the open window!"—which provides his needed inspiration: "A bat! That's it! It's an omen. I shall become a BAT!" In the next frame, he stands in full costume: "And thus is born the weird figure of the dark ... this avenger of evil, 'The Batman'" (Kane et al. 2006: 63). The three-panel sequence repeats not only Griffith's structure—hero alone, chance inspiration, first image of costumed persona—but also the "superstitious" rationalization for the disguise. Griffith' scene dramatizes the first costume origin story, one duplicated in later iconic superhero texts.

Perhaps the most enduring mark of the Klan on the formula is the superhero's paradoxical relationship toward law and order. Narratives repeatedly express a core tension between romanticizing vigilantes and acknowledging their threat to a democratically governed society—a tension Dixon himself anticipated: "There can be but one end to a secret order of disguised men. It will grow into a reign of terror which only martial law will be able to put down" (Newton and Newton 1991: 166). Both of the two most highly acclaimed superhero graphic novels, Alan Moore and Dave Gibbons' *Watchmen* (the title translates "Vigilantes") and Frank Miller's *The Dark Knight Returns*, create universes in which superheroes have been vanquished not by the menace of supervillains but by the U.S. government through legislation outlawing costumed vigilantes. Moore, through a fictional editorial, describes the Watchmen's actions as "glorified Klan-style brutality" and "costumed heroes as direct descendants of the Ku Klux Klan" (Moore and Gibbons 1987: Ch. 8; 12, 30). Brad Bird's 2004-animated film *The Incredibles* is premised on another anti-superhero legislation scenario, and in 2006–7, Marvel Comics explored the same tension in the strikingly titled *Civil War*. The

multi-title series, which imagines a Superhuman Registration Act to end vigilante secret identities, culminates in the government control of all superheroes and the death of the original state-sponsored superhero-turned-vigilante Captain America. Garth Ennis and Darick Robertson explore similar issues in *The Boys*, in which the CIA is tasked with controlling "the most dangerous power on earth," superheroes (2008: 13).

All of these narratives repeat actual government battles against the Klan. In 1871, Congress passed the Ku Klux Klan Act, which, in addition to creating criminal penalties designed to bolster the Fourteenth Amendment, gave the President the power to suspend *habeas corpus* against suspected Klan members. In 1922, Chicago's city council outlawed the wearing of masks in public in an effort to combat Klan activity, and seventeen state legislatures followed with similar anti-mask laws. In 1944, the Internal Revenue Service filed a lien against the Klan for unpaid taxes, finally forcing the twenty-nine-year-old organization to disband.

With the superhero's historical link to the Klan remains essentially erased, rather than acknowledging similarities between Klansmen and superheroes, comic book writers have consistently distanced their heroes from Klan-like adversaries. Bradford W. Wright recounts the October1965 issue of *The Avengers* featuring "an organization called the Sons of the Serpent, which bore a close resemblance to the Ku Klux Klan and pledged to rid America of 'foreigners' and those of different 'creed' and 'heritage'" (2001: 219). The next month in *The X-Man*, Stan Lee and Jack Kirby created the Sentinels, giant robots with a mission to rid humanity of the mutant race because of its genetic threat. The following year in *Fantastic Four*, Lee and Kirby introduced the first African superhero, Black Panther, who in 1976, writer Don McGregor pitted against an undisguised representation of the Klan in *Jungle Action*. In DC Comics, Dennis O'Neil and Neal Adams introduced equally direct political commentary into the character of Green Arrow who in 1969 became a left wing social advocate, further aligning supeheroes to a liberal, anti-discriminatory agenda anathema to Klan politics.

The progressive trend, however, only strengthens the paradox at the core of the character type. A vigilante fighting for tolerance is still a vigilante. Siegel and Shuster turned Superman's stated mission against the Klan, but the formula of a disguised hero disregarding

laws and using violence to enforce his own moral judgments still embeds fundamental Klan values. Content cannot erase form, and the more overt the anti-Klan politics of a superhero the greater the contradiction in his actions. In 2001, *Green Lantern* writer Judd Winick introduced Terry Berg, an openly gay character, and the following year sympathetically portrayed him as the victim of a near-fatal hate crime. When one of Terry's attackers is taken into police custody, the enraged Green Lantern enters the prison and breaks the man's wrists in order to learn the identities of the other criminals who he then hunts down and beats nearly to death. Sixty years after Superman thwarts his first lynching and wife-beating, the superhero remains a vigilantism-fighting vigilante, stopping just short of murder to punish other perpetrators of violence. Valerie Palmer-Mehta and Kellie Hay analyze reader reaction to the episode, showing that 19 percent of letter writers "express concern with the vigilante violence" (2005: 397). One fan encapsulates the genre's inherent contradiction: "Just because he is a superhero doesn't mean that he can take the law into his own hands, even though he does it every day fighting super villains" (Palmer-Mehta and Hay 2005: 397). Another declares that "force is only justified in self defense. Non-aggression, as a matter of principle is morally better than aggression" (398). It is precisely this moral principle that the Klan-derived superhero formula contradicts.

"The basic elements of the superhero genre," observes Jeffrey A. Brown, "have remained almost unchanged since the formula was established"; "The form", however, can "reconfigure the staples of the genre to reflect a changing cultural environment" (2001: 148, 150). As a result, a range of non-WASP superheroes have emerged in recent decades, further disguising the gulf between the genre's increasing diversity and its white supremacist roots. So Dwayne McDuffie and M. D. Bright's 1993 character, Icon—an African-American Superman adopted not by a mid-western white couple but a slave woman of the pre-Civil War South—appears as merely a variation on a theme and not a fundamental reversal. The surface agenda of the superhero is malleable and evolves with social contexts, but his modus operands is one of the formula's constants. Hoods and capes change color, but it is always a fist clenched inside the glove.

DC Comics repeatedly rewrites its past to reintroduce its characters to readers, deleting former facts from their histories. For

a 2003 reboot, DC assigned Mark Waid to "re-imagine Superman for the twenty-first century" (2005: 4). In the resulting *Superman: Birthright*, Waid determined that instead of "turning his back on his alien heritage," Superman would "*embrac[e]* that heritage" and "take his rightful place" in the world (8). Waid's Superman gleans that he was born from "a race of adventurers and explorers eager to plant their banner to mark the victory of their survival. His birth race were a people of accomplishments and great deeds," and so Superman adopts that "pride" and "sense of tradition" (9). Waid seems unaware that his focus on genetic heritage and birthright recreates the influences and cultural context of Superman's original publication. Both Superman and the Grand Dragon are thrown into existence by the destruction of their birth homes, making Kyrpton and the defeated South their sources of power, identity, and mission.

3

Historical Overview, Part 2: Pre-Code and First Code Origins

I

The Fascist Superhero

Comic book superheroes, in the wake of Superman's market-transforming debut in 1938, arose with the threat of war and declined to near extinction in its aftermath. "No other fad in entertainment," claims Gerard Jones, "has ever paralleled real-life events as closely as the superheroes paralleled World War II" (2004: 231). The correlation does not show causality, but it does establish a relationship between the comic book genre and the war against fascism. Fruitful examinations of Superman as an adolescent power fantasy and Depression-era restorative have been offered to explain the character type's emergence, and the drop in popularity has been similarly linked to a variety of causes, including the loss of military readership and the expansion of television audiences. These interpretations also accompany a more general conclusion that superheroes, having been linked to the war effort, lost their purpose and sales with the defeat of the Axis. Though accurate, the observation does not address the political contradictions contained in the figure and how they may also have influenced its reception.

Summarizing the character type from the vantage of the twenty-first century, Andrew Bolton describes superheroes as upholders of "American utopianism as expressed in the Declaration of Independence and Constitution" (2008: 47), but viewed in their late 1930s and early 1940s context, they also express the paradox that such utopianism can only be defended through the anti-democratic means of vigilantism and authoritarian violence. Comic book superheroes were conceived during the threat of fascism, reached their highest popularity with the expansion of a fascist-fighting

war, and began to wane not at the close of that war but at the earliest signs of a still-distant victory. Although the character type and its popular progression must be understood within a confluence of cultural forces and factors, the parallel rise and fall of fascism provides insight into the hero type's conception, market surge, and ideological renunciation.

Nazism and Fascism, while historically, geographically, and ideologically separable, were both dictatorial, anti-democratic, totalitarian, nationalistic, and militaristic. The terms were often used interchangeably during the 1940s. The 1945 *Time* article "Are Comics Fascist?," rather than excluding Nazism, uses fascism as a generic term that includes both German Nazis and Italian Fascists. Since Fascism and Nazism shared a mostly undifferentiated impact on the popular productions of comic books, this chapter continues the practice of referencing Nazism as a sub-category of fascism. In this more general sense, fascism, like superheroism, champion acts of anti-democratically authoritarian violence committed in the name of the national good.

Although fascism appears anathema to a current understanding of superheroes, contemporary journalists have commented on the fascist aesthetics of the genre: in "The Real Problem With Superman's New Writer Isn't Bigotry, It's Fascism," the *Atlantic*'s Noah Berlatsky remarks that "superhero-as-oppressor is almost as much of a trope as superhero-as-savior" (2013); "Superheroes," writes Joe Queenan in the *Guardian*, "operate in a netherworld just this side of fascism" (2013); and in his critique of *The Dark Knight Rises*, Andrew O'Herir declares that the character's "universe is fascist," arguing that the screenplay "pushes the Batman legend to its logical extreme," a version of "the ideology that was bequeathed from Richard Wagner to Nietzsche to Adolf Hitler" (2012). Scholars have observed the character type's fascist qualities for decades: Peter Coogan presented "F For Fascism: The Fascist Underpinnings of Superheroes" at the Midwest Popular Culture conference in 1989; Leonard Rifas, responding to a 1995 comics scholar survey, "suggested that the question asked by *Time* magazine in October 22, 1945, 'Are [superhero] comics fascist?' is due for reinterrogation" (Coogan 1995); Geoff Klock explores "the degree to which superhero narratives boil down to a choice among various modes of fascism" (2002: 106); Craig Fischer poses a similar question, can superhero comics "function as fascist

propaganda?" (2003: 334), the same year Scott Bukatman referred to superheroes as "innately fascist" (2003: 185); and Jose Alaniz more recently describes superheroism as "primary-color fascism" (2014: 9).

Such observations, however, typically treat fascism as a characteristic independent of historical fascism. Alaniz, for instance, responds to "the nature of violence in the genre as particularly reactive and reactionary" (2014: 9); Klock analyzes Alan Moore's 1999 series *Tom Strong*; Bukatman looks at the contemporary character type as "authority and order incarnate" (2003: 185); and Fischer questions what effect comics could have on "kids from disenfranchised backgrounds" (2003: 334). Coogan explains the correlation between fascism and superheroism as expressions—one political, the other literary—of a shared central core, since both "mediate the same unreconcilables" for the "same audience" using "similar methods" and "similar if not identical justifications" (1989). The focus is again on the current genre, not the circumstances of its development. Even O'Herir, despite a reference to Hitler, suggests that only now through Christopher Nolan has Batman reached his "logical extreme" (2012). But if that fascist logic is embedded in the character type, and if the comic book genre was created and overwhelmingly popularized during a fascist crisis, then contemporary superheroes' violent, nationalistic, anti-democratic, totalitarian heroism bears some relationship to historical fascism.

The ahistorical use of fascism as a generic term has also triggered scholarly backlash. Marco Arnaudo, for example, acknowledges that characteristics of superheroes' "heroic code of ethics are also part of the fascist imaginary" but rejects "seeing such a sequence as necessarily and exclusively fascist" since then "all heroism is by definition fascist" (2010: 73). Arnoudo, like most other scholars, is not studying the genre's historical roots, and his reasoning relies on a straw man of exclusivity and a slippery slope of generalized heroism. Similarly, for Jeffrey J. Kripal, "equating the Superman, much less the superhero, in toto with fascism" is "a half truth," "a gross misrepresentation," and even "a precise reversal of the truth"; and yet, while arguing that "the idea of the superman" has "no necessary connection to Nazism," Kripal figures Superman as a "Future Human," "a model for the future evolution of human nature" (2011: 74, 75), which was the precise aim of Nazi eugenics.

When historical fascism is mentioned, it is often presented in opposition to superheroism as the genre's formative threat. For Christopher Murray, for example, the Depression and "the rise of Fascism" are why superheroes "struck a chord," "demonstrating that, despite the hardships it faced, America" still had "the will to fight to protect freedom and justice" (2011: 10). Tom De Haven briefly acknowledges that the "small-s superman" of Nietzsche was, among many other things, the stuff of "Nazi politics," and so "the capital-S Superman was a product of that particular time and cultural tumult" (2010: 68), and Lance Eaton also notes that superheroes "were not understood as the nearly perfect moral characters that their creators slowly developed them into over time" and which gained popularity as the U.S. looked "towards Europe's forthcoming war" (2013: 35). Lawrence and Jewett go further and identify the 1930s as "the *axial decade* for the formation of the American monomyth" in which "alien forces too powerful for democratic institutions to quell" require the rise of a violent, authoritarian hero, but they regard the period's "unprecedented foreign threats to democratic societies" as merely "the background for the creative advance" and not its cause (2002: 36, 132, 36). They also observe the "final extension of powers into the superheroic scale" with "a proliferation of superheroes … to complete the formation of the monomythic hero," but they do not suggest why such an extension occurred at this particular historical moment nor do they analyze its social-political context to explain the completion (41, 43).

Other scholars have focused on the comic book genre as a Jewish response to the period's fascist-fueled anti-Semitism abroad and at home. Danny Fingeroth asserts that "creation of a legion of special beings, self-appointed to protect the weak, innocent and victimized at a time when fascism was dominating the European continent from which the creators of the heroes hailed, seems like a task the Jews were uniquely positioned to take on" (2007: 17). To answer what led him "into conceiving Superman in the early thirties," Jerry Siegel's response includes: "Hearing and reading of the oppression and slaughter of helpless, oppressed Jews in Nazi Germany" (1975: 8). Although Siegel created the character before the Holocaust, Hitler's government passed six anti-Jewish laws in 1933 when Siegel was beginning his collaboration with Joe Shuster.

To envision a figure capable of opposing the new Nazi regime, Siegel appropriated the central, anti-democratic symbol of eugenics. Sharing his name with his fascist-appropriated Nietzschean forebear, the comic book Superman may be analyzed as a reactionary fantasy figure who countered totalitarian might by paradoxically adopting it for opposite political purposes. Robert Weiner sees "irony" because Captain America and the Human Torch look like "the Master Aryan man of superior stature" (2005: 86), but the nature of the irony changes if superheroes are understood to intentionally reflect and co-opt their foes' traits. John Moser asserts that Americans were "simultaneously repelled and fascinated by [the Nazis]; the ideas were too alien, of course, to be embraced by any significant portion of the population" (2009: 24), but with democracy under attack, a very large portion of comic book creators and buyers did embrace fascist-fighting heroes who were themselves fascist-like.

The relationship between Superman's appeal and "our national aspirations of the moment" was argued in one of the first analyses of the genre. In 1940, psychiatrist and future Wonder Woman creator William Marston identifies two wish fulfillments behind "Superman and similar comics":

> to develop unbeatable national might, and to use this great power ... to protect innocent, peace-loving people from destructive, ruthless evil ... You don't think for a moment that it is wrong to imagine the fulfillment of those two aspirations of the United States of America, do you? (Richards 1940: 22)

Marston, however, does not acknowledge the political complexities of wishing for the defeat of destructive might through an agent of destructive might—a continuing contradiction of the character type born during the fascist period. Other early 1940s writers—Brown, Vlamos, North, Doyle, Southard—link comics and fascism, a critique that even when cursory deepened the public impression of superheroes as unwholesome subject matter. After the fall of Germany, the threat of Communism did not maintain the figure's popularity, and those few superheroes who survived the industry's Wertham-led, anti-fascist purging in the mid-1950s no longer displayed anti-democratic, authoritative violence. The historical relationship between World War II era heroes and fascism was

further distanced in the early 1960s when creators reproduced the formulas apart from their original context. While superheroes are not exclusively a fascist phenomenon, and while their enduring popularity is a product of myriad factors, their fascist origins remain embedded in the genre and continue to influence the hero type.

Champion of the oppressed

Siegel's choice of "superman" for the name of his and Shuster's 1938 character was peculiar since the word—appropriated from Nietzsche by George Bernard Shaw in 1903 for eugenics—was by the 1930s a ubiquitous term for individual exceptionalism. Though the line of influence was almost certainly indirect, Arie Kaplan asserts that "Siegel and Shuster derived the name 'Superman' from *'Ubermensch','*" and, more problematically, regards "the term's Nazi associations" as merely "ironic," believing it would only "later become associated with the Nazi notion of Aryan superiority" but was at the time "associated with Nietzsche's philosophy and nothing more" (2008: 11). Nietzsche' philosophy, however, had been linked to eugenics since the late nineteenth century, and "superman" denoted German military aggression well before World War II. The Great War, considered the product of German elitism, was sometimes dubbed "Nietzsche in Action" or "The Euro-Nietzschean War" (Salter 1917: v). A 1916 *New York Times* editorial "Two Years of the Superman" declares that, although the first year of the war ended with "Superman everywhere in ascent," "the common men" were now "coming towards their own" proving that Germany's "arrogance, egotism, cruelty and tyranny cannot conquer the world". A 1935 *Time* article, reporting the League of Nation's response to Germany's violation of the Treaty of Versailles, was titled simply "THE LEAGUE: Superman!" The unglossed, one-word exclamation encapsulated international protest against Germany's rearmament.

Siegel first used the term in his short story "The Reign of the Superman," self-published in January 1933, the month Adolf Hitler was appointed Chancellor after performing well in the earlier presidential election. Like Hitler, Siegel's Superman intends to provoke

war: "The Superman" disrupts the "International Conciliatory Council," "the greatest Peace Conference of all time," by mentally "broadcasting thoughts of hate" that would "send the armies of the world to total annihilation" (1933: 13). *Times* correspondent Norman Ebbutt articulated similar fears, warning that Germany, despite Hitler professing "a peaceful foreign policy," intended "to recover all it has lost and has little hope of doing so by peaceful means" (Reed 1941: 18). In this political climate, a "flood of stories about mental and physical supermen," observes Thomas Andrae, "hit the newsstands," each featuring a superman who is "a sinister figure who is so obsessed with his power and so contemptuous of mankind that he threatens to dominate and enslave the world" (1987: 125). The subgenre, writes Peter Coogan, dramatizes "the threat of generational genocide—the replacement of humanity" by "the next and more advanced version of the human genus" (2006: 128), the goal of eugenics. "The idea of the superman," explains Andrae, "was in the air during the early thirties, oppressively evident in the Nazi's distorted use of the Nietzschean concept of the Ubermensch to glorify Aryan racial superiority and to justify their program of totalitarian domination" (125). In response, science-fiction writers, including Siegel, depicted the defeat of Germany through the destruction of stand-in supermen.

Similarly, the protagonist superman character type that evolved in early 1930s pulp adventure magazines, observes Coogan, was "a physically and mentally superior individual who acts according to his own will without regard for the legal strictures that represent the morality of society" (161), but instead of depicting the defeat of superman, pulp authors employed the figure as a paradoxical protector who "reinforce[s] the very rules of society [he] breaks" (163). Because Lester Dent's 1933 Doc Savage places "his superiority in service to the community," Coogan argues that he "never risks turning into a ruler" (143). Publisher Street and Smith promoted *Doc Savage Magazine* with an ad banner: "SUPERMAN," a "man of Master Mind and Body" (Murray 2008: 71), on a mission "of doing good to all" (Dent 2008: 9).

The upheaval in literary formula shares its historical moment with the political upheavals of fascist Europe. While Siegel and Shuster were transforming the villain of "The Reign of the Superman" into a do-gooder, Hitler was withdrawing Germany from the League of Nations after a Jewish citizen petitioned the

League to void Germany's anti-Jewish laws. While the League proved unable to enforce its minority protection clause, two second-generation American Jews created a fantasy rescuer, who indirectly defied the Aryan superpower by co-opting its symbol. "Superman, the literary child of Jews," writes Simcha Weinstein, "became on pulp paper what Hitler could not create even on the ashes of millions of flesh-and-blood Jewish children: the *ubermensch*" (2006: 25). This inverted Superman did not strive to dominate the weaker but to protect them, a reversal of Nietzsche's philosophy and Hitler's social agenda.

After "The Superman" met with rejections from multiple comic strip syndicates, Siegel approached artist Russell Keaton. As discussed in Chapter 2.III, Siegel's June 1934 script describes the three-year-old Clark Kent as "a child whose physical structure was millions of years advanced from" humans because he was a child of earth "in its last days"; as "Giant cataclysms were shaking the reeling planet, destroying mankind," "the last man on earth" "placed his infant babe within a small time-machine ... launching it" to "the primitive year, 1935, A. D." (qtd in Trexler 2006). Siegel would later introduce Krypton, but in 1934 his planet of supermen were not aliens but evolved humans. Siegel co-opts the product of an explicitly pro-Aryan, anti-Semitic pseudo-science developed in the U.S. and championed by Germany, making the superman the adoptive son of Sam and Molly Kent who have a "duty to train him ... so that he will use his super strength to help those in need of assistance." The genetic child of the fascist future would be nurtured by parents of the American present, turning the goal of eugenics, the literal "Man of Tomorrow," against its creators. Marston, unaware of this original script, understood the character in the same terms, concluding that Siegel "believed that the real superman of the future would use his invincible strength to right human wrongs" (Richard 1940: 11).

After Siegel returned to Shuster as his collaborator, the Japanese invasion of China drew international condemnation with the seizure of Nanjing, and Japan's sinking of a U.S. gunboat further alerted the American public to the threat of war. The following month, *Detective Comics* editor Vin Sullivan contracted a thirteen-page feature from Siegel and Shuster, while allotting the other nine stories between only one and eleven pages (Daniels 1998: 30). Siegel and Shuster had spent the previous five years amassing

rejections, but as war fears reached a new high, Sullivan selected from the several features they sent to him the incongruent fantasy of an anti-superman Superman, not as filler, but for lead feature and debut cover.

When discussing why children liked the character, William Marston's interviewer suggested "it was story value—the primitive thrill of danger and adventure"; Marston disagreed, asserting that Siegel's "radical" comics, which lack "plot, danger, menace, and all suspense," "have almost no story value at all" but "nearly 100% wish-fulfillment ... The wish for strength and power, and the wish to benefit other people" (Richard 1940: 22). As previously noted, Marston raises that superheroic wish from an individual to a national level, paralleling what Richard Slotkin identifies as a "loose consensus" between leftists and conservatives unified as a "Popular Front Against Fascism" (1998: 281). The character type, amplified from earlier pulp traditions, was already partly fascist. Bruce Graeme, for example, borrowed his 1925 hero's name and costume from Mussolini's paramilitary Blackshirts. In addition to a black mask, the "super-criminal" wears a black shirt and black tie—"Sounds to me like a Fascist!" (1925: 13)—while committing his Robin Hood-esque crimes. Superman would share Blackshirt's disregard for legal procedure, employing the standard fascist tactics of violence, physical threats and even manslaughter to achieve his anti-fascist goals.

While *Action Comics* #1 was moving into production, Germany annexed Austria and threatened Czechoslovakia. In his second adventure, Superman ends a South American war by kidnapping the opposing commanders who quickly "shake hands and make up" (Siegel and Shuster 2006: 1, 30). Siegel scripted the Superman-brokered peace deal while allied leaders were embroiled in actual peace talks with Germany and Italy. The fantasy version satisfied comic book readers so successfully that, while Czechoslovakia was being divided under German control, Detective Comics contracted a nationally syndicated newspaper strip. By issue eleven *Action Comics* sales were nearing half a million (Daniels 1998: 35), due entirely to the popularity of a character "beyond the power of the armed forces, should he choose to oppose state power" (Reynolds 1992: 15).

The appeal of the character was in part political. "It was clear from the start," writes Bob Hughes, "that Superman voted for

Roosevelt" (2005: 6). Superheroes, argues Wright, "assumed the role of super-New Dealers" (2001: 24). Unlike his Nietzschean counterpart, Siegel and Shuster's Superman fought for the common man, battling unscrupulous business from Wall Street to college football fields. Despite Superman's progressive social and political agenda, however, Wright recognizes that "Superman's America was something of a paradox" (13). The hero stopped corruption with the totalitarian methods of a one-man army. The New Deal Superman mirrored the Nazi superman, reversing political aims as an anti-democratic dictator. "To the Depression-weary average American," writes Hughes, "Superman appeared to be what it took to change the world" (6). After invading a radio station to announce his "war on reckless drivers," he destroys impounded cars, a used car lot, and a car manufacturing plant, before kidnapping the mayor to enforce traffic laws (Siegel and Shuster 2006: 156). His "one-man battle" includes demolishing the city's "filthy, crime-festering slums" because he concludes that poor living conditions produce juvenile delinquents (98, 109). "Only the righteous violence of Superman," observes Wright, "... could relieve deep social problems—a tacit recognition that in American society it took some might to make right after all" (13).

The fantasy of benign totalitarianism was further enabled by Superman's emergent medium. Scott McCloud explains "the simplified reality" of the comic book "as a form of amplification through simplification ... By stripping down an image to its essential 'meaning,' an artist can amplify that meaning in a way that realistic art can't" (1993: 30). Shuster's style produces a character as devoid of complexity visually as he is ethically. Flat backgrounds, stark body lines, monotone colors, repetitive facial expression, all contribute to a world view of reassuringly simple choices. Shuster amplifies his hero's body, filling panel after panel with Superman's destructive actions, as if the justification for those actions were morally self-evident. The stripped down meaning of Superman is authoritarian violence, an arguably juvenile response to the threat of violence tailored for a juvenile market.

The Ultra-Humanite, the first comic book supervillain, appeared in the June 1939 issue, and the antagonist was featured in five of the next seven. Previous pulp heroes infrequently faced the same character more than once, and Siegel is first to employ a villain with such consecutive repetition. Echoing "The Reign of the Superman,"

the Ultra-Humanite's goal is "Domination of the world!!" (Siegel 1933: 190). Like Hitler, "Ultra" pursues an explicitly eugenics agenda: "The human race shall be blotted out so that I can launch a race of my own" (Siegel and Shuster 2007: 139). De Haven notes the "one-to-one synonyms for 'super' and 'man'" (2010: 123) without commenting that the Ultra-Humanite also reverses the new Superman as "a paralyzed cripple" possessing "terrible hatred and sinister intelligence" (Siegel 1933: 190). Siegel, having designed Superman as a distortion of his Nietzschean namesake, refracts the image back at its source, personifying fascism as a would-be ultra-human dictator.

When Germany's war threats culminated in the September 1939 invasion of Poland, a dozen Superman imitations were already appearing across newsstands. In the following years, that number would reach 700 (Benton 1992: 65). The growth—both in artistic output and consumer reception—paralleled the war in Europe. Four months after the Polish invasion publisher MLJ responded with *Pep Comics* #1, featuring Harry Shorten and Irv Novick's The Shield in the first American flag-inspired superhero costume. Full patriotic flight followed in February with the Eagle in *Science Comics* #1 and Bill Parker and C. C. Beck's Spy Smasher in *Whiz Comics* #2; despite United States neutrality, Bill Everett's Sub-Mariner attacks a German submarine in his first cover appearance for *Marvel Mystery Comics* #4.

The same February, Siegel and Shuster presented Superman (whose red and blue costume already evoked the U.S. flag) battling German soldiers to capture Adolf Hilter in "How Superman Would End the War," a feature in *Look* magazine and the character's first venture outside the children's market. The superhero method of "entertaining people with imagined fulfillments of their own deepest wishes," declared Marston that year, "... worked with both children and adults beyond anybody's wildest expectations" (Richard 1940: 22). When Superman tells Hitler "I'd like to land a strictly non-Aryan sock on your jaw" (*Superman in the Forties* 2005: 161), he expresses the collective fantasy of over one million adult buyers of the general-interest bi-weekly magazine. It is impossible to calculate how many adults were reading the comic daily strip, but distribution expanded to 300 newspapers, and the new *Superman* comic book, launched in the summer of 1939, was selling 1,250,000 copies per issue (Hadju 2008: 31).

Das schwarze Korps, the weekly newspaper of Germany's S.S., responded to the *Look* feature, identifying Siegel's appropriation of the Nietzschean term:

> Jerry ... heard of Germany's reawakening, of Italy's revival, in short of a resurgence of the manly virtues of Rome and Greece. "That's fine," thought Jerry, and decided to import the idea of manly virtue and spread them among young Americans. Thus was born this "Superman." ("Jerry Siegel Attacks!" 1940)

The editorialist argues that "these fantasies of Jerry Israel Siegel" subverted the "Superman" of Nazi politics and so sowed "hate, suspicion, evil, laziness, and criminality in their young hearts" of "the American youth, who must live in such a poisoned atmosphere and don't even notice the poison they swallow daily."

The lament was echoed by American critics too, for fear that fascist politics were infecting American culture. Familiar with the black "arts of modern demagogy," Slater Brown "understood why this new comic should have become so generally and fantastically popular." In his 1940 *New Republic* essay "The Coming of Superman," Brown identifies Nietzsche in "this popular vulgarization of his romantic concept" and condemns the pro-fascist adults in "Nietzsche's own native land and in the neighboring country where he lived ... who have embraced a vulgarized myth of Superman so enthusiastically" (1940: 301). Similarly, the following year James Frank Vlamos sees Superman and his imitations as "Hitlerite," "the nihilistic man of the totalitarian ideology" (1941: 416, 411).

Consumers, however, embraced fascist-inspired superpowers employed against greater fascist threats. DC licensed a radio serial in 1940 and a TV cartoon in 1941, the year Siegel and Shuster brought the war to *Action Comics*. In this barely fictionalized version, "The armed battalions of Toran unexpectedly swoop down upon a lesser nation, Galonia" (Siegel and Shuster 2007a: 18). "The democracies are definitely opposed to aggressor nations," explains Clark Kent, before discovering that the Toran invasion is part of "Luthor's plan ... to engulf the entire continent in bloody warfare" in order to make himself "supreme master of th' world!" (22, 36, 44). Luthor, replacing the Ultra-Humanite, embodies the same "madman" characteristics, including "hypnotic

influence" (38, 39), the Hitler-inspired power in "The Reign of the Superman." Siegel's choice of names also echoes Hans Luther, the German ambassador to the U.S. from 1933–7. Brown describes Luthor as "a character endowed with fictional potentialities almost as stupendous as those of Superman himself" (1940: 301), justifying Superman's methods and his expanding genre.

Of the roughly 200 superhero titles indexed in Mike Benton's *Superhero Comics of the Golden Age*, roughly half were introduced in 1940 and 1941. Buyers ignored Sterling North's warning that such "Superman heroics" and "cheap political propaganda" were "furnishing a pre-fascist pattern for the youth of America through the principle of emulation" and that the "chances of Fascism controlling the planet diminish in direct proportion to the number of good books the coming generation reads" instead of comics (1941: 17). By the time Germany was attacking Moscow, nineteen more flag-clad superheroes had swept across newsstands (Benton 1992: 52), including Joe Simon and Jack Kirby's Captain America, depicted on his debut cover punching Adolf Hitler— the desire Siegel and Shuster's Superman articulated but did not enact. Brian Hack terms Captain America "an idealized, eugenically created American," and the Aryan-looking prototype for an intended army of super soldiers further dramatizes the reversed use of eugenics to protect democracy in the literal guise of American colors (2009: 79).

Eager to strike back

The year 1942 marked an end to the introduction of new costumed characters, due in part to the paper shortage, which restricted the total number of titles that could be published and blocked new companies from entering the medium (Benton 1992: 52), and by the drafting of the creators who had written, drawn, and edited comic books during the creative boom. Gerard Jones names Marston and Harry G. Peter's Wonder Woman "the last big hit of the genre," suggesting that "the novelty was fading from superheroes" (2004: 224). Superheroes in the build-up toward war, however, had not been about novelty but formula repetition. "In the comic book industry," concludes Wright, "imitation ... was

company policy" (2001: 17–18). Moreover, Wonder Woman was
the last superhero introduced before the U.S. entered the war. Her
All Star Comics premiere was on newsstands only weeks before
the December bombing of Pearl Harbor. She made her first cover
appearance the following month as American troops shipped out
to Britain and the rest of the pre-existing roster of superheroes
converted to the yet more overt war effort.

In Siegel and Shuster's daily strip, Clark Kent is among the
"Patriotic Americans" who "jam the entrances of recruiting offices
... eager to strike back at the enemies of decency and democracy"
(*Superman in the Forties* 2002: 158). The panel is preceded by a
depiction of Pearl Harbor and then Uncle Sam downing Hilter,
Mussolini, and Hirohito in a single blow—a still bolder variation
of Superman's and Captain America's pre-war punches. The April
Pep Comics features the slogan "Remember Pearl Harbor!," and
Hitler would appear on at least fifty covers in 1942 (Hadju 2008:
55). Sales continued to climb, with the added market of G.I.s
boosting superheroes to unprecedented levels. Marston estimates
"Eighteen million comic magazines" were sold every month, with
a "total of 70,000,000" readers, nearly half adults (1943: 34).

Greg Sadowski, editor of *Supermen! The First Wave of Comic
Book Heroes 1936–1941*, suggests that superheroes became "pretty
boring" after 1941: "They spent the war years fighting the Axis
powers, then after the war they fell out of fashion" (Smith 2008). The
comment encapsulates conventional wisdom, but superheroes were
fighting the Axis before the war began, and their fall in popularity
began before the war ended. The earliest signs of decline correlate
with early Allied military success. By the close of 1942, Japan had
been critically defeated at Midway and Guadalcanal, and German
forces were halted at Stalingrad and in retreat across Africa. The
year 1942 is also the first in which year that discontinued superhero
titles were not offset by the introduction of new titles; where 1941
saw a net gain of thirty-six, 1942 suffered a net loss of six.

In January 1943, Churchill and Roosevelt met to plan the
invasion of Italy. Rather than spurring superhero expansion, the
optimism parallels erosion in the genre. For the February 1943
Pep Comics cover, Bob Montana's Archie Andrews, a teen humor
character relegated to back pages since his 1941 debut, sits atop
the shoulders of The Shield and The Hangman in his first cover
appearance. The pair are presenting readers with a promise of a

carefree future, embodied by a girl-obsessed teenage jokester who bears no relationship to totalitarian violence. For the next year and a half, as the planned invasion of Italy became reality and the Axis ceded more and more territory, Archie and The Shield vied for cover space, with Archie permanently replacing The Shield, formerly MLJ's most popular character, during the 1944 liberation of Paris. No superhero would appear on the cover of *Pep Comics* again. Similarly, Captain Marvel, the largest selling superhero during the war, peaked in 1944, a year before the war's conclusion. Superheroes waned not as a result of victory, but rather in anticipation of it.

Allied successes also parallel a resurgence of criticism. As Germans surrendered to Soviet forces at Stalingrad in February 1943, Thomas F. Doyle asked "What's Wrong with the 'Comics'?" reminding readers of *Catholic World* of a link between Siegel's Superman and Nietzsche whom he likens to "a Nazi pamphleteer" (qtd in Hadju 2008: 81). While the Japanese retreated in India and American forces closed around Rome, Robert Southard condemned the "anti-American, dictator propaganda in the glorification of these wrong-righting supermen," fearing the U.S. could be "ready for a Hilter" and lamenting that we "would not now have a war on our hands" if "German youth" had not been similarly "persuaded that [Hitler] was a superman with a mission to right the wrong of the German state ... the Hitler way" (Southard 1944: 4).

While Southard lectured, Fawcett Publications anticipated an end to fascism by introducing Radar, a superpowered but uncostumed International Policeman, because, although 1944 was "too early to do anything officially," soon "an international police force will be necessary to maintain the peace" (Binder and Beck 1944). Like Archie, the new character was introduced to readers by the company's leading superhero, Captain Marvel (and though Radar is uncredited, the two characters likely shared creators Otto Binder and C. C. Beck). Radar echoed Southard and Doyle: "victories against the fascists on the battlefield are pointless unless we also clean out all home front fascists!" These included anyone "ruthless in his use of ... violence to attain his ends," a description of all superheroes. DC literalized the movement away from the superman to the common man by introducing a common man hero in *World's Finest Comics*, a showcase omnibus for Superman since 1939. Jack Schiff and John Daly's Johnny Everyman has no superpowers and

travels the world teaching tolerance, with no recourse to violence or other totalitarian tools of persuasion. The year 1944 also began the major wave of superhero cancellations, with the last pre-Code appearances of Doctor Fate, the Hangman, Steel Sterling and the Spectre (Benton 1992: 57). Even the once popular and overtly patriotic Shield and Miss America lost their titles.

Ian Gordon sees the World War II Superman as "synonymous with American democracy" (1998: 137), and yet the Superman depicted in comic books at this time no longer bears a clear relation to the world conflict. With Siegel drafted and so no longer writing, DC limited war themes and, according to Gordon, instead aligned its "characters with home front campaigns for responsible consumption" (146). Reading *Superman* March–April 1944, De Haven observes, "you would never know there was a war going on," concluding that "shutting out current events" was "a wise editorial decision" since *Superman* and *Action Comics* continued to sell well (2010: 82, 83). De Haven, however, does not analyze why the symbol of democracy maintained high sales by severing connections to what it purportedly symbolized. If Superman was never simply a personification of democracy but was fascism redirected to defend democracy, then the contradiction could not be maintained after democracy no longer needed defending.

Siegel had pitted his pre-war Superman against soldiers in fictional but overtly analogous European and South American nations, but when replacement writer Don Cameron penned "America's Secret Weapon" for *Action Comics* in 1943, he placed Superman no closer to combat than a U.S. training camp where he participates in "a full-dress rehearsal of the tidal wave of retribution that has already begun to sweep over half the world, blotting out flames of destruction set by mad criminals at the head of misled nations" (*Superman in the Forties* 2005: 150). Because his team loses their "mock war," Superman declares, "American soldiers cannot be defeated by Superman or anyone else—not even by Mr. [Hitler's] so-called master race!" (157). Superman is not merely removed from combat; his defeat projects the Allies' coming victory against the Axis. Instead of aiding the cause, superheroes were an obstacle to be defeated.

Heroic doings

While Soviet troops were liberating Auschwitz, superhero comic book sales continued to drop. With Hitler six months dead and Hiroshima and Nagisaki destroyed, *Time* magazine asked, "Are Comics Fascist?," moving anti-superhero rhetoric to the mainstream a month after Japan's surrender. "Superman is a Nazi," answered Walter J. Ong: comparable to "Hitler and Mussolini," the superhero "is a super state type of hero, with definite interest in the ideologies of herdist politics" and "Hitlerite paganism" ("Are Comics Fascist?"1945). The allegations echo pre-war analysis, but now the general public reflected the sentiment through their changing consumer habits.

Superhero sales dropped to two-thirds of their wartime peak—this despite an overall industry rise, DC by 30 percent in the first quarter of 1946 (Wright 2001: 56). Even *Superman* and *Action Comics* sank more than 20 percent from 1944 to 1946 (Jones 2004: 245). Benton records an increase from 1,100 comic book issues in 1945 to 1,500 in 1946, "the largest increase since the beginning of the decade" (1992: 56), but superheroes were excluded. As Archie continued to sell more and more copies of *Pep Comics*, MLJ, publisher of the first American flag-themed superhero, changed its name to Archie Publications. Over thirty superhero titles vanished between 1944 and 1945, and an additional twenty-three in 1946. Southard continued his attacks, expressing the increasingly widespread attitude that, although "Superman and his ilk ... do such commendable things as ... aiding the war effort," superheroes are "paper incarnations of the devastating Nietzsche Nazi Philosophy of force" ("Priest Warns of Peril" 1946). They weren't simply falling out of fashion; superheroes were anathema to a post-fascist world.

Wright attributes "the decline of the superheroes" in part to "editorial policies" that grew "conservative and weary of innovation" (2001: 59), but five of the eight superhero titles introduced from 1947 to 1949 were comparatively innovative, placing new emphasis on superheroines titles including *Namora*, *Sun Girl*, *Lady Luck*, and *Phantom Lady*. The Blonde Phantom towered over Captain America, Sub-Mariner, and the Human Torch on the second cover of the new *All-Winner Comics* after receiving her

own title in 1946. Even 1949's *Superboy* was a bold re-invention compared to the recycled formulas of the last decade. Meanwhile, non-superhero comics that sold well during the war continued to do so afterward. *Walt Disney Comics*, which launched in 1940 and averaged three million copies per issue in 1942, bragged similar figures in the mid-1950s.

"When the moral courage of World War II was no longer needed on the European front," writes Kripal, "the superheroes simply went away" (2011: 73). Benton concludes similarly: "By 1949, there was no place for the amazing if occasionally absurd super heroes who had defined the Golden Age"; Kripal offers no further explanation, and Benton alludes vaguely to genre competition: "old heroes ... just faded away while everyone was busy reading cowboys, crime and love" (1992: 60). Raphael and Spurgeon also refer to competition: "audiences for comic books made their preference known for the sturdier realism found in other genres." They also note, however, that Timely, like most comic book publishers, "never initiated trends" but was "always quick to produce a slew of imitations" (2003: 32). The market move to genres of "sturdier realism" then was a result not the cause of declining superhero sales. Benton agrees with Captain Marvel creator C. C. Beck's assessment that the decline was due in part to the loss of superheroes' "most avid readership," G.I.'s returning from overseas (1992: 58). Circulations had included millions of issues purchased by the U.S. government to be distributed to armed forces, sales which ceased at the end of the war. While significant, the change does not account for the massive upswing of the genre in the pre-war years. Benton also argues that superheroes lost "some of their inherent appeal" because of the "disappearance of such satisfying villains as the Nazis and the Japanese" and their "turn to more prosaic villains like common criminals" (1992: 58–9). Superheroes, however, had been fighting "common criminals" well before the war, and Batman, one of the very few superhero characters to survive in the postwar market, was premised on such conflicts.

Another twenty-nine superhero titles vanished between 1947 and 1949, including former hits *Flash Comics*, *The Green Lantern*, *The Human Torch*, and *Sub-Mariner*. Sales for *Captain Marvel Adventures*, the top superhero comic during the war, were down by half, while criticism of the character type continued to build.

The Association for the Advancement of Psychotherapy held its 1948 New York symposium, "The Psychopathology of Comic Books," where Gershon Legman and Fredric Wertham warned against comics in which "Fists that smash against faces settle all problems" ("Medicine: Puddles of Blood" 1948). With an increasingly receptive audience, Legman expanded his attack the following year, declaring that Superman comics "have succeeded in giving every American child a complete course in paranoid megalomania such as no child ever had, a total conviction of the morality of force such as no Nazi could ever aspire to" (2004: 119). As dropping sales reinforced Legman's opinion, the Timely flagship *Marvel Mystery Comics* was converted to a horror omnibus as was *Captain America Comics* shortly before its cancellation. The few superhero titles that survived did so by eliminating their characters' fascist-like characteristics. William Woolfork's scripts refocused Superman around romance. The 1949 *Superman* story "Lois Lane Loves Clark Kent!" centers on a psychiatrist's recommendation that Lois transfer her "love for Superman to a normal man!" (*Superman in the Forties* 2005: 38), and Superboy finds his first love interest in "Superboy Meets Supergirl" the same year.

Timely introduced its last pre-Code superhero in 1950. Though switching from fascist to Communist supervillains, Marvel Boy still embodies Legman's critique of Superman as a "provincial apotheosis" of "the Nazi-Nietzschean *Ubermensch*" who "save[s] us" by "peddling a philosophy ... in no way distinguishable from that of Hitler" (Legman 2004: 118). Consumers expressed their own condemnation when the title lasted only two issues. After the 1953 cancellation of *Captain Marvel Adventures*, only Superman, Batman, Wonder Woman, and Plastic Man survived in their own titles by evolving away from the authoritarian violence that had defined their genre.

Although Marshall McLuhan in 1951 still critiqued Superman's "strong-arm totalitarian methods" and his readers' "political tendencies" to "embrace violent solutions" (2004: 105), as the decade continued, writes De Haven, the post-Siegel and Shuster Superman became "far less like a force of nature and more like, well, your favorite uncle—affable, available, a little bit melancholy, but just a big old kid at heart" (2010: 4–5). In Bill Finger's 1955 "The Girl Who Didn't Believe in Superman!" Clark thinks: "It's nice to be able to become Superman without having to use my

super-powers against criminals for a change!" (*Superman in the Fifties* 2002: 36), and after curing a little girl of her blindness and reuniting her with her father, he declares: "Nothing I've ever done before has made me so glad that I really am a Superman!" (44). This is a stark change from Siegel's 1939 Superman who "Champions Universal Peace" by watching an arms dealer die begging for help while inhaling poisonous gas: "One less vulture!" (Siegel and Shuster 2007: 81). Superman of the 1951 film *Superman and the Mole Men* protects a harmless subterranean race from attack by a mob of xenophobic Americans. "Stop acting like Nazi storm troopers!" shouts Superman (De Haven 2010: 103). Superman still fights fascism, but the threat is no longer foreign and the answer is no longer violent.

After the successful 1953 TV season of *Adventures of Superman*, Timely, rechristend Atlas Comics, attempted a revival of its World War II heroes, but none of the three would last a year. Soviet sickles and hammers replaced swastikas on Sub-Mariner's first cover, and Captain America stands with his shield raised in a self-congratulatory cheer below his new tag phrase "Commie Smasher!" The Red Scare seemed an ideal context for the old formulas. Moser links *Captain America Comics* to the "Brown Scare" of the 1940s and argues that by "helping to encourage a generation of young people that American institutions are subject to infiltration by enemies," superheroes "bear some share of responsibility for the Red Scare" (2009: 28). However, readers, according to Raphael and Spurgeon, now rejected "the moral certainty that he had brought to the Nazi conflict" and the "simple transposition of old ways ... into new settings" (2003: 57). In contrast, *Adventures of Superman*, although first "conceived in a 'violent' police drama vein" (Gabilliet 2010: 35), emphasized the "human interest side of Superman," toning down his violence and softening his crooks (Benton "1992: 8) and rejecting fascism with scripts that "give gentle messages of tolerance" (qtd in Jones 2004: 259). Stan Lee blamed the failure of Atlas' Commie smashers on "the stridently conservative scripting," which Raphael and Sturgeon agree "doomed the ... revival to almost immediate extinction" (2003: 57).

The violently patriotic superhero was even evolving into an object of satire. While their first flag-wearing hero was being cancelled a second time, Joe Simon and Jack Kirby were producing *Fighting American*, another star-chested super soldier now parodically

jingoistic. Prize Comics cancelled the series after seven bimonthly issues, but Raphael and Sturgeon note how *Fighting American* "used the powerful but simplistic icons of the previous decade's patriotic superheroes to satirize and explore the murkier political waters of the Cold War" (2003: 67). The transition into satire and Atlas' failed revival parallel Joseph McCarthy's rise and fall in popularity. The Senator gained national attention in 1950 with the claim that the State Department was infested with Communists. When political cartoonist Herbert Block of the *Washington Post* coined the pejorative term "McCarthyism," the senator embraced it, publishing the 1952 *McCarthyism: The Fight for America* in which he likens Communism to Hitler (1952: 101). As a Senate chairman, he investigated the U.S. Army, prompting the Senate's Army-McCarthy hearings in April 1954.

Comics historian Leonard Rifas links the move to satire with McCarthy's negative exposure: "Within weeks of the first issue reaching stands, Edward R. Murrow made McCarthy look foolish on television, and Simon and Kirby tried to transform *Fighting American* into a comic making light of McCarthysim rather than a comic against communism" (Rifas). Though James Bucky Carter notes that Fighting American has been called "Joe McCarthy in tights" (2004: 367), Kirby and Simon both "hated" McCarthy; Simon recalled: "They were exposing McCarthy all over the place, and this one day—it was either after the first issue or before it—and we said, 'Ah, the hell with it.' It became a satirical book" (Simon 1990). On sale while Murrow's *See It Now* attack on McCarthy was televised on CBS, the first April-May-dated cover of *Fighting American* boasts: "Where there's Danger! Mystery! Adventure! We find The NEW CHAMP OF SPLIT-SECOND ACTION!" (Simon and Kirby 2011: 8). June-July was the last non-satirical issue, and the logo was redesigned for the August-September cover, which includes two clownish Communist villains and the ironic warning: "Don't laugh—they're not funny—POISON IVAN and HOTSKY TROTSKI" (Simon and Kirby 2011: 56). The hearings ended in June, also the cover date of the last issue of *Human Torch*. The last *Captain America* was slated to be removed from newsstands in July, suggesting that Timely also made its cancellation decisions in response to McCarthy's fall in popularity.

Despite an eighth and partial ninth issue ready for the printer, *Fighting American* was cancelled too—one of 400 titles that

vanished between 1954 and 1956 (Hadju 2008: 326). Although Farrell revived several Fox superheroes in 1954, and Benton identifies almost a dozen new titles at the start of 1955, the majority would vanish within the year (1991: 7). Daniels contends that the revival "was cut short when sales plummeted as a result of" Fredric Wertham's influential *Seduction of the Innocent* (1991: 72). Wertham, a German psychiatrist who left Germany before the rise of the Nazism, once again identifies superheroes as "an off-shoot of Nietzsche's superman" and joked that Superman, a "symbol of violent race superiority," should wear an S.S. on his chest (1954: 97, 381, 34). Wertham cites Paul D. Witty, warning that comics "present our world in a kind of Fascist setting of violence and hate and destruction" that "is bad for children" because it overlooks "the democratic ideals the we should seek" (34). The "Superman type of comic book tends to force and super-force," and its readers, based on Wertham's interviews of juvenile delinquents, show "an exact parallel to the blunting of sensibilities of cruelty that has characterized a whole generation of central European youth fed the Nietzsche-Nazi myth of the exceptional man who is beyond good and evil" (34, 97). *Seduction of the Innocent* prompted a Senate Subcommittee Hearings into Juvenile Delinquency, which met simultaneously as the Army-McCarthy hearings. "Hitler," Wertham told the seneators, "was a beginner compared to the comic-book industry" (U.S. Congress 1954).

Scholars disagree about Wertham. De Haven labels him the "industry's real-life supervillain" and dismisses his arguments because they "made no sense" (2010: 86). Benton refers to *Seduction of the Innocent* as "a classic of wrong thinking," lampooning Wertham's assertion that war comics provided an additional setting for comic book violence, "as if the books had inspired the war and not the other way around" (1991: 71); yet Benton also acknowledges that comic books "declared war more than a year before the United States government did" (36). In contrast, Amy Kiste Nyberg sees Wertham as "largely misinterpreted by fans and scholar," arguing that "the image of Wertham as a misguided pioneer in media effects research is erroneous" (1998: xiii, x). Bart Beaty documents how Wertham's work has been erroneously dismissed as "valueless" and "systematically excluded from the mainstream of research into popular culture," despite the absence of "detailed scientific refutations" (2005: 4, 144).

Jones acknowledges that Wertham was "genuinely concerned" but ultimately misguided in his tendency to "see fascism" "when he saw any hero using physical force" (2004: 271, 273). Wright, with ample misgivings, agrees with Wertham, calling his "basic argument ... perceptive and prophetic" (2001: 178). Hadju, with even more detailed misgivings, also sides with Wertham, declaring that the "the comic book war" fought and won by Wertham and his allies "was worth the fight" (2008: 7).

Hadju's analysis, however, bypasses superheroes, referring only to the "noble tales of costumed heroes and heroines" that preceded the "lurid stories of crime, vice, lust, and horror" (6). Comics, according to Hadju, recovered in the early 1960s by "shifting back to the heroic doings of superheroes" (330). But that recovery was not a simple reflection of cultural attitudes. Where the decline of the superhero allowed new genres, the elimination of crime and horror comics through censorship created an artificial market vacuum that spurred publishers to reintroduce previously successful formulas. Even in this nurturing environment, the superhero reemerged slowly. DC editor Julius Schwartz tentatively reintroduced Flash in 1956, not risking a new bimonthly title on the character until 1959. Green Lantern and the Justice League of America followed, triggering new characters from imitative companies such as Charlton and Marvel, the publisher formerly known as Atlas.

Although still defined by Cold War antagonism, the new Marvel characters were not military proxies in the vein of their failed 1950s Commie-smashing predecessors. In *Fantastic Four* #1, the team sneaks past an armed soldier to board their rocket because there is "No time to wait for official clearance! Conditions are right tonight! Let's go!" (Lee and Kirby 2008: 9). Lee repeats the motif in *Amazing Spider-Man* #1 when the hero commandeers a jet and webs a soldier who shouts, "Halt! Identify yourself!" because Spider-Man has "No time for that now!" (Lee and Ditko 2009: 23). While neither scene suggests a fascist rejection of democratic law, the new superheroes are not extensions of the government. Marvel's superheroes are independent agents who oppose the military when needed.

After declaring the 1954 incarnation of Captain America an imposter, Marvel reintroduced their top-selling World War II super soldier again in 1964. The revived character, however, was not the

same as his original incarnation. Brian Hack notes how his variously revised origin story "negates the historical record of the nation's interest in eugenics," further distancing the character from his roots (2009: 85). Stan Lee explained in an interview that he wanted to express his own "ambivalent feelings" through the character and "show that nothing is really all black and white"; Captain America "realizes that there's a lot of things that are wrong" and that there is "no real simple, legal, effortless way to correct them short of extreme measures. ... He's afraid that too much violence will breed too much violence and where do you stop it" (McLaughlin 2007: 22). In short, fascist tactics were no longer the answer.

Superheroes of the 1960s rose in popularity for different reasons than their forebears, but the new characters continued to embody an ethic inherited from those predecessors. When Umberto Eco examined the genre in 1962, he saw that "Each of these heroes is gifted with such powers that he could actually take over the government, defeat the army, or alter the equilibrium of planetary politics" (2004: 162). However, like Superman's earliest advocates, Eco concludes that because each "uses his powers only to the end of good" the "pedagogic message" is "highly acceptable," including the "episodes of violence ... directed toward this final indictment of evil and the triumph of honest people" (162). Writing a quarter century after Superman's debut, Eco duplicates Marston's original pre-war summary of the character: "unbeatable national might" used "to protect innocent, peace-loving people from destructive, ruthless evil" (Richard 1940: 22).

It is beyond the scope of this chapter to survey the role of fascism through a complete history of superhero comics. However, when creators began to challenge and overturn the inherited formulas of the genre in the 1980s, the ideological implications of super-powered authoritarian violence did become a defining motif. Early examinations include Alan Moore's *Marvelman*, Frank Miller's *The Dark Knight Returns*, Alan Moore and Dave Gibbons' *Watchmen*, Mark E. Gruenwald's *Squadron Supreme*, and Alex Ross and Mark Waid's *Kingdom Come*. Although the generative evil of fascism is generally obscured in contemporary comics, its means-justifying end is fossilized in the formula. Romanticized authoritarianism remains a crucial element of the superhero forumula, and its appeal is partly fueled by a nostalgia that seeks the fantasy of moral certitude once embraced by a democratic society besieged by fascism.

II

The MAD Superhero

New York Times reviewer J. D. Biersdorfer likens the change in early 1960s' superheroes as "the comics equivalent of the literary shift from Victorian melodrama to Chekhovian realism" (2012: 15). The two-dimensional character type, largely static since its 1930s' introduction into comics, received a new level of psychological complexity that would define its early Code-era incarnation and influence decades of descendants. This literary shift occurred as Cold War tensions reached what would be their high mark, with the American public bracing not only for war but the potential for humanity-ending nuclear holocaust. Those tensions ebbed, but superhero comics remained fundamentally altered.

Charlton Comics' *Space Adventures* #33 introduced Steve Ditko and Gil Kane's Captain Atom in 1960, drawing on the Cold War's Space Race and the fear of radioactive fallout that Atlas—soon to be renamed Marvel—would capitalize to defining success with *The Fantastic Four* the following year. DC, in contrast, continued to avoid current topics, especially political ones. Although for the 1948 *Superman* #53 Bill Finger explained the destruction of Superman's home planet in post-Hiroshima terms, "Krypton is one gigantic atomic bomb!" (*Superman in the Forties* 2005: 49), "In the world of Superman comic books," writes Mike Benton, "communism did not exist" (1991: 35).

While Marvel's early 1960s' comics are products of their political times—"The stories published in the first year of *The Fantastic Four*," observes Rafiel York, "virtually overflow with Cold War themes" (2012: 214)—scholars disagree about the

political attitudes they express. Matthew J. Costello, for example, sees primarily a repetition of Golden Age models: "The stories represented the moral certainties of the Cold War, with plotlines that defined the conflict in stark contrasts between good and evil" and "mirrored the comics of World War II in their unquestioning portrayal of American virtue" (2009: 63). Marc DiPaolo, however, while acknowledging such "World War II nostalgia," regards the same comics as only "pro forma propaganda" and "half-hearted in their demonizing of the Red Menace" (2011: 28, 27).

The failure of Atlas' 1954 "Commie Smasher" superhero revival, discussed in the previous chapter, does suggest that the original formula was ill-suited for the Cold War context—at least without modification. The new superhero would not be purely heroic. Although resulting in their gaining superpowers, the Fantastic Four's 1961 space trip fails because they had not "done enough research into the effects of cosmic rays" (Lee and Kirby 2008: #1; 9). They launch too soon for fear of appearing cowardly and not wanting "the Commies to beat us to it!" resulting in the destruction of "the mighty ship Reed had spent years constructing" and Ben "hating Reed for what happened" (#1; 9, 21). Rashness, hatred, failure of any kind—these are not traits found in Golden Age superheroes. Marvel introduced a wide range of new villains, but the Manichean view of absolute good and evil central to World War II comics shifted too. Though the Fantastic Four's first super-villain is called an "evil antagonist," the Moleman seeks to "have the entire world in his power!" only because "the people of the surface world mocked" his appearance, a sympathetic motivation anathema to the Hitler stand-ins of the Golden Age (#1; 25, 21, 22). Rather than destroying or even capturing him, Reed declares after they have prevented his invasion and escaped his underground kingdom: "I left him behind – He'll not trouble anyone again!" (#1; 25). The second issue concludes similarly. After their invasion is prevented, the shape-shifting Skrulls beg, "Don't kill us! Don't! We promise to cause no more harm! We'll live among you in peace!" before transforming into cows to become "the most contented creatures on Earth—as they grazed peacefully" (#2; 23). This is not propaganda for a nation perceiving itself menaced by unquestionable evil.

The return and rise of superhero comics in the early 1960s parallels a similar change in Cold War opinion. The Soviet Union

itself was no longer understood as the greatest threat to U.S. safety. After the bombing of Hiroshima and Nagasaki and the surrender of Japan, public opinion polls initially focused on how an atomic war might be waged and won, with 49 percent of 1945 respondents believing "we can develop a way to protect ourselves" and 60 percent in 1949 predicting such defenses would be developed within ten years (Erskine 1963: 161). Come 1958, however, the median prediction for survivors was only three in ten (163). Seventy percent of 1949 respondents had opposed the U.S. pledging not to use the atomic bomb "until some other nation has used it on us first," suggesting that the bomb was seen as a military asset to be used for U.S. advantage. But polls soon switched to questions of whether an atomic war "would mean an end to mankind," with the 19 percent who agreed that it would in 1950 rising to 27 percent five years later (182, 162). As Atlas superheroes were being pulled from newsstands in early 1954, *The Bulletin of the Atomic Scientists* referenced "the widespread realization that an atomic war would be mutually suicidal" (Meyerhoff 1954: 122). In July of the following year, eleven of the most prominent experts signed the Russell–Einstein Manifesto, calling for disarmament because "a war with H-bombs might possibly put an end to the human race" through untargeted and widespread radioactive fallout (1955). While only 17 percent of poll respondents could define the term "fall-out" in 1955, the figure more than tripled to 57 percent in 1961 (Erskine 1963: 188). Americans were not afraid of the Soviet Union; they were afraid of the Soviet Union's and the United States' nuclear weapons and the prospect of mutually assured destruction should a conflict arise.

"The doctrine," writes Dewi I. Ball, "propagated the notion that each side had equal nuclear firepower and that if an attack occurred, retaliation would be equal to or greater than the initial attack ... The final result would be the destruction of both sides" (2012: 146). The acronym MAD is commonly credited to Manhattan Project mathematician John von Neumann, who served on President Eisenhower's Atomic Energy Commission from 1954 to 1957, the year he died of cancer (commonly believed to have resulted from witnessing bomb tests in Bikini Atoll in the late 1940s). Von Neumann had advocated for a pre-emptive strike against the Soviet Union before it developed its own nuclear arsenal after testing its first bomb in 1949. In the early 1950s, Secretary

of State John Foster Dulles also emphasized a policy of "massive retaliation" against even conventional weapon attacks and claimed his threat of nuclear strikes ended the Korean War. That brinksmanship attitude changed in 1957 when the Soviet Union launched both Sputnik and its first intercontinental ballistic missile, making defense against nuclear attack less plausible. Though the U.S. still possessed more nuclear missiles, Kennedy's 1960 presidential campaign fueled the public perception of the Soviet Union leading the arms race. The development of submarine-launched ICBMs further strengthened U.S. second-strike capability, and when the Soviet Union reached nuclear parity in the 1960s, the two superpowers already stood at a MAD stalemate.

Comics of the period reflect these changes. Ferenc Morton Szasz observers that by the early 1960s, "the early ambiguity had completely vanished from comic book depictions of the fissioned atom. The editorial warnings to young people to 'use the power wisely' had dissolved into widespread Cold War anxiety" (2012: 85–6). "More than just entertainment," writes John Donovan, "comics during the Cold War were a reflection of the concerns of Americans in a politically dynamic and unstable world" (2013: 88). Those concerns were international, with the Buenos Aires newspaper strip *The Eternaut* beginning in 1957 with the U.S. detonating "a new kind of atomic bomb" in the Pacific that produces "massive amounts of radioactive dust" that covers Argentina in deadly "phosphorescent snow" (Oesterheld and López 2015: 5, 8). The shift in atomic anxiety also corresponds with changes in the superhero formula. Whereas World War II superheroes served as a proxy military enacting reassuring fantasies of U.S. triumph, early 1960s superheroes also stood-in for the U.S. military, which the American public now regarded with ambivalence. Rather than a force for unequivocal good, the U.S. nuclear arsenal was a necessary evil, one capable of destroying what it was designed to protect.

Crisis: 1961–2

In this cultural context, Stan Lee suggested a central "gimmick" in his original 1961 synopsis for the Fantastic Four:

let's make The Thing [sic] the heavy—in other words, he's not really a good guy ... Let's treat him so the reader is always afraid he will sabotage the Fantastic Four's efforts at whatever they are doing—he isn't interested in helping mankind the way the other three are ... the other three are always afraid of The Thing getting out of their control some day and harming mankind with his amazing strength ... The Thing doesn't have the ethics that the other three have, and consequently he will probably be the most interesting one to the reader, because he'll always be unpredictable. (Lee et al. 2011: 484–5)

Although Ben Grimm is an "ex-war hero," Lee describes him as "surly," "unpleasant," and "brutish," even before radiation transforms him "in the most grotesque way of all," making him "more fantastically powerful than any other living thing." Early issues emphasize the same qualities. While Kirby and other artists had previously drawn superheroes as uniformly handsome, the Thing is "a walking nightmare" with a misshapen body and a face as unattractive as Moleman's (Lee and Kirby 2008: #1; 5). In the second issue, Sue whispers to Reed: "Sooner or later the Thing will run amok and none of us will be able to stop him!" (#2; 6), and Ben, "a juggernaut of destruction," confesses: "sometimes I think I'd be better off—the world would be better off—if I were destroyed!" (19, 12). Many readers felt the same about nuclear weapons.

Even aside from the Thing, Kirby and Lee portrayed the Fantastic Four as superheroes who produce rather than assuage anxiety. Kirby opens the first issue with an image of frightened pedestrians pointing at the flare Reed has fired to gather the team; police officers remark that "the crowds are getting' panicky!" and that "[r]umors are flyin' about an alien invasion!" (#1; 1). During their origin sequence, Johnny calls both Ben and Reed "monsters," before uncontrollably transforming into a Cold War version of the pre-Code Human Torch and accidentally starting a forest fire (13). "Together," declares Reed, "we have more power than any humans have ever possessed," a familiar superhero refrain now given new contextual meaning. The second issue opens with a three-page sequence of the Fantastic Four committing acts of sabotage, causing news agencies to declare them "public enemies" and "the most dangerous menace we have ever faced!" (#2; 4–5)—an opinion

repeated in #7 when a "hostility ray" turns the world against them as "four monsters," "the worst menaces ever to threaten this land!" (#7; 5, 13, 8). The acts of sabotage were actually performed by shape-shifting Skrulls, and though the Fantastic Four are not powerful enough to defeat "the mighty invasion fleet menacing Earth," they end the "stalemate" by showing the Skrulls other Jack Kirby drawings from *Strange Tales* and *Journey into Mystery* and so convincing them that humans have armies of "monstrous" warriors ready to protect them (#2; 16, 18). The first cover features one such monster, only now the Fantastic Four serve as monster-fighting monsters trying to protect the city from it—a defining introduction for the MAD-era superhero type.

The Fantastic Four's early antagonists evoked similar atomic fears with striking repetition. Moleman targets "every atomic plant" (#1; 23), the Skrulls attack a "new rocket" test site (#2; 11), Miracle Man steals an "atomic tank" (#3; 13), and the 1940s Sub-Mariner vows revenge on the human race when he finds his underwater city destroyed: "The humans did it, unthinkingly, with their accursed atomic tests!" (#4; 13). Dr. Doom, after bringing "forth powers he could not control" (#5; 4), stokes the Sub-Mariner's hatred, describing "that monster of a bomb" that destroyed his civilization (#6; 9). The Thing mistakes an alien spaceship for "a new missile test," while on Planet X, "Driven by fear and panic, our people are turning against each other! Soon nothing will be able to stop the riots ... nothing except the doom which is hurtling toward us!" (#7; 8, 16). Finally, the Puppet Masters controls his victims by carving their likenesses in "radio-active clay" (#8; 7).

DC, in contrast, was maintaining its 1950s' Cold War attitudes. Beginning in 1960, every third issue of *Strange Adventures* included John Broome and Murphy Anderson's Atomic Knights, a series set in the postwar future of 1986: "World War III—the Great Atomic War—is over ... and in its wake lies an Earth in ruins! Of plant life, there is none! On animal life, only a small number of humans linger on!" (Broome et al. 2014: 94). Despite the seemingly bleak premise, the series is overall optimistic, focused "on this critical time of Earth's history" in which the Atomic Knights rise "to represent law and order and [...] to help right wrong and prevent evil" (94), with one of their first adventures ending with a son declaring to his father as they rebuild: "We have a new lease on

life, Dad!" (117). The explicit message is that, despite increasing awareness and fear of mutual assured destruction, an atomic war is survivable. The eleventh Atomic Knights episode is cover-dated December 1962, the same as *The Fantastic Four* #9, providing comics buyers with two simultaneous and opposing portrayals of the nuclear threat.

As Lee predicted in his Fantastic Four synopsis, the Thing did prove to be the most interesting character to readers—so much so that after four issues, Marvel premiered a new title that featured a main character that not only imitated the Thing but made its Cold War focus even more explicit. "The Hulk," write Lois Gresh and Robert Weinberg, "took paranoia about the bomb to the next level" (2003: 23). According to Adam Capitanio, the series "articulates ... American anxieties over military technology and nuclear weaponry" (2010: 252), and Robert Genter concludes similarly, calling the series "an explicit warning about the dangers of scientific and technological developments ... one of the many pieces of popular culture that used monstrous images to issue warnings about nuclear holocaust" (2007: 960). The first cover makes the monster motif explicit, asking "Is he man or monster or ... is he both?" Lee combined the standard superhero alter ego trope with the uncontrolled transformations of a Dr. Jekyll and Mr. Hyde, and Kirby models the Hulk on Boris Karloff in the 1931 *Frankenstein*. Like those mad scientists, Dr. Bruce Banner is "tampering with powerful forces," only now in the MAD context his hubris transforms himself into his own monstrous creation. Instead of Reed's rocket, the opening panel features "the most awesome weapon ever created by man—the incredible G-Bomb!" moments before its "first awesome test firing!" (Lee et al. 2006: #1; 2). Kirby draws its creator with the same "genius" signifying pipe that Reed smokes in *The Fantastic Four* #1, but here the scientist takes "every precaution," even as a Ben-like General Ross insults him for cowardly delays. Though Banner risks his life to save Rick, a teenager who has driven onto the bomb site, that kindness is erased by the Hulk who, after his first Geiger-counter-triggering transformation, swats Rick aside, uttering his first words: "Get out of my way, insect!" (5). Lee likens him to a "dreadnought," the twentieth-century's most massive battleships, and soon he is speaking like a supervillain, "With my strength—my power—the world is mine!," and threatening to kill Rick to keep his identity a

secret (7, 11). "You could call the Hulk a superhero," writes Sean Howe, "but what was he saving? And from whom?" (2012: 40).

The first issue would be a complete repudiation of the superhero formula if not for the late entrance of another "brilliant" scientist-turned-radioactive-monster; the Soviet Union's Gargoyle captures the Hulk, threatening the balance of power: "If we could create an army of such powerful creatures, we could rule the Earth!" (#1; 21). Like the Hulk, the Gargoyle is controlled by no nation, savoring that his "cowardly" comrades and "some day all the world will tremble before" him (16). But like the Fantastic Four's sympathetic Moleman and Skrulls, who "hate being Skrulls! We'd rather be anything else!" (#2; 24), the crying Gargoyle, like Ben, would "give anything to be normal!" and, as Ben blames Reed, Kirby draws him shaking his fist at a portrait of Khrushchev because he became "the most horrible thing in the world" while working "on your secret bomb tests!" (#1; 23). As a result, he accepts Banner's offer to cure him "by radiation," and in turn destroys the Soviet base and rockets Banner and his sidekick back to the U.S.: "So we're saved! By America's arch enemy!" (24). Although Banner hopes for the end of "Red tyranny," he remains "as helpless as" the Gargoyle against his own "monster" (23). The Gargoyle is stopped not by the Hulk's might, but Banner's "milksop" kindness, reversing the Clark Kent trope that had defined the superhero genre for two decades (2). In the second issue, the Hulk seizes control of an alien spaceship to use it for his own purposes: "With this flying dreadnaught under me, I can wipe all of mankind!" and it is again Banner, using his "Gamma Ray Gun" invention, who stops the alien invasion (10, 23). These are not the tales of a dual-identity superhero, but a Clark Kent battling both external threats and his own supervillainous alter ego.

Steve Ditko inked Kirby's pencils for the second issue, cover-dated July 1962, a month before the premiere of Lee and Ditko's Spider-Man in *Amazing Fantasy* #15. Ditko's Hulk bore an even greater semblance to Karloff, and now Peter Parker looked like a younger version of Bruce Banner. The origin story again empha-sized the unpredictability of atomic power, with "a demonstration of how we can control radioactive rays" causing Parker to acquire unintended superhuman powers (Lee and Diko 2009: 3). But in the Cold War context that also produced the Thing and Hulk, power alone does not produce a hero. Like the sympathetically villainous

Moleman, Parker is a mistreated outcast, loyal only to his aunt and uncle: "They're the only ones who've ever been kind to me [...] the rest of the world can go hang for all I care!" (8). Like Ditko and Lee's other *Amazing Fantasy* collaborations, the tale features an ironic ending, with Parker's selfishness resulting in his Uncle Ben's death—another reversal of the Golden Age superhero formula. Only on the final page does Parker accept social responsibility, but since the story was intended as a one-off, the lesson was final punishment for the character and another warning to readers about the dangers of misusing atomic power.

Kirby and Lee's Thor debuted in *Journey into Mystery* the same month. Though his pseudo-mythical origin includes no atomic elements, the character shared his name with the U.S. Air Force's first operational ballistic missile deployed in 1958, and before the end of the year he would face Communists in Europe, aid the U.S. military with missile flights, and, as his human alter ego, be abducted by Russians. Ant-Man in *Tales to Astonish* followed a month later. Henry Pym, Ant-Man's alter ego, had appeared eight issues earlier in the role of a mad scientist boasting to his mocking colleagues: "I'll show you! Then, you shall know I'm a greater scientist than any of you!" (Lee et al. 2011: 71). Pym imagines how his reducing and enlarging potions will have military benefits: "An entire army could be transported in on airplane" (72), but he cannot control his own shrinking. After barely surviving the "nightmare" of an ant-hill, he decides "the first thing I must do is destroy these growth potions. They're far too dangerous to ever be used by any human again" (76). This, Lee decided afterward, would be the origin story for an ongoing superhero character— another Dr. Frankenstein struggling to control his too-powerful creation.

The Hulk does not begin to resemble a superhero until the following month. In the third issue, the military attempts to destroy the Hulk by launching him into the same radiation belt that created the Fantastic Four, but instead his transformations, which were previously trigged by nightfall, become unpredictable. Rick briefly gains hypnotic power over the "live bomb" of the now golem-like Hulk, evoking another admonitory fable and encapsulating the MAD dilemma: "It's too much for me! I've got the most powerful thing in the world under my control, and I don't know what to do with it!" (#3; 22, 11). In the fourth issue, Banner invents a

self-radiating machine in order to "regain the Hulk's body—but
with my own intelligence," which, though seemingly successful,
creates a "fiercer, crueler" version of Banner inside a Hulk who
is still "dangerous" and "hard to control" (#4; 12, 14). The new
Hulk no longer tries to kill Rick, but now speaking like Ben, he
tells him to "Shut your yap" and to "get outa my way!" before
foiling the Soviets' next attempt to capture him and again build
"a whole army of warriors such as you!" (6). Though he prevents
another invasion, this time by an underground race led by an
ancient immortal tyrant, the Hulk ends his first adventures in the
following issue articulating his defining allegory: "Let 'em all fear
me! Maybe they got reason to!" (#5; 11). In the issue's second
story, he thwarts a Chinese Communist general, and yet the Hulk
insists that "the weakling human race will be safe when there
ain't no more Hulk—and I'm planning on being around for a long
time!!!" (13). By the sixth issue, the last of the original, one-year
title run, the Hulk has reverted to a supervillain and considers
teaming-up with an invading alien against the human race "to pay
'em all back!" (#6; 10). Though the Hulk ultimately defeats the
alien, winning a pardon for his past crimes, Banner has less and
less control of his transformations, suffering delayed and partial
effects with Banner briefly retaining some of the Hulk's strength
and the Hulk briefly retaining Banner's face. Rick concludes: "The
Gamma Ray machine—it grows more and more unpredictable each
time it's used! If Doc has to face it again—what will happen next
time?" (#6; 24).

Marvel cancelled the series after the March 1963 issue, also
the cover date of *The Amazing Spider-Man* #1. Although now an
ongoing superhero series, the splash page opens with Spider-Man
facing a chorus of angry fists and pointing fingers beneath the
words "Freak!" and "Public Menace!" (Lee and Ditko 2009: 14),
and Parker contemplates using his powers to commit crimes (16).
Ditko and Lee return to the Space Race theme, with Spider-Man
preventing the death of an astronaut in an out-of-control capsule.
The issue also introduces the long-term plot of J. Jonah Jameson,
the newspaper editor bent on portraying Spider-Man as a threat.
Parker laments:

How can I prove I'm not dangerous? How can I convince
people that I wasn't responsible for the failure of that capsule?

Everything I do as Spider-Man seems to turn out wrong! What good is my fantastic power if I cannot use it?? Or, must I be forced to become what they accuse me of being?? Must I really become a menace? (27)

Iron Man also premiered in *Tales of Suspense* the same month. Once again, the military theme is explicit. Tony Stark is another "genius," and the opening panel locates his laboratory "in the U.S. defense perimeter" because "The Commies would give their eyeteeth to know what he's working on now!" (Lee et al. 2011: 170). After destroying a vault door with a tiny magnet, Stark asks a general: "Now do you believe the transistors I've invented are capable of solving your problem in Vietnam?" (170). Two panels later, scripter Larry Lieber narrates that Stark "is soon destined to become the most tragic figure on Earth!" (171). When he travels to Vietnam, where his "weapons are everything we hoped for!", he is injured and captured. His technology prevents shrapnel from entering his heart and killing him, but in the process he turns himself into "the most fantastic weapon of all time!" (173). The armor is a "metallic hulk" colored the same gray as the Hulk in his first issue, transforming its creator into a "thing which is now Anthony Stark!!" (181, 177). Also like Banner, Stark thwarts "the evil red tyrants," but at great allegorical cost: "to remain alive, I must spend the rest of my life in this iron prison!!" (173, 177). Public sentiment would grow to regard the Vietnam conflict in similar light. The U.S. had begun sending military advisors to French Indochina in 1950, but, following the colony's independence and partition into two warring states, their number rose to 900 in 1960, 3,2005 in 1961, and 11,300 in 1962 (Gilder Lerhman n.d.).

Turning point: 1962–3

Applying an average production time of four months, the first Iron Man issue was likely conceived no later than October 1962—and so in the earliest stages of production during the Cuban missile crisis. After the revolution in 1959, Fidel Castro formally allied Cuba with the U.S.S.R., and in 1961 the U.S. backed the Bay of Pigs Invasion in a failed attempt to overthrow the Communist

government. In October 1962, a U.S. spy plane photographed Cuban sites housing Soviet intermediate-range ballistic missiles. As President Kennedy ordered a blockade of the island and readied for air strikes and invasion, the Soviet Union sent cargo ships toward Cuba and warned of full-scale war. At the height of tensions, U.S. Strategic Air Command was operating at DEFCON 2, the highest defense readiness condition reached during the Cold War. The international community was braced, with Pope John broadcasting on Vatican Radio: "We beg all governments not to remain deaf to this cry of humanity. That they do all that is in their power to save peace. They will thus spare the world from the horrors of a war whose terrifying consequences no one can predict" (Rychlak 2011). The crisis ebbed after Khrushchev called back his ships and agreed to remove Soviet missiles in exchange for the U.S. removing its missiles from Turkey and publicly declaring that it would not invade Cuba.

The long-term effects of the crisis on the American public were paradoxical. Rather than further stoking fears of war, anxiety decreased. This was in part related to actual improvements in U.S.–Soviet relations: the Washington–Moscow Direct Communication Link connected the Pentagon and Kremlin by teletype in August 1963, the same month both nations signed the Limited Test Ban Treaty, limiting nuclear tests to underground explosions and so preventing further fallout from entering the atmosphere. However, Spencer R. Weart argues that "this drop was not because of any great change in the public's beliefs and concerns. People still admitted their nuclear fear if asked about it, but they no longer brought it up spontaneously. Brushing the whole issue aside was the easiest way of all to ward off cognitive dissonance" (2012: 154). Weart documents a "worldwide collapse of interest in nuclear war" with "published attention," including "bibliographies of magazines, indexes of newspaper articles, catalogs of nonfiction books and novels, and lists of films," dropping "to a quarter or even a tenth" of its 1962 levels: "Even comic books with 'Atom' in the title faded from newsstands" (152). Broome and Anderson's Atomic Knights was one such casualty. Their twelfth episode, likely the first to begin production after the Cuban missile crisis, is cover-dated March 1963, and the series was discontinued three episodes later.

The cancellation of The Incredible Hulk after its March 1963 issue might be an early indication of the same trend. It might also

be a result of Kirby and Lee's not settling on a clear premise, with the Hulk changing personalities and transformation plot devices every other issue—itself a reflection of instability. Atomic anxieties continue in *The Amazing Spider-Man*, but at a lessened rate. Of the ten supervillains introduced in its first year, only the Sandman is nuclear related. As an escaped prisoner, he alludes a police dragnet by hiding in an "atomic devices testing center!" where "he remained on the lonely, forbidden-area beach until that fateful day that a nuclear test explosion caught him unawares," causing his body to take on "the qualities of the sand itself" (Lee and Ditko 2009: 94). Issue #6, cover-dated September 1963, was written while terms of the Limited Test Ban Treaty were being negotiated. The Sandman's "incredible accident" would be the last of its kind (94).

In his first year Iron Man faces a range of Communist super-villains, including the Red Barbarian, Crimson Dynamo, and the Mandarin, as well a "master of evil" who commands "the most cunning scientists and power-mad military men on Earth!" and detonates "a 200-megaton bomb" in outer space before giving "the world my ultimatum ... surrender to Dr. Strange, or extinction!" (Lee et al. 2008: *Tales of Suspense* #41; 7, 11, 10). The May 1963 issue would have been scripted by Robert Bernstein after the Cuban missile crisis, when both the U.S. and the Soviet Union detonated high-altitude nuclear warheads as acts of intimidation. Larger than the 58-megaton bomb detonated by the Soviet Union in 1961, Dr. Strange's "S-Bomb" also appears to have been inspired by the U.S.'s July 1962 "Starfish Prime," the largest nuclear test explosion conducted in outer space. The issue concludes with Dr. Strange's own daughter foiling his plot and then asking, "Oh, Iron Man ... why? Why does he use his great gift, his genius to menace the world, instead to help it, as you do?" (#41; 13). Readers could have asked the same question of the U.S. and the Soviet Union.

The early Iron Man series also repeats the Fantastic Four's modified superhero attitude toward enemies. The stories vacillate between plot closures in which Iron Man vanquishes his enemies, as was standard of the Golden Age superhero formula that paralleled World War II military goals, or merely deters them, as paralleled current MAD military policy. Of the first eight issues plotted by Lee, drawn by Don Heck, and scripted by Bernstein, Iron Man kills the "Guerilla Chief" in his origin episode, causes the death of a lead spy in his fourth, and defeats an opponent in

a "Waterloo" battle in his seventh. The other four episodes avoid direct victory, with aliens stopping their planned invasion for fear of facing an army of Iron Men, an invading underground queen halting her attack after Iron Man reveals that the surface air will age her beauty, a Roman army fleeing rather than facing Iron Man in battle, and the Crimson Dynamo defecting to the U.S. after Iron Man convinces him his Soviet superiors intended to execute him. Iron Man also prevents Dr. Strange's world conquest, but only by turning his daughter against him, and Strange himself escapes. The pattern continues after Ditko partners with Lee. The Melter retreats when Iron Man tricks him into believing he has invented a defense to his melting ray: "if he ever should return, I may not be able to trick him this way a second time!" (#47; 18). Iron Man's next enemy ends "thoroughly defeated!! "(#48; 17), but he then faces the X-Men character Angel who is caught in what is likely Marvel's last depiction of an atomic text explosion. The radiation makes the Angel a "smarter, craftier, slyer person! And, yes ... I admit it! A far more evil person!" (#49; 3). Iron Man not only fails to capture him, but begins to fall to his death—which shocks Angel into saving him, because "Even under the influence of atomic radiation, Angel could not permit a fellow mortal to die!" (18). Finally, when facing the Mandarin for the first time in #50, it is Iron Man who barely escapes the encounter. Not only are these not the unqualified victories of a Manichean superhero, Stark himself is humbled by his own superhero premise, forced to wear his Iron Man chest plate at all times and to sit plugged into a wall socket as it recharges. Unlike the prototypical Golden Age Superman, Marvel's superheroes are their own kryptonite.

Marvel published Lee and Kirby's *The X-Men* #1 with a September 1963 cover date, and so it was on sale as the Limited Test Ban Treaty was signed. As Marvel's first post-Cuban crisis superheroes, the X-Men mark a change in Cold War attitudes. Though the treaty was not yet signed, Kennedy had announced in early June that the U.S. and the Soviet Union had reopened negotiations. In the same commencement speech Kennedy identified what he termed "the most important topic on Earth: world peace," not one "enforced on the world by American weapons of war," but "genuine peace ... not merely peace for Americans but peace for all men and women." War, he repeated three times, "makes no sense," describing how "the deadly poisons produced by a nuclear

exchange would be carried by the wind and water and soil and seed to the far corners of the globe and to generations unborn" (Kennedy 1963). When Lee filled in Kirby's speech bubbles for Professor X that same summer, he described the same generational effects: "I was born of parents who had worked on the first A-Bomb project! I am a mutant ... possibly the first such mutant!" (Lee et al. 2011: 245). The five teenaged members of his school would have been born after World War II, and so were products of the atmospheric radiation from Hiroshima, Nagasaki, and the far more powerful Bikini Atoll tests begun in 1946. Before atmospheric tests were officially banned, Lee was already looking to the past for his characters' origin. With the exception of Thor and his missile namesake, the X-Men were the first Marvel superheroes not created as a result of a current experiment or military action. They were the next generation coping with the aftermath of others' mistakes.

Where Banner struggles unsuccessfully to control the Hulk, at Professor X's school, "we learn to use our powers for the benefit of mankind—to help those who would distrust us if they knew of our existence!" (245). Though when Xavier "was young, normal people feared" him and were "not yet ready to accept those with extra powers!" (245), that changes when a military officer accepts their offer of assistance and then at the end of the episode declares: "You call yourselves the X-Men! I will not ask you to reveal your true identities, but I promise you that before this day is over, the name X-Men will be the most honored in my command!" (258). Of course nuclear power is still dangerous, as represented by "evil mutants" who "hate the human race, and wish to destroy it!" (246). The later stories would emphasize all mutants as feared outcasts, but the first issue is a thematic return to the 1950s dichotomy, what Weart terms a "fairy tale" structure of "Good and Bad Atoms" featuring "the atomic genie that could be either menace or servant" (2012: 88). Magneto accordingly targets "the mightiest rocket of all," causing the newspaper headline "Sixth Top Secret Launching Fails at Sea!" (246, 247). He next controls "an underground silo where one of democracy's silent sentinels wait, at the ready!" and uses his "invisible waves of pure, powerful energy" to lift "the silo head, activating the mighty missile" (249). Though the X-Men deter rather than kill or capture Magneto, assuring an ongoing stalemate, Marvel superheroes would no longer embody

the ambivalence the U.S. population felt toward its nuclear arms. Both were now effective at preventing destruction.

Lee collaborated with Bill Everett for his last major Marvel superhero. *Daredevil* #1 began production shortly after the X-Men's debut, again drawing on radiation as a source of fantastical powers, but, also like the X-Men, Daredevil is focused on the aftermath of past nuclear events. Instead of an explosion, Matt Murdock is struck by an out-of-control truck labeled "Ajax Atomic Labs Radio-Active Materials DANGER" (Lee et al. 2011: 280). Everett appears to have intended the truck itself to be the cause of Murdock's blindness and superpowers, but Lee reveals in a bystander's speech bubble that an undrawn "cylinder fell from the truck ... it struck his face! Is ... is it something radioactive??" (280). Regardless, the episode is a further departure from past origins because the Ajax company has no military connection—the drivers are dressed as civilians and the truck is a domestic make— and its radioactive materials are, as later clarified, waste. The incident is not an atomic experiment gone wrong, but a failure to dispose of a past experiment safely. Also like the X-Men, Daredevil receives immediate acceptance by the authorities. Even though he causes the death of his first enemy, police arrest the criminal's partner after Daredevil subdues him. As Lee collaborated with artists Joe Orlando, Wally Wood, and then John Romita, Sr. over the next two years, only one *Daredevil* issue features a Cold War enemy, a Communist spy who gains mind control powers when accidentally doused with chemicals. Rather than aiding the Soviet Union, however, the Purple Man becomes a criminal in the U.S., the same as the vast majority of Daredevil's antagonists.

Aftermath

Daredevil #1–6 are cover-dated April–December 1964, the year David Walbert reports 16 percent of Americans identified nuclear war as "the nation's most urgent problem," down from 64 percent in 1959 (Walbert n.d.). "Ironically," writes Walbert, "the threat of annihilation—what would come to be known as 'mutually assured destruction'—made both sides reluctant ever to use nuclear weapons." Marvel's superheroes parallel that same spike and fall

in anxiety. Those changes in public opinion also help to explain Biersdorfer's observation of comics' genre shift from melodrama to relative realism.

Lee's "gimmick" to include a bad guy within a team of good guys altered the standard superhero plot structure by splitting the heroes' focus between fighting external threats and containing an internal one. At the level of character, the Thing and the directly imitative Hulk added complexity because they were not simply supervillains either. "Much like nuclear energy itself," observes Jeffrey K. Johnson, "the Hulk can be defined as neither hero nor villain, but rather is a complex and often uncontrollable natural force" (2012: 60–1). Alan Moore, reading *The Fantastic Four* #3 as a child, had "the impression that [the Thing] was on the verge of turning into a full-fledged supervillain," not "the cuddly, likeable 'Orange Teddy-bear' of later years (1983: 45). Stan Lee recalls writing the character in a 1981 interview:

> I tried to have Ben talk like a real tough, surly, angry guy, but yet the reader had to know he had a heart of gold underneath … People always like characters who seem very powerful yet, you know they are very gentle underneath and you know they would help you if you needed it. (McLaughlin 2007: 94)

Lee's recollection is of the later characterization, not the Thing of 1961, whose surliness was not a disguise. When Ben says to Sue in the first issue, "Now let's go find that skinny, loud-mouthed boy-friend of yours!", Lee scripts her response at face value: "Oh, Ben—if only you could stop hating Reed" (Lee and Ditko 2008: #1; 21). According to Lee's original synopsis, Ben "has a crush on Susan," "is jealous of Mr. Fantastic and dislikes Human Torch because Torch always sides with Fantastic," and "is interested in winning Susan away from Mr. Fantastic" (Lee et al. 2011: 484).

Despite Lee' stated intention, his and Kirby's rendering and readers' perceptions of Ben grew more sympathetic. Ben complains to Reed: "At least you're human! But how would you like to be me?" (Lee and Ditko 2011: #2; 6), and Sue herself is sympathetic: "Thing, I understand how bitter you are—and I know you have every right to be bitter!!" (12). When Ben returns to human form for a few moments after passing through the radiation belt again, Torch consoles him too: "She's right, pal! That was just a start!"

(21). In #3, despite renewed fighting with Torch, Ben intervenes to save Reed's life: "Reed can't dodge those dum-dums forever, I gotta do something!!" (20). By #6, Kirby and Lee are no longer portraying overt conflict between the characters, and with #8— coincidentally on sale during the Cuban missile crisis—Ben's "crush" ends and his character is redefined by the introduction of an alternate love interest. The Puppet Master's blind step-daughter, Alicia, disguises herself as Sue, fooling all of Sue's male teammates. Though Ben suffers another temporary transformation to human form, Alicia's love is permanently transforming: "This man—his face feels strong and powerful! And yet, I can sense a gentleness to him—there is something tragic—something sensitive!" (9). The Thing transfers his affection to Alicia, who reciprocates and humanizes his previously inhuman character: "the clinker is—she likes me better as the Thing!" (13). In the following issue, cover-dated December 1962, Alicia calls Ben "my white knight! You are good, and kind, and you will never desert your friends when they need you most!" (#9; 4), prompting Ben to hug his teammates: "us white knights don't desert their companions in arms! I'm with ya, gang!" (5). Marvel realism began with a MAD-era plot gimmick that resulted in unplanned character complexity and then ad hoc revision, producing the unified family-like Fantastic Four that would define the post-Cuban missile crisis series.

The radioactive-monster-turned-hero motif occurred outside of comics too. When the film monster Godzilla debuted in 1954 in Japan, and then in a heavily edited 1956 version in the U.S., he was an embodiment of the dangers of the U.S.'s nuclear tests in the Marshall Islands. He returned as a continuing threat in three sequels, but the fifth, Ghidorah, the Three-Headed Monster, made in Japan in 1964 and released in the U.S. in 1965, Godzilla helps to defend the Earth against alien attack. In the next films made over the following decade, Godzilla would continue to appear as protagonist and protector.

When recalling the Hulk, Lee again described the character's revised incarnation: "I just wanted to create a loveable monster— almost like the Thing but more so ... I figured why don't we create a monster whom the whole human race is always trying to hunt and destroy but he's really a good guy" (95). Though monstrous, the 1962–3 Hulk was not loveable and was no good guy. After appearances in other titles, the Hulk's own cancelled series was

renewed in 1964 as one of two ongoing features beginning in *Tales to Astonish* #59, with Ditko replacing Ayers for pencils beginning #60, and Kirby co-penciling with multiple artists beginning #68. The 1964 Bruce Banner no longer uses his Gamma Ray device to transform into the Hulk, and when Giant-Man comes searching, Banner thinks, "So! The Avengers are still seeking the Hulk, eh? Will they never leave him in peace?" (Lee et al. 2006: #59; 5), reflecting Lee's revision. The Hulk himself later laments: "There is nothing for Hulk—nothing but running—Fighting! Nothing—" (#67: 7). The character is still antagonistic and can take "off like a missile" (11), but, like the revised Ben, he saves Giant-Man when both are targeted by an atomic shell, also throwing it to explode far from the nearby town (#59: 17). Costello still reads the new series as essentially the same as the original, because it, along with Iron Man, does not "question Cold War policy as a quarter of the stories between 1964 and 1966 feature them fighting communists" (2015: 131). The Leader, the primary antagonist from #62–75, was "an ordinary laborer" until yet another "one-in-a-million freak accident occurred as an experimental gamma ray cylinder exploded" transforming him into "one of the greatest brains that ever lived" (#63; 2–3). Also, as earlier, Banner gains control of the Hulk's body for several episodes, continuing the struggle of the 1962 series.

After the January 1966 issue, however, the premise changes. When the military fires Banner's experimental "T-Gun," the Hulk is sent to "some far distant future," a "dead world" in which Lincoln's memorial statue sits in the ancient ruins of Washington, D.C. (#75; 9). A future commander declares: "We cannot allow a destructive, rampaging brute to run amok in our land!" (#76; 2). This "grim, ominous war-torn world of the far future" (#76; 6) recalls Kennedy's 1963 "war makes no sense" refrain, and when the Hulk returns from it to his own time, he settles into a new, toddler-like personality, no longer posing a threat unless attacked. Moreover, as with Ben and Alicia, Banner's love interest, Betty Ross, views the Hulk in transformative light: "His arms—so huge—and brutal—but yet, so strangely gentle—!" (#82; 10). Although he has brought her to an isolated cave, she adds: "It's strange! I find I'm not afraid of him any longer! As powerful, and as unpredictable as he is … I can't help feeling he's not truly evil!" (#83; 4). Even General Ross, who has hated and hunted the Hulk since his debut,

changes attitude: "The strongest ... most dangerous being on Earth ... but my daughter tells me he rescued her ... tells me she loves him ...! And yet ... somehow ... I find myself beginning to understand" (10). When the military test fires another of Banner's weapons, an "anti-missile proof" missile and so "the greatest weapon of all!" (#85; 3), the Hulk prevents it from destroying New York.

With the Hulk's secret identity no longer a secret, Betty declares: "Now there can be no doubt! The Hulk isn't a monster—he never was! He was always you!" (#87; 8), and her father now asks for Banner's help in stopping the next menace and praises the Hulk because "he saved us—from our own folly!" (10). President Johnson sends General Ross an executive order: "If, in your opinion, the Hulk is no longer a menace, you are authorized to grant him full and immediate amnesty, clearing him for all guilt, or suspicion of same," but because a villain tricks the Hulk into a rampage Ross shreds the order (#88; 5). Though the Hulk remains an outcast, the ongoing narrative has shifted. Like the X-Men who are also distrusted and pursed by government figures, readers understand the government to be definitely wrong. By losing ambiguity, the Cold War superhero regains its original Golden Age status as a misunderstood vigilante. General Ross is little different from Detective Captain Reilly who pursues Superman in *Action Comics* #9 or Commissioner Gordon who orders his officers to shoot at Batman during his debut in *Detective Comics* #27.

The change affected other superheroes too. "After 1968," writes Chambliss, "as public opinion toward U.S. Cold War policy shifted, Iron Man underwent a conversion. The symbolic Cold War enemies and confrontations that framed the series were no longer emphasized" (2012: 148). "Comic book superheroes in the second half of the decade," observes Costello, "confronted political issues that revealed not unity and moral certainty but division and moral ambiguity" (132). With the paradoxical stability of MAD now fully in place, public attention shifted away from the central fear of direct confrontation with the Soviet Union to a range of other issues, including the U.S.'s anti-Communist commitment to conventional warfare in Vietnam. While Lee and Kirby were shifting the Hulk further away from his Cold War origins in *Tales to Astonish*, for his final, July 1966 issue of *Amazing Spider-Man*, Ditko drew Peter Parker refusing to join a protest on his college campus (#38), and the following April, Lee and John Romita, Sr.

would send Flash Thompson, Parker's former high school bully but now college friend, to fight in Vietnam (#47).

When Flash Thompson returned from combat, the world of comic book heroism had shifted even further from Golden Age norms. The war—especially U.S. soldiers' participation in the 1968 My Lai massacre—further complicated the genre's former Manichean absolutes. When Len Wein returned to the post-nuclear war future established in the discontinued Atomic Knights series a decade earlier, it was in the horror title *House of Secrets* not the optimistic *Strange Adventures*. Wein's 1970 "The Day After Doomsday" concludes: "The last man on Earth had lived too long in the ruins to remember such things as patriotism and honor" (Broome et al. 2014: 62). Not only did Flash Thompson similarly witness the destruction of a temple and village by a U.S. air strike in 1972 (#108), Marvel introduced several new superheroes in the early 1970s that reprised and expanded the monstrous qualities of their early 1960s predecessors. Stan Lee, Roy Thomas, Gerry Conway, and Gray Morrow's 1971 Man-Thing was a radical refiguring of Marvel's patriotic icon Captain America. Like Reed Richards, Bruce Banner, and Tony Stark, Ted Sallis is a brilliant scientist, but one who even before his transformation suffers for his military involvement. With the words "Napalm" and "Bomb" in the newspaper in his hand, he laments: "It's bad enough that chemical will be used for more killing [...] Every time I close my eyes, I <u>hear</u> them—the people I've helped kill—Thousands of them ... <u>screaming</u> all around me" (Thomas et al. 2011: 33). Though his girlfriend (soon to be revealed as a spy) assures him that "What the army does with your—your what-ever-it-is doesn't matter," Ted wishes he "had the guts to destroy it" (33, 34). Rather than allowing criminals to steal it, he injects himself with the serum designed to "change an ordinary soldier into an indestructible warrior!" (37). As with previous Cold War-era military technology, something goes wrong, and he is transformed into not simply a monstrous Thing or Hulk, but "a grotesque Man-Thing!" whose touch burns like napalm and whose mind lacks all comprehension and language: "Well, you made it, Ted Sallis. You have your super-soldier—your indestructible killer. Too bad you couldn't have known that your ultimate victim would be—yourself!" (40). This is the superhero formula that Lee and Kirby introduced in 1961 and 1962, only exaggerated into a still more monstrous extreme.

The explicit military motif and warped super-soldier allusions to Captain America continued in Rich Buckler and Doug Moench's 1974 Deathlok the Demolisher, whose first *Astonishing Tales* cover echoes the question posed on the Hulk's debut: "Is he Man—or Machine—or Monster?" (#25). Similar to his forebears, "Col. Manning was the most brilliant military strategist alive," and that knowledge is preserved in "the most ghoulish surgical procedure since Frankenstein," because, as Major Ryker (whose moustache and shouting demeanor echo Banner's General Ross) explains: "We need super-soldiers—men with bodies of steel and minds of computer precision!" (Thomas et al. 2012: 223). A doctor calls the project "blasphemous" and the product "hideous," one that must be kept secret since "there are still some taxpayers who wouldn't like the idea of the military spending its time making monsters" after Ryker has duped "the entire military into funding his private obsession" (224). Instead of Betty Ross looking on adoringly at Bruce Banner, Ryker's wife, Nina, finds Manning "repulsive. Just looking at him makes my flesh crawl. Do I have to watch this demonstration with you, Simon?" (226). Though Ryker expects "a being totally subservient to my command," Manning's personality reasserts itself, which prevents Ryker from building an army of super-soldiers, but the result is Deathlok, a "hit-man" filled with "hate and contempt" and who enjoys killing for the "beautiful agony" of his victims (225, 220). Though set in the future world of the 1980s, this is Marvel's post-My Lai update of their superhero formula, a yet more extreme rendering of the monster-heroes of a decade earlier. Gerry Conway and John Romita, Sr.'s 1974 Punisher, introduced in *Amazing Spider-Man* #129, and Roy Thomas, Len Wein, and Romita's 1974 Wolverine, introduced in *The Incredible Hulk* #180–1, continued the trend toward more violent and morally ambiguous superheroes.

Meanwhile, Russian supervillains, once an essential feature of Cold War plotting, grew comparatively rare, and sympathetically portrayed Russian heroes increased. Len Wein, Marv Wolfman, and Bill Draut brought DC into the contemporary world in 1968 by introducing Starfire in *Teen Titans* #18; allegorizing U.S.–Soviet relations, the team and Starfire meet with initial distrust but end as friends. Black Widow, formerly a Soviet spy and Iron Man antagonist introduced in 1964, received her own *Amazing Adventures* series in 1970, co-starred in the retitled *Daredevil and the Black*

Widow from 1972–4, and led *The Champions* from 1975–8. Len Wein and Dave Cockrum's Colossus premiered in the revived X-Men in 1975, Steve Gerber and Sal Buscema's Red Guardian joined *The Defenders* in 1976, and Paul Kupperberg and Joe Staton's Negative Woman joined *Doom Patrol* in 1977. Since most of the characters are defectors, superhero comics still portrayed the Soviet government in a negative light, though more indirectly. "You want me to go with you ... to America?" asks Colossus. "But if I possess such power as you say—does it not belong to the state?" Professor X answers: "Power such as yours belongs to the world, Peter—to be used for the good of all" (Thomas et al. 2012: 249). Though the attitude suggests that the U.S., not the Soviet Union, represents the world, Marvel is no longer portraying tragic victims of Communism as first embodied by the Gargoyle in the Hulk's premier.

The 1970s also made MAD explicit. The *OED* cites the first published use of the term in 1971 *New York Times* editorial. Donald G. Brennan wrote:

> It is widely argued that the most peaceful, stable, secure, cheap, and generally desirable arrangement is one in which we and the Soviets maintain a "mutual assured destruction" posture, in which no serious effort is made by either side to limit the civilian damage that could be inflicted by either side ... I believe that the concept of mutual assured destruction provides one of the few instances in which the obvious acronym for something yields at once the appropriate description for it; that is, a Mutual Assured Destruction posture as a goal is, almost literally, mad. MAD. (1971: 31)

Brennan outlined his objections, but MAD faced no significant challenges until 1983 when President Reagan announced the creation of the Strategic Defense Initiative Organization to oversee a proposed missile defense system that would end the deterrent policy of MAD. Although never developed, SDI—popularly called "Star Wars" because it was to include orbital platforms and lasers—echoed the late 1940s' belief that the U.S. would soon deploy effective defenses against nuclear attack. Reagan also restored the Manichean rhetoric of World War II, likening "the evil empire" of the Soviet Union to Nazi Germany in a speech two

weeks before announcing SDI. Addressing the National Association
of Evangelicals, Reagan warned not "to simply call the arms race
a giant misunderstanding and thereby remove yourself from the
struggle between right and wrong and good and evil" (Reagan
1983).

DC responded by reprising its Atomic Knights in 1983, revealing
that the early 1960s events had actually taken place inside a
simulation program which the mind of the main character took
over as he lay in suspended animation:

> because the utter devastation of a nuclear war [...] was too
> ghastly for the mind of the average person to cope with!
> So instead of a world of helplessness, despair and suffering,
> Gardner reprogrammed the simulation to create a fantasy world
> of great adventure ... a place where he would change as a hero
> who is in charge of events rather than the faceless victim of
> them! (Broome et al. 2014: 562)

The fantasy threatens to destroy the real world as the computer
nearly triggers a nuclear launch, awakening the leader of the
Atomic Knights to realize his mistakes:

> The whole project was misguided from the start—trying to
> figure out how to live in post-holocaust world [...] To believe
> that civilization can continue in the face of that cataclysm is a
> fantasy. [...] The task before mankind isn't to survive an atomic
> war! It's to work in this world we're living in to make certain
> such a war can never happen! And we all have to do it—all of
> us, and now! Because the clock is ticking for every man and
> woman and child on Earth. (571)

Although U.S.–Soviet relations improved after Mikhail Gorbachev
assumed leadership in 1985 and advanced Glasnost and other
reforms in 1986, superhero comics expressed such nuclear anxieties
at a rate unseen since 1962. Months prior to the Chernobyl disaster,
Mike W. Barr and Jim Aparo's *The Outsiders* #1 (November
1985) premiered with the two-issue arc "Nuclear Fear" about
terrorists attacking a nuclear power plant to destroy the world
with radiation, the same month that Barr and Alan Davis included
Gorbachev in a Star Wars plot in *Batman and the Outsider* #27.

Barr and Aparo also featured Gorbachev as a villain in *The Outsiders* #10 (August 1986).

DC published the first of Frank Miller's four-issue *Dark Knight Returns* in early 1986, and Alan Moore and Dave Gibbons' twelve-issue *Watchmen* began that summer, as did Miller and Bill Sienkiewicz's eight-issue *Elektra: Assassin*. All three limited series were conceived in 1985 and highlight the threat of nuclear destruction. Miller draws Superman destroying Soviet fighter planes and tanks as a newscaster reports: "urging the public not to panic, the President has placed Strategic Air Command on Red Alert. 'We won't make the first move,' said the President, 'but we're ready to make the last" (Miller 1986: #3; 27). After a Cuba-like crisis over the fictional island of Corto Maltese, the Soviets withdraw and fire a nuclear warhead at the island: "This is it, folks—first strike!" (#4; 13). The President, though advised that "we'll look like wimps if we don't," waits before ordering a counterstrike to "see what our own little deterrent can do," and though Superman diverts the missile, the force of its electromagnetic pulse proves "Russia has taken the lead in the arms race" (#4; 13, 16). In *Elektra: Assassin*, Miller portrays a Manichean struggle at a literal level, with the Beast possessing a Kennedy-like Presidential candidate whose "first act as President will be to launch a full nuclear strike [...] The Russians will have time to strike back ... It'll be the end of the world" (Miller and Sienkiewicz 2012: 222). Instead of Miller's Ronald Reagan caricature, Sienkiewicz draws the current President as an even more cartoonish Richard Nixon, always clutching the launch button: "I've got the box. And I've got the guts. Damn straight ... Soviet Attack? Who needs one?" (207). Moore and Gibbons also depict Nixon in *Watchmen*. As the literal countdown to Armageddon progresses on the series' logo and the cover of #10 features a radar panel and the readout DEFCON 2, the President moves to a protected bunker with the launch device handcuffed to his wrist. When an adviser tells him, "I see no profit in employing MAD bomber tactics," the President interrupts, "Don't you start that 'MAD bomber' shit," and a second adviser adds that "our analysis shows good percentages on a first strike" (Moore and Gibbons 1987: #10; 3). Ozymandias, having anticipated the inevitable conflict, saves the world by inventing the appearance of an alien invasion, destroying New York but bringing an "immediate end to hostilities" and literal "Peace on Earth" (#12; 19, 28).

The 1980s' surge in nuclear fears, however, was relatively short-lived. When Reagan visited Moscow in 1988, he stood beside Gorbachev and told reporters that his reference to "the evil empire" five years earlier was "about another time, another era" (Meisler 1988). The Soviet Union officially dissolved three years later, but the legacy of MAD permanently altered the superhero character type. While reprising the anxieties of the Cuban missile crisis, Moore and Miller's 1986 works are also two of the most lauded superhero comics in the history of the genre. *Watchmen* especially critiqued the character type by presenting a range of deeply flawed superheroes: the nihilistic Comedian, the Manichean Rorschach, the impotent Nite Owl, and the nearly omnipotent but indifferent Dr. Manhattan. Though regarded as a major turning point in superhero comics, *Watchmen* is also an expansion of the themes established by Lee, Kirby, and Ditko in the early 1960s. Based on Charlton Comics characters, including Ditko's 1960 Captain Atom, the Watchmen are variations on Marvel's first MAD-era hero-monsters, authored at the moment when MAD policy was shifting for the first time in two decades. "With Ben Grimm," recalled Moore, "you knew that he was quite likely to pull someone's arms and legs off one at a time for no better reason than that his corn-flakes had gone all soggy before he got round to eating them that morning" (Moore 1983). The description applies better to Moore's own Comedian—another bad guy on a team of good guys, one who as a soldier in Vietnam murders a woman pregnant with his own child because she cut his face with a broken beer bottle. Also like the Thing of Lee's original treatment, Dr. Manhattan is a morally ambiguous superhuman capable of destroying the world, one who does not intervene as the Comedian commits his murder.

While more monstrous than their Marvel forebears, Moore's nominal superheroes—also spanning *Miracleman*, *V for Vendetta*, and *Swamp Thing*—achieved the same effect for 1980s' readers that Moore experienced himself reading *The Fantastic Four* #3 as a child:

> I doubt you can imagine the sheer impact that single comic possessed back there in the comic-starved wastelands of 1961 ... Especially to someone whose only exposure to the super hero had been the clear-cut and clean-living square-jawed heroes featured in DC comics at the time. (1983)

This is why Alin Rautoiu argues for a "Theory of superhero comics as two distinct genres," the first featuring superheroes as "the anthropomorphisation of a moral principle through which the world is brought to equilibrium," and the second "concentrated on reshaping or even destroying the original narrative," beginning with the comparative complexities of "Kirby, Ditko and Lee's heroes" (Rautoiu 2016). The first was created in the context of World War II, the second in the Cold War context of MAD. Both continue as the two poles that define the spectrum of superhero comics today.

4

Social and Cultural Impact

I

The Black Superhero

Because comics publishers seek to maximize sales, the superhero genre may be viewed as a largely conservative one, typically reinforcing rather than challenging cultural norms. A mainstream comic that reflects either socially antiquated values or progressive values beyond the majority of its readership could sell poorly. The market corrects for the status quo. The genre itself has established its own norms as well, many unexamined and self-reproducing, especially in terms of hero identity. "The word 'superhero,'" Carolyn Cocca observes in her recent study of diversity in the genre, "pretty much assumes that the hero in question is male, and white, and heterosexual, and able-bodied" (2016: 6). As a result, Rebecca Wanzo writes, "for many people of color in the United States, the experience of consuming comic book heroism ... has involved reconciling themselves to representing the antithesis of heroic ideals" (95). Conseula Francis goes further, suggesting that because superhero comics are predicated on "the whiteness of American heroism": "It is entirely possible that a successful black American superhero is impossible because it seeks to combine two ideals that are antithetical to each other: superheroes and American racial thinking" (2015: 139, 138).

While this division is not absolute, its historical presence creates a unique window into white America's evolving conceptions of race. "Given that white writers and artists created the majority of black superheroes," observes Blair Davis, "these characters ... can therefore be seen as touchstones for how white American society regards black identity ... in any given period" (2015: 211). Black

superheroes, a nonexistent category for the first thirty years of the superhero comics genre, emerged in the late 1960s, suffered reductive racial conceptions and poor sales in the 1970s, and, as more black creators gained influence, grew in prominence and complexity during the 1980s, 1990s, and early twenty-first century. Tracing these phases reveals how superhero comics relate to the wider context of U.S. society and so form a pop cultural microcosm of racial representation and history, one initially told by white creators for white consumers.

Pre-Code era, 1934–54

Superhero comics in the pre-Code years of the 1930s, 1940s, and early 1950s are dominated by a lack of black representation and punctuated by instances of extreme racist caricature. "Racism was built into the foundations of entire once-popular genres, especially jungle comics ... and war comics," writes Leonard Rifas, noting the predominance of "early American comic books that show white characters in dominant positions of over nonwhite domestics, natives, or sidekicks" (2010: 28). The pattern begins with the first recurring black character in superhero comics, Lothar, created by Lee Falk for his daily newspaper strip *Mandrake the Magician*. For the June 11, 1934 debut, artist Phil Davis drew Mandrake's sidekick in what would be the character's signature wardrobe: shorts, cummerbund, lion-skin sash, and fez (Falk and Davis 1934). Although identified as the prince of several African tribes, Lothar chooses to live in the United States as an ambiguously slave-like servant to a white, orientalist magician. In the second installment Lothar introduces his "Master" in what was termed General American English in the 1930s, but before the end of the year, Lothar's speech had devolved into ungrammatical fragments: "Three men fight lady. Is bad. Me almost get mad." The "lady" is Barbara, Mandrake's white love interest, who then dubs Lothar "My watchdog" (Falk and Davis 1934a). Five years later, Lothar's speech remained ungrammatical; after rowing his master through a swamp and holding an umbrella over Barbara's head, Lothar faces the ghosts of two pirates: "Me scared—but me sock!" (Falk and Davis 1939).

During *Mandrake*'s 1930s' run, readers also witnessed Jesse Owens' Olympic triumph and Joe Louis' boxing victory, as well as the appointment of the first African-American federal judge, William H. Hastie, events that did not alter the portrayal of African-Americans in newspaper comic strips. Will Eisner introduced readers to another crime-fighting sidekick, The Spirit's Ebony White in 1940. Non-white sidekicks were a standard outside of comics, with the Lone Ranger's Tonto and the Green Hornet's Kato speaking broken English on the radio, and The Spider's "turbaned Hindu" valet Ram Singh speaking in faux middle English in the pulps: "Fortunate it is that thy servant obeyed his orders" (Page 2007: 135, 52). Eisner introduced Ebony as an unnamed taxi driver in the first newspaper insert of *The Spirit*. In the second, he apologizes for speeding: "Sorry, boss, dis car jes' nachelly speeds up when ah drives past Wildwood cemetery!!" (2000: 28). In the third, he acquires his name and becomes the Spirit's "exclusive cabby" (37), though by July, the Spirit has his own car, and Ebony is his "assistant" in August (107). Ebony's face dominates the entire splash page the following month: bulging cheeks, round and crossed eyes, a tiny upturned nose, two protruding teeth, and, most prominently, enormous red lips—a cartoon embodiment of blackface minstrelsy (126). Eisner described the caricature as "a product of the times" (10).

Black characters in comic books were rarer. Joe Shuster drew no African-Americans in the first three years of *Action Comics*, and Harry G. Peter drew only four in Wonder Woman's first two years: a train porter, two hotel workers, and an elevator operator. The first three speak in slightly abbreviated General American English: "Yes, Ma'am! Suitcase comin' up! This suitcase is heavy! Must be fulla books!" (Marston and Peter 2010: 40), but the last William Marston scripts: "Bell done buzzed f'om dis floah—but dey ain' nobody heah!" (Marston and Peter 2011: 162). Analyzing the seventy-eight issues of Captain America's 1940–54 titles, Richard A. Hall counts only two African-Americans: a cowering and superstitious butler named Mose in 1942 and a member of the adolescent Sentinels of Liberty named Whitewash a year earlier (2011: 75). Both are rendered in a style Hall terms "Amos and Andy-esque," referencing one of the most pervasive and demeaning representations of African-Americans by white authors of the period (76). Charles Nicholas Wojtkoski's rendering reproduced the enormous

lips of nineteenth-century cartoons, the same tradition Eisner followed.

Beginning in 1941, the zoot-suit-wearing, harmonica-playing, watermelon-eating Whitewash Jones regularly appeared in *Young Allies*, which ran twenty issues before being cancelled in 1946, and in ten issues of *Kid Comics* from 1943–6. Although Hall concludes that "There were literally no non-white heroic figures during this period" (2011: 83), Whitewash, while fulfilling the role of comic relief through racist caricature, is also the first African-American hero in superhero comics. In the *Young Allies* premiere, Wojtkoski and writer Otto Binder present him as an equal member of the "small band of daring kids" (Burgos et al. 2013: 315), one who wrestles Nazi spies, discovers a trail that leads to the Red Skull's cave, saves team leaders Bucky and Toro by triggering a cave-in, and saves the entire team by discovering that their drinks have been poisoned (327, 328, 332, 342). When a military officer presents "each with a distinguished service medal" for "exceptional bravery in action," Wojtkoski draws Whitewash beside Toro and in front of two other white members (338), and for the chapter four splash page, contributing artists Joe Simon and Jack Kirby place Whitewash at center, pinning Hitler with his team members (344). In one panel, the character leads the team on bicycles stolen from German soldiers (345). Yet Whitewash also exposes the team as stowaways and is chided for his shocking "ignorance" (328). He is, however, no more comic than his teammates. Though Whitewash is afraid to enter the cemetery, Knuckles dives head-first behind a bush at the sound of an owl (329). Whitewash trips over his own rifle, but only because Tubby backs into him (320). Whitewash complains about walking, while Tubby complains about hunger, and Jefferson Worthington Sandervilt about the smell of fish (339). Sandervilt also voices fear, "My. What a harrowing experience!" before Whitewash, "Is dey gone?" (320). Arguably all four of the secondary Young Allies characters are sidekicks to Bucky and Toro, and so are not independently heroic themselves. But Whitewash, while a grotesque amalgam of African-American caricatures both visually and verbally, is not singled out for comic relief and often contributes more significantly than his white teammates.

Despite these exceptions, non-white protagonists remained a rarity in pre-Code comics, superhero-oriented and otherwise, and black creators were even rarer. Jackie Ormes is considered the

first African-American woman cartoonist, her 1937 comic strip *Candy* running in the *Pittsburgh Courier*, a nationally distributed African-American newspaper (Goldstein 2011: 71). Beginning in the early 1940s, Alvin Hollingsworth drew for Holyoke's *Cat-Man Comics*, as well as "Captain Power" in Novack's *Great Comics,* female Tarzan knock-off "Numa" in Fox Feature Syndicate's *Rulah, Jungle Goddess,* and "Bronze Man" in Fox's *Blue Beetle.* In 1947, Philadelphia publisher Orrin Cromwell Evan's one-issue *All-Negro Comics* featured artist George J. Evan, Jr.'s "Lion Man," the first African-American superhero by black creators and one, the publisher explains in his introduction, intended "to give American Negroes a reflection of the natural spirit of adventure and a finer appreciation of their African heritage" (Evans 1947).

Matt Baker achieved the highest level of success and, indirectly, notoriety in the early comics industry. Alberto Becattini and Jim Vabedoncoeur, Jr. index over 600 credits for Baker in roughly 150 different titles (Amash and Nolen-Washington 2012: 68–93). Working through the Iger Studio, which had previously included Will Eisner and Jack Kirby, Baker began his career on "Sheena, Queen of the Jungle" and "Sky Girl" in Fiction House's *Jumbo Comics* in late 1944, before expanding to "Skull Squad" in *Wings Comics* and "Wambi the Jungle Boy" in *Jungle Comics.* Baker rendered his African tribesman in the same relatively realistic style as his white characters, with no hint of Eisner's and Wojtkoski's racist cartooning. Baker's off-page experiences were less integrated. A fellow Iger artist recalled how Baker "would go off on his own" during lunch breaks, "acutely aware of the perceived chasm that separated him" in "an industry almost totally dominated by white males" (Amash and Nolen-Washington 2012: 39). Baker's greatest successes came in his sexualized renderings of women—a style that may have been influenced by Jackie Ormes' *Patty-Jo 'n' Ginger* one-panel comics that ran in the African-American newspaper *Chicago Defender* beginning in 1945. After Sheena imitations "Tiger Girl" and "Camilla," Baker drew Fox Features' redesigned *Phantom Lady* as one of his last projects before expanding to freelancing. While Baker was amassing romance credits in the 1950s, Fredric Wertham reproduced his April 1948 *Phantom Lady* cover in *Seduction of the Innocent* with the caption: "Sexual stimulation by combining 'headlights' with a sadist's dream of tying up a woman" (Wertham 1954: 212–13), and a

blow-up of the "objectionable" cover was displayed during the 1954 Senate Subcommittee Hearings into Juvenile Delinquency. Wertham condemned "race hatred" in his testimony (specifically a Tarzan comic in which a "Negro" blinds twenty-two white people, including "a beautiful girl"), but the absence of any mention of Baker in the hearing transcripts is likely due to committee members not knowing that a black man had drawn the images of a scantily-clad white woman (U.S. Congress 1954). Juvenile Emmett Till would be murdered for presumably flirting with a white woman and his killers acquitted the following year.

Future Marvel publisher Martin Goodman, having rechristened Timely Comics as Atlas Comics, employed Baker until his death in 1959 on over a dozen western, romance, and monster titles, including *Journey into Mystery*, future home of "The Mighty Thor." Atlas also published seven issues of *Jungle Tales*, which included Don Rico and Ogden Whitney's African hero "Waku, Prince of the Bantu," a rarity in the white-skinned Tarzan genre. Waku first appeared in 1954, the year of the Senate hearings and subsequent formation of the Comics Code, as well as the Supreme Court's decision on Brown vs. Board of Education of Topeka, Kansas, ending the "separate but equal" precedent of 1896.

First Code era, 1954–71

The Comics Code mandated that "Ridicule or attack on any religious or racial group is never permissible," and its first decade and a half saw an end to overtly racist caricatures and an incremental shift toward more complex representations (Code 1954). Initially, however, superhero comics avoided black characters entirely and employed no well-documented black creators. President Eisenhower's use of federal troops to enforce school desegregation in Little Rock, Arkansas in 1957, and the 1961 freedom riders bus tour, testing desegregated interstate travel in the South, produced no immediate reaction in superhero comics. But when Marvel's Stan Lee and Jack Kirby returned to World War II for the first issue of *Sgt. Fury and his Howling Commandos* in 1963, they included African-American soldier Gabriel Jones in the seven-member outfit—even though historically President Truman had

not signed the executive order desegregating the armed forces until 1948, three years after the war ended. The first issue was on sale while Martin Luther King, Jr. was arrested during anti-segregation protests in Birmingham, Alabama and the second while King gave his "I Have a Dream" speech to 250,000 civil rights marchers in Washington, D.C.

Obeying Code guidelines barring racial ridicule, Kirby gives Jones no caricatural features. If not for his skin tone—rendered in the African-American-signifying gray typical of the period—he could be mistaken for white. Kirby instead renders two white characters with occasionally exaggerated expressions (188, 189). If Jones's musical skills are a racial stereotype popularized by jazz celebrities Louis Armstrong, Dizzy Gillespie, and Miles Davis ("'Gabe' used to blow the sweetest trumpet this side of Carnegie Hall!"), they do not stand out in the relatively diverse but otherewise all-white company of an "ex-jockey from Kentucky," a "one-time circus strongman," "an Ivy-League college" grad, an Italian "swash-buckler" actor, and a Jewish mechanic (Lee et al. 2011: 184–5). While Kirby and Lee treat Jones respectfully, they also employ him minimally. He is one of the least depicted characters in the premiere episode, and, unlike Binder and Wojtkoski's 1940s' Whitewash Jones, Gabe Jones is never central in terms of plot or panel composition, speaking only four times in twenty-three pages. Whitewash spoke more than twice as often, twenty-eight times in the first fifty-seven pages.

The following year saw the ratification of both the 24th Amendment, which overturned voting taxes in the South, and the Civil Rights Act of 1964, which prohibited discrimination based on race, color, religion, sex, or national origin. Lee Falk had been scripting General American English for Lothar since the mid-1950s, and after artist Fred Fredericks replaced the late Phil Davis on *Mandrake the Magician* in 1965, Lothar would no longer wear his 1930s' costume but rather open shirts, trousers, and shoes. Fredericks also experimented with facial features, which, given the black-and-white newspaper medium, sometimes resulted in a European-looking African prince. The year 1965 also saw the murder of Malcolm X in February, the attack on protestors in Selma, Alabama in March, the passage of the Voting Rights Act and riots in Watts, California in August, President Johnson's "affirmative action" executive order in September, and the first African-American hero in his own comic

book title. Dell Comics' western *Lobo*, featuring the titular black cowboy, premiered in December, but the magazine folded after its second issue, nine months later.

Jack Kirby and Stan Lee's most significant contribution to the representation of racial and ethnic minorities in superhero comics was the introduction of Black Panther in *Fantastic Four*. The issue is cover-dated July 1966, three months prior to the founding of the national Black Panther Party for Self-Defense organization. Kirby had intended the character to be named "Coal Tiger," and his costume design would have revealed his race by exposing his face. Lee, who routinely reprised Golden Age characters and characteristics, may have revised the character's name after Paul Gustavson's 1941 Black Panther, a white superhero in Centaur Comics. *Fantastic Four* #52 is also a variation on Richard Connell's classic pulp fiction short story "The Most Dangerous Game," with Black Panther, the chieftain T'Challa of the fictional African nation of Wakanda, inviting the Fantastic Four to his kingdom "for the greatest hunt of all!" (Lee and Kirby 2011: #52; 4). After being nearly overpowered by Black Panther's superior Wakandan technology, the Fantastic Four escape his traps, and he surrenders. Despite this villainous introduction, the following issue begins with a "dance of friendship" performed by tribesman reminiscent of 1940s'-era Africa stereotypes, as Black Panther recounts a Batman-like origin story in which his father is murdered and he vows revenge against the killer—who coincidentally is attacking Wakanda at that moment. With the Fantastic Four's help, Black Panther defeats his enemy and, at their urging, pledges himself "to the service of all mankind!" (#53; 20). As a result, the character does not serve what Kenneth Ghee identifies as "the sociological function of any redeeming hero mythos; that is working to save *his own* people *first*" and so is only "a generalized 'humanitarian,'" not a "Black superhero" (2013: 232, 233).

Lowery Woodhall regards Black Panther's first story arc as "a frustrating one to read from a racial standpoint," beginning with "a ruthless, cunning and ferociously independent black man" and concluding with his "almost immediate emasculation" (2010: 162–3). While Lee and Kirby replace Black Panther's personal duty of avenging his tribe's previous leader with a superhero's generically all-inclusive and so predominantly white-focused mission, they also portray him in a complex mix of racial tropes. While his costume

and codename reinforce animalistic stereotypes, Black Panther reverses the racial structure of "The Most Dangerous Game" by assuming the role of the white hunter. He also defeats his enemy primarily through his intelligence: "You did not realize—I am a scientist too--!" (Lee and Kirby 2011: #53; 19), an opinion echoed by the Fantastic Four: "Apparently the talent of inventive genius is not limited to any one place, culture, or clime!" (#54; 8). His "jungle" palace includes "the latest fashions from Paris" and a grand piano played by "the world's most renowned pianist" (#54; 7, 4). Lee also uses the Thing's dialogue to mock his and Kirby's use of African tropes common to comics since the 1930s: "Yer talkin' to a guy who seen every Tarzan movie at least a dozen times!" (#53; 6), and Black Panther admits, "Perhaps my tale does follow the usual pattern" (#53; 7). Kirby's visual merging of Tarzan motifs with science-fiction technology, however, reversed those Golden Age patterns. Still, Derek Lackaff and Michael Sales note how the character is undercut by the fact that "the sovereign Black monarch of a high-tech civilization is rarely allowed to exercise that power and authority" (2013: 68).

Lee followed Black Panther with the 1967 introduction of newspaper editor Robbie Robertson, second only to editor-in-chief J. Jonah Jameson at Spider-Man's *The Daily Bugle*. Identified only as "Robbie" through dialogue, the character enters giving orders to a white reporter after Jameson has been abducted: "I'll hold down his desk, while you see what you can uncover! Let's go, boy! There's no time to waste!" (Lee and Romita 1967). Depending on production time, the August cover-dated inclusion of a graying black man in a position of authority directly follows President Johnson's June nomination of Thurgood Marshall to the Supreme Court. Marvel integrated the Avengers when Black Panther joined the team in an issue on sale while Martin Luther King, Jr. was murdered in Memphis and President Johnson signed the third and final Civil Rights Act in April 1968. Lee editorialized in his December 1968 "Stan's Soapbox" in *Fantastic Four* #81: "Bigotry and racism are among the deadliest social ills plaguing the world today ... if man is ever to be worthy of his destiny, then we must fill our hearts with tolerance" (Lee 1968). DC, in contrast, prevented creators from introducing black characters. Future Marvel editor-in-chief Jim Shooter, who wrote for *Superboy and the Legion of Super-Heroes* from 1966–70, recalled:

I wanted Ferro Lad to be the first black Legionnaire, and Mort [Weisinger] said, "No, we'll lose our distribution in the South." … those were the rules back in those days. That's another reason why Marvel appealed to me, because they were daring to do things that DC wouldn't do. (Cadigan 2003: 53)

Weisinger, who had edited Superman since the 1940s and was vice president of public relations, left in 1970.

Reflecting the legislative gains of the civil rights movement, superhero comics featured black characters at an increasing rate. Though more African-American artists entered the industry, black superheroes were still written exclusively by white authors who relied on shifting stereotypes and expressed ambivalent attitudes about black political power. Acknowledging both the "good intentions" and "cultural ignorance" of white creators, William L. Svitavsky summarizes black superheroes of the era as combining "a veneer of streetwise attitude with a core of values comfortable for middle-class white readers" (2013: 153, 156). In 1969, Stan Lee and artist Gene Colan introduced Sam Wilson as the Falcon in a three-issue *Captain America* story arc, with a fourth-issue epilogue leaving the new hero to fight crime in Harlem. Because Black Panther is African, the Falcon is considered comics' first African-American superhero. He returned for a single episode six months later, in which he tells Captain America: "Your skin may be a different color … But there's no man alive I'm prouder to call … Brother!" (Lee et al. 1970). Like Kirby and Lee's Black Panther, the Falcon places interracial unity above black identity. Colan's chest-exposing costume design echoed the open-shirt of the 1960s' Lothar and established a norm for black superheroes for the coming decade. Though white superheroes of the 1970s also sometimes wear shirts with v-shaped openings (Sub-Mariner, Killraven), the pattern is disproportionately common for black men, who, writes Conseula Francis, "in the popular American imagination, are often read as hypersexual" (2015: 141). The costume design reflected that hypersexuality visually while writers contained it narratively by portraying black men as physically powerful but willingly subservient.

For the Falcon's one-issue return to *Captain America*, Stan Lee had pitted him against a black gang whom the Falcon denounces:

"They're like a black version of the Klan! All they preach is hate Whitey! They can set our progress back a hundred years!" (Lee et al. 1970). After another six months, Sam Wilson becomes a permanent character. The January 1971 *Captain America* cover includes the bottom subtitle "Co-Starring: the Falcon!" and for the following issue the title was redesigned *Captain American and the Falcon*, which it remained until 1978. Captain America's previous sidekicks included Bucky from 1941 to 1947 and Golden Girl, from 1948 to 1949, making the Falcon his longest serving partner. Andre Carrington argues:

> Narratives of the black and/or female superhero as a team player promulgate a reductive politics of representation that puts minoritized characters on the page in order to support white male characters' claims to iconic status. Black and female characters frequently appear to buttress the notion that the white male superhero is the sine qua non of the idealism that white Americans spread throughout the globe. (2015: 155)

While Sam Wilson significantly increased the representation of African-Americans in comics, in terms of social power, the character also positioned a black man as the equivalent of a white adolescent male and a white adult female.

Second Code era, 1971–89

The Comics Code Authority's revised guidelines went into effect in February 1971, and one of the first new series affected was Jack Kirby's *New Gods*. Issue #3, cover-dated July, introduced Black Racer, an incarnation of death in the form of a paralyzed Vietnam vet, months after the Supreme Court upheld bussing as a means of integrating public schools. July also saw the release of *Shaft*, widely popularizing the "Blaxploitation" film genre and heavily influencing the portrayal of defiant African-Americans in subsequent superhero comics.

Between the Falcon's premiere and his 1970 return, Dennis O'Neil and Neal Adams had started their seminal run on DC's *Green Lantern Co-Starring Green Arrow*, beginning with an

indictment of Green Lantern by an unnamed African-American
man:

> I been readin' about you ... how you work for the blue skins...
> and how on a planet someplace you helped out the orange skins
> ... and you done considerable for the purple skins! Only there's
> skins you never bothered with—! ... the black skins! I want to
> know ... how come?! (O'Neil and Adams 2012: 13)

Now a year into their run, O'Neil and Adams replaced the previous
Green Lantern substitute with John Stewart, an architect who
lives in an "urban ghetto" and challenges white authority figures,
including police officers, a Senator, and the Hal Jordan Green
Lantern: "Listen, whitey, that windbag wants to be President!
He's a racist ... and he figures on climbing to the White House on
the backs of my people!" (276, 280). Two months later, Marvel
premiered the first superhero comic book series featuring an African-
American character, *Luke Cage, Hero for Hire*. Archie Goodwin
and George Tuska's Cage gains his superpowers by volunteering
for human experimentation while wrongly imprisoned, calls people
"baby" and "jive-mouth," and utters "a cry of raging defiance"
(Thomas et al. 2011: 192, 208). Tuska's splash page features Cage
posed in his open shirt, giving an eye-clenching, open-mouthed
roar, his apparent response to the "Harlem" backdrop surrounding
him (190). The creative team also included inker Billy Graham, one
of the first African-American artists employed at Marvel.

Where Adilifu Nama reads Stan Lee's earlier Falcon dialogue as
signaling "a rejection of the type of race-based political brotherhood
(and sisterhood) advocated by Black Power nationalism" (2011:
72), Marvel's new editor-in-chief Roy Thomas retitled the series
Luke Cage, Power Man the following year, echoing the increas-
ingly popular movement. Beginning in 1974, Ron Wilson, another
recently hired African-American artist, would provide cover and
pencils, and when the series changed to *Power Man and Iron Fist*
in 1978, it would be the second Marvel title in which a white
character received second billing after an African-American. In
1972 Marvel also premiered "Reno Jones and Kid Cassidy" in the
western *Gunhawks*. Reno is the third African-American Marvel
character named "Jones," and the seventh and final issue, retitled
Reno Jones, Gunhawk, featured him alone. Also due to dropping

sales, DC cancelled O'Neil and Adams' *Green Lantern Co-Starring Green Arrow* in 1972, two issues after introducing John Stewart. Samuel R. Delany, possibly the first black writer in superhero comics, scripted two issues of *Wonder Woman* in 1972. He left before completing his intended arc because of DC's decision to restore Wonder Woman's original costume and powers. Delany was replaced by Robert Kanigher, who with Don Heck co-created a dark-skinned Wonder Woman named Nubia for three issues in 1973, ending the industry's forty-year exclusion of black women from superhero comics. Jack Kirby also introduced a young black sidekick, Shilo Norman, in *Mister Miracle* #12—a title cancelled seven issues later. The same year, Marvel elevated Black Panther to the cover-feature of *Jungle Action*, which had previously starred Tarzan knock-off Tharn the Magnificient. *Luke Cage* alum Graham penciled twelve issues of writer Don McGregor's nineteen-issue run, which included the story arc, "Panther vs. the Klan." A month after Black Panther's *Jungle Action* debut, Marv Wolfman and Gene Colan's Blade the Vampire-Slayer premiered in *The Tomb of Dracula*, with likely the first comic book cover to depict a black man protecting a white woman from a white man. Colan again draws a black man with an open shirt, and Marv Wolfman scripts Blade with standard Blaxploitation slang, "dig?" and "dude" and telling a disrespectful police officer that he did not understand "Pig English" (Wolfman et al. 2004: 6). At the end of the same summer, Len Wein and Gene Colan's Brother Voodoo began a five-issue *Strange Tales* run. The Haitian wizard is a "noted psychologist" who dismisses voodoo as "superstitious bunk" before assuming his dead brother's role as the island's "Houngan, voodoo priest" in a costume that reproduces Colan's chest-revealing Falcon design (Thomas et al. 2012: 49, 52). Joining the small but expanding group of African-Americans in mainstream comics, Wayne Howard, who worked mostly in horror and had received his first credit at DC in 1969, inked the October issue of *Marvel Team-Up* in 1973. Keith Pollard and Arvell Jones received their first Marvel credits in 1974. Jones would move to DC in 1977, and Pollard would pencil and ink the final issue of Black Panther's *Jungle Action* in 1976, later taking over as penciller for *Amazing Spider-Man* in 1978.

Jeffrey A. Brown acknowledges DC's and Marvel's attempts "to create legitimate black superhero characters," but attributes their failure "to achieve any long-lasting success" to those characters

being "too closely identified with the limited stereotype commonly found in the Blaxploitation films of the era," including *Super Fly* in 1972, *Coffy* in 1973, and *Mandingo* in 1975 (2001: 4). Marvel's Blaxploitation phase peaked in 1975, with Steve Englehart's retconning of the Falcon's past as a Harlem criminal named "Snap." Marvel introduced its first two black female superheroes that year. Influenced by actress Pam Grier's performances in *Coffy*, *Foxy Brown*, and *Sheba Baby*, Tony Isabella and Arvell Jones created Misty Knight for an episode of *Marvel Premier Featuring Iron Fist*. Her bionic arm later established her as the first African-American cyborg—a motif for black superheroes expanded in later decades. Len Wein and Dave Cockrum's Storm had debuted in the new, multi-ethnic X-Men team a month earlier. Cockrum had intended the character to be called "Black Cat," before merging her with another of his unused ideas for a white male superhero "Typhoon." Storm is worshipped as a rain goddess by a tribe in Kenya in her first appearance. The year 1975 also saw Tony Isabella and George Tuska's Black Goliath debut in *Luke Cage, Power Man*. The superhero's alter ego, Bill Foster, was originally created by Lee and Don Heck in 1966 as an assistant to Henry Pym, a.k.a. Goliath, in *The Avengers*. Marvel launched a *Black Goliath* solo title the following year, which, like Brother Voodoo, lasted only five issues. Rather than an open shirt, Tuska's costume design included a bare midriff, another variation on the skin-exposing costumes of female superheroes. Black Goliath, like John Stewart Green Lantern earlier, casts a black superhero as an imitative replacement of a white character and so, argues Svitavsky, "falls too easily into the cliché of the competent ethnic supporting character, such as Tarzan's ally Mugambi or the Lone Ranger's Tonto, who ultimately reinforces the white hero's pre-eminence" (2013: 158). At DC, Dennis O'Neil's Bronze Tiger shared the first cover though not title of *Richard Dragon, Kung-Fu Fighter*, and a second, unrelated Powerman appeared in 1975 too. Commissioned by a Nigerian ad agency and designed by British artist Dave Gibbons of later *Watchmen* fame, the black-and-white *Powerman* was distributed in Nigeria for two years. On the color covers, "Africa's Hero with Super Powers!" sports a fuchsia unitard and lion-print briefs.

Murray Boltinoff, who had been editing *Superboy* since the late 1960s, prevented artist Mike Grell from introducing a black character in 1975. Grell recalls Boltinoff's explanation: "You can't

do that because we've never had a black person in the *Legion of Super-Heroes*, and now you're going to have one in there who's not perfect. We can't do that" (Cardigan 2003: 89). Boltinoff's concern that a black superhero must be depicted as "perfect" reflects the overwhelmingly white-dominated industry's anxiety over representing African-Americans, especially when the general lack of representation places a greater burden on each individual character. Grell still drew the character, Soljer scripted by Jim Shooter, as "a black man who had been colored pink" (89). Soljer's pink skin thematically reverses the norm of white authors creating black characters who are what Kenneth Ghee terms "White heroes in Black Face" (2013: 232), as signified most obviously with the use of "Black" as a modifier, indicating "White" as the unstated norm.

The DC policy barring black superheroes changed in 1976 when Grell and Cary Bates created Tyroc, who defends his all-black island against the Legion of Super-Heroes before joining the team. "When it comes to race, we're color-blind!" explains the white-skinned Superboy, who is then echoed by three of his multi-colored teammates: "Blue skin, yellow skin, green skin ... we're brothers and sisters ... united in the name of justice everywhere!" (qtd in Singer 2002: 111). Grell so disliked Bates and Boltinoff's handling of race that, now given the opportunity to draw a black superhero as he had previously advocated, he intentionally undermined the character by designing what he considered an unappealing costume for Tyroc—which included the same open-shirt design as worn by the Falcon, Brother Voodoo, Luke Cage, and soon Black Lightning (Cardigan 2003: 89). DC's change regarding black superheroes coincides with Jeanette Kahn succeeding Carmine Infantino as publisher in January 1976. The Tyroc episode of *Superboy Starring the Legion of Super-Heroes* is cover-dated April, and a second black superhero was added to a pre-existing team that fall. After the series had been cancelled in 1973, *Teen Titans* resumed with "The Newest Teen Super-Hero of All ... The Guardian!" on its cover (#44). Mal Duncan, an amateur boxer from "Hell's Corner" introduced in 1970, assumes the superhero identity of the pre-Code character Guardian—and then the magic trumpet-wielding Hornblower in the subsequent issue, which also introduced his girlfriend Karen Beecher, who would become Bumblebee and join the team three issues later. Both remained on the team until the next cancellation in 1978. Paul Kupperberg and

Joe Staton's Tempest joined Doom Patrol in 1977, becoming the third black superhero to join one of DC's pre-existing teams.

Marvel introduced its next black superhero, Thunderbolt, in 1977 for three issues of *Luke Cage, Power Man*, but killed the character after his next appearance in 1980. Lee Alias's costume design is the first since Black Panther to not feature an exposed chest—though, also like Black Panther, the costume also completely disguises the hero's racial identity, repeating the second most common pattern for black superheroes. Thunderbolt, like DC's Guardian/Hornblower, also reprised a black character first introduced in 1970, this time in *Daredevil* #69. The practice of reusing and expanding previous secondary characters is common—though here it also emphasizes the dearth of such black characters since both sets of authors went back seven years to find ones to transform into new superheroes.

As Jack Kirby returned to Marvel and a new *Black Panther* series, DC premiered its first African-American superhero title in 1977, Tony Isabella and Trevor Von Eeden's *Black Lightning*, a late example of Blaxploitation influence. The hero's costume includes a mask attached to an afro wig to disguise his identity as a school teacher who wears his hair conservatively short. "The Afro-mask," writes Blair Davis, "also serves to make an ethnic minority character 'more ethnic' by giving him a hairstyle that was viewed not only as a fashion statement but also as a form of political expression in the 1970s" (2015: 203). Isabella was originally hired to script a very different black character:

> The Black Bomber was a white bigot who, in times of stress, turned into a black super-hero. This was the result of chemical camouflage experiments he'd taken part in as a soldier in Vietnam. The object of these experiments was to allow our [white] troops to blend into the jungle ... I convinced them to eat the two scripts and let me start over. To paraphrase my arguments ... "Do you REALLY want DC's first black super-hero to be a white bigot?" (Isabella 2000)

Von Eeden, the first African-American artist employed at DC, recalled, in a 2016 interview, how his white colleagues "chose to play a very mean-spirited and ill-advised 'prank' on me" involving a collapsing chair. He never "heard of any other such pranks

being played on anyone else at DC Comics," and in addition to "being ALWAYS treated as a 'black' artist (as if I represented an entire nation of fundamentally alien people, all by my lonesome)," he soon found "it was very hard to even want to do one's best for people who seemed to not only not really appreciate it—but had actually tried to punish and humiliate me, in return." Von Eeden later left during "DC's eventual downsizing of its entire staff (freelancers like me being the first to go)," concluding that the "very same people who'd given me the opportunity to live my dreams, had directly caused that dream to become a living nightmare" (Gill 2016).

DC cancelled *Black Lightning* after its October 1978 issue, and Marvel cancelled *Black Panther* after its May 1979 issue. Gerry Conway also scripted Black Lightning in a 1979 *Justice League of America* issue in which Superman asks him to join the team. Len Wein had desegregated the team in 1974 when he included the John Stewart Green Lantern in a single episode, but Conway's Black Lightning declines. Nama reads the issue as "a clear critique of black tokenism" (2011: 26). Marvel, however, expressed no qualms when Falcon joined two issues of *The Defenders* in 1978 and eleven issues of *The Avengers* beginning in 1979. DC had intended to debut their first African-American female superhero in her own series in 1978, but *Vixen* and a range of other planned and low-selling titles were cancelled due to the company's financial troubles during a industry-wide slump. Gerry Conway and Bob Oksner's Vixen debuted in *Action Comics* in 1981 instead. The character echoes Black Panther's African-based animalistic powers, but with a sexualized name, and like Cockrum's Storm, cover artists Ross Andru and Dick Giordano draw her hair in flowing waves for her debut image. DC also briefly introduced E. Nelson Bridwell and Ramona Fradon's Doctor Mist in *Super Friends* in 1978, adding the character to main continuity in 1981. Like Black Panther, Doctor Mist hails from a fictional African nation.

Reviewing superhero comics in 1982, Hal Blythe and Charlie Sweet formulated "a descriptive framework of the general patterns found in the subgenre," concluding that a superhero is "an adult white male" because "Black heroes (Black Panther, Black Goliath, Black Lightning, the Falcon) don't seem to appeal to a predominantly white readership; they are not role models" (1983: 18–56). Roy Thomas, Marvel's editor in chief from 1972–4, observed the

phenomenon with frustration: "It's kind of a shame. You could get blacks to buy comics about whites, but it was hard to get whites to buy comics in which the main character was black" (Howe 2012: 131). The early 1980s, however, is a transitional moment in black representation. When DC re-introduced the Teen Titans in a 1980 *DC Comics Presents* backstory, Guardian/Hornblower was absent, but the team now included Marv Wolfman and George Pérez's Cyborg, who would also be featured in the following month's *The New Teen Titans* first issue. Pérez's black-and-white costume design literalized the duality of African-American identity by juxtaposing the character's exposed skin with his white machinery—arguably an extension of Lee and Kirby's Africa/technology binary established in Black Panther's 1966 debut. Pérez's costume design, at least the eighth iteration of a black male superhero with a chest-exposing top, pushed the motif to its final extreme. The effect, writes Davis, reminds "the reader that he is more than just a mere robot," while "reinforcing the double consciousness that he embodies" as a black character (2015: 209).

Cyborg also deepened the trend away from the use of "Black" in superhero names and so de-emphasized race as a black characters' most defining trait. *Uncanny X-Men* writer Chris Claremont established Storm as team leader in 1980, a role the character would play extensively and through multiple authors and titles for the following four decades. Marvel followed with two new superheroes in 1982: Bill Mantlo and Ed Hannigan's Cloak of the Cloak and Dagger duo premiered in *Peter Parker, the Spectacular Spider-Man*, and Roger Stern and John Romita, Jr.'s new female Captain Marvel, Monica Rambeau, in *Amazing Spider-Man Annual*. A *Cloak and Dagger* mini-series followed in 1983, and Captain Marvel would appear regularly in *The Avengers* until 1988, including as team leader. The Falcon also received a mini-series in 1983, and Jim Rhodes, as scripted by Dennis O'Neil, assumed the lead role in *Iron Man* and in the mini-series *West Coast Avengers* until 1985. Beginning in 1984, John Stewart similarly replaced Hal Jordan in *Green Lantern*, until the retitled *Green Lantern Corps* was cancelled in 1988, the year Black Panther returned in a mini-series. In 1986, John Ostrander, Len Wein, and John Byrne introduced Amanda Waller in *Legends*; though not a superhero, and often villainous, Waller would become one of the most prominent black female characters in the superhero genre.

The 1980s also marked an increase in African-American creators working in superhero comics. Mark Bright entered in the late 1970s, soon followed by Denys Cowan, Larry Stroman, and Paris Cullins. Wayne Howard left the industry in 1982, and Billy Graham died in 1985, but Ron Wilson continued to draw Marvel titles through the 1980s. Bright teamed with writer Jim Owsley on the 1983 *Falcon* four-issue mini-series and the final ten issues of *Power Man and Iron First* in 1986. Arvell Jones became the primary artist for DC's *All-Star Squadron* in 1984, and Keith Pollard's titles included *Green Lantern* and *Vigilante*. Chuck Patton was lead artist on *Justice League of America* from 1983 to 1985, Milton Knight drew the retro-style *Mighty Mouse* for Marvel in 1987, and Malcolm Jones inked DC's *Young All-Stars* into the late 1980s. Cowan drew the 1988 *Black Panther* four-issue mini-series, while also teaming with Dennis O'Neil on the 1987–90 *The Question*. Joe Phillips started his career on NOW Comics' *Speed Racer* in 1987, and Brian Stelfreeze would be featured as the primary cover artist for DC's *Shadow of the Bat* in the 1990s.

Third Code era, 1989–2000

As black writers grew more prominent, black representation grew more complex. In 1989, Bright and Dwayne McDuffie revived Monica Rambeau for the single issue *Captain Marvel*. Bright replaced Rambeau's previously vague afro with distinctly rendered cornrows, a first for a black superhero. Beginning in 1990, Cowan drew McDuffie's *Deathlok*, a reboot of the early 1970s' cyborg super-soldier. Matt Wayne, eulogizing McDuffie after an award for diversity in comics was named after him, called McDuffie "the first African-American to create a Marvel comic," one who "challenged our worldview, but so subtly that we could ignore it and watch the explosions, if that's all we wanted" (Wayne 2015). McDuffie said himself of *Deathlok*: "I also managed to sneak in something of myself, Humanistic values somewhat at odds with the conceit of vigilante fiction" (2002: 29). In his March 1991 script draft for issue #5, he explained to Cowan: "I'm trying to implicitly connect the cyborgs to mutants and oppressed minorities" (2002: 49). At the story's conclusion, Deathlok holds a copy of W. E. B. DuBois's

The Souls of Black Folk, which he quotes at length (56). McDuffie's collected run is titled *The Souls of Cyber-Folk*.

In 1993, McDuffie and Cowan created Milestone Media with Michael Davis and Derek T. Dingle. Jim Owsley was originally involved, but left before the founding. Unlike other independent comics companies, minority-owned and otherwise, Milestone partnered with DC in order to secure wide distribution while also maintaining creative and legal control of its properties. Both the Milestone and the DC logos appeared on all covers. Milestone launched four titles in its first month: *Hardware*, *Blood Syndicate*, *Icon*, and *Static*, all written or co-written by McDuffie, with three more titles to follow in 1994, plus the DC-Milestone multi-title crossover and one-shot *Worlds Collide* the same year.

Like Deathlok, Icon's Robin-esque sidekick Rocket, Raquel Ervin, reads from her copy of DuBois in the *Icon* premiere. McDuffie also alludes to Booker T. Washington and Toni Morrison, but the four-page wordless opening is most striking for its revision of the Superman origin story. Instead of the early twentieth-century mid-West, Icon's spaceship crashes near a 1839 cotton field where an enslaved black woman, not an elderly pair of white farmers, adopts the alien infant. August Freeman, now a lawyer and a "big rich, conservative" (McDuffie and Bright 2009: 167), hides his abilities until challenged by his future sidekick: "I told him how just seeing him opened up a whole new world of possibilities for me … how I thought he could help lots of people if only they could see what he can do" (23). Her challenge also encapsulates Milestone's mission. Echoing O'Neil's 1970 Green Arrow and Green Lantern, Rocket teaches Icon that submission to authority is misguided when authorities abuse their power—as when white police officers attack them without provocation. She also brokers a truce with a gang of mutated criminals, the Blood Syndicate, challenging them to do more than fight turf wars (143). With a supporting cast that includes Raquel's grandmother and a female African-American mayor, *Icon* contain a range and density of black characters previously unseen in superhero comics.

The presence of black superheroes continued to expand across the comics industry in the 1990s. Former sidekick Shilo Norman assumed his predecessor's identity in *Miracle Mister*—though in a costume that entirely obscured his racial identity, as had the Jim Rhodes Iron Man five years earlier. Former characters continued:

Don McGregor wrote another *Black Panther* mini-series with artist Dwayne Turner in 1991, John Stewart starred in *Green Lantern: Mosaic* and Luke Cage in *Cage* in 1992, Darryl Banks penciled a new *Green Lantern* series beginning in 1994, and Tony Isabella renewed *Black Lightning* in 1995, the same year newcomer Doug Braithwaite began penciling at Marvel. New characters debuted too: Whilce Portacio and Jim Lee introduced Bishop to *The Uncanny X-Men* in 1991, Louise Simonson and Jon Bogdanove's Steel first appeared in *The Adventures of Superman* in 1993, and Marvel's *Night Thrasher* series began in 1993. The most influential new character, however, came from Image Comics, a creator-owned company that formed a year before Milestone. Todd McFarlane's 1992 *Spawn* altered the unchallenged domination of Marvel and DC in superhero comics, with reports of the first issue selling 1.7 million copies. Where Black Panther's skin-covering costume might have been an avoidance of race in 1966, Spawn's equally skin-covering costume might suggest the altered significance of race as a comparatively incidental characteristic a quarter of a century later. Svitavsky, however, argues otherwise: "This concealment is yet another way of soft-pedalling black superheroes to resistant readers," noting the costume pattern in nine black characters (2013: 159).

Less commercially successful, Ania, a consortium of Dark Zulu Lies Comics, Africa Rising, UP Comics, and Afro Centric Comic Books, released a number of short-lived titles in the early 1990s (Poole), and Dawud Anyabwile and Guy A. Sims' *Brotherman Comics* debuted in 1990 and ran for five years. Pioneering artists Jones and Pollard both left comics in 1995 after co-penciling *Daredevil* #343. Ania folded shortly after its formation, and Milestone began cancelling titles in 1995, before closing its comics branch in 1997. McDuffie moved to TV animation, writing for *Teen Titans*, *Justice League*, and *Justice League Unlimited*, and beginning in 2000 his Milestone character Static starred for four seasons on the WB's morning cartoon *Static Shock*. McDuffie returned to DC for a *Milestone Forever* mini-series in 2008, and after 2008's *Final Crisis*, the Milestone universe was merged into DC's main continuity, with Static joining the Teen Titans, while Icon, Rocket, and their team members appeared in a *Justice League of America* story arc. After McDuffie's death in 2011, Milestone Media and DC continued their partnership with a *Static Shock*

reboot as part of the initial lineup of DC's company-wide New 52 reboot in 2011 and with the Milestone universe entering DC's multiverse as Earth-M in 2015.

Other superhero comics by black creators continued through the 1990s. Jimmie Robinson founded his Jet Black Graphiks imprint in 1994, soon expanding into Image Comics and later Marvel. Kerry James Marshall presented *Rhythm Mastr* as an art installation in Pittsburgh's Carnegie Museum of Art and weekly in the *Pittsburgh Post-Gazette* beginning November 1999: "Marshall's comics propose an alternative to mainstream superhero culture by introducing protagonists taken from African archetypes and African-American cultural life" and spirit powers "which once guided enslaved Africans to insurrection and freedom" (Carnegie). Jim Owsley, having changed his name to Christopher Priest, developed the new title character Xero for DC with artist ChrisCross in 1997. *Xero* continued the black cyborg motif of the 1970s' Misty Knight, the 1980s' Cyborg, and the 1990s' Deathlok, now with a black man "reconstructed of chemically-dependent bio-mechanical implants" (Priest and ChrisCross 1997: 21), earning Marc Singer's praise for "its richness and complexity, free of the tokenism and erasure which have dominated the genre" (2002: 116). Though introduced and drawn as "a 6'6" blond man" (Priest and ChrisCross 1997: 7), Xero removes his light-skinned face and wavy hair to reveal dark skin and a black goatee near the conclusion of the first issue (19). Priest wrote all twelve issues, before beginning yet another *Black Panther* series in 1998. This iteration proved to be one of the most commercially successful, with Priest writing the final 62nd issue in 2003.

Fourth Code and Post-Code eras, 2001 to present

Aware of the dearth of black superheroes in the first several decades of the genre, twenty-first-century comics have literally rewritten superhero history. The 2004 miniseries *Truth: Red, White & Black* retconned a black Captain America into a super-soldier variation of the infamous Tuskegee Syphilis Study, followed by the character's grandson joining *Young Avengers* in 2005. In 2008, Blue Marvel was retconned as 1962 superhero forced to retire when the public

learned he was black. For the revisionist *Young Allies Comics* in 2009, Whitewash Jones was renamed Washington Carver Jones, with an explanation that the World War II comics produced by the Propaganda Office "exaggerated the story" and that the "art was all caricature," with Jones made to "look like something out of a minstrel show!" (Stern and Rivera 2009). Cyborg also received a miniseries in 2008, was retconned as a founding member of the rebooted *Justice League* in 2011, and starred in an on-going *Cyborg* title in 2015.

Black representation continued and in some cases has increased in other twenty-first-century titles. DC recreated its 1930s' Crimson Avenger as a black woman in 2000. Alex Simmons and Dwayne Turner premiered Orpheus in DC's *Batman: Orpheus Rising* in 2001. Marvel's 2002 *The Ultimates* introduced an alternate Earth Nick Fury based on Samuel L. Jackson, who would play the film version of the character in 2008. In 2003, the daughters of Black Lightning became the duo Thunder and Lightning, and a black teenager assumed the title-role of DC's *Firestorm* in 2004. Reginald Hudlin wrote a new *Black Panther* series beginning in 2005, giving the title to the sister of the original character in 2009. Luke Cage joined as a permanent member of *The New Avengers* in 2005, before becoming team leader in 2010 and finally leaving the team after ninety-five issues in 2012. Coordinating with the animated TV series *Young Justice*, DC introduced a new black Aqualad in 2010 and added an African *Batman Incorporated* character David Zavimbe in 2011, giving him his own *Batwing* series the same year, before passing the Batwing identity to African-American veteran Luke Fox in 2013. Beginning in 2011 *Ultimate Spider-Man* featured Miles Morales, a mixed black and Hispanic teen, as title character. Marvel's Storm was featured in 2005 and 2014 miniseries, and in 2014 Marvel introduced its fifth *Deathlok* series, with a new black character in the title role. Continuing the John Stewart Green Lantern and Jim Rhodes Iron Man tradition, the final December 2014 issue of *Captain America* introduced the Falcon as the new Captain America, launching *All-New Captain America* the following month, followed by the ongoing series *Sam Wilson: Captain America* in 2015. As a result, four of the seven members of the 2016 *All-New All-Different Avengers* are characters of color: Sam Wilson Captain America, Miles Morales Spider-Man, Sam Alexander Nova, and Kamala Khan Ms. Marvel.

The five-member 2016 *Ultimates* include one white woman, Carol Danvers Captain Marvel, and four characters of color: Monica Rambeau, Black Panther, Blue Marvel, and Miss America Chavez. Three new black lead characters also premiered in 2015: Lunella Lafayette of *Moon Girl and Devil Dinosaur*, the first black Robin, Duke Thomas in a team of Robins in *We Are Robin,* and a new black female Iron Man, Riri Williams Ironheart, who assumed the title role with *Invincible Iron Man* #1 (January 2017).

Fifty years after Kirby and Lee's Black Panther premiered in *Fantastic Four* and coinciding with the introduction of the film version of the character, renowned journalist Ta-Nahesi Coates and Brian Stelfreeze's *Black Panther* debuted in spring 2016, selling roughly 300,000 copies, one of the year's best-selling superhero comics—a reversal of Roy Thomas's early 1970s' lament that it is hard to get whites to buy comics in which the main character is black. The change in representation, writes Carolyn Cocca, reflects "how much the fan base has changed just over the last several years," one that includes readers who, "due to changing population demographics and gains of civil rights movements, are not only more diverse but also more vocal with their desires and their dollars"; "The superhero genre," she concludes, "has come far in a number of ways, but has far to go" (2016: 2–3). Laura Hudson draws a similar conclusion in a 2015 *Wired* editorial, acknowledging that "the faces on the pages [of] popular comic books have steadily grown more diverse," while also critiquing a "demographic imbalance" in which "the editors and creators of mainstream comics remain overwhelmingly Caucasian" (Hudson 2015). According to Tim Hanley, roughly one of every five comics employees was non-white in 2014 (Hickey 2014). As editors Sheena C. Howard and Ronald L. Jackson II write in their introduction to *Black Comics*, "comics are still only peppered with representations of the multifaceted Black experience by Black artists" (2013: 4).

The majority of black superheroes are also male. Even setting aside pre-1966 sidekicks and supporting characters, the black superheroes named in this chapter include thirty-eight men and thirteen women, roughly a three-to-one ratio. Perhaps more significantly, Storm is arguably the only black female superhero with a significant pop cultural presence outside of comics. The next chapter explores this gender divide and its cultural significances further.

II

The Gendered Superhero

More than any other hero type, superheroes emphasize physicality. Their bodies are definingly extraordinary, and that emphasis highlights their other physical qualities, most overtly gender. As a result, Jeffery A. Brown describes the "conventional superhero" as "an adolescent fantasy of hegemonic masculinity" (2013: 135), and Derek Lackaff and Michael Sales similarly call superhero comics "the ultimate male fantasy," one that gives "the male id an unbridled place to be free and play like a child" (2013: 67). These fantasies are predicated on gender binaries that define masculinity in opposition to equally artificial definitions of femininity. Because the traditional superhero is, among other things, male, heterosexual, and cisgender, any change in visible sex characteristics, sex identity, or sexuality contradicts the dichotomies of the gender formula encoded in the Golden Age character type—even as the evolving genre has and continues to challenge those norms.

Super binaries

Because of the visual nature of the medium, superheroes are foremost their bodies, and their costumes are an extension of those bodies. "The Superhero," writes John Jennings, "is a symbol of power that is reified as the hyper-physical body," one that is "perfect" and whose "skintight costume seems directly connected to the display, performance, and execution" of its power (2013: 59, 60). Joe Shuster, an aspiring body-builder in high school, partly

modeled Superman's costume on strongmen and acrobat leotards, the thinnest and so most body-revealing of real-world costumes— second only to nudity. Except for a literal fig leaf or padlock, the early twentieth-century superhero-influencing celebrities Eugen Sandow and Harry Houdini were photographed nude to display their physiques. When attempting "to delimit the elements of the superhero wardrobe," Michael Chabon accordingly reduces it to "nothing," a "pseudoskin" that "takes its deepest meaning and serves its primary function in the depiction of the naked human form, unfettered, perfect, and free" (2008: 67–8). Superhero legs, which may be indicated as naked or enclosed in fabric by a colorist, demonstrate that flesh and costume are often indistinguishable through penciling and inking alone. Superhero shirts often differ only slightly, represented by additional lines at the neck and wrists. Superman, as he appears in the only surviving image of Joe Shuster's original 1933 drawings, is bare-chested, and Shuster's Dr. Occult in the 1936 *More Fun* #16 would appear to be a drawing of Superman if not for his bare legs and chest—even though the occult detective's exposed and idealized physique is unrelated to his occult powers.

Comics artists rarely alter this norm for male superheroes. Steve Ditko's 1963 Doctor Strange is a notable exception. Like Dr. Occult, the sorcerer's powers do not require a body or costume that emphasize physicality, and Ditko draws Doctor Strange in puffy sleeves and black leggings that emphasize the thinness of his legs and obscure musculature. After Ditko left Marvel in 1966, subsequent artists drew the character with a more muscular physique. Ditko's 1962–6 Spider-Man is also a partial variation on the norm, especially in contrast to Jack Kirby's original, broad-shouldered character design, but even Ditko's relatively thin-limbed drawings emphasize the character's musculature in a pseudoskin costume. Sara Pichelli's 2011 *Ultimate Spider-Man*, however, wears a similar costume to opposite effect, emphasizing the relatively undeveloped thinness of his adolescent body. In contrast to most other superheroes, Spider-Man does not have a "perfect" physique.

Chabon does not examine his use of the adjective "perfect," but Jennings acknowledges that a "hyper-physical body" embodies a variety of "cultural and social values" and "belief structures" (2008: 59–60). Although narratively superheroes are presumed to be intelligent, the superhero body emphasizes physical over mental ability. James Bucky Carter observes, for example, that "the muscular

American body" of Joe Simon and Jack Kirby's Fighting American is "stressed as an asset over the prowess of the American mind" and that "the American seat of power resides within the vigorous body the creators so obviously favor" (2004: 364). The Fighting American, a self-conscious 1950s' recreation of the pioneering creators' 1940s' Captain America, is representative of the hyper-masculine body and the plot structure of physical domination that the imagery encourages across the genre. That formula reflects and reinforces a cultural ideology of "*machismo*," which psychologists Donald Mosher and Silvan Tomkins define as exalting "male dominance by assuming masculinity, virility, and physicality to be the ideal essence of real men who are adversarial warriors competing for scarce resources (including women as chattel) in a dangerous world" (1988: 64). As fantastical embodiments of traditionally defined masculinity, male superheroes express two of the three traits of the "macho personality constellation": "violence as manly" and "danger as exciting" (61). The third, "entitlement to casual sex," is outside of the initially children-focused superhero market—though later comics authors have explored the character type for rapist implications. The Comedian of Alan Moore and Dave Gibbon's 1986 *Watchmen* is the best-known example, and Garth Ennis and Darick Robertson's 2007 *The Boys* expands the critique to the genre as a whole, presenting all male superheroes, even a version of Superman, as endemic rapists.

Gender ideology also shapes the cultural meaning of the physique. For male superheroes, physical attractiveness and physical effectiveness are merged. As the two qualities are summarized by psychologists Jacqueline N. Stanford and Marita P. McCabe, male superheroes combine "the level to which one's physical appearance is viewed as pleasing to the eye" and "the degree to which an individual's body and body parts allow activities engaged in to be successful" (2002: 676). A male superhero's "hyper-physical" body then may be termed perfect in the sense that it expresses both hyper-effectiveness and hyper-attractiveness, embodying the belief that optimal effectiveness and attractiveness should be combined and that a male body is attractive to the extent that it is effective—a concept that reached its apex in the cartoonishly exaggerated male muscularity of 1990s' superhero art.

As discussed in the previous chapter, the interplay of race complicates superhero masculinity. Many black male

superheroes—beginning with Mandrake the Magician's sidekick
Lothar in the late 1960s, expanding to the Falcon, Luke Cage,
Brother Voodoo, Tyroc, Black Lightning, and Black Goliath in the
1970s, and concluding with Cyborg in 1980—featured costumes
with v-shaped openings similar to the cleavage-exposing necklines
of female superheroes. Luke Cage's costume also echoed Wonder
Woman's bracelets and tiara, "further aligning him with histori-
cally feminine costume patterns" (Davis 2015: 198). It is as if white
creators, in order to balance the cultural impression of black men
as "already hyperembodied" (Wanzo 2015: 317) and so possessing
"excessive masculinity" that is "transgressive rather than heroic"
(Francis 2015: 141), emasculate black male superheroes in order
to preserve the perceived level of masculinity represented in white
male superheroes as the cultural ideal.

Female superheroes disturb gender dichotomies to an even
greater degree. If, as Mosher and Tomkins write, "affects are
divided into antagonistic contrasts of 'superior and masculine'
or 'inferior and feminine'" (1988: 64), how can a character be
both superior and feminine? Fredric Wertham's 1954 response
to Wonder Woman as "a horror type" encapsulates the conflict:
because a "superwoman" is "physically very powerful," she is
then also "the cruel, 'phallic' woman," "a frightening figure for
boys," and "an undesirable ideal for girls, being the exact opposite
of what girls are supposed to want to be" (1954: 34). Although
U.S. cultural attitudes have shifted since the 1950s, studies show
the same gender discrepancy continuing into the twenty-first-
century. Stanford and McCabe report in a study of mostly white,
middle-class U.S. college students that conceptions of ideal male
and female bodies differ significantly. Not only were "males' ideal
ratings ... larger than for females," females "wanted to decrease
their upper body, while the "majority of males indicated an ideal
upper body that was substantially larger" (2002: 679, 681). Males
also "indicated an ideal middle body that was slightly increased in
size," while females "wanted to decrease it substantially" (679).
Despite shifting ideals for female beauty, the expectation of a thin
waist has been a cultural constant since the popularity of corsets
in the mid-nineteenth century. Ideal female body mass index has
also decreased, a trend apparent in Miss American pageant winners
from 1922 to 1999, an increasing number of whom were under
nutrition when crowned (Rubinstein and Ballero 2000).

Although a corseted, malnourished body may be physically attractive according to a culture's beliefs, it cannot be physically effective. Where men combine attractiveness and effectiveness, the two qualities are divorced and even opposed for women. "Obviously," explains Stan Lee in the 1978 *How to Draw the Marvel Way*, "we do not emphasize muscles on a female ... a woman is drawn to look smooth and soft as opposed to the muscular, angular rendition of a man" (Lee and Buscema 1984: 44). Within the superhero visual system, female bodies are designed to appear comparatively weak, necessitating their rescue by strong male bodies. Drawing from centuries of precedents, Siegel and Shuster established Lois Lane as the prototype for the male superhero's female love interest in comics. In the first six issues of *Action Comics*, Superman rescues Lois from a firing squad, a flood, a fall from a skyscraper window, and multiple gangsters. In each case, while Lois is unable to protect herself, Shuster draws her stereotypically attractive body in calf-revealing, form-fitting skirts and dresses, and with a strap slipping down a shoulder as she encounters Superman for the first time. Inverting the attractive-because-effective logic of the male body, an appearance of female physical ineffectiveness is attractive specifically because that ineffectiveness invites male intervention. She is attractive because she is weak.

In what sense then can a female superhero have a "perfect" or "hyper-physical" body? Depictions must emphasize one spectrum over the other, and superhero comics overwhelmingly emphasize perceived physical attractiveness, even when it explicitly contradicts effectiveness. Thus female superhero bodies are, for example, often large breasted, when breast size has either no or a negative correlation to athletic and combat effectiveness. Female superheroes are not drawn to resemble female body-builders—even when the character herself narratively displays the equivalent or greater strength. Superhero worlds provide a range of non-naturalistic explanations for the discrepancy, but when a character is not fantastically enhanced and so bound by rules of human anatomy, her performed strength still contradicts an appearance of relative weakness through thinly drawn arms and legs. Muscles are somehow not her source of physical strength.

Since visually a female superhero's power is her physical attractiveness, the quasi-nude norm of male superheroes also serves

a different function. Rather than displaying, performing, and executing the power of a perfectly effective physique, the body of a female superhero displays, performs, and executes her attractiveness only. Harry G. Peter accordingly drew Wonder Woman's costume with high heels and strapless top even though both would decrease effectiveness. While male superhero costumes operate as pseudoskins, female costumes bare a greater amount of actual skin, often exposing legs, arms, and cleavage. The norm can be traced to the first superpowered female character in comics, Olga Mesmer of Watt Dell Lovett's 1937 series "The Astounding Adventures of Olga Mesmer, The Girl with the X-Ray Eyes," which premiered in the softporn pulp magazine *Spicy Mystery* published by Harry Donenfeld the same year he co-founded Detective Comics Inc. Mesmer also possessed super-strength and was drawn in ripped clothing that exposed much of her body. Despite her ability to swing a man effortlessly through the air, her arms, waist and legs are as thin as any of the female victims' appearing elsewhere in *Spicy* magazines and subsequent superhero comics. The so-called Good Girl Art of the late 1940s and 1950s expanded this style, as seen in Russell Stamm's newspaper strip *Invisible Scarlet O'Neil*, Matt Baker's *Phantom Lady*, and Bill Ward's *Torchy*. Female artists conformed to the same drawing norms, as seen in Jackie Ormes' *Candy* (1937), Tarpé Mills' *Miss Fury* (1941–52), and Barbara Hall's "Blonde Bomber" (1942–7).

The style's popularity overlaps with an influx of female superheroes after World War II. Of eight superhero titles debuting between 1947 and 1949, six feature women: *Namora*, *Lady Luck*, *Venus*, *Phantom Lady*, *Miss America*, and *Moon Girl*. Black Canary was introduced in the 1947 *Flash Comics* #86, and the Blonde Phantom towers over Captain America, Sub-Mariner and the Human Torch on the cover of the 1948 *All-Winner Comics* #1. Timely also replaced Captain America's sidekick Bucky with Golden Girl in 1947 and the Human Torch's sidekick Toro with Sun Girl in 1948. The trend was brief, however. *Blonde Phantom Comics* switched titles to *Lovers* after twenty-two issues, Golden Girl appeared beside Captain America for less than a year, and *Namora* lasted only three issues. EC Comics' single issue *Moon Girl and the Prince* became *Moon Girl Fights Crime!*, which became *A Moon, a Girl ... Romance,* which became *Weird Fantasy*—reflecting the larger industry trend away from superheroes and toward crime,

romance, and horror comics. Black Canary is the only female superhero introduced at this time with a significant later history. Co-creator Carmine Infantino costumed her in a leather jacket, strapless top, and fishnet stockings, following scripter Robert Kanigher's directive to draw "your fantasy of a good-looking girl" (2003: 31).

Joe Shuster preferred to draw women with disproportionately small feet (as seen most disturbingly in the 1954 *Nights of Horror*), and Matt Baker drew women with disproportionately small hands (see the 1948 cover of *Phantom Lady* #7). This lessening of the female body is a visual form of "hyper-feminity," which Sarah K. Murnen and Donn Byrne define as "an exaggerated adherence to stereotypic feminine gender role" (1991: 480). Where a male superhero expands the male body into its cultural ideal, a female superhero body achieves hyper-physicality by paradoxically shrinking. They are hyper-corseted and hyper-body-mass-indexed. For the 1961 cover of *The Fantastic Four* #1, for example, Jack Kirby highlights three fantastically expanded male bodies: the Thing exaggerates roughly human anatomy; Mr. Fantastic's limbs stretch and bend to impossible proportions; and the Human Torch and the tail of fire he produces are indistinguishable, making his body a winding column of flame. Only Invisible Girl is physically lessened. With the lower half of her body invisible, she occupies half as much visual space as she would otherwise, her transparent legs less present than the monster's hand gripping her. The gender division extends to Kirby and Lee's other 1960s characters. The Avengers' Wasp literally shrinks, gaining superpowers by reducing her body to the size of an insect, and the X-Men's Marvel Girl, typically positioned in the background of cover images, exerts her powers invisibly, as depicted by thin, wavering emenata lines, what Mike Madrid terms "'strike a pose and point' powers" (2009: 292). Kirby never draws any of the three throwing a punch, the most standard of male superhero action. One exception, Kirby and Lee's 1965 Medusa of The Inhumans, whose body is physically expanded and useful in direct combat, reinforces gender norms with her fantastical hair, a body part associated with female beauty.

The visual hyper-femininity correlates with the characters' shrunken narrative roles. In an early, metafictional issue in which the Fantastic Four read fan mail, Invisible Girl sobs to her teammates: "A number of readers have said that I don't contribute

enough to you ... you'd be better off without me!" and the Thing
defends her: "If you readers wanna see women fightin' all the time,
then go see lady wrestlers!" (Lee and Kirby 2008: #11: 9–10). Alan
Moore, recalling reading *Fantastic Four* #3 as an eight-year-old,
describes the "wimpy and fainthearted" Invisible Girl as looking
"as if she'd be much happier curled up in an armchair with a bottle
of valium and the latest issue of *Vogue*" (1983). Trina Robbins
calls her "a caricature of Victorian notions of the feminine" (1996:
114) and Laura Mattoon D'Amore "the superhero equivalent of
the suburban housewife" (2008). Despite gaining superpowers
and facing enemies every issue, she proves an incompetent fighter
who is routinely captured—as the first cover establishes. Twelve
issues later her skills have not improved. After the team is shown a
picture of the Hulk, Mr. Fantastic shouts: "Sue! Where is she?" and
she answers: "Right here, Reed! Forgive me! The—the sight of that
monster unnerved me so that I lost control of my visibility power!"
(Lee and Kirby 2008: #12: 6–7). If "visibility" is her power, then
she is naturally invisible and so must struggle to be seen at all.

Portrayals of female effectiveness changed in the following
decades. For the 1970 *Green Lantern Co-Starring Green Arrow*
#76, Neal Adams draws a full page of six uninterrupted images
of Black Canary punching, kicking, shoving, and swinging three
thugs into physical submission (O'Neil and Adams 2012: 59).
Adams' collaborator Dennis O'Neil, in an attempt to emphasize
her alter ego Diana Prince, had depowered Wonder Woman in
1968. Samuel R. Delany's interrupted 1972 run ends with the
cover headline: "SPECIAL! WOMEN'S LIB ISSUE," and Wonder
Woman's powers were restored in the following issues, reportedly
in response to criticism by *Ms.* co-founder Gloria Steinman. Marvel
introduced a range of female characters and titles in the following
years: Valkyrie in *The Avengers* #83 and Black Widow in *Amazing
Adventures* #1 (1970), *The Cat* #1 (1972), *Shanna the She-Devil*
#1 (1972), Satana in *Vampire Tales* #2 (1973), Tigra in *Monsters
Unleashed* #10 and Colleen Wing in *Marvel Premiere Iron Fist* #20
(1974), Misty Knight in *Marvel Premiere Iron Fist* #20 and Storm
in *Giant-Size X-Men* #1 (1975), Red Guardian in *The Defenders*
#35 (1976), and Carol Danvers in *Ms. Marvel* #1 (1977). The
Defenders also became the first gender-balanced superhero team
under writer David Kraft in 1977, and for the single, 1979 #77
issue, scripter Steven Grant cast the team with all female members:

"Hellcat, the Valkyrie, the Wasp, and Moondragon—who now comprise the dynamic Defenders" (Gerber et al. 2005: 205).

Marvel also revised many of its female 1960s' characters. Beginning in 1976, *Uncanny X-Men* writer Chris Claremont transformed Marvel Girl into Phoenix, the most powerful member of her team. In the 1968 *The Avengers* #56 Roy Thomas scripted a Wasp who was so ineffective, she not only remained behind while the male Avengers time-traveled to World War II, she also fell asleep at the controls, nearly killing her teammates, but in the 1982 *The Avengers* #217, Jim Shooter scripted the Wasp as the team's elected leader. During his 1981–6 run of *The Fantastic Four*, John Byrne transformed Invisible Girl into Invisible Woman, also making her the team's most powerful character—while avoiding the tragic punishment Marvel editor Jim Shooter required for Phoenix in 1980. The Scarlet Witch, who as originally written by Kirby and Lee could not control her ill-defined powers, was eventually scripted by Brian Michael Bendis as so powerful that she altered all of reality in the 2005 *House of M*. Bendis, however, also emphasized the Scarlet Witch's emotional instability, especially in relation to parenthood, recurring themes for female superheroes.

Overall social changes in gender norms over the last half century are well documented. In 1950, 34 percent of women worked outside the home; fifty years later, 60 percent did (Toossi 2002). In 1977, 74 percent of men and 52 percent of women believed husbands should earn money and wives stay home; thirty years later, only 40 percent of men and 37 percent of women held those now minority opinions (Galinksy et al. 2008). Viewing the superhero genre beyond comics, Kaysee Baker and Arthur A. Raney's study "investigated whether or not animated superheroes were portrayed in gender-role stereotypical ways" (2007: 35) and, contrary to their hypothesis and historical precedents, found fewer differences between gender portrayals than they expected, especially in the category of aggression. "One way to interpret these findings," they write, "would be to proclaim that female superheroes are finally breaking down the gender-based stereotypes that have permeated children's cartoons for decades" (36). The researchers, however, were skeptical, and Edward Avery-Natale provides another reason. Analyzing 257 images of six superheroes from 1938 to 2008, he found that where first appearances included no significant anatomical exaggerations, 75 percent of recent

representations of Superman, Batman, and Green Lantern included
exaggerated musculature and 67 percent of recent Wonder Woman,
Mary Marvel, and Black Canary drawings included breasts the size
of heads or larger, while "a lack of obvious muscles as a repre-
sentative of femininity has remained constant across the seven
decades of superhero comics" (2013: 86). Avery-Natale, like Baker
and Raney, notes that female superheroes have "gained equal
narrative footing," but the change has paralleled an increase in
hyper-sexualization, as if the "sheer power of the female superhero
may require that she be hyper-feminine in order to not be seen as
masculine" (90, 92). Carolyn Cocca links the shift to the rise of
direct market shops in the 1980s and 1990s, which

> intersected with the broader conservative backlash against the
> gains of the Second Wave of feminism, civil rights movements,
> and gay rights movements. Most mainstream superhero comics
> began to display very particular and very binary representations
> of gender: hypermuscular men and hypersexualized women.
> (2016: 11)

The 1990s' hyperbolic style is best associated with artists Todd
McFarlane, Rob Liefeld, and Jim Lee, who, with other former
Marvel employees, co-founded Image Comics in 1992. In 2013,
McFarlane defended superhero comics' "high-testosterone
storytelling" as depicting all superheroes as "beautiful. So we
actually stereotype both sexes. We just happen to show a little
more skin when we get to the ladies" (Hinckley 2013).

The 1990s also coincides with Gail Simone's identification of the
"Women in Refrigerators" trope encapsulated in *Green Lantern*
#54 (August 1994) in which the hero discovers his girlfriend's
corpse stuffed in a refrigerator by his arch enemy. In 1999, Simone
published an online list of dozens of female characters who had
been "killed, raped, depowered, crippled, turned evil, maimed,
tortured, contracted a disease or had other life-derailing tragedies
befall her" (Simone 1999). Simone hypothesized that the "comics-
buying public being mostly male" was a reason for the trend:

> So, it's possible that less thought might be given to the impact
> the death of a female character might have on the readership.
> Or, it's possible that there's rarely a fan outcry when a female

is killed. Or, maybe since many major female characters were spin-offs of popular male heroes, it was felt that they had to go to keep the male heroes unique, and get rid of "baggage". Or maybe many of the male creators simply relate less to female characters. Or maybe it's a combination of these. (Simone 1999)

Whatever the reason, she asked:

if most major women characters are eventually cannon fodder of one type or another, how does that affect the female readers? ... Combine this trend with the bad girl comics and you have a very weird, slightly hostile environment for women down at the friendly comics shoppe. (Simone 1999)

Many online responses to the list confirmed that hostility, but most comics creators responded sympathetically, including Ron Marz, who wrote the *Green Lantern* episode that inspired the list's title:

Comics have a long history as a male-oriented and male-dominated industry ... I do think comics can and should be more sensitive to female characters. But these are times in which the general editorial mindset is "cut to the fight scene," in which half-naked women on covers spike sales. Publishers are unfortunately more concerned with survival than with sensitivity to women. And that's a shame. If we want to save our industry, maybe we should stop ignoring half the population as possible readers. (Simone 1999)

Dwayne McDuffie responded with that hope that "maybe more women will be inspired to take the reins and write some female characters who aren't plot devices to complicate the hero's life" (Simone 1999). Simone would later write *Wonder Woman* and *Birds of Prey*, which featured Barbara Gordon, a character prominently featured on the WiR list.

While "half naked women" remain a major trope of the genre, the style lessened in twenty-first-century comics. Beginning in the 2001 *Jessica Jones: Alias*, Michael Gaydos drew Jones in loose-fitting civilian clothes that obscure, rather than accentuate her body—a contrast emphasized by the brief inclusion of drawn photographs of the character in her former form-fitting and

shoulder-baring costume. Writer Kelly Sue DeConnick's 2012 *Captain Marvel* established the most recent trend of desexualized female designs, with Carol Danvers drawn by Dexter Soy and Ed McGuinness in a new, skin-covering costume. From the 2015 *Ms. Marvel* onward, Adrian Alphona draws the adolescent Kamala Khan without exaggerated or costume-emphasizing sexual anatomy, while expanding her shape-shifting fist to extraordinary proportions. G. Willow Wilson also scripts overt critiques of typical female superhero costumes when Kamala asks to "wear the classic, politically incorrect costume and kick butt in giant wedge heels," to which the hallucinatory version of Carol Danvers Captain Marvel responds, "You must have some kind of weird boot fetish"; Kamala soon complains that "the boots pinch ... and this leotard is giving me an epic wedgie" (Wilson and Alphona 2015: #1; 17, #2; 12).

Other titles, however, have continued and expanded female hyper-sexualization. Bryan Hitch's Engineer in the 1999 *The Authority* literalizes the near-nudity of pseudoskin costumes by omitting nipples and labia to what otherwise appears to be an unclothed female body. Though Hitch draws a female body more idealized for its relative lack of Liefeld and McFarlane's cartoonish exaggerations, Art Adams' issue #29 cover returns to those 1990s norms with the Engineer's head, breasts, waist, and thighs drawn in similar proportion. More recently, Ryan Benjamin's cover for the 2011 *Suicide Squad* #1 features the redesigned Harley Quinn. Instead of a form-fitting but body-covering costume, the character wears thigh boots, bikini briefs, and a stomach-baring corset barely able to contain her breasts through its cleavage-exposing lacing—the character's now canonical appearance repeated in DC's top-selling *Harley Quinn* beginning in 2014.

The legacy of the genre's gender imbalance is also long lasting. Walt Hickey data-mined online wiki sources to find that 29 percent of DC and 25 percent of Marvel characters were female. For characters with ten or more appearances, the statistic rises to 31 percent for both companies (Hickey 2014). Female representation however rose in the second decade of the twenty-first-century. In 2012, Marvel cancelled *X-23*, its only title starring a female superhero. After its 2015 reboot, however, All-New All-Different Marvel reintroduced the character in *All-New Wolverine*, alongside fifteen other female-led titles: *A-Force, Angela: Queen of Hel, Black*

Widow, Captain Marvel, Gamora, The Mighty Thor, Mockingbird, Moon Girl and Devil Dinosaur, Ms. Marvel, Patsy Walker A.K.A. Hellcat, Scarlet Witch, Silk, Spider-Gwen, Spider-Woman, and *The Unbeatable Squirrel Girl.* The cast of *Ultimates* also included three women and two men, a gender imbalance once anathema to the genre. The shift corresponds to reader demographics. In 2012, women reportedly accounted for 40 percent of comics readers; in 2015, the figure had risen to 53 percent, the first time women outnumbered men (Fermosa 2015).

Demographics may also account for Marvel's decision to withdraw a variant cover of the then-upcoming *Invincible Iron Man* #1 that featured a sexualized depiction of fifteen-year-old Riri Williams. After the comics site The Mary Sue criticized the image for promoting the attitude that the character was "not a true female superhero until you can imagine having sex with her," Artist J. Scott Campbell responded on Twitter that "'sexualizing' was not intended," though he added, "Is it THAT different?" (Carissimo 2016). The character's crop top and and low-cut leggings would be unremarkable by 1990s standards.

Super queer

Despite some variations in female superhero depictions, the genre as a whole has encoded a fear of crossing gender binaries. Neil Shyminsky concludes that "the mainstream superhero narrative is often surprisingly conservative, aimed at legitimating normative ideologies and containing that which threatens them," including "anxiety that is endemic to the superhero's identity and sexuality" and so threatens their "unproblematically hetero, masculine" appearance (2011: 288–90). Sarah Panuska concludes similarly: "Given the typification of heterosexuality through the superhero's masculine privilege, heterosexuality exists as an assumption– an implication – of the genre" (2013: 25). Shyminksy is analyzing twenty-first-century films and Panuska gay superheroes in recent comics, but the U.S. cultural desire for absolute gender divisions applies even more to the origins of the genre. Lewis M. Terman and Catharine Cox Miles write in their 1936 *Sex and Personality: Studies in Masculinity and Femininity*: "The belief is all but universal

that men and women as contrasting groups display characteristic sex differences in their behavior and that these differences are so deep seated and pervasive as to lend distinctive character to the entire personality" (1936: 1). The rationale underpins the authors' influential M-F Personality Test, including "an explicit recognition of the existence of individual variant forms: the effeminate man and the masculine woman … ranging from the slightly variant to the genuine invert who is capable of romantic attachment only to members of his or her own sex" (2–3). While Terman and Miles hoped "concepts of M-F types existing in our present culture be made more definite," superhero comics defined and reinforced those same concepts through fiction (3).

By establishing a very particular hyper-muscular, able-bodied masculinity as an ideal, the male superhero body projects all other physical variations as inferior and so potentially antagonistic. "In the misogynistic, homophobic (and racist) view of this ideology," writes Yann Roblou, "the despised Other that masculinity defines itself against conventionally includes not just women but also feminized individuals" (2012: 84). For Fighting American, notes Carter, "the mind is the strength of the evil other" who is variously "emasculated" and "through differing body constructions" is depicted as physically "dysfunctional, blemished, or otherwise misshapen" (364). The trend is apparent as early as Action Comics #13, in which Siegel and Shuster introduce Superman's first supervillain, the Ultra-Humanite, a balding, wheelchair-bound scientist who must rely on his henchmen to carry him from a burning building— in a pose that echoes Superman carrying Lois Lane from dangers in previous episodes (Siegel and Shuster 2006: 192). Beginning in 1931, Chester Gould's Dick Tracy comic strip features an array of physically "blemished" villains—Pruneface, Flattop, Doc Humo— all supporting by contrast the hero's masculinity. Finger and Kane continued the approach with Batman's villains, including Joker and Clayface in 1940, Penguin in 1941, and Two-Face in 1942. Marvel expanded the motif in the 1960s with Doctor Doom's scared face, the one-armed Dr. Connor's transformation into the Lizard, the Kingpin's visual obesity, the radiation-deformed bodies of the Gargoyle, Abomination, and the Leader, Baron Zemo's skin-affixed mask, and the giant-headed M.O.D.O.K., who, writes Mike Conroy, plagued "Captain America, whose physical perfection he so resented" (2004: 253). Contemporary examples include

the 2004 Punisher villain Finn Cooley, whose skinless face is enclosed in a transparent plastic mask, and the 2004 anti-mutant villain Ord, an alien whose face is mutilated during combat with the X-Men. Because of the contrasting structure of "superior and masculine" vs. "inferior and feminine," each antagonist's physical inferiority is itself emasculating and so self-defeating even prior to a superhero's narrative domination. The superhero's victory is visually a self-fulfilling prophecy.

The gender binary also equates "variant" men with women—a thematic implication first literalized by Siegel and Shuster in *Action Comics* #20 when the Ultra-Humanite transplants his "tremendous brain" into a movie actress' "young, vital body" (Siegel and Shuster 2007: 316, 191). Though Superman concludes the story wondering, "Did Ultra escape? If so, will he continue his evil career?" (192), in the following issue, the narration switches pronouns to explain that Ultra "miraculously survived her last encounter," and Superman refers to her now as a "madwoman" (Siegel and Shuster 2007a: 5, 7). The episode is rife with apparent sexual visual puns too, with Ultra first seducing a male scientist with her kitten and later falling into the yonic opening of a volcano's crater. DC appears to have been troubled by a sexually fluid antagonist, because Luthor permanently replaces Ultra in the subsequent issue. Siegel and Shuster, however, only made the genre's hyper-masculine binary logic explicit: not only is a partly paralyzed male body parallel to an ideally beautiful female body, a male genius is so feminized by his intellect that his sex identity is also female. Though the character's sexuality is more ambiguous, the seduction of the scientist suggests that Ultra was what Terman and Miles term a so-called "genuine invert" even prior to the fantastical sex-change operation.

The superhero plot structure of physical domination, despite overtly expressing traditional gender values, may also encode a subtext of bisexuality. Male antagonists and female love interests share the same oppositional relationship to the male superhero, who expresses his masculinity and so his physical superiority by rescuing the weak female and by emasculating the weaker male. By dominating both, he places them in parallel gender positions, and since his relationship to the female love interest is overtly romantic, his relationship to a male supervillain may be read similarly. Bisexuality is also paradoxically supported by heterosexual

romances between male superheroes and female supervillains, suggesting an erotic subtext to all hero-villain relationships. Bill Finger and Bob Kane established the motif in the 1940 *Batman* #1 in which Batman allows Catwoman to escape after her debut appearance, musing: "Lovely girl! – what eyes! Say – mustn't forget I've got a girl named Julie! Oh well … she still had lovely eyes! Maybe I'll bump into her again sometime" (Kane et al. 2006: 177). That flirtation evolved into an overt sexual relationship in Judd Winick and Guillem March's 2011 *Catwoman* #1, which concludes with a multi-page sex scene. Typical superhero battle scenes feature two male bodies in equally close contact—a trope expanded into gay erotica in the 2007 short story collection *Unmasked: Erotic Tales of Gay Superheroes*.

Whether analyzed as gay, female, transgender, emasculated, feminine, intellectual, or disabled, the Ultra-Humanite expresses superhero gender norms because the character is Superman's opponent. Like a female superhero, however, a LGBTQ superhero disturbs cultural dichotomies that dictate male, heterosexual, cisgender heroes. The 1941 Wonder Woman was preceded by at least eight other female superheroes, and the postwar period produced a surge of short-lived ones, with a second surge in the early 1970s, followed a gradual but more lasting increase in the 1980s to the present. But sexual orientation and sex identity were considered so socially taboo that the first gay superheroes were not named as such until the 1980s, and the first transgender superheroes until the 1990s. However, where female superheroes are almost always visually overt even when not hyper-sexualized, gay characters do not necessarily carry visual markers. As a result, readers could interpret characters as gay. Wertham again provides an early and striking example: "Only someone ignorant of the fundamentals of psychiatry and of the psychopathology of sex can fail to realize a subtle atmosphere of homoeroticism which pervades the adventures of the mature 'Batman' and his young friend "Robin'" (1954: 189–90). The ambiguity is due in part to Bill Finger modeling Batman on earlier pulp heroes such as the Shadow and the Spider, characters who instead of male sidekicks adventured with female fiancées. Alan Moore, through the autobiography of a retired superhero in *Watchmen*, identifies "the repressed sex-urge" of these pulps: "I'd never been entirely sure what Lamont Cranston was up to with Margo Lane," acknowledging that the relationships

were not entirely "innocent and wholesome" (Moore and Gibson 1987: "Under the Hood," 6). Narratively, Robin fulfills the same plot roles of confidante and secondary adventurer. "Like the girls in other stories," observes Wertham, "Robin is sometimes held captive by the villains and Batman has to give in or 'Robin gets killed'" (1954: 190–1). Bob Kane created Robin in 1940 to provide Bill Finger more opportunities for dialogue, repeating the young pal character type of the anthropomorphic Tinymite Kane created for the comic strip "Peter Pupp" while working for the Iger studio in the 1930s. The formula spread through superhero comics, with Toro joining the Human Torch and Pinky Whiz Kid joining Mr. Scarlet later in 1940, followed in 1941 by Captain America's Bucky, Sandman's Sandy, Black Terror's Tim, and Superman's Jimmy Olsen.

The Association of Comics Magazine Publishers apparently did not interpret these relationships as homosexual, and so their 1948 Code did not bar homosexuality, only "Sexy, wanton comics" (ACMP Publishers Code). Though Wertham's critique decimated male sidekicks, the 1954 U.S. Senate Subcommittee on Juvenile Delinquency did not address the topic. The word "homosexual" appears only once in transcripts, with the publication *Homosexual Life* listed as an example of "everything of the worst type" that's been mailed to "youngsters at preparatory schools" (U.S. Congress 1954). New York State assemblyman James Fitzpatrick also condemned transgender characters in his testimony, describing a comic in which a female character "turns out to be a man— complete and utter perversion." When the Comics Magazine Association of America formed two months later, its Comics Code Authority adopted and expanded the ACMP code, with the new "Marriage and Sex" subsection specifying that "sexual abnormalities are unacceptable" and "Sex perversion or any inference to same is strictly forbidden"; as far as the "treatment of love-romance stories," they must "emphasize the value of the home and the sanctity of marriage" (Code 1954).

Although England's Wolfenden Commission recommended decriminalizing homosexuality in 1957, and the American Law Institute made a similar recommendation in 1962, the 1971 Comics Code update remained unchanged, with "sexual abnormalities" still "unacceptable," and "the protection of the children and family life" paramount—even after the American Psychiatric

Association struck homosexuality from its mental disorder list in 1973 (Comics Code Revision 1971). As a result, superhero comics avoided gay characters until 1980, and early depictions cast them as villains. Beginning in *Peter Parker, The Spectacular Spider-Man* #43, Roger Stern scripted Roderick Kingsley as a thin, limp-wristed, ascot-wearing fashion designer who another characters calls a "flaming simp!" and who is later revealed to be the supervillain Hobgoblin (Stern and Zeck 1980). Kingsley is not directly identified as gay, but the same year in the non-Code *Hulk Magazine* #23, Jim Shooter and Roger Stern scripted two men, one black and one white, attempting to rape Bruce Banner, who escapes a YMCA shower room by threatening to transform into the Hulk: "You hurt me and I'll get big and green and tear your ... head off!" (Shooter et al. 1980). Alan Moore and John Totleben recreate a similar scene eight-years later in *Miracleman* #14 when three teens succeed in raping the pubescent Johnny Bates: "You love it. You littul poof. Say you love it" (1988: 13). He escapes by actually transforming into the monstrous Kid Miracleman, who then massacres thousands of Londoners before being forced to transform back, leading Miracleman to murder Johnny to prevent future massacres—all the results of a homosexual rape.

Early depictions of transgender characters are comparatively positive. Because a character's consciousness is often depicted as existing independently of the character's body, superhero comics provide a range of opportunities for fantastical gender-switching. In 1975, writer Steve Gerber introduced Starhawk, a male superhero who exchanges bodies with his female lover, Aleta. Jim Shooter scripted Starhawk in *The Avengers* #168: "Aleta gestures in defiance as her persona submerges, giving way—as the persona of Starhawk assumes command, the corporeal form they share shimmers... changes" (Shooter and Pérez 1978: 16). Although both characters are heterosexual and cisgender, the visual depiction of a woman transforming into a male superhero alters the male-to-male norm established in *Action Comics* #1. Mike W. Barra and Brian Bolland's 1982 *Camelot 3000* introduced a more overtly transgender superhero, the legendary knight Sir Tristan reincarnated into a woman's body. Tristan rejects a female sex identity until the maxi-series' conclusion when he chooses to live as a woman with his reincarnated female lover Isolde. Beginning in the 1987 *Alpha Flight* #45, Bill Mantlo scripted a more

convoluted, multiple body-swapping plot that concluded with the spirit of a previously deceased male character, Walter Langkowski, inside a formerly deceased female body—except when Langkowski transforms into the male body of the Hulk-like Sasquatch for superheroic adventures. Like Sir Tristan, Langkowski, taking the first name "Wanda," continued a previous romantic relationship with his female lover.

While challenging gender binaries, these early depictions of transgender and gay superheroes also maintain aspects of traditional masculinity and heterosexuality. The female Aleta transforming into the male Starhawk literalizes the emasculated or female-like nature of Clark Kent already implicit in the formula. With Tristan and Langkowski, a female body is controlled by a male consciousness, and the male consciousness is male by virtue of having existed previously in a male body. The physicality of the male body, even when not currently present, is primary. Tristan and Langkowski also treat transgender as a temporary plot conflict resolved by a male consciousness accepting a female sex identity through what visually appears to be a lesbian romance, normalizing same-sex female relationships as fantastical expressions of heterosexuality. None of the narratives present a female consciousness inhabiting a male body or male bodies in sexual relationships. Since only female homosexuality is visually portrayed and because early depictions of gay men are villainous, superhero masculinity remained heterosexual and homophobic.

John Byrne challenged that norm in 1983 with *Alpha Flight* superhero Northstar. Because the Code barred openly gay characters, Byrne suggested the character's sexuality indirectly, for example, introducing his friend Raymonde Belmonde whom Byrne draws in a nearly identical light blue suit and red ascot that Mike Zeck designed for Roderick Kingsley four years earlier (Byrne 1984). Byrne was either alluding to Zeck or both were drawing on the same cultural stereotype (arguably the blue suit worn by an emaciated David Bowie on the album cover of the 1974 *David Live*). Despite more direct portrayals of same-sex superhero relationships in non-Code-approved issues of *The Defenders* and *Vigilante* in 1984, Bill Mantlo continued the pattern of indirection when scripting *Alpha Flight* in 1985. When he began a 1987 story arc in which Northstar contracts AIDS, Marvel under the editorship of Jim Shooter altered the disease to a fantastical ailment, forcing

the character into temporary retirement. Other writers followed a similar approach, including gay characters while avoiding identifying their sexualities overtly. Scripter Al Milgrom in the 1988 *Marvel Fanfare* #40 moved closer to confirming the relationship between mutants Mystique and Destiny originally intended and implied by Chris Claremont in 1981. Paul Levitz, during his sixty-three-issue, 1984–9 run of DC's *Legion of Super-Heroes,* also indirectly indicated that the 1960s' characters Lightning Lass and Shrinking Violet were lesbian lovers, a subplot continued by the next team of writers in 1989. Alan Moore's 1986 *Watchmen* memoirist Hollis Mason alludes to two gay superheroes, Hooded Justice and the Silhouette, both of whom may have been murdered as a result of their sexuality. DC's Steve Englehart and Joe Stanton's 1988–9 *The New Guardians* featured the flamboyantly effeminate Extrano, who wore a large golden earring and a purple cape, but was never explicitly identified as gay. John Byrne also introduced police captain Maggie Sawyer to Superman in 1987, interrupting Superman mid-sentence before he could explicitly identify her as lesbian.

The increase in gay representation parallels gains of the gay rights movement of the 1980s. Wisconsin became the first state to outlaw discrimination on the basis of sexual orientation in 1982, and 600,000 protesters marched in Washington in support of gay rights in 1987. "After decades existing in a subtextual closet of metaphors, tropes, and stereotypes," writes Sean Guynes, "in 1988 openly gay characters exploded in the pages of superhero comics" (2016: 182). When the Comics Code Authority revised its guidelines in 1989, it reversed its quarter-century of anti-gay mandates. The Code's new "Characterizations" subsection required creators to "show sensitivity to national, ethnic, religious, sexual, political, and socioeconomic orientations" (Comics Code Revision 1989). The revision also acknowledged that heroes "should reflect the prevailing social attitudes," potentially allowing positive portrayals of openly gay superheroes. Rick Veitch's 1990 non-Code *Brat Pack* is a notable counter example. Publishing outside of Marvel and DC's mainstream market, Veitch spoofed Wertham's reading of Batman and Robin with the overtly gay and grotesquely pedophilic Midnight Mink and Chippy: "When I was younger I could ignore the double entendres and innuendos … but when I turned eighteen he became more insistent" (2009: 14). Publishing in

DC's non-Code Vertigo imprint, Neil Gaiman's ongoing *Sandman* introduced comics' first overt and non-fantastical trans characters in 1991, another "Wanda," who Shawn McManus renders with awkwardly masculine features. (Marston and Peter' 1946 supervillain Blue Snowman, a female scientist who takes a male disguise, significantly precedes Wanda, but it is unclear to what degree the character identities as male.)

Within Code-approved comics, scripter William Messner-Loebs revealed the first openly gay character, the Pied Piper, in *Flash* #53. Flash asks whether the Joker is gay and the former 1960s super-villain answers: "He's a sadist and a psychopath ... I doubt he has real feelings of any kind ... He's not gay, Wally. In fact, I can't think of any super-villain who is ... Well, except me of course" (Messner-Lobes and LaRocque 1991). Marvel now allowed Scott Lobdell to script Northstar's declaration in the 1992 *Alpha Flight* #106: "For while I am not inclined to discuss my sexuality with people for whom it is none of their business – I am gay!" (Lobdell and Pacella 1992). Mark Pacella's cover features a close-up of Northstar's shouting, eye-clenched face and the header: "NORTHSTAR AS YOU'VE NEVER KNOWN HIM BEFORE!" Pacella also renders him in the hyper-muscular style that was standard for male super-heroes in the 1990s. His costume, the same worn by all Alpha Flight members, is non-symmetrical and so metaphorically a rejection of binaries. Four months later at DC, *Legion of Super-Heroes* writers Mary and Tom Bierbaum revealed that Element Lad's long-time girlfriend had been born in a male body and was transforming it with the fantastical drug Profin. The two continue their previously heterosexual relationship now as male lovers: "it doesn't matter," says Element Lad, "You just have to understand—this is not what's changed between us [...] anything we shared physically ... it was in spite of the Profin, not because of it!" (Bierbaum et al. 1992). The relationship echoes Tristan and Isolde of a decade earlier, only now with a gender-fluid character accepting a male sex identity through the resolution of a same-sex male romance. Male homosexuality had entered superhero masculinity.

LGBTQ superheroes increased significantly in the following decade. In 1993, the year President Clinton signed "Don't Ask, Don't Tell" into military policy, Milestone Comics' *Blood Syndicate* #1 introduced scripters Dwayne McDuffie and Ivan Velez, Jr.'s Masquerade, a black trans man who assumes a male form as a

shapeshifter. The same year, DC's Vertigo published two limited series featuring gay superheroes as title characters: Grant Morrison and Steve Yeowell's *Sebastian O* and Peter Milligan and Duncan Fegredo's *The Enigma*, which included an image of a gay kiss and a full-page image of the naked lovers entwined in bed after sex: "two men redrawing the maps of themselves." In 1994, David Peter scripted the Pantheon superhero Hector as gay in *Incredible Hulk*. In 1997, *Supergirl* featured the shapeshifter Comet who alternates between a female human identity and a male centaur. In 1998 James Robinson's *Starman* #48 featured the title character kissing his boyfriend. Alan Moore included a trans woman incarnation of the female superhero *Promethea* in 1999. In 2001, Peter Milligan and Mike Allred's *X-Force* #118 included a kiss between two male superheroes, and the following year in *The Authority* #29 Mark Millar and Gary Erskine married superheroes Apollo and Midnighter, whom creator Warren Ellis had established as openly gay in 1999. Writer Judd Winick introduced the openly gay character Terry Berg to *Green Lantern* in 2001, and the 2002 #154–5 "Hate Crime" plot portrays his brutal beating and Green Lantern's near deadly retaliation—reversing the 1980 and 1988 portrayals of gay men as violent predators.

Twenty-first-century comics continued the expansion of LGBTQ representation, including John Constantine in *Hellblazer* (2002), Moondragon and Marlo Chandler-Jones in *Captain Marvel* (2002), Renee Montoya in *Gotham Central* (2003), Xavin and Karolina in *Runaways* (2003), Miss Masque in *Terra Obscura* (2003), the rebooted Rawhide Kid in *Rawhide Kid: Slap Leather* (2003), Hulking and Wiccan in *Young Avengers* (2005), Freedom Ring in *Marvel Team-Up* (2006), Erik Storn as Amazing Woman in *Infinity Inc.* (2007), Daken in *Wolverine Origins* (2007), Loki in *Thor* (2008), Kate Kane and Maggie Sawyer in *Batwoman* (2011), Bunker in *Teen Titans* (2011), Miss America Chavez in *Vengeance* (2011), Northstar's marriage in *Astonishing X-Men* (2012), Alan Scott Green Lantern in *Earth Two* (2012), Hercules and Wolverine in *X-Treme X-Men* (2013), and Alysia Yeoh in *Batgirl* (2013). The year 2015 alone includes Iceman in *Uncanny X-Men*, Sera and Angela in *Angela: Asgard's Assassin*, Catman in *Secret Six*, Alpha Centurian in *Doomed*, Harley Quinn and Poison Ivy in *Harley Quinn*, Batwoman in *DC Comics Bombshells*, and *Catwoman*. Probably the most prominent challenge to the

superhero's traditional gender binaries is Deadpool, who in the opening pages of the 2016 *Spider-Man/Deadpool* #1 "Isn't it Bromantic?" Joe Kelly and Ed McGuiness depict in an explicitly sexual conversation with Spider-Man as the two are tied together and about to be killed by a demon horde as they hang upside down.

DEADPOOL: I have to tell you one last thing that is, in my humble opinion, the single most important thing you need to know in the whole universe right at this second ... If you don't stop squirming, I am totally going to "unsheathe my katana" all up against your "spider eggs." And by "katana" I mean —

SPIDER-MAN: What is wrong with you?

DEADPOOL: What?! I'm a red-blooded Canadian male! It's friction and junk-biology and spandex grinding on leather and just please stop wiggling your webbing —

SPIDER-MAN: Would you just shut up so I can think!

DEADPOOL: Don't yell at me ... that's totally one of my turn-ons. (2016: 1–3).

The 2015 film *Deadpool* also alluded to the character's pansexuality—a stark contrast to the contractual agreement between Sony and Marvel requiring that Peter Parker be "Caucasian and heterosexual" (Biddle 2015). Finally, new *Wonder Woman* writer Greg Rucka stated in an interview that Wonder Woman's home island "is a queer culture" and that Wonder Woman "has been in love and had relationships with other women," facts he hopes to "show" rather than "tell" in future episodes (Santori-Griffith 2016).

Visually and narratively, however, LGBTQ superheroes are often little different from heterosexual, cisgender superheroes. "Though demarcated by an explicit declaration of their same-sex object choice," writes Panuska, "it is often difficult to otherwise cordon ... 'gay' superheroes from their heterosexual counterparts" because they still conform "to the traditions of a nearly 80-year-old genre" and so do not "stray from traditional associations" (2013: 25). While female and LGBTQ superheroes have significantly challenged the traditional superhero formula, Michael A. Chaney

in the *Encyclopedia of Sex and Gender* still concludes that the genre affirms "the fantasy of a masculine universe" in which "the objectifying conventions of superhero illustration disrupt the very forays into progressive gender politics (cyborg sexuality, transgender, nongender, etc.) that superhero stories increasingly undertake" (2007).

John G. Cawalti, writing in 1976 while black superheroes embodied racist stereotypes and LGBTQ superheroes were non-existent, analyzed the relationship between formula literature, such as superhero comics, and the culture that produces it, arguing that such "stories affirm existing interests and attitudes by presenting an imaginary world that is aligned with these interests and attitudes" and so "help to maintain a culture's ongoing consensus" by "confirming some strongly held conventional view" (1976: 35). The comic book superhero—white, male, heterosexual, cisgender, and non-disabled—has served this function since its conception. But, as Cawalti also argues, popular fiction formulas also "assist in the process of assimilating changes in values to traditional imaginative constructs" and so "ease the transition between old and new ways of expressing things and thus contribute to cultural continuity" (36). The comic book superhero, a continuous cultural construct since 1938, demonstrates this capacity by evolving in response to larger social attitudes, reflecting progressive shifts within conservative norms. The history of black and LGBTQ superheroes demonstrates that superhero comics are rarely agents of cultural change, but that once a social attitude has shifted, comics quickly follow and so reinforce the new status quo.

5

Critical Uses

I

The Visual Superhero

Because superhero comics are not only a literary but also a visual art form, this chapter details six tools for visually analyzing superhero comics: layout rhetoric, framing rhetoric, juxtapositional closure, page sentencing, image–text relationship, and representational abstraction. Some of these tools apply to a range of visual arts, while others are specific to comics. All are essential for understanding superhero comics. The final section applies these tools to a specific example, the first issue of Frank Miller and Bill Sienkiewicz's 1987 *Elektra: Assassin.*

1. Layout rhetoric

Think of a comic book page as a one-wall gallery on which an artist has framed and hung a set of paintings. Not only the content of the images but the arrangement is important. Traditionally comics arrange images in discrete **panels** (of any shape, though traditionally rectangular) with **frames** (traditionally black) and **gutters** (traditionally a white space thicker than a frame) dividing them. Images may also be **insets** (a panel surrounded entirely by another image) or **overlapping** (in which a framed panel edge appears to intrude into or to be placed over top another framed panel). **A page panel** is the image space defined by the physical edges of a page and typically understood as the background visible in the gutters between drawn panels. When white, black, or otherwise uniform, the page panel appears to be the page itself and so is understood

as a neutral space outside of the actions and events of the other images. All other panels are insets superimposed over the page panel. If the background page panel includes drawn images, those images should be understood as the underlying and so in some way dominating background element to all other images on the page. If one panel is **unframed**, its content may be understood as part of the larger page panel. A page panel with no insets and a single unified image is a **full-page panel**. A full-page panel with titles and credits is a **splash page**, though some splash pages include more than one panel. A **two-page panel** includes two facing pages designed to be read as a single unit.

Layout gives more meaning to the images than each would have if viewed individually. Viewed together, one image may be differentiated and, therefore, given greater importance, while a page of identical frames communicates equality between all image content. Generally, the larger an image in relation to other images, the greater its significance. Images may also be differentiated by frames (including shape, thickness, and color, or by being unframed), with larger or distinctively shaped frames drawing greater attention and so communicating greater importance for their content. Although frames can be tilted, curved, circular, or otherwise shaped, superhero comics traditionally feature frames drawn as rectangles parallel with page edges. Positions on the page also differentiate images, with first, center, and last panels tending to dominate.

Images are typically arranged and read in either rows or columns. When arranged in rows, images are read horizontally, from left to right for Anglophone comics, and right to left for Manga. In a **row grid**, each row is divided into the same number of panels, forming unified horizontal and vertical gutters. Grids may be labeled according to the number of rows and then the number of panels in each row: 2x2, 2x3, etc.; 3x2, 3x3, etc.; 4x2, 4x3, 4x4, etc. Grids may be either regular, irregular, or implied:

> **Regular grid**: each row is divided into the same number of panels, and all panels are the same size and shape, creating uniformly spaced gutters.

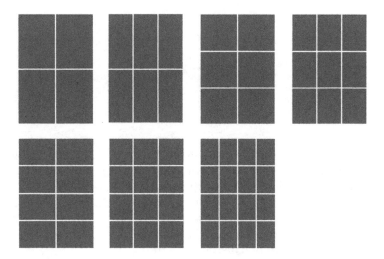

Irregular grid: rows are divided into the same number of panels, but panels are not the same size or shape, creating variably spaced gutters.

Implied grid: panels vary in size and shape but only through combinations or subdivisions of regular grid panels, creating uniformly spaced gutters that are interrupted and/or augmented with additional uniformly spaced gutters. An implied regular 3x3 grid is one of the most common in superhero comics.

In layouts of **2-row, 3-row, 4-row**, etc., rows are divided into a different number of panels with no consistent vertical gutters. Rows may be either regular or irregular:

> **Regular 2-row, 3-row, 4-row**, etc.: rows are the same height, creating uniformly spaced horizontal gutters, often with a different number of panels in each row.

> **Irregular 2-row, 3-row, 4-row**, etc.: rows are different heights, creating variably spaced horizontal gutters, often with a different number of panels in each row.

Panels may also be categorized for regularity within rows.

Regular panels: panels in a row are the same size and shape.

Irregular panels: panels in a row are different sizes and shapes.

Full-width panel is a row-wide panel extending horizontally across the page. An **isolated panel,** one that is not clearly part of any row or column and so creates an L-shaped area in the surrounding image, is also product of layout.

In terms of visual design, grid layouts communicate stability and solidity. Vertical gutters are akin to pillars and horizontal gutters to crossbeams or flat landscapes. While the content of a superhero comic likely depicts violent action and movement that changes from frame to frame, often using diagonal and curved lines, the frames themselves may suggest immobility and permanence, with each frame resting like a box on a shelf. Irregular rows with irregular panels however may communicate movement and volatility, more so if the gutters are not parallel to each other or the page edges.

When arranged in columns, images are read vertically, from top to bottom. Because of the norm of reading horizontally before

vertically, columns are less common than rows. Although columns can be divided into grids, row and column patterns are indistinguishable without content to determine reading direction. A 4x2 layout, for example, could be read as two columns divided into four panels each, but it is more likely to be read instead as four rows divided into two panels each.

Because Anglophone readers move across a page first right then down, **column grids** are limited almost exclusively to **full-height panels** extending vertically down the whole page to establish vertical reading.

Regular column grid (1x2, 1x3, 1x4, etc.): columns are full-height panels of the same width, creating uniformly spaced vertical gutters.

Irregular column grid (1x2, 1x3, 1x4, etc.): columns are full-height panels of different widths, creating variably spaced vertical gutters.

In layouts of **2-column**, **3-column**, **4-column**, etc., columns are divided into a different number of panels. To break horizontal reading, a **full-height panel** often establishes a column layout, with a second column divided into multiple panels. 2-columns are the most common column layout in superhero comics.

Regular 2-column, 3-column, 4-column, etc.: columns are the same width, creating uniformly spaced vertical gutters.

Irregular 2-column, 3-column, 4-column, etc.: columns are different widths, creating variably spaced vertical gutters.

Mixed row-column layouts must be read both horizontally and vertically, combining rows and columns on a single page. Mixed layouts sometimes result in ambiguous reading paths that may be clarified with **discursive arrows**.

Row-column grid (2x1, 3x1, 4x1, etc.): rows and columns are merged by including only full-width panels within a single column. These may be **regular** (rows are the same height) or **irregular** (rows are different heights).

Isolated column: a single, full-height column appearing in otherwise row-based layout.

Sub-column: a single column shorter than the page height. It does not trigger vertical reading because it is followed or preceded by rows. Isolated sub-columns can produce reading path confusion and so traditionally are often accompanied with discursive arrows that bridge gutters.

Paired sub-columns: two side-by-side sub-columns, usually with the first undivided to establish vertical reading. The pair establishes temporary vertical reading.

Horizontal columns: If a row of three or more panels occupies half or more of the page, the panels are column-shaped, though they do not break the horizontal reading path.

Non-rectangular layouts: panels do not follow vertical or horizontal divisions, and so are neither clearly rows nor columns. These may be diagonal, circular, or other shapes.

Overlapping layouts de-emphasize gutters with panels that are drawn as if each were an independent card-like unit stacked so that their corners and edges are sometimes obscured. Despite the additional visual complexities, overlapping layouts tend to follow the same row and column norms as traditional, gutter-focused layouts.

Individual page layouts combine in multi-paged narratives to create **page schemes.** A **base pattern** repeats a panel arrangement on more than one page. Pages that repeat layouts may be said to "rhyme." Page schemes may be **strict,** with repetitions from page to page containing no variations in a base pattern; **flexible,** with

some variations, especially through combined panels and **halved panels** in which the base pattern is only implied; or **open**, with no repeating base pattern.

Since 1930s' comic books were reprint collections of multiple newspaper titles, they tended to feature one-page installments in regular 4-row layouts. A Sunday newspaper comic page typically featured only one comic, which a comic book publisher would resize. Collecting dailies might require additional adjustments to accommodate new page dimensions, and so top title banners and bottom ad space varied around four strips previously published independently. Comic books that published original material followed the same newspaper-driven formatting. Siegel and Shuster's first publications, the one-page "Henri Duval of France, Famed Soldier of Fortune" and the one-page "Doctor Occult, the Ghost Detective" in *New Fun* #6 (October 1935), both use a regular 4x2 grid. Come 1938, Shuster switched to 3-row layouts for *Action Comics* #1–6, before reverting back to a regular 4x2 grid for #7, 8, 10, 14, and 16, a regular 4x2 with irregular panels for #9, then an implied regular 4x2 grid broken by occasional full-width panels for #11–13 and the first 3-panel row in #15. Other superhero comics adopted 4-row base pattern layouts too. Eisner's 1939 "Wonderman" used a regular 4-row with irregular panels. Timely's 1939 *Marvel Comics* #1 included Carl Burgos' "The Human Torch" and Paul Gustavon's "The Angel," both in regular 4-row with a flexible base pattern often implying a 4x3 grid. But Bill Everett's "The Sub-Mariner," included in the same issue, fluctuated between irregular 4-row and 3-row pages. Shuster fluctuated too, returning to 3-row for *Superman* beginning with issue #2 in 1939, while keeping 4x2 for *Action Comics*.

Three-row layouts soon dominated the genre. Jack Kirby, despite previous fluctuation and experimentation, defined a regular 3-row base pattern as Marvel's house style during the 1960s, one Steve Ditko employed for his entire *The Amazing Spider-Man* run. Late 1960s newcomers Neal Adams and Jim Steranko challenged that norm. The transition is most apparent in "Nick Fury, Agent of S.H.I.E.L.D." in Marvel's *Strange Tales*. Steranko inked Kirby's pencils for issues #151–3, with regular 3-row base patterns that fluctuated with occasional 2-row pages. Steranko assumed pencils beginning with # 154, creating an open base pattern with layouts that included irregular 4-row, 3-row, 2-row, full-page panels, and

the series' first mixed row-column page. Steranko introduced his signature 2-column layout featuring a full-height figure beside a 3-panel column in #168, and by the time the series moved to its own title in 1968, the continuously shifting layouts of irregular rows, columns, and insets established new norms for 1970s' superhero comics. When Dave Gibbons drew a regular 3x3 grid for a strictly implied base pattern for *Watchmen* in 1986, the rigid approach was anathema to the genre. While far more flexible, Frank Miller's implied 4x4 base pattern for *The Dark Knight Returns* was almost as rare. While open base patterns continued to dominate, gutters decreased in the 1990s with an increase of overlapping panels and insets. Contemporary superhero comics' layouts fluctuate similarly.

2. Framing rhetoric

How the size and shape of a frame relates *to other frames* describes **layout rhetoric.** How the size and shape of a frame relates *to its subject* describes **framing rhetoric,** which may be divided into three broad categories: the placement of the subject in relation to the center of the frame (centered or off-centered); the aspect ratios of the frame and the subject (symmetrical or asymmetrical); and the frame and subject size relationship (proportionate, expansive, and cropped or broken)

In **centered framing,** the middle of the subject is at or near the center of the frame. The closer the subject is to center, usually the more significant the subject appears, with the middle 50 percent of the frame conveying the most importance to its content. Off-centered subjects, those in the outer 50 percent, communicate less importance by being literally and figuratively marginal. The effect is always in combination with the other two categories.

In **symmetrical framing,** the proportional relationship between the frame's height and width (its aspect ratio) matches the aspect ratio of the subject. Although the frame and subject may be very different shapes (for example, a human form with extended limbs within a rectangular frame), measuring from the subject's furthest points of height and width produces roughly the same ratios. In **asymmetrical framing,** the frame's and the subject's aspect

ratios differ in either height or width, producing content area not dominated by the primary subject.

Because frame-subject relationships can vary while either symmetrical or asymmetrical, framing may be further divided into four subcategories. In **proportionate framing,** the subject fits inside the frame. If the subject and frame aspect ratios also match, then the two appear balanced. Because the combination of **symmetrical, proportionate,** and **centered** framing draws no attention to subject-frame relationships, the style appears "neutral."

This is the default framing style in superhero comics. A frame-subject relationship is significant to the degree that it varies from this norm.

If **asymmetrical and proportionate,** the subject fits the frame, but because of their dissimilar ratios the panel also includes surrounding content along one dimension, either height or width.

The effect de-emphasizes the subject by including surrounding content, and as a result, the subject may appear less significant.

In **expansive framing**, the subject matter is smaller than the frame, so the panel includes surrounding content. The effect is spacious. If **symmetrical and expansive**, the surrounding content appears along both dimensions, regardless of how the subject is centered:

 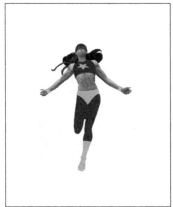

If **asymmetrical and expansive**, the surrounding area is greater because of the differing aspect ratios:

The subject appears less significant because it is proportionately smaller and because the panel frames more additional content. All types of expansive framing tend to make the subject appear less significant.

In **cropped framing,** the subject appears to be larger than the frame, so the frame appears to cut out some portion of the subject. The effect is cramped, as if the frame is too small. If **symmetrical and cropped,** the aspect ratios remain the same, often creating a zoomed-in effect, especially if also **centered:**

If **asymmetrical and cropped,** the subject may appear to be cut off in only one dimension or in both if also zoomed-in or off-center:

If **off-centered and cropped,** the effect is of a misaimed camera, especially if also **proportionate:**

Impressions of the subject's significance varies. If centered, the zoomed-in effect of symmetrical cropping generally increases the impression of power; if cropped and off-centered, subject power decreases.

In **broken framing,** as in cropped, the subject appears to be larger than the frame, but now with elements of the subject extending beyond the frame. The frame-breaking elements are often in movement or otherwise express energy, whether also symmetrically or asymmetrically framed and/or centered or off-centered:

The effect creates an impression of greater subject significance, as if the frame attempts but is unable to contain the subject.

An image may also be unframed:

If unframed, an image may use surrounding panel frames as a secondary frame:

An unframed image also implies a symmetrical and proportionate frame by remaining inside the undrawn borders. Multiple **implied frames** may appear in a single row.

Interpenetrating images eliminate the illusion of implied frames by combining two or more unframed images so that elements appear to overlap even though they are understood as to be separate images depicting physically disparate objects:

A content element of one unframed image may serve as a framing line for an adjacent image, making a **diegetic frame**. Finally, if a frame contains only words, it is a **caption panel**, which tend to be smaller and subdivided from larger panels. Secondary frames, implied frames, diegetic frames, interpenetrating images, and caption panels may all be analyzed in the same rhetorical relationships of centering, size, and aspect ratio as other frames.

Because a majority of comics, including an overwhelming majority of superhero comics, are drawn in a naturalistic mode, framing also creates three-dimensional effects through **reader perspective**. Where frames establish an image's height and width, perspective creates an illusion of depth. An image is often divided into three **planes** of increasing distance: **foreground, middleground,** and **background**. In superhero comics especially, an artist may **foreshorten** a subject or part of a subject, making it appear to be closer to the reader by disproportionately expanding its dimensions. Generally, the subject is more significant the closer it appears. Subjects on the same plane will more likely appear equal. This is partly because closer subjects typically occupy more image space, though larger, more distant subjects that occupy more image space may also appear more significant than smaller, nearer subjects. **Angles** of perspective also influence a reader's perception, altering

a subject's significance by looking **upward, parallel,** or **downward.** A subject drawn higher in the image space and so above another subject may appear more significant too. Finally, consider image and frame orientation. The depicted plane may be **parallel** with the frame, or it may be **tilted.** Because parallel framing is the norm, tilted framing may create a sense of disorientation. In rare cases, the plane may be so tilted as to be **perpendicular.**

The emphasis on perspective in superhero comics suits its content. While Charles Shultz draws his visually flat *Peanuts* characters in a visually flat world, superhero artists emphasize the physicality of their characters' bodies by creating the illusion of three-dimensional space. Superhero characters are vehicles for action, and as characters they are defined by what their bodies are able to do. A style that emphasizes perspective is their standard visual form. It is not, however, a genre requirement, as Jillian Tamaki demonstrates in *SuperMutant Magic Academy* (2015).

3. Juxtapositional closure

In *Understanding Comics*, Scott McCloud writes: "Comics panels fracture both time and space, offering a jagged, staccato rhythm of unconnected moments. But closure allows us to connect these moments and mentally construct a continuous, unified reality" (1993: 67). He identifies six types of panel transitions (moment-to-moment, action-to-action, subject-to-subject, scene-to-scene, aspect-to-aspect, and non-sequitur). Although McCloud's approach remains common, readers of superhero comics may not come to a clear consensus when analyzing a particular sequence. Instead of categorizing single types of transitions, readers can categorize types of closure, which occur in combinations:

1 **Spatial:** Subjects drawn in separate images are understood to exist in physical relationship to each other. (What McCloud identifies as aspect-to-aspect, subject-to-subject, and some scene-to-scene transitions require spatial closure.)

2 **Temporal:** A period of time is understood to pass between images. (What McCloud identifies as moment-to-moment, action-to-action, and some subject-to-subject and scene-to-scene transitions require temporal closure.)

3 **Causal:** Drawn action is understood to have been caused by an element absent from the image. (None of McCloud's transitions, not even action-to-action, accounts for this type of closure.)

4 **Associative:** An image is understood to represent something about a subject drawn in a different image. (Though McCloud does not identify this type of closure, Jessica Abel and Matt Madden in *Drawing Words Writing Pictures* add "symbolic" to McCloud's list of transition types. Such symbolic transitions usually require associative closure.)

Consider a 3-panel sequence from *Watchmen* (Moore and Gibbons 1987: Ch. 8:28):

In the first image, Dave Gibbons draws the shadow of a statuette cast over the face of a frightened man kneeling on the floor. The second image shows the statuette held in the attacker's fist. **Spatial closure** is required to understand that the two images occur within a few feet of each other, with each image drawn from one of the two men's points of view. This occurs despite the white background of the second image (a choice made by colorist John Higgins), which would otherwise suggest a different location. The movement to the second image also requires **temporal closure** because the statuette is behind the attacker's head at an angle that would not cast the shadow seen on the victim's face in the first image. To understand that the shadow was cast by the statuette requires **causal closure**.

The third image depicts a toppled jack-o-lantern and falling books and uses four types of closure: the pumpkin exists in the same space as the two now undrawn men (**spatial**); the pumpkin is crushed at a moment immediately following the second image (**temporal**); the falling books have been knocked down by an attacker (**causal**); and, because it resembles a human head and breaks open at the moment a reader anticipates the statuette striking the man's head, the man's head has been similarly damaged (**associative**).

Consecutive panels may also depict continuous space viewed from a single perspective so that the gutter produces no spatial or temporal closure. Though the gutter divides the panels, we understand that the content "underneath" is interrupted. This produces a problem for comics' terminology. A reader interprets the visual gap of the gutter through the Gestalt law of closure: our brains perceive incomplete images as complete by filling in their missing parts. A ball composed of a dotted outline is understood to be a ball through, as McCloud writes, "the phenomenon of observing the parts but perceiving the whole." McCloud's "closure," however, describes a different phenomenon, the range of perceptions required to interpret *two* juxtaposed images. Gestalt closure requires a reader to fill in a gap that exists only at the level of discourse in order to perceive a diegetic subject: dots arranged in a circle, for example, may be understood as a ball. Juxtapositional closure involves **Gestalt closure** only when the gutter segments a *single* image.

Gestalt closure may also be combined with temporal closure. If the same figure appears in two consecutive panels that represent continuous space (**Gestalt closure**), the figure will be understood

as having moved during the time elapsed in the space of the gutter (**temporal closure**). The implied movement will occur even if there is no gutter: the repetition of the figure within a continuous and unsegmented setting produces the same temporal closure because the panel is understood to contain two, interpenetrating images. A gutter is only necessary in cases of Gestalt closure. All other types of juxtapositional closure are independent of gutters and panel frames. Interpenetrating images require a kind of reverse Gestalt closure: although the visual information is drawn as a *single* image, it is perceived as *two*. **Interpenetrating closure** then is a sixth type of closure.

4. Page sentencing

While closure explains what happens between two images, a superhero comic book contains many images and many pages, creating narrative effects that include but extend well beyond immediate juxtaposition. Telling a story in the comics' form requires **encapsulation**. An artist depicts only certain elements, leaving other moments, subjects, and information to be described verbally or implied visually. In his 2013 *The Visual Language of Comics*, Neil Cohn explains encapsulated story images through visual language grammar. Cohn categorizes images according to the kinds of narrative information they encapsulate and how that information creates a **visual sentence** when read in sequence. He identifies five **narrative panel types**, which I paraphrase here:

> **Orienter:** introduction of a setting for a later interaction (no tension).
> **Establisher:** introduction of elements that later interact (no tension).
> **Initial:** onset of interactive tension.
> **Prolongation:** continuation of interactive tension.
> **Peak:** high point of interactive tension.
> **Release:** aftermath of interactive tension.

Consider the above, 3-panel *Watchmen* sequence again. The first panel is an **Initial**, beginning the interactive tension between the

victim on the floor and the attacker holding the statuette. The second panel is a **Prolongation**, continuing the interactive tension as the attacker cocks his arm to strike. And the third panel is a **Peak**, implying the high point through associative closure.

Cohn applies his visual sentencing to comic strips, which typically express a single sentence in a linear arrangement of three or four panels, but longer graphic narratives can express multiple sentences on a single page or extend a single visual sentence over multiple pages. Analyzing the range of possibilities requires further terminology:

Closed sentences: two uninterrupted sentences that begin and end without sharing panels.

Overlapping sentences: sentences that share panels.

Interrupted sentence: a sentence that does not complete or initiate its tension before another sentence replaces it.

Dual-function panel: in overlapping sentences, one panel performs two narrative functions. A panel may, for example, serve as the Release of one sentence and also the Orienter, Establisher, or Initial of the next. Or an Orienter may serve as the Establisher of an interrupted sentence that initializes tension later.

One-panel sentence: a lone Peak or Release that implies an undrawn Initial.

Since comic books contain multiple pages, visual sentencing may also be analyzed in relationship to page layout. Sentence layouts require further terms too:

End stop: a visual sentence ends on the last image of a page.

Enjambment: a page ends before the visual sentence ends.

Multi-page sentence: a sentence that extends beyond one page.

Page sentence: a sentence that begins with the page's first panel and ends with the page's last panel.

Sub-page sentence: a sentence that begins and ends on one page but does not fill the entire page.

Row sentence: a sentence that begins with a row's first panel and ends with the row's final panel.

Sub-row sentence: a sentence that begins and ends on one row but does not fill the entire row.

Finally, a **scene** contains one or more continuous actions, usually set in a unified time and place, may contain one or multiple visual sentences and may extend over multiple panels and pages. A **page scene** begins and ends on a single page. Superhero comics tend to use a combination of page sentencing approaches, often ending a page with enjambment to create a cliff-hanger effect, while using other page breaks for scene changes. Fight scenes, one of the most pervasive narrative elements of the genre, tend to use multiple overlapping sentences.

5. Image-texts

Although not all comics include words, essentially all superhero comics do. A near exception, the five-page "Young Miracleman" in *Miracleman* #6, includes two talk balloons each containing the transformation-triggering word "Miracleman!" and a range of sound effects, newspaper headlines, and signage. How images and text work together is one of the most complex and distinctive qualities of the form.

Words in comics have their traditional linguistic meanings, but they are also drawn images that must be understood differently than words in prose-only works. Their line qualities and surroundings influence their meanings. Dialogue and narration are typically rendered at a later stage of production by a separate letterer, after the penciler and sometimes the inker have completed their work. The size, shape, and color of lettering can denote volume, tone, or intensity, especially when representing speech. Bolding is especially common, typically multiple words per sentence. Sound effects, however, are most often drawn by a penciler as part of the images. These are onomatopoeic words or letters that represent sounds in the story world. Often the lettering style is so expressive it communicates more than the letters' linguistic meaning.

Words are typically framed within a panel. Spoken dialogue appears in **talk balloons** (traditionally an oval frame with a white interior), internal monologues in **thought balloons** (traditionally a cloud-like frame with a white interior), and unspoken narration in **caption boxes** (traditionally rectangular and colored, though sometimes narration appears in separate caption panels or in white

gutters). Adding a **pointer** to a word container and directing it at
an image of a character turns the words into sound representa-
tions or, if a thought balloon, into representations of an unspoken
but linguistic mental process, both linked to the specific place
and time of the image. The absence of a pointer on a caption box
indicates that the words originate from outside of the depicted
scene. First-person narration with no pointer may be linked to
a remote setting if the words are composed by a character from
some implied moment and location not drawn. Though the words
in talk balloons are understood to be audible to characters, the
drawn words and containers are not visible within the story world
even when drawn blocking diegetic elements. As with lettering,
the size, shape, and color of containers communicate additional
meanings about the words. For talk balloons, the graphic quality
of the balloon edges denotes how the words are thought, spoken,
whispered, shouted, etc. Finally, the containers create semantic
units similar to line breaks or stanzas in poetry.

Words also influence and are influenced by surrounding images.
Will Eisner identifies two kinds of images: a "visual" is a "sequence
of images that replace a descriptive passage told only in words,"
and an "illustration" is an image that "reinforces (or decorates)
a descriptive passage. It simply repeats the text" (2008: 132).
Scott McCloud goes further, identifying seven "distinct categories
for word/picture combinations" (2006: 130). Two of McCloud's
categories, "word-specific" and "duo-specific," correspond with
Eisner's "illustration," while the other five (picture-specific, inter-
secting, parallel, independent, montage) fall under Eisner's "visual,"
which "seeks to employ a mix of letters and images as a language
in dealing with narration" (139).

To indicate the level of image-text integration, I will combine
and arrange McCloud's and Eisner's categories in a spectrum,
beginning with the highest level integration.

> **Montage visual**: images include words as part of the depicted
> subject matter. This is the only instance in comics in which
> words are part of the diegesis. All other words are discourse
> only.
> **Interdependent visual**: images and words communicate different
> information that combines.
> **Intersecting visual**: images and words communicate some of the

same information, while also communicating some information separately.

Image-specific visual: images communicate all primary information, while words repeat selected aspects.

Word-specific illustration: words communicate all primary information, while images repeat selected aspects.

McCloud also includes two categories that are not integrated, and I will add two more.

Duo-specific illustration: images and words communicate the same information. Although this might appear to be the most integrated category, there is no integration if each element only duplicates the other so that no information is lost if either element is ignored. Words and images are so independent they are mutually redundant.

Image-only visual: isolated images communicate all information. Since comics do not require words, this is one of the most fundamental aspects of the form.

Word-only text: isolated words communicate all information. This requires the highest level of reader visualization, an approach at odds with graphic narratives as a form.

Parallel visual: images and words communicate different information that do not combine. This requires the same level of reader visualization as word-only texts, but the presence of images complicates and influences that visualization. In some sense, parallel visuals are the most integrated image-texts because the words and images communicate a unified effect with no overlap. The spectrum then is circular.

With the exception of the most integrated category, montage visuals, all combinations of words and pictures produce some level of image-text tension because words, unlike images, exist only as discourse. Superhero comics create further image-text tension by highlighting the potential gap between text-narration and image-narration. In graphic memoirs, the **text-narrator** and the **image-narrator** are understood to be the same person, the actual author. When a character in a superhero comic controls the first-person text-narration in caption boxes, it is not necessarily clear whether that character is also controlling the image-narration in

panels. If the words are generated by an omniscient third-person text-narrator, does that same narrator generate the images, or are the images generated by a separate narrator?

Unintegrated image-texts imply a separate text-narrator and image-narrator. In the case of a duo-specific image-text, the two modes of narration duplicate information without any integration, as if two narrators are unaware of each other. Integrated image-texts, however, imply a single narrator controlling both words and images in order to combine them for a unified effect. At the center of the spectrum, a word-specific illustration implies an image-narrator aware of text but a text-narrator unaware of image. Similarly, an image-specific visual implies a text-narrator aware of images but an image-narrator unaware of text.

Parallel visuals are more complex; although the two narrations are independent and so seemingly unaware of each other at the level of the panel, the overarching effect is integrated. In such cases, the separate text- and image-narrations may create a **double image-text referent**, in which a word has one meaning according to its linguistic context but, when read in the context of the image, acquires a second meaning. Alan Moore is best known for this approach, having perfected it with Dave Gibbons in *Watchmen*.

6. Representational abstraction

Because they tell stories through images, superhero comics also create tensions between how a subject matter is depicted and the subject itself—or between the story world of the characters (diegesis) and the physical comic book in the world of the reader (discourse). Is a drawing of a superhero a photo-like document of the superhero as others in the story see him? Or is the drawing an interpretation of the character which may be in some way diegetically inaccurate? This tension occurs less in the non-fiction genres because the images represent real-world content and so are understood as interpretations. Graphic novels, because their content is fictional, create a greater tension, and superhero comics, because they are an amalgam genre that includes fantasy and science fiction, heighten it by depicting subject matter that both does not and cannot exist.

Joseph Witek identifies two modes of comics art, the cartoon and the naturalistic. The first "is marked by simplified and exaggerated characters which are created primarily by line and contour" (1994: 20). The second, which he also terms "realism," creates "a plausible physical world using shading, consistent lighting sources, texture, and linear perspective" (31). Scott McCloud identifies the equivalent of five modes in his "iconic abstraction scale," beginning with a reproduced photograph of a face on the far left and ending on the far right with a face comprised only of an oval, two dots, and a straight line (29).

The fifth face, which McCloud also labels a "cartoon" (29), corresponds roughly with Witek's cartoon mode, while the middle face, which contains "Only outlines and a hint of shading" (2012: 29), corresponds roughly with Witek's naturalistic mode. Both Witek and McCloud identify the middle face with "stories of adventure and romance" (Witek 2012: 28) and "adventure comics" (McCloud 1994: 29), which is the genre of superheroes.

Individual artists vary widely in style, but this is the baseline level for abstraction in a superhero comic. Superheroes and their worlds contain fantastical elements, but their visual framework is naturalism. Or at least that is the expectation the genre presents. The categories, however, are not always clearly divided. Witek's cartoon mode appears to include both McCloud's fourth, unlabeled face and his fifth, "cartoon" face, and his naturalistic mode would appear to include both McCloud's second face, which McCloud terms "realistic," and his third, "adventures comics face." Witek acknowledges that his two modes are "by no means mutually exclusive; comics combining both modes are extremely common" (28). Rather than a dichotomy, McCloud's scale establishes a spectrum, since "nearly all comics artists apply at least some small measure of cartooning" (42).

McCloud does not give a precise definition of cartooning, but all of the faces to the right of the photograph, he argues, further "abstract [it] through cartooning" which involves "eliminating details" by "focusing on specific details" (30). But this is also roughly the definition of abstraction, whether talking about art, information technology, or knowledge in general. In *Introduction to Knowledge Management*, Todd Groff and Thomas Jones define abstraction: "The process of taking away or removing characteristics from something in order to reduce it to a set of essential characteristics" (2003: 52). To abstract is to extract or remove, implying in art the transfer or duplication of characteristics from a subject to a visual representation of that subject. According to McCloud, abstracting and cartooning are the same. Reducing some details to focus on others accurately describes some of the differences between photography and representational art that reduces subject matter to outlines and a few interior lines or shadings.

Photography, however, is not the same as realism. We might instead describe images as imitating the expectations of optical perception—which itself is not reality either.

Regardless, McCloud's "amplification through simplification" (30) does not account for all of the differences between the five faces of his abstraction scale. His second, "realistic" face does differ from the photographed face primarily through the elimination of details, but the third, "adventure comics" face differs not only in the quantity of details, but also through changes in the quality of those details. The lines themselves are different. His "simplification" also does not account for the differences between the following two images, which contain a similar number of lines and so are equally "simple" in terms of quantity only:

There is then more to simplification than simply eliminating details. The following five head images consist only of outlines, and so are also equally simplified, and yet they differ radically, suggesting an alternate five-point abstraction scale.

The first head appears to duplicate the outline of a photograph, while the others alter that line, the last into a circle. The only difference then is line shape, one of the most fundamental elements of comics art. Douglas Wolk explains in *Reading Comics*:

> The line itself is an interpolation, something the cartoonist adds to his or her idea of the shape of bodies in space. In a cartoon, every object's form is subject to interpretive distortion … A consistent, aestheticized distortion, combined with the line that establishes that distortion, adds up to an artist's visual style. (2007: 123)

Drawn lines may be thick or thin, angular or rounded, straight or jagged, straight or squiggly, continuous or broken, etc.; and whatever their individual qualities, lines may be consistent or variable within a single image. Though not part of the diegetic world, line style defines the subject matter they represent. When comparing the "traditional" style of 1990s' comics "that feature super-defined, hardcore bodybuilder costumed heroes" and the "streamlined" style popularized in the following decade, Christopher Hart observes:

> At first glance, the difference between the two appears to be a matter of more detail on the traditional drawings and less on the simplified ones. Though that's technically true, it misses a key point. The traditional drawings are full of small, choppy lines,

whereas the simplified drawings are created with clean, fluid lines: Everything extraneous to the form is omitted.

Just as important is the quality of the line itself; the simplified line tends to curve rather than break into sharp angles. The lines bends without any abrupt changes of direction (sharp, right angles, for example). And the streamlined characters are highly stylized. (2007: 8, 12)

Hart's ambiguous use of "stylized" refers to a "[s]lightly retro, cartoon-style influence" (52), one that appears to combine the elimination of details and a quality of line shapes.

McCloud's scale similarly conflates two kinds of abstraction. Each step to the right of his spectrum appears simpler because the image contains fewer lines and also because the lines are in themselves less varied. Flattening peaks and raising lows into median curves exaggerates lines into simpler contours. So each of McCloud's faces is increasingly both "simplified and exaggerated," the two stylistic elements Witek accurately identifies with the cartoon mode (31).

Although superhero comics art is traditionally naturalistic, analyzing it benefits from a combination of McCloud's and Witek's approaches. Each face on McCloud's scale is altered both in density and in contour. Density describes the number of lines, and contour describes the magnification and compression of line shape and thickness. Abstraction in density reduces the number of lines, while abstraction in contour warps the lines. The greater the density and the lower the line distortion, the more an image conforms to expectations of optical perception.

A spectrum is a more effective tool for analysis than two-mode categorization, and so I scale both forms of abstraction, offering nomenclature for descriptive purposes.

Density Scale

1 Opacity: The amount of detail is similar to the amount expected when optically perceiving a real-world object. In general, photography and photorealism show opaque density.

2 Semi-Translucency: The amount of detail falls below photorealism, while the image still suggests optically perceived subject matter.

3 Translucency: While reduced well beneath the range of
 photography, the amount of detail evokes real-world
 subject matter as its source material. This is the standard
 level of density in superhero comics art.

4 Semi-Transparency: The sparsity of detail is a dominating
 quality of the image, and subject matter can evoke only
 distantly real source material. Semi-Transparency is more
 common in caricature and cartooning.

5 Transparency: The minimum amount of detail
 required for an image to be understood as representing
 real-world subject matter. Often transparency includes
 outlines only.

Contour Scale

1 Duplication: Line shapes closely imitate optic perception.
 Optic-duplicating lines exceed the norms of superhero art
 by reproducing too much information.

2 Generalization: Line shapes are magnified and/or
 compressed to medians for an overall flattening effect that
 conforms to naturalistic expectations. Generalization is
 the standard level of abstraction for inanimate objects in
 superhero art.

3 Idealization: Some line shapes are magnified and/or
 compressed to medians while others are magnified and/
 or compressed beyond their medians for an overall
 idealizing effect that challenges but does not entirely break
 naturalism. An idealized line shape is usually implausible
 but possible in real-world subject matter. Idealization is the
 standard level of abstraction for superhero characters.

4 Intensification: Line shapes are magnified and/
 or compressed beyond their medians for an overall
 exaggerating effect that exceeds naturalistic expectations.
 If the intensification is explained diegetically, the line
 shapes are understood to be literal representations of
 fantastical subject matter within a naturalistic context. If
 the intensification is not explained diegetically, then the
 line shapes are understood as stylistic qualities of the image
 but not literal qualities of the subject matter. Diegetic

intensification is common for fantastical subject matter
in superhero art; diegetically unexplained or non-diegetic
intensification occurs selectively.

5 Hyperbole: Line shapes are magnified and/or compressed
 well beyond medians for an overall exaggerated effect
 that rejects naturalism entirely. Hyperbole is relatively
 uncommon in superhero art because the stylistic qualities of
 the image dominate and so prevent a literal understanding
 of the subject matter. Hyperbole in a naturalistic context
 may be understood metaphorically.

Consider the following image "Punch":

Because both figures are outlines, they both have the lowest
possible level on the density scale. But they do differ in contour. The
figure on the left is more abstract in the sense that its lines, while
clearly representing a human outline, exaggerate beyond real-world
subject matter. Though cartoonish in this sense, the figure does still
evoke human proportions and so is not hyperbolic. On the contour
scale, its lines vary between idealization and intensification. The
figure on the right, however, evokes the contours of real-world
subject matter. An actual human being could plausibly fit its
outline—though the lines themselves have been variously simplified
or, using the suggested nomenclature, generalized or idealized.

Because such image analysis requires both scales, the two may
be combined into a density-contour grid or **Abstraction Grid**.

The grid takes optic perception as the norm that defines varia-
tions. McCloud's photographed face is the most optically realistic,
combining opacity and duplication, 1–1 on the grid, demonstrating
the highest levels of density and unaltered contour. Its opposite,
however, is not McCloud's fifth, "cartoon" face, which combines
transparency with idealization. McCloud's scale progresses 1 to
5 in terms of density, but also partly rises in terms of contour
distortion. His first face begins with duplication, his second moves
to generalization, and his last three plateau at idealization. The
level of density reduction for his "cartoon" face is the highest and
so the least realistic, but its contour distortion is moderate and so
comparatively realistic, especially for a so-called cartoon. Replace
the oval with a circle to form a traditional smiley face and the
contour quality would rise to hyperbole, 5–5, the most exaggerated
and so the least realistic position on the grid.

Returning to the image "Punch," the figure on the left is 5–3
bordering on 5–4, and the figure on the right is 5–2 bordering on
5–3. Cartooning covers a range of grid points, but most traditional
cartooning falls between 4–4 and 5–5, demonstrating low-density
and high-contour distortion. This is why Witek identifies the
cartoon mode as growing "out of caricature, with its basic
principles of simplification and exaggeration" (28), principles that
correspond with density reduction and warped contours. Charles
Shultz's circle-headed and minimally detailed Charlie Brown, for
example, achieves 5–5.

McCloud's middle, "adventure comics" face combines trans-
lucency and idealization, 3–3, the center point of the grid and a
defining norm of naturalistic comics art. Like all grid points, 3–3
allows for a variety of stylistic variation between artists, within
a single artist's work, and even within a single image, but it does
provide a starting point for visual analysis by defining areas of
basic similarity. The faces on Jack Kirby's opening splash page
of *The Fantastic Four* #1, for example, resemble McCloud's
"adventure comics" face. Neil Cohn analyzes styles in terms of
"dialects," identifying the "'mainstream' style of American Visual
Language [that] appears most prevalently in superhero comics"
as "'Kirbyan,' in honor of the historical influence of Jack 'King'
Kirby in defining the style" (2013: 139). Cohn names Neal
Adams, John Byrne, and Jim Lee as significant Kirbyan contrib-
utors too, all of whom work within 3–3 parameters. Adams was

Table 1 Abstraction Grid

1–5 Opaque Hyperbole	2–5 Semi-Translucent Hyperbole	3–5 Translucent Hyperbole	4–5 Semi-Transparent Hyperbole	5–5 Transparent Hyperbole
1–4 Opaque Intensification	2–4 Semi-Translucent Intensification	3–4 Translucent Intensification	4–4 Semi-Transparent Intensification	5–4 Transparent Intensification
1–3 Opaque Idealization	2–3 Semi-Translucent Idealization	3–3 Translucent Idealization	4–3 Semi-Transparent Idealization	5–3 Transparent Idealization
1–2 Opaque Generalization	2–2 Semi-Translucent Generalization	3–2 Translucent Generalization	4–2 Semi-Transparent Generalization	5–2 Transparent Generalization
1–1 Opaque Duplication	2–1 Semi-Translucent Duplication	3–1 Translucent Duplication	4–1 Semi-Transparent Duplication	5–1 Transparent Duplication

especially influential on 1970s' norms, which shifted away from the 4–3 that was more prominent in the 1940s, 1950s, and 1960s.

When superhero art moves from 3–3 norms, it may create visual tension because the style contradicts genre expectations. Michel Allred's *iZombie* art, for example, demonstrates an atypically sparse density but with little contour distortion, or 4–3 on the abstraction grid. The effect evokes the simplicity of cartooning in which figures are composed primarily of outlines with little shading, while also suggesting an underlying realism in which figures could be derived very distantly from photography. Allred's style is also reminiscent of children's comics that are drawn in a style of simplified naturalism, such as *Spidey Super Stories* published in the 1970s by Marvel in conjunction with the PBS children's show *The Electric Company*. Nineteen forties superhero artists commonly worked in 4–3, a style sometimes perceived as simplistic by contemporary superhero comics norms due to its low density. At times, Joe Shuster's Superman, Bob Kane's Batman, and Harry G. Peter's Wonder Woman all demonstrate semi-transparent idealization, though Peter also selectively employs a cartoonish 4–4 effect on secondary character faces.

Steve Ditko's 1960s' art vacillates between 3–3, 4–3, and even 4–4, when his otherwise idealized anatomy achieves intensification due to rigid joint angles and disproportionately large heads or facial features. Chester Gould's Dick Tracy and Will Eisner's The Spirit warp anatomy to similar 3–4 effect, which is also common for superhero figures, though the effect does not typically evoke cartooning because the intensification is applied to specific characters and is diegetically explained. The radiation-amplified body of the Hulk—whether drawn by Kirby, Ditko, Byrne or any of the other dozens of artist who have illustrated the character over the last half century—is always intensified, but surrounding characters and objects are not.

Sometimes artists will selectively employ non-diegetic intensification for dramatic effect. M. D. Bright draws Icon's trailing cape at varying lengths, ranging from human height to three times that length, in an otherwise 3–3 image. Rob Liefeld, however, warps anatomy for an overall 3–4 effect, with female figures that are roughly two-thirds legs—an intensification more common in fashion art—and breasts and waists the width of human heads. His male figure's musculature also vacillates, displaying non-diegetically explained intensification when in action, but only

idealization when at rest, so that the line quality of the character's bodies function expressionistically. For Liefeld, the baseline reality remains 3–3, but Kevin O'Neil's *The League of Extraordinary Gentlemen* achieves an overall 3–4 effect, as does Adrian Alphona's *Ms. Marvel*.

Bill Sienkiewicz sometimes extends intensification to hyperbole, while maintaining translucency or increasing density to semi-translucency. In *Daredevil: Love and War*, his Kingpin achieves a rare 2–5, with absurdly impossible proportions—shoulders and back that extend more than two head-lengths above his own head—paired with painterly detailing that approaches photorealism. Dave McKean works in a similar opaque to semi-translucent range, though often with lower-line distortion. Alex Ross applies similar density, but his forms tend toward superheroic idealization at 2–3. Eliot Brown's photographic covers—*The Amazing Spider-Man* #262, for example—are of course 1–1.

In the twenty-first century, superhero comics shifted toward a less detailed style of 3–4, though, as Hart notes, the streamlined approach "doesn't replace [traditional comic book style] but is a vital addition to the genre" (2007: 8). Contemporary comics maintains of diversity of styles in contrast to the regimented approaches of previous decades. When Jack Kirby penciled Superman in 1972, DC editor Carmine Infantino assigned Murphy Anderson to ink the head and chest emblem to match the character's standard appearance:

> Because we had to maintain the look of the Superman character. We had a licensing agreement all over the world, and they wanted—expected—a consistent look to the characters. You don't change the look no matter who the artist is. Mickey Mouse has to look like Mickey Mouse. Same thing with Superman. (Amash and Nolen-Weathington 2010: 117)

In contrast, the first dozen issues of the 2012 *Captain Marvel* feature artists Dexter Soy, Emma Rios, and Filipe Andrade rendering the title character in idiosyncratically distinct styles, most also in overt contradiction with each issue's cover art (DeConnick et al. 2016). Such contradictory approaches are an increasing norm at Marvel. Each of the first five issues of the 2016 series *Scarlet Witch* feature a different artist working in strikingly different styles, so much so

that the title character has little to no visual continuity—producing the opposite effect of Infantino's 1970s' Superman mandate.

Regardless of time period, superhero comics art features a great deal of **emanata** and **blurgits**, terms coined by cartoonist Mort Walker to describe radiation and motion lines (2000: 28, 37). Though visually similar, the two types differ in terms of Witek's naturalistic and cartoon modes. Blurgits, what Walker calls a "stroboscopic technique," abstract the visual experience of seeing an object in motion by simplifying the streaks of motion-blurred photography (2000: 37). Motion lines are optic afterimages reduced to the minimal density and idealized contours, so 5–3 on the abstraction grid. The Flash, for example, is typically drawn with motion lines extending behind his body to indicate his path and speed.

Radiation lines communicate energy, physical or psychological, emanating from a subject. The sun, for instance, is iconically drawn with yellow radiation lines, and Spider-Man's head emanates wavy lines when his spider senses tingle. Superhero fight scenes use a range of radiation lines, often clustered into bursts at points of impact. The lines of a panel frame may express energy in the same way. Though integrated into the naturalistic environment, radiation lines do not represent optical perception.

7. Visualizing *Elektra*

Having outlined six areas of visual analysis, this chapter concludes with a case study of Frank Miller and Bill Sienkiewicz's *Elektra: Assassin*, a superhero comic especially rich in the formal modes of visual storytelling. Jean-Paul Gabilliet describes the graphic novel as "excessively confusing" and "too esoteric in form and style" (2010: 93), while the 20th Annual International Comic Art Convention in Lucca, Italy awarded the Italian edition its 1986 Yellow Kid Award for "for bridging the gap between American and European artistic sensibilities." Given the graphic novel's contradictory reception, this chapter's visual tools provide a range of useful methods for studying it.

Marvel published the original eight-issue limited series through its imprint Epic Comics in 1986–7. Unlike its parent company, Epic granted ownership rights to creators, a policy instituted in 1982 when the imprint was launched. Epic titles were sold only through

direct market outlets and so did not require Comics Code approval, allowing for a higher range of violent and sexual content. DC had published Miller's creator-owned limited series *Ronin* in 1983–84, as well as his seminal *Batman: The Dark Knight Returns* in 1986. Miller, who had completed his first run of *Daredevil* for Marvel in 1983, returned to the series in 1985 to write the *Born Again* arc, which ended with the same August 1986 cover date as the debut issue of *Elektra: Assassin*. Miller and Sienkiewicz collaborated on *Daredevil: Love and War*, published as a Marvel Graphic Novel in 1986, too. Sienkiewicz began illustrating *Moon Knight* for Marvel in 1980 and then, leaving behind his early Neal Adams-inspired style, drew and painted the visually innovative *New Mutants* from 1984–5, and the three-issue film adaptation *Dune* in 1985.

Miller approached Epic editor Mary Jo Duffy in 1985 with an idea for an Elektra limited series and Sienkiewicz as his choice for artist. Miller conceived the project as an untold story taking place prior to Elektra's death in *Daredevil* #181 (April 1982). According to Duffy, Miller would first discuss the concepts for each issue with her, write a formal script, discuss the script with her, and then revise it at least once more before giving it to Sienkiewicz. Unlike most superhero comics artists, Sienkiewicz served the roles of penciler, inker, and colorist, leaving only the lettering to Jim Novak and Gaspar Saladino. Sienkiewicz also eliminated the typical two-step pencils and inks process by working in atypical mediums that included paints, photocopies, doilies, staples, and thread. Although uncredited, Sienkiewicz is also a co-writer since Miller, after receiving Sienkiewicz's painted issues, "would do a final draft, taking advantage of whatever new and unexpected touches Bill had incorporated into the artwork" (4). The final drafts presumably included revisions to the scripted text to appear on the otherwise finished pages, revisions made in response to Sienkiewicz's visual content. Sienkiewicz later described this collaborative ideal: "There's the writer, and there's the artist, and then there's this other, third entity that is the combination and intersection of those two roles. That overlap is where real creative magic happens" (Bendis 2014: 95).

This section analyzes Chapter 1 in the reissued graphic novel format, which is reproduced in black and white reductions here:

27

28

29

30

35

36

37

38

The effect of "confusion" is established in the opening pages by three elements: high-closure demands, shifting abstraction styles, and shifting image-text modes with an emphasis on parallel visuals. Though naturalistic at a glance, the first page opens the issue with a range of naturalistic challenges. The full-page panel is a parallel image-text, typical of splash pages because titles inherently divide discourse and diegesis. The division, however, is heightened by the roughly textured font and the title itself, "HELL AND BACK," both of which contradict the placid image of edgeless clouds, island vegetation devoid of interior detail, and a sailboat reduced to basic shapes as if by distance (7). The image and "HELL" seem either unrelated or contradictory. Since the boat is drawn on the same middleground plane as the island, the palm trees appear impossibly large, roughly four times the height of the sail mast and so about eight stories. The blue sky also merges into non-diegetic shades of green at the top of the page, further emphasizing the disconnection of the parallel image-text of the title.

Turning the page, the top full-width unframed panel depicts a pregnant woman, with a hand touching her head from off-frame left and the fetus visible in cross-section (8). The transition produces ambiguous spatial closure by not including any location-defining details. The mother could be sun-bathing on the island beach, the most prominent location of the previous image, rather than on the previously tiny and now undrawn sailboat. Four captions appear in the right half of the panel and so are read sequentially after the image. The first-person narration in the first two does not initially relate to the image and so works in parallel, with words and image each communicating information that does not combine into a coherent image-text (passages are divided here by indentation according to their original text containers, in this case caption boxes):

"This one is worn and dull like an old coin."
"But patches here and there still glint. If I rub them very carefully I can make them shine."

"This" has no immediate referent, verbally or visually. It is also not initially clear that the "patches" are the image content and that Elektra can only metaphorically "rub" them, apparently making them "shine" and so visible on the page. This opening establishes

a later motif present only in texts, in which Elektra recalls events which she verbally describes as spinning globes, but that are never visually represented as such (8, 9, 11, 14, 20, 23, 27). Because her disconnected verbal and visual narrations are soon revealed to take place in the setting of the asylum, these parallel image-texts also suggest her fragmented psychological state.

The second two captions in the first panel switch to intersecting image-texts:

"This patch ... I am riding on a boat in my mother's stomach."
"Poppa touches her."

The image and the phrases, "in my mother's stomach" and "touches her," communicate the same information, but only "Poppa" and "I am riding on a boat" communicate the identities of the hand and the fetus and the fact of the undrawn boat, and only the image communicates the sunny weather and that the mother is sun-bathing in a bikini. The first-person narrator is now linked to the fetus—adding a different kind of ambiguity, since the fetus presumably was not aware of these events at the time as so the narrator is not retelling memories but second-hand information. The long, rectangular frame is symmetrical and proportionate with the mother's body, but if the father is considered part of the subject matter, the framing is extremely off-center, cropping him out almost entirely.

The image-texts continue in the intersecting mode in the five captions of panel two:

"... and me."
"The Aegean Islands are nearby."
"It is shortly before noon on August thirteenth."
"These are the facts."
"They are written on my birth certificate."

The image, mostly a repetition of the first panel now framed around the mother's head and the fetus, also communicates the smiling Elektra's pleasure at being touched in utero by her father. Because of the off-centered and cropped framing, the father remains only a hand, but now drawn from the opposite side of the frame—demanding a range of ambiguous spatial, temporal, and

causal closure. For no inferable reason, the undrawn father would need to have walked around the mother aboard the still undrawn boat during what appears to be otherwise consecutive moments, emphasized by the mother's nearly identically drawn face. The difficult closure demands further emphasize the unreliability of the images as accurate memories. The intersecting image-text also divides the parents. While the text-narration emphasizes "Poppa" over the unnamed mother by giving him the only action "touches," the framing rhetoric emphasizes the mother with a symmetrical and proportionate frame, while eliminating him completely. The divided modes of narration also suggest Elektra's own psychological division.

Closure demands increase with panel three, which includes two types of image-texts, the word-specific: "I make a picture to check," and the drawn montage visual: "CERTIFICATE OF BIRTH" and "YES". The montage also reveals the text-narration and image-narration relationship, clarifying that the images are not omniscient but are Elektra's first-person drawings. The panel transition resists closure, since the certificate and the parents exist visually in unrelated spatial and temporal settings, and causal closure occurs only at the level of the image-text with the word-specific "my birth certificate," which the next panel illustrates. It is also unclear in what sense she "makes a picture," since the image could be a literal drawing by a narrating child or (as soon becomes clearer) are representations of her adult thoughts.

The next row of five panels includes one caption each:

"Still this one spins—faster now, too fast—"
"—Because I was making pictures and not paying attention—"
"—I must slow it—"
"—eggbeater eggbeater—"
"—or miss the chance to make it shine."

All are again parallel image-texts but the fourth, which is interdependent with the image of the helicopter, turning "eggbeater" into a text-narrated sound effect. It is unclear, however, how the five panels spatially and temporally relate. Four depict a similarly but not identically drawn palm tree, which might represent four separate trees or only one. The point of view is from beneath, presumably from the mother or the imaginatively cognizant

fetus—a spatial impossibility since the sailboat is too distant as drawn on the opening page and in the bottom panel. The fourth panel depicts a helicopter from the same angle, but it is also flying in front of a sun and red sky absent from the other panels, preventing the expected causal closure that the helicopter just flew into view. Instead the helicopter wings echo the palm fronds, suggesting possible associative closure: these images are linked in Elektra's thoughts because of their visual resemblance. No temporal closure occurs because the construction of memory appears to take place outside of time—or (as is later revealed) from an undepicted moment in time. The image-text is also multiply interdependent because "spins" and "eggbeater" describe both the helicopter wings and the coin-like memory, creating double image-text referents.

While clarifying the spatial relationships, the bottom full-width panel includes a now less detailed helicopter against a white sun, further establishing instability in representation. Rather than naturalism, Witek's cartoon mode seems to be governing the depictions. The bottom panel also introduces a new type of image-text type. Two instances of uncaptioned words are overtly part of the drawn image and include arrows labeling image content:

"UHOH—here comes <u>trouble</u> ..."
"DAD AND His wife here."

Though intersecting, the two image-texts briefly unify text-narration and image-narration into a single drawn voice—an effect rare in the normally naturalistic style of superhero comics. After the repetition of another interdependent "eggbeater," the second caption is also intersecting:

"She is Clytemnestra. He is Aggamemnon." [*sic*]

And the final two are parallel:

"I think I misspelled her name but that is unimportant. It is not her real name. I gave them those names—picked them from a story Poppa read me."
"Their real names were burned away."

Like the "patches" of the opening caption, the referent of "burned away" is not depicted in the image, ending the page as ambiguously as it began. The entire page includes ten intersecting, eight parallel, two interdependent, one montage, and one word-specific image-texts, with the multiple, intertwining types contributing to a disjointed narrative effect.

The artistic style also grows more disjointed with the facing page. First, the page transition demands high closure with a scene-changing spatial and temporal leap caused only by Elektra's verbal narration—which is now centered in a specific place and moment in the asylum, retroactively clarifying the meaning of "make a picture" as a mental process. The explanatory effect is heightened by the first instance of a duo-specific image-text, with both the gutter caption describing and the image depicting Elektra's electro-shock treatment. The image also establishes the asylum as the primary setting by increasing detail density, which reaches a 2–2 level of abstraction with the inset of Elektra's face. Since this is the most detailed artistic style, Elektra in the asylum is the most optically realistic element in the narrative and so the stylistically implied source of the previous images. The base style, however, is not naturalism. The asylum images, though drawn with greater density, varies in contour distortion for surreal effects—including the white and black scribbles of wiring and electricity emanating like radiation lines from her head. The white circle around her enlarged right black pupil may also represent her coin-like memory, but if so, it is through associative closure and the image-only visual understood in retroactive relation to the earlier text.

Elektra's 2–2 face further contrasts the bottom row of 4–4 images of the cartoonishly injured father. The 5–5 white 'V' seagulls in the first panel echo the childishly drawn sun and radiation lines of the previous page, but the V's then become emanata—along with what cartoonist Mort Walker terms squeans and a spurl—in the last panel to illustrate the duo-specific image-text "Then he sits and looks stupid," accentuated by the drawn sound effect "TWEET TWEET TWEET" (9). The text-narration deepens the sense that the images exist only in Elektra's imagination as she is able to revise their content, depicting and then negating the father's fatal wounds. The word-only captions also narrate the most dramatically essential detail: "—on the side of the helicopter a man holds an uzi" and "—the gun spits—" (9). The helicopter, shooter, and

gun are not drawn, demanding high causal closure to interpret the intersecting image-texts of the father's injuries. By not depicting the assassin shooting his gun, Sienkiewicz does not encapsulate one of the most narratively significant elements of the opening scene, requiring maxim reader visualization—an effect further crafting the "confusion" of the opening pages.

The first three pages also use three different types of layouts, establishing a norm of constant fluctuation:

1 (numbered 7 in the book compilation): full-page panel (splash)
2 (8): irregular 4-row with irregular panels
3 (9): regular 2-row with irregular panels (including inset)

Like the image-texts and shifting abstraction style, the first set of facing pages emphasize minimal connection, with four rows of one, two and five panels combining into two rows of two and three panels. Only the center horizontal gutter links the two pages. Categorizing the layouts of the entire issue produces a similarly complex page scheme:

4 (10): regular 2-row with irregular panels
5 (11): irregular 5-row
6 (12): regular 3x3
7 (13): irregular 3-row
8 (14): regular 3-row with irregular panels
9 (15): regular 5x2
10 (16): irregular 5x1
11 (17): irregular 5x1
12 (18): full-page panel
13 (19): regular 2x3
14 (20): irregular 4-row with irregular panels (including broken and interpenetrating)
15 (21): irregular 5x1
16 (22): irregular 4-row
17 (23): irregular 4x1

18 (24): mixed row-columns, top row of two regular panels, second row of paired sub-columns

19 (25): irregular 2-row with irregular panels

20 (26): mixed row-columns, top row of paired sub-columns, second row of irregular panels

21 (27): irregular 3-row with irregular panels (including interpenetrating)

22 (28): regular 4x3

23 (29): implied 6x2

24 (30): irregular 4-row with irregular panels

25 (31): regular 3-row with irregular panels

26 (32): mixed row-columns, top full-width panel, second row of paired sub-columns

27 (33): irregular 3-row with irregular panels

28 (34): irregular 2-row with irregular panels (including one isolated)

29 (35): irregular 3-row with irregular panels (including one fragmented and literally threaded)

30 (36): irregular 3-row

31 (37): regular 2-row with irregular panels

32 (38): full-page panel

No base pattern dominates the issue. The most common layout, repeating on eight of the thirty-eight pages, is 3-row, representing between a quarter and fifth of the overall issue. Six pages are 2-row and another six 4-row, each less than a sixth of the issue. Five pages are 5-row, three are full-page panels, another three mix columns and rows, and one page is 6-row. This open page scheme emphasizes irregular row heights and panel widths, with only five pages divided into regular grids.

Irregularity then is the norm, which matches the subject matter. Heightening the effect of Elektra's disjointed narration, events move between at least seven discrete time segments: Elektra's childhood, her early training, her brief romance with Matt, her recruitment by the Hand, her assassination of President Huevos, her pursuit of Ambassador Reich and the Beast, and the present events in the

asylum. Though the seven time segments and the seven layout types do not correlate, the present actions, like the varying layouts, are interwoven. Of the 189 total panels, fifty-seven take place in the asylum, and nearly two-thirds of the pages include at least one asylum image. In contrast, the childhood, training, romance, recruitment, assassination, and Reich scenes receive 28, 18, 2, 17, 23, and 24 panels, respectively. Each also appears on four or fewer pages. The 112 non-asylum panels outnumber the fifty-seven asylum panels, but the asylum is the single most dominant. The "confusion" then is carefully crafted and off-set by a central setting that governs the other elements of the narrative.

Sienkiewicz also employs distinctive framing. Images depicting present events in the darkly drawn asylum are enclosed in jagged black frames, further suggesting Elektra's mental state while imprisoned. Images depicting past events are framed only by gutters, implying comparative freedom. In cases where the non-diegetic white of the gutter is undifferentiated from the diegetic white within a panel (such as white sky, white snow, or a white table), the panel image appears partly unframed and so even freer. Sienkiewicz breaks the pattern only twice, framing non-asylum events in asylum-defined frames to produce thematic connections: when the adolescent Elektra attempts suicide, leading to her first incarceration "in a place like this one only cleaner" (12), and in the isolated panel that links the Beast attacking her to the asylum staff preparing to lobotomize her (34). In both past events, Elektra is in physical danger and will soon be incarcerated as a direct result, and so the narrative moments prefigure the asylum too. The frames express a consistent meaning.

Sienkiewicz's layouts also follow the norms of the publishing period, which had emphasized continuously fluctuating page schemes since the late 1960s. Despite emphasizing irregularity, Sienkiewicz's layouts also obey a number of formal constraints. There are only three insets (two of which are the equivalent of thought balloons), one isolated panel, and no overlapping panels, full-height panels, or column-based pages. Except for three full-page panels, all page panels are undrawn, creating the effect of white gutters between framed images. Excluding caption boxes which routinely overlap gutters and panels, Sienkiewicz breaks frames on only two pages. When Elektra remembers her father's death, his arm and the panel itself appear to shatter and spread

into adjacent panels, interrupting her 2-panel romance with Matt. Sensei's dripping blood from her weapon also interpenetrates into an image of Elektra lying in the asylum as she tries not to remember (20). Later, after she has freed herself from a straightjacket, her figure breaks two frames and interpenetrates into two chronologically previous panels above it (27). Although her figure is nearly stationary, the broken frames suggest her increasing power, as if the frames, like the straightjacket, cannot contain her. In both cases, the broken frames and interpenetrating images convey specific diegetic meaning. Sienkiewicz draws all other panels as if over top an independent neutral space, placing the images figuratively and thematically on the same plane—even though temporally many occur at radically different moments.

For all of Sienkiewicz's innovations, gutters dominate his pages, reflecting another norm of the period. But he does not apply the norm generically. The white of his page panels produce metaphorical meanings specific to Elektra's story. When after training with the Seven the young Elektra falls from the cliff and vanishes into the white of the snow, she also vanishes into the nothingness of the page-panel, suggesting her emotional state at being rejected by her mentor (19). The effect increases when she nearly loses consciousness under anesthesia and Sienkiewicz literally slices her image into fragments and pulls apart the physical threads holding them together to reveal and expand the surrounding whiteness underneath—as if that white itself were unconsciousness. White is also the color of the Beast's milk pictured splattering in an adjacent frame and so an even greater threat (35). The three images— snow, white unconsciousness, milk—taken together imply that the neutrality or relative freedom of the gutter is actually oblivion. And this is also the overriding plot threat later revealed as the Beast plans the destruction of the planet through nuclear Armageddon. Finally, Elektra's first-person narration is contained by white caption boxes—in contrast to the colors used to differentiate other characters' speech and thoughts. Once her narration occurs in the open white space above a top panel (9), and, on the same page, she draws "SAPrise" in the white outside a cartoon of her father being shot. Elektra's then is the only voice visually linked to whiteness. Since the white of the page-panel is also the white of the literal page, it is as if Elektra can drop out of the story world and into the reader's world. There is arguably no greater superpower. But, like

the Beast's white milk, which is later described as a brain-altering narcotic and the source of her abilities (89), the underlying white is an ambivalent source of power. Because it maintains the gutter, it is the most dominant formal element of the comic, but it is also linked to both diegetic and discursive nothingness.

Only three pages, because they are full-page panels, have no gutters. They are also the three largest images and so visually linked. One opens the issue, one ends it, and one appears roughly at the one-third mark. The first and last also frame the issue diegetically, since the first begins the earliest flashback, and the last is the last chronologically, ending Elektra's imprisonment as she leaps from an asylum window. The middle full-page is an interior of the asylum, in which Elektra is passive, barely differentiated from the other emaciated nude female bodies, placed off-center at the bottom left area of the panel with one foot cropped, and dwarfed by her surroundings. If her figure is the subject, the framing is asymmetrical and expansive. If the rows of beds are the subject, the framing is asymmetrical and cropped. Both communicate Elektra's unimportance. The concluding page-panel, however, depicts the lone Elektra in mid-motion, where her figure commands the center area of the symmetrical and expansive frame. The opening page-panel does not depict her at all, except retroactively inside her mother who is a passenger aboard the tiny sailboat in the bottom left corner. If the sailboat is the subject, the framing is symmetrical but radically expansive and off-centered, shrinking the unborn Elektra's presence to nothing—a nothingness also akin to the nothingness of the white page-panel gutters. The three full-page panels taken as their own sequence then show Elektra's literal rise and expansion, a theme paralleled narratively.

Because they are the only instances of vertical reading, the three mixed row-column pages are formally significant too. The first page of her three-page recruitment scene includes a sub-column pair, with a one-panel sub-column on the left and two irregular panels in the right sub-column (24). The left panel expansively frames Elektra standing over the corpse of Sensei as a member of the Hand explains the way of the Beast. The third page of the scene begins with another sub-column pair, with Elektra chained in the right panel and the left column divided into four regular panels as she experiences the power of the milk (26). The layout repeats six pages later when she confronts Reich in the embassy:

Reich occupies the left column, and the right is divided into four nearly regular panels with images of the milk and the Beast's hand (32). All three mixed pages then disrupt horizontal reading when depicting the disruptive force of the Hand, Beast, and milk. These layouts alter one of the most fundamental elements of the page, the direction of reading, and so metaphorically reveal the world-altering power of Elektra's antagonists.

Although Elektra is empowered by the milk, the page scheme also reveals the equally powerful and continuing effects of her training with the Seven. Where the Hand's mixed row-column pages are the most disruptive in the issue, the most regular page depicts the Seven, whose names, like the page's 5x2 grid, "fit together like chess pieces," evoking the square 8x8 grid of a chessboard (15). Her training, two irregular 5x1 pages, may suggest both her inability to master their skills but, through ten consecutive full-width panels, how near she comes (16–7). Her departure occurs in a regular 2x3 grid in which she surprises Stick with her mastery of telepathy (19). Because the grid echoes the Seven's earlier grid, Elektra appears to have the necessary qualities to become their Eighth as she had hoped, and so, according to the layout, Stick is wrong to cast her out.

Regular grids occur twice more: a 4x3 when she accepts the assignment to kill Huevos and, on the facing page, an implied 6x2 disturbed only by a bottom full-width panel when she kills him (28, 29). The assassination requires extraordinary skill, firing a crossbow from a spinning ride and, missing the child in his lap, striking Huevos in the neck as he sits on another spinning ride. Because the action is drawn on a regular grid, it echoes the earlier grid of the Seven, linking Elektra's skill to her training rather than to the powers of the Beast's milk.

The issue includes only one other grid, an earlier 3x3 depicting Elektra's childhood interactions with her father, ending with her attempted suicide and then her current incarceration (12). The regularity of layout, however, is undermined by the irregularity in visual sentencing. The page includes four sub-page sentences, the most of any page. The top row-sentence features an Initial in which her father bends toward her in bed, followed by a Peak in which he kisses her cheek, and ends with a Release as he walks away. The middle row uses the top row as an Establisher ("I only want to feel something"), continuing with a new sentence of three

Prolongations which is interrupted and then completed six pages later with the father's death: "—He leaves me—punishes me—" (20). The bottom row begins with a 1-panel sentence, a Peak in which Elektra attempts suicide, followed by a 2-panel sentence: an Initial in which Elektra listens to a fly and then a Peak in which she catches it. The narrative is highly fragmented, contrasting the four page sentences of the other four grid pages, each beginning with an Orienter and ending with a Peak or, in one case, a Release.

All five of the grid pages also end in end stops, comprising between a quarter and a third of the issue's seventeen end-stopped pages, a total only slightly higher than the fifteen enjambed pages. Though roughly equal in number, the placement of each page type is significant. The issue opens with four enjambed pages (7–10), depicting Elektra's traumatic birth and current incarceration. Following the splash page Orienter, the second page contains Establishers and ends with an Initial, creating a cliff-hanger parodied in the drawn text: "UHOH—here comes trouble ..." (8). The third page briefly interrupts the sentence with an asylum Initial, resuming the first sentence with three Prolongations that are also a sub-sentence ending with the father's non-fatal injury. The end-stop effect, however, is prevented by the continuation of the scene and overlapping sentence, which continues onto the fourth page which depicts the mother's death, Elektra's birth, and her father's mourning. Both the sentence and scene end mid-page, followed by an Orienter placing Elektra in the asylum. The next page then contains two sub-sentences: the top-row continuing from the asylum Orienter and four full-width panels depicting Elketra's possible sexual abuse by her father. The end stop is undermined by the following page which replays the scene with a different, non-abusive Peak and Release, before continuing with three additional sub-sentences discussed above (12).

The sentence layout adds to the opening pages' disjointedness, but the effect is brief and gives way to a less chaotic pattern. After four pages, the sentence layouts change from multiple sub-page sentences ending in enjambment to complete page sentences and page-sentence scenes with end-stops. Despite the continuing shifts in abstraction and page scheme, the sentencing creates an underlying uniformity. Though narratively Elektra is still struggling to recall past events and so gain control of her chaotic situation, the formal structure reveals that she has already begun to accomplish

that goal. The next ten pages depict Elektra's childhood, training, and asylum incarceration (11–20). Though events remain narratively traumatic (abuse by asylum attendant, abuse and casting out by Stick, death of her father), the formal structure stresses order. Only two overlapping sub-page sentences appear, and each frames a flashback sentence within an asylum sentence, providing a greater sense of narrative balance than the interrupted sentences and enjambments of the opening pages (14, 20).

When the scenes expand in page-length again, the underlying order continues—as if Elektra's ability to understand and control her experiences is expanding too. Two three-page scenes follow, each ending in end-stops. The visual sentence depicting the attempted rape by the attendant ends in a Peak and Release at the top of its third page (21–3), followed by a 2-panel sentence that transitions into the next three-page scene of the Hand's recruitment, each its own page sentence (24–6). The choppy sentence layouts of the opening pages are gone. The next following three pages are also page sentences, depicting Elektra's recovery in an isolated cell, the assignment, and the assassination (27–9). Huevos' 3-panel funeral overlaps with Elektra's pulling out her stitches, ending with a cliff-hanger: "Ambassador Reich—fills the air—with the stench of the Beast" (30), the most pronounced cliff-hanger since the "trouble" of the helicopter (8).

The cliff-hanger marks a return to enjambment for the next five pages, as Elektra attempts to kill Reich but instead is overcome by the Beast (31–5). The reprised page sentencing format links her battle with Reich and the Beast to the opening attack on her family. However narratively traumatic her other memories and asylum ordeals appear, they occur within a sentencing style that emphasizes page unity. Formally, only the opening and the penultimate scenes employ awkward or anticipatory page breaks that propel the narrative action forward. Psychologically then for Elektra, the horror of the Beast recalls the horror of her birth—a conclusion revealed only through formal visual analysis.

In the final three-page scene, Elektra regains her full memory and escapes the asylum. The narrative events are paralleled and heightened by four formal changes: sentencing, closure, abstraction, and image-text narration. The scene begins as a multiply interrupted overlapping sentence spread over five pages: an Initial panel of Elektra being strapped to a gurney (31), a Prolongation of the

gurney being wheeled (32), a Prolongation of her being prepared for operation (34), and finally three Prolongation panels of her receiving anesthetic gas followed by a previously discussed Peak in which her image is literally pulled apart, suggesting loss of consciousness and near death (35). The apparent end-stop, however, is negated after the page turn when the same image, now a whole, full-width panel, repeats and so continues the same sentence (36), echoing the end-stop of the fifth page which also restarts at the top of its subsequent page where it appears that Elektra's father, in fact, did not rape her (11, 12). The parallel structure further links her father with the Beast and the asylum attendants. While the flashback sentences ended each of the previous pages with enjambments (30–4), the narratively temporary end-stop returns the sentence layouts to end-stops for the final three pages too (36–8).

The final pages include five sub-sentences, all components of one larger scene sentence: in the panel three Peak, Elektra removes the straps visible in panel two; she kills the male attendant in the panel four Peak; and she faces the female attendant in the panel five Initial, and kills her in the panel six Peak, ending the page with an end-stop (36). The next page begins with a row-sentence: an Initial of Elektra facing the second man; a Prolongation of Elektra throwing the scalpel; and a Peak of the cropped man dropping his gun with a scribble of blood. The nearly full-width panel of row two serves as a dual-function Release for all three sub-sentences by displaying the three bodies in the foreground. In the background, Elektra looks out of the window, making the dual-function panel also an Establisher for the issue's final 3-panel sentence. The page ends on an enjambed Prolongation, and after the page turn, her foot strikes the green of the outside world as the tips of her hair trail from the window square. The sentence layout change from the highly interrupted pages 31–5 to the unified 36–8 marks Elektra's own transformation. She is now psychologically unified too.

The final three pages also mark a change in closure. The panel transitions on pages 31–5, like so many of the previous pages, often require high-temporal closure and no spatial closure due to the interwoven time frames in separate locations, but 36–8 encapsulate only consecutive moments in a single space. Two previous scenes extend for the same length, but the attempted rape sequence requires high-associative closure when transitioning in and out of the seven metaphorical images of the rat and turtle (21–3). The

final sequence, in contrast, is unified by continuous spatial closure. The Hand's recruitment is also three pages, but with one transition of unexplained temporal and causal closure when Elektra appears at the top of the middle page chained and in costume despite the seemingly continuous speech. Also, the bottom row of the third page requires associative closure for the metaphorical images of the fighting dogs.

The issue's penultimate scene also requires extreme spatial closure demands through asymmetrical and cropped framing (33). Panels two and three are so off-center that the subject matter—the Beast and the impact of Elektra's thrown sai—do not appear, only the partially misaligned "THUNK." The last three panels variously crop Elektra's thighs and upper body with all but the Beast's hand always out of frame—associative echoes of the father's hand from the opening sailboat scene, further linking the two events. The next page's isolated panel crops Elektra's head, followed by three partially cropped framings of her head only, suggesting the violent motion of her struggle. These are interwoven with the previously discussed operating room images, demanding associative closure between the Beast's hand and the gas mask. These final twelve panels do include two transitions of causal closure (Elektra's removal of the straps and gas apparatus, the man's gun dropping due to the impact of the scalpel), but the sequence creates the most spatially and temporally unified pages of the issue—a unity that again formally reflects Elektra's newly achieved psychological state.

The final four pages are also drawn in the most consistent style of any sequence in the issue. Fifteen of the earlier pages include at least one internal shift in abstraction, and none of the remaining thirteen maintain styles for more than two consecutive pages. The psychological implications of the abstractions change too. Prior to the concluding sequence, increased abstraction suggests escape. Although expansively framed full-width asylum images reach 4–4 detail and contour with Elektra undifferentiated from the other women (10, 13, 14), Sienkiewicz renders Elektra's face in 2–2 when framed in isolation (9, 11, 12, 14, 20, 27, 30, 31). Most images set outside of the asylum show lower-density and greater contour distortion, allowing her to leave the stylistic norms of the asylum and so thematically the asylum itself.

As she sits and eats at the asylum table, she recalls training with her mentor in two panels. In the first, their figures are roughly

3–3, and the background 4–3. In the second, both the figures and
background are reduced to 5–3. Elektra and her remembered world
are Matisse-like cut-outs of white and orange, contrasting with the
2–2 blacks and grays of the asylum panels framing the flashback
sequentially. Similarly, her memories of her training with the
Seven are rendered in blocks of undifferentiated colors, with skin
in non-diegetic blue. She also escapes the trauma of her attempted
rape and her killing of her attacker through the stark shapes and
solid coloring of the rat and turtle abstractions (21, 22). Her killing
of the ninjas and her violence toward the embassy guards are
rendered similarly (26, 31).

Her inability to kill the Beast, however, marks a change in
abstraction connotation (33). Her body, rendered in 3–3 when
throwing her sai in the top full-width panel, loses both power and
detail in the last three panels. She narrates:

"—my muscles—hang from my bones—
"—I run—
"—slowly, through liquid—"

The second to last frame asymmetrically crops her legs which are
now rendered in 5–3 as choppy blocks of red. Instead of allowing
her escape, greater abstraction weakens her and leads to her
incarceration.

The reversed abstraction level of the final pages instead
empowers Elektra with uniformity of style and by grounding her in
2–2 realism. She no longer seeks metaphorical escape, but physical
escape within that baseline reality. The physicality of that change
is especially prevalent in her acts of violence. All of her previous
violence is visually obscured: the 4–3 embassy guards (31), the
metaphorical 5–3 animals (22, 26), the expansively framed and
so inexactly distant corpse of Sensei (24), and the radically
off-centered and cropped framing of the Huevos assassination (29).
Only the corpse of her attempted rapist appears in 2–2 realism,
but Elektra herself seems unaware of it as the incident triggers
her scene-transporting memory of the Hand (23). The final pages,
however, depict her killing her three opponents in unobscured 2–2
detail and the intersecting text: "Eggshell skull splinters—" (36).
(The image-text also creates a retroactive pun with the assassi-
nated "Huevos," meaning "eggs," while recalling the "eggbeater"

of the opening scene.) Where earlier she depicted animal images at moments of violence, now animal imagery appears only in her text-narration:

"The woman is a fat, fearful rabbit."
"I am a cobra."

The stylistic change reflects both her rediscovered ability to kill skillfully and her ability to image-narrate that violence without relative abstraction, suggesting psychological acceptance of her physical powers and her overall unity.

Elektra's text-narration alters too. The top full-width panel repeating the now unified image of her receiving gas includes four captions, followed by two in the top left corner of the second, full-width panel:

"—I have fought the Beast.
"He forced me again to drink the milk.
 "Too much.
"It shattered my mind.
"He let me live. I do not know why.
"He sent me here—"

The narration is word-only, with no drawn images depicting their content. This echoes the undrawn assassin firing an uzi at her parents on the third page, the mirror position to the third to last page here. In both, the most dramatically central information is visually absent. Where the absence suggested Elektra's mental fragmentation in the opening, in the closing it marks the expansion of her mental abilities. She can now text-narrate independently of image-narration. She also for the first time uses past tense ("fought," "forced," "shattered," etc.), where all previous past events were narrated in present tense, linking the text-narration to other moments in time or mental states of visual abstraction. Now she narrates exclusively from caption boxes inside asylum panels. She is both acting and narrating in the present moment.

The change calls attention to the absence of thought balloon pointers. Though narrating in present tense, she is not thinking in present tense, because in-scene thoughts and first-person present-tense narration are not the same linguistically or psychologically.

The last three captions of the penultimate page are followed by a final caption on the last page:

"Of course I should not leave just yet.

"Leave nothing alive. It is the first order.
"But the wind is hot and wet and ripe with spring.

"And I jump."

Where two previous pages end in a similar sentence: "And I fall" (19, 23), the change in verb emphasizes her choice and agency. The captioned words, however, are not represented thoughts because of the gap between Elektra's text-narrating "I" and the depicted Elektra of the image-narration. The Elektra in the image may be experiencing the hot, wet, ripe-with-spring wind, and she may even may be thinking about the wind in those ways, but the actual words "the wind is hot and wet and ripe with spring" are not passing through her mind at this framed moment. If they were, the caption would be a thought balloon with a tail pointing toward her image, and the Elektra in that image would be composing those subvocalized words at that moment. Instead, the words are somehow composed by her simultaneously narrating self, which creates a gap between the words and the images. The text-narrating Elektra is not drawn on the page. If the text-narration were in past tense, "The wind was hot … and I jumped," a reader could imagine her in some undrawn present location looking back at the past events depicted in the images—as was implied and then confirmed in the opening pages. Instead, the text-narrating Elektra is disembodied, as if she exists apart from the images of her body. Elektra's mind is safely situated outside of time and space as if now in the milky white of the gutters.

Such narration gaps do not occur in prose-only texts because neither the present-tense experiencing "I" and the present-tense narrating "I" are drawn. In the opening pages, Elektra is both the text- and image-narrator, as she can both describe verbally and "make a picture" of the childhood events. In the closing pages, the images are no longer linked to Elektra's consciousness. The 2–2 rendering has already been established as baseline reality, which, unlike the abstractions of her memories, Elektra appears not to

control directly or indirectly. The image-narration then is third-person omniscient. To become a unified and powerful character within the formal world of a superhero comic, she has to relinquish control of the images and "jump" into reality.

6

Key Texts

Key Terms

I

The Authorial Superhero

While there is no definitive canon for superhero comics, this chapter presents a list of key works as defined by a variety of elements including aesthetic quality, historical impact, and medium innovation. In terms of genre, a work's influence on other creators is as noteworthy as its merits individually. Some works listed here are historically significant, some are individually excellent, and some are both. While a comics text might include anything from a single comic strip to a collected comic book series to a graphic novel created and published as a single work, I define and so divide texts according to authorship, most often writer-artist collaborations on a single series. When an ongoing comic book title changes authors, it also changes texts. While a complete list of key texts might number into the hundreds, I have imposed practical limits, selecting only four works from each of the six Code-defined historical periods outlined in the introduction. In order to provide a wider range of important writers and artists, I have also limited the appearance of primary authors to one entry each. As a result, authors such as Alan Moore, the most repeatedly acclaimed creator of the genre, occupies only one of the twenty-four slots. Finally, I categorize texts into eras according to their beginning dates, meaning some bridge eras. The final, post-Code selection is the most tentative, since the period is ongoing.

Pre-Code era, 1934–54

**Siegel and Shuster's Superman in *Action Comics* and *Superman*
(1938–40).** After premiering in *Action Comics* #1 (June 1938),
the original incarnation of Superman was relatively short-lived.
Jerry Siegel continued to write the character, but due to his failing
eyesight co-creator Joe Shuster was no longer the primary artist
after the second year. Shuster penciled and inked the Superman
episodes in *Action Comics* #1–5, penciled and co-inked #6–10,
and then penciled or co-penciled all but three issues of #11–24
(May 1940), after which he contributed sporadically. After the
initial *Superman* July 1939 reprint edition, he penciled the entire
sixty-four-page quarterly *Superman* #2 and #3 (March 1940).
Shuster's run coincides roughly with Superman's first arch-nemesis,
the Ultra-Humanite, retconned in #13 as the mastermind behind
Superman's first year of adventures, seemingly killed in #21, and
replaced by Luthor in #23. Shuster however retained some artistic
control by subcontracting replacement artists through his "Shuster
Studio." Siegel and Shuster formally left DC, then National Allied
Publications, after their ten-year contract expired and they lost
their suit against the company for copyright of Superman.

**Finger and Kane's Batman in *Detective Comics* and *Batman*
(1939–43).** Because writer Bill Finger was employed by artist Bob
Kane who alone was contracted by Detective Comics, Inc., Kane
received sole creator and author credit for Batman. Though Finger
appears to have been the primary creator, he wrote only the first
two episodes before Gardner Fox's six-issue run from #29–34,
which introduced discordant supernatural and fantastical elements
that Finger eliminated upon his return on #35. Kane and Finger's
partnership and creative control of the character ended through
attrition. Finger wrote all of the Batman episodes in *Detective
Comics* from #35–59, seven of #60–68, and then only four of the
next seventeen issues, leaving the series after #85 (March 1944).
Kane penciled all but one issue from #27–74 and then four of the
next eight, leaving the series after #82 (December 1943). Kane
exclusively penciled the multi-story *Batman* #1–8 (December–
January 1941), and Finger wrote all of #1–10 (February–March
1942). *Batman* #14 (December–January 1942) was the first without

a story by Finger and #19 (April–May 1943) the first without art by Kane, after which both creators became increasingly rare. Finger wrote for a range of other DC titles, and Kane maintained credit for Batman after renegotiating his contract in 1949.

Eisner's *The Spirit* (1940–2). In 1939, Will Eisner left his comics studio partnership with Jerry Iger to manage a sixteen-page tabloid-sized insert for Sunday newspapers distributed by the Register and Tribune Syndicate. Unlike almost all other pre-1980s' creators, Eisner negotiated ownership of his work and received high artistic freedom. The first insert was published on June 2, 1940 and featured the first seven-page *The Spirit* episode written, penciled, and inked solely by Eisner. Initially a police detective, Denny Colt is seemingly killed and buried but returns to fight crime under a mask and alias. Eisner had created and co-created previous comic book heroes, including the Flame, Doll Man, Blackhawk, and the copyright-infringing Wonderman, but *The Spirit* provided the opportunities for innovation that would establish Eisner as a central pioneer of the comics medium. Beginning May 3, 1942, Eisner, now serving overseas in the military, turned co-pencils and inks over to ghost artists and scripts to ghost writers beginning June 7. He contributed sporadically during the war, returned as the primary writer on December 23, 1945, and as primary artist January 12, 1947. His writing contributions decreased again in 1949 and his art in 1951, until he was primarily only supervising when the series ended October 5, 1952.

Marston and Peter's Wonder Woman in *All Star Comics, Sensation Comics, Wonder Woman*, and *Comics Cavalcade* (1941–8). Wonder Woman was conceived by psychologist William Moulton Marston, who selected Harry G. Peter as artist and credited their collaboration under the joint pseudonym Charles Moulton. Marston also served on publisher M. C. Gaines' advisory board for All American Comics, a sibling company to Detective Comics and National Allied Publication, later jointly known as DC. Wonder Woman premiered in *All Star Comics* #8 (December 1941), on sale during the bombing of Pearl Harbor, before expanding to *Sensation Comics* (January 1942), *Wonder Woman* (Summer 1942), and *Comics Cavalcade* #1 (December 1942). Marston's run is notorious for themes of BDSM, which he intended to be instructional for young readers

because he believed that sexual bondage—pleasurable submission to another's loving authority—was central for conditioning good citizens. Marston died in 1947, but his writing continued to appear until Robert Kanigher officially replaced him on *Wonder Woman* #31 (September 1948). Peter continued on the series until his own death, with his last pencils and inks appearing in #97 (April 1958). With Superman and Batman, Wonder Woman is one of only three superhero characters in essentially continuous publication since their pre-World War II premieres.

First Code era, 1954–71

Lee and Kirby's *The Fantastic Four* (1961–70). Former Iger Studio employee Jack Kirby established himself as a major comics artist during World War II, most famously co-creating Captain America with Joe Simon in 1941 for Marvel's predecessor, Timely. Kirby and Stan Lee's nine-year run on *The Fantastic Four* from #1 (November 1961) to #102 (September 1970), is likely the longest continuous collaboration on a single title in comics history. The first issue marks publisher Martin Goodman's transition from the financially struggling Atlas Comics of the 1950s to the soon market-leading Marvel of the 1960s. The series redefined the superhero genre, while also retroactively exposing authorial and legal ambiguities that run to the core of the industry. Though Lee received sole writing credit, Kirby not only penciled but often produced storylines and drafted captions and dialogue independently, creating such characters as the Silver Surfer without Lee's prior input or even knowledge. Kirby died in 1994, and his estate filed for copyright termination for the characters that Kirby co-created. Marvel sued, arguing that he had been contracted on a work-for-hire basis. The Supreme Court was preparing to hear the case in 2014 when the recently Disney-purchased Marvel Entertainment settled out of court for an undisclosed sum. Had the Court ruled in favor of Kirby' heirs, not only would Marvel's blockbuster film franchise have been affected, but the precedent would have threatened all of Warner Brother's DC copyrights too. Lee continued writing *The Fantastic Four* for a year following Kirby's departure to DC in 1970, leaving the series after #115 (October 1971).

THE AUTHORIAL SUPERHERO 277

Lee and Ditko's Spider-Man in *Amazing Fantasy* and *The Amazing Spider-Man* (1962–6). Although Kirby drew the first sketches of the character, Lee chose to collaborate with Steve Ditko, who had been working with Atlas/Marvel since 1955. Publisher Martin Goodman had little faith in the character, largely because teenagers were typically cast as sidekick not lead heroes, slotting the original eleven-page episode in the series-cancelled *Amazing Fantasy* #15 (August 1962). Increased sales however allowed Lee to reintroduce the character six months later in a new title, *The Amazing Spider-Man* #1 (March 1963), which has in some form run continuously since. Ditko penciled and inked every issue through #38 (July 1966), after which he left Marvel for Charlton Comics. By the end of their collaboration, tensions between Lee and Ditko grew so high that the two reportedly no longer communicated directly, with Lee receiving Ditko's completed artboards through a third party. Unlike Kirby, Ditko objected to Lee's so-called Marvel Method in which pencilers worked without scripts and so assumed uncredited and uncompensated writing duties. Lee continued officially to write the series until #110 (July 1972).

Steranko's *Strange Tales, Nick Fury: Agent of S.H.I.E.L.D.* and *Captain America* (1967–9). Jim Steranko applied for a position at Marvel in 1966 and, after auditioning by inking two unused pages of Jack Kirby's original 1965 Nick Fury draft (Steranko 2013: 330–1), Stan Lee assigned him to "Nick Fury, Agent of S.H.I.E.L.D." in the split-feature *Strange Tales*. Steranko inked Kirby's twelve-page layouts for #151–3 and then wrote and produced all art from #154 (March 1967) to #168 and, when the series switched to twenty-page installments, #1–3 and #5 (October 1968) of its own title. After producing the covers for #6 and #7 (based on Salvador Dali), he created *Captain America* #110, #111 and #113 (May 1969), which featured crossover appearances by H.Y.D.R.A. and Nick Fury. Though Steranko's total output was modest and, as evidenced by others' fill-in work for *Nick Fury* #4 and *Captain America* #112, not always produced on deadline, his art was the most innovative since Will Eisner's in the 1940s, overturning the layout norms set by Kirby during the preceding decade. Steranko however disliked the editorial changes Lee sometimes imposed. On #111, for example, a panel sequence was to read counter-clockwise, but Lee reordered the talk balloons

so the images and dialogue contradict in the published version (Lee et al. 2014: 217, 280). As a result, Steranko produced only cover art for Marvel into the early seventies.

O'Neil and Adams's *Green Lantern Co-Starring Green Arrow* **(1970–2).** Neal Adams began his comics career illustrating newspaper strips in the early sixties, before starting at Warren and DC in 1967 and Marvel in 1969. Dennis O'Neil began as a writer at Marvel in 1966, before moving to Charlton and then DC where he famously reinterpreted *Wonder Woman* by eliminating the character's powers and iconic costume in 1969. Like Steranko, Adams and O'Neil are often cited in the transition from the Silver to the Bronze Age. They first worked together on two issues of *X-Men* and two issues of *Detective Comics* published at the start of 1970, but they are remembered for their redesign of *Green Lantern*, which beginning with #76 (April 1970) included Green Arrow. Though Adams' layouts are sometimes as innovative as Steranko's, his longest-lasting influence is the comparably realistic style he brought to the genre: "If superheroes existed, they'd look like I draw them" (Smith 2011). O'Neil brought a similar level of literary realism to the series by portraying Green Lantern outgrowing the naïvely simplistic understanding of good and evil that had defined superhero morality since the 1930s. After the title was cancelled with #89 (May 1972), the series finished as a back-up feature in four issues of *Flash*.

Second Code era, 1971–89

Claremont and Byrne's *The Uncanny X-Men* **(1977–81).** Chris Claremont has the longest run on any mainstream comics title. After Len Wein and Dave Cockrum's one-issue reinvention of the series, which had been reprinting 1960s issues since #67 (December 1970), Claremont wrote *The Uncanny X-Men* from #94 (August 1975) to #279 (August 1991), as well as numerous spin-offs including *New Mutants*, *Wolverine*, and *X-Men* #1 (October 1991), the highest-selling comic book of all-time. John Bryne penciled and often co-wrote #108 (December 1977) to #143 (March 1981), before moving on as writer-artist of a wide range of Marvel and DC titles including *Alpha Flight* (1983) and the Superman reboot

mini-series *The Man of Steel* (1986). Byrne further developed
the Adams-influenced visual style that would continue to define
superhero comics for the next decade, and Claremont's long-term
approach to multi-issue plotting and characterization became
increasingly standard. Claremont and Byrne's joint run includes the
X-Men's most acclaimed narrative arc, *The Dark Phoenix Saga*,
#129–38, ending with the death and funeral of Jean Grey (events
Byrne would help to retcon out of existence during his five-year
run of *The Fantastic Four* in 1986). Instead of Byrne, Claremont
initially partnered with Neal Adams for *God Loves, Man Kills*
(1982), one of the first graphic novels published in the Marvel
Graphic Novel format, but because Adams refused a standard
work-for-hire contract, Marvel replaced him with Brent Anderson.
Byrne returned to Marvel in the late 1980s to work on several titles
including *West Coast Avengers* and *Sensational She-Hulk*, after
which he wrote creator-owned titles for Dark Horse Comics.

Moore and Gibbons' *Watchmen* (1986–7). The most acclaimed
superhero comic of all-time, the twelve-issue *Watchmen*, along
with Frank Miller's four-issue *The Dark Knight Returns* (1986),
mark a turning point in the genre, with a leap in psychological
realism and a rejection of the Code-mandated triumph of absolute
good over absolute evil. Moore initially plotted the series with
characters DC had recently acquired from the defunct Charlton
Comics. When editors objected, he and Dave Gibbons nominally
redesigned the cast, creating morally flawed counterparts that
interrogate the decades-old norms of the superhero character type.
Because the series stood apart from the rest of the DC universe,
Moore and Gibbons received unusual creative freedom, and the
limited series format enabled them to work in a closed narrative
form that barred sequels, a rarity in comics at that time and a major
factor in the series' excellence. *Time* magazine listed *Watchmen* in
its one hundred best English-language novels published since 1923
(Grossman 2010). Moore's other major superhero works include
Marvelman / Miracleman (1982–9), *V for Vendetta* (1982–8), *The
Saga of the Swamp Thing* (1984–7), *The League of Extraordinary
Gentleman* (1999–2003), and *Promethea* (1999–2005).

Miller and Mazzucchelli's *Batman: Year One* (1987). Following
the successes of his first *Daredevil* run (1979–83), *Ronin* (1983–4),

and *The Dark Knight Returns* (1986), Frank Miller partnered with artist Bill Sienkiewicz for the graphic novel *Daredevil: Love and War* (1986) and the limited series *Elektra: Assassin* (1986–7) and penciler–inker David Mazzuchelli for the 1986 *Born Again* arc in *Daredevil* and DC's history-redefining *Year One* arc in *Batman* #404 (February) to #407 (May 1987), ending Miller's most productive period with DC and Marvel, after which he began publishing with Dark Horse. *Year One*, *Born Again*, and *The Dark Knight Returns* are widely regarded as Miller's best work. *Born Again*, however, is marred by a literal deus ex machina ending, and though less genre-influencing than the fascist-leaning *Dark Knight Returns*, *Year One*'s time scope pushed Miller into storytelling innovations where John Byrne's parallel *The Man of Steel* suffers in contrast. Unlike the sometimes cartoonish excesses of Miller's *Dark Knight Returns* art, Mazzuchelli's comparatively sparse style provided a realistic baseline rendered in short, grainy lines for the series' much praised gritty effect. Mazzuchelli soon left superhero comics, publishing an adaptation of Paul Auster's postmodern detective novel *City of Glass* in 1994 and the even more highly acclaimed *Asterios Polyp* in 2009.

Gaiman's *The Sandman* (1988–96). Neil Gaiman entered comics as a fan of *Swamp Thing* and then as a journalist, interviewing Alan Moore and other creators for a 1986 *Sunday Times Magazine* article that was never published because the editor was expecting a Wertham-esque critique of the industry (Gaiman 2016: 265, 233). DC first hired him for the 1987 *Black Orchid* limited series with the Sienkiewicz-influenced artist Dave McKean, after which Gaiman requested Sandman, a minor and largely forgotten superhero created by Gardner Fox and Bert Christman in 1939 and briefly reinvented by Joe Simon and Jack Kirby in 1974. Working with a wide range of artists including McKean for covers, Gaiman wrote the entire series, from #1 (January 1989) to the final #75 (March 1996), creating one of DC's most popular titles of the 90s and drawing acclaim and readership from outside traditional comics audiences. Reprint compilations sold well in trade paperback formats, expanding readership beyond direct market comic shops to general bookstores. Though the title began before DC instituted its creator-owning imprint Vertigo in 1993, Gaiman retained copyrights, and so when he left the series, it and its characters were

not continued. Gaiman moved from comics to a highly successful and ongoing career in literary speculative fiction, with sporadic returns to superhero comics, most notably *Marvel 1602* (2003).

Third Code era, 1989–2000

Morrison and McKean's *Arkham Asylum: A Serious House on Serious Earth* (1989). The term "graphic novel" emerged in the 1970s, and Marvel published Marvel Graphic Novel and Epic Graphic Novel imprints beginning in the 1982 that featured stand-alone works rather than collected reprints of pre-existing series. DC Graphic Novel used the same trade paperback format, and *Arkham Asylum*, published the October after the summer release of Tim Burton's *Batman* film, was one of the first printed in hardback, a norm of non-comics literary publishing. It soon became one of DC's best-selling graphic novels. Writer Grant Morrison had joined DC a year earlier, reviving the character Animal Man in a limited and then ongoing series and then *Doom Patrol* in early 1989. When DC assigned *Arkham* to artist Dave McKean, Morrison revised his original forty-eight-page script into a sixty-seven-page, screenplay-like format, giving McKean greater freedom for his expressionistic paintings, which expanded to 120 pages. Morrison later worked on a wide range of superhero titles, including his own creator-owned *The Invisibles* (1994–2000) through DC's Vertigo. Dave McKean left superhero comics to produce a range of acclaimed graphic novels, including most recently *Black Dog: The Dreams of Paul Nash* (2016) for Dark Horse.

McFarlane's *Spawn* (1992). Because Marvel refused to share copyrights, a prominent group of creators, including *Spider-Man* artist Todd McFarlane and *X-Men* writer Chris Claremont, left the company to form Image Comics in 1992. *Spawn* #1 (May 1992), one of Image's first publications, was a top-selling superhero comic of the year, drawing new attention to independent publishers in the Marvel-DC dominated market. Image joined Eclipse, which had formed in the late 1970s and was publishing Alan Moore's and briefly Neil Gaiman's *Miracleman*, and Dark Horse, which had formed in 1986 and featured Paul Chadwick's *Concrete* and

soon Mike Mignola's *Hellboy*. Image Comics, distributed entirely through the increasingly dominant direct market system, never joined the Comics Magazine Association of America and so *Spawn* and its other titles were never subject to the Comics Code. Though McFarlane partnered with various guest writers, including Moore and Gaiman, their contributions are largely forgotten, and *Spawn* is remembered primarily for its impact on the wider industry. McFarlane, along with fellow Image artists Rob Liefeld and Jim Lee, also largely defined the hypermuscular and hypersexualized style of the 1990s. Despite its emphasis on creator rights, Image, using the work-for-hire argument Marvel used against Jack Kirby, claimed full copyright of the character Angela co-created by Gaiman and McFarlane and introduced in *Spawn* #9 (March 1993). Gaiman won a lawsuit against Image in 2002, after which McFarlane relinquished his rights and Gaiman sold the character to Marvel where Angela was introduced in 2013.

McDuffie and Bright's *Icon* (1993–7). Another independent publisher, Milestone Comics formed in 1993 but in a distribution partnership with DC with both company logos appearing on covers. Milestone consisted entirely of African-American creators who retained ownership and creative control of their work. Dwayne McDuffie wrote or co-wrote all four of the initial titles, including *Icon*, penciled by M. D. Bright, who, like McDuffie, had worked on previous superhero titles for DC and Marvel. The two collaborated on all but five issues of the complete run, #1 (May 1993) to #42 (February 1997). The series features a Superman-like hero who, instead of landing in the twentieth century mid-west to be raised by white farmers, lands in the Antebellum South to be raised by an enslaved plantation worker. His Robin-like sidekick, Rocket, is a black teenager whose out-of-wedlock pregnancy and motherhood are central plots of the series. *Icon* is widely praised for bringing a diversity of accurately portrayed black characters to superhero comics. The series ended when the market collapse of the mid-1990s drove Milestone out of the comics business.

Waid and Ross' *Kingdom Come* (1996). The limited series *Kingdom Come* #1 (May 1996) to #4 (August 1996), was co-written by Mark Waid and Alex Ross and painted by Ross. As an Elseworld imprint, the story features a wide range of DC superheroes, but

outside of company continuity, enabling Waid and Ross to freely interpret and in some cases kill characters in a plotline involving the morally indifferent children of today's heroes. Ross conceived the story while working with writer Kurt Busiek on the similar, four-issue *Marvels* (1994), and DC teamed him with Alex Waid, who had written for a range of Marvel and DC titles, including *Captain America* and *The Flash*. The work is most significant for marking the highpoint of photorealism in the genre. In contrast to the comparably cartoonish standards of the period, Ross worked from live models and, instead of following the pencils-inks-colors process norm of the industry, painted in opaque watercolors. While Bill Seinkiewicz and Dave McKean had achieved similar moments of painterly photorealism, Ross maintained the style across his work. Due to the labor intensiveness of the approach, he produced mainly cover art after *Kingdom Come*.

Fourth Code era, 2001–11

Bendis and Gaydos' *Alias* (2001–3). Brian Michael Bendis is one of the most prolific Marvel writers of the twenty-first century. He wrote *Ultimate Spider-Man* (2000–9), has been the primary author of multiple Marvel cross-over event series, including *Avengers Disassembled* (2004), *House of M* (2005), *Age of Ultron* (2013), and *Civil War II* (2016), and as of 2016 was writing *Spider-Man*, *Guardians of the Galaxy*, and *Invincible Iron Man*. He partnered with artist Michael Gaydos to create *Alias* #1 (November 2001) through #28 (January 2004), after which he continued the characters Jessica Jones and Luke Cage in *The Pulse* and *New Avengers*. Gaydos, who also works in fine art and graphic design, renders his characters in a strikingly less idealized style than standard superhero comics art, with little or no attention to muscular and sexualization, while employing overlapping panel arrangements that highlight atypical amounts of undrawn gutter space. Gaydos' approach parallels Bendis' avoidance of standard superhero story tropes, including costumes and fight scenes. *Alias* is also notable as the first series published under Marvel's MAX imprint, created for the equivalent of R-rated content when the company stopped working under the Comics Code. This series is collected under

the title *Jessica Jones: Alias*, and Bendis and Gaydos reunited to continue the series in 2016.

Morales and Baker's *Truth: Red, White & Black* (2003). The idea of a World War II super-soldier program mirroring the infamous Tuskegee Syphilis experiments, in which the U.S. Public Health Service intentionally infected and left untreated hundreds of black men, originated from a comment made by Marvel publisher Bill Jemas to Marvel editor Axel Alonso (Carpenter 2005: 53–4). Alonso solicited a proposal from writer Robert Morales, and Kyle Baker, who had illustrated a *Vibe Magazine* comic strip with Morales, penciled and inked the series, #1 (January 2003) to #7 (July 2003). Alonso required changes when Morales' script drafts veered too far from the Tuskegee events, but the tragic ending in which the black Captain America, Isiah Bradley, suffers permanent brain damage akin to Muhammed Ali, was Morales' (Carpenter 2005: 54–5). The story is a uniquely grim but historically honest reimagining of Marvel's Golden Age. Baker's art is significant for stepping outside of the standard range of representational styles by taking the most overtly cartoonish approach in superhero comics at that time. The following year, Morales wrote eight issues of *Captain America*, with the last, #28 (August 2004), featuring both Steve Rogers and Isiah Bradley in the "Captain America & Captain America" cover banner and logo. Bradley's appearance and the debut of his grandson, the Patriot, in *Young Avengers* #1 (April 2005) established the events of *Truth* within official Marvel continuity.

Simone's *Birds of Prey* (2000–7, 2010–11). In 1999, Gail Simone co-founded the website Women in Refrigerators, which featured her list of dead or depowered female characters, created in response to *Green Lantern* #54 (August 1994) in which the hero finds his murdered girlfriend in his refrigerator. She wrote for Bongo Comics' *The Simpsons*, and then for Marvel's *Deadpool* in 2002, before moving to DC's *Birds of Prey* in 2003. Simone wrote #56 (August 2003) to #108 (September 2007) of the first series, as well as #1 (July 2010) to #13 (August 2011) of the second. She significantly expanded the all-female cast and the role of Barbara Gordon, the original Batgirl, who leads the group as Oracle. Wheelchair-bound after the rape and maiming depicted

in Alan Moore's 1988 *The Killing Joke*, Oracle is one of the few disabled but non-superpowered superheroes in the genre. Simone collaborated with a range of artists, including penciler Nicola Scott who continued to work with her on her next project, *Secret Six*, in 2009. Simone also moved to *Wonder Woman* in 2008, becoming the title's longest running female creator, *Batgirl* in 2011, and *Red Sonja* for Dynamite in 2013.

Rucka and Williams' Batwoman (2009–10). Following the Neil Gaiman-scripted funeral of Batman in the previous issue, *Detective Comics* #854 (August 2009) to #863 (May 2010) featured the redesigned Batwoman as its cover series. Greg Rucka wrote all ten episodes, and J. H. Williams III penciled all but two. The original character was introduced in 1956 as a love interest for Batman and so arguably a response to Frederick Wertham's claim that Batman and Robin were lovers. The rebooted lesbian character was introduced in 52 #7 (June) and as the cover feature of #11 (July 2006). She was DC's highest profile LGBTQ character, a theme Rucka continues by introducing Police Captain Maggie Sawyer (a lesbian character created by John Byrne for *Superman* in 1987) as her long-term love interest. Williams' use of two-page spreads and complex framing sequences are some of the most innovative layout designs since Steranko's and Adams' late 1960s work. Batman returned as the cover feature of *Detective Comics* #864, and Batwoman, as co-written and drawn by Williams, moved to her own ongoing series with the one-off *Batwoman* (January 2011) and *Batwoman* #1 (November 2011). The Rucka-Williams' *Detective Comics* #854–60 are collected under the title *Batwoman: Elegy*.

Post-Code era, 2011 to present

Fraction and Aja's Hawkeye (2012–15). Matt Fraction, husband of fellow Marvel writer Kelly Sue DeConnick, wrote the complete series, #1 (October 2012) to #22 (September 2015), with several artists, including David Aja who penciled roughly half of the issues. Unlike his earlier work, Fraction wrote only partial scripts in order to give Aja more creative freedom: "he produces things I'd never think of, let alone know how to explain in a script for someone to draw" (Bendis 2014: 58). Aja's style is reminiscent of

David Mazzuchelli's *Batman: Year One* and *Daredevil: Born Again* art, but incorporates non-naturalistic elements of abstract signage and diagrams to innovative effect. The series was one of the most acclaimed during the period of its three-year run, especially #11, an episode told from the perspective of the main character's dog, and #19, an episode told primarily in American Sign Language. Both Aja and Fraction worked, and continue to work, on a wide range of Marvel titles.

DeConnick's *Captain Marvel: Earth's Mightiest Hero* #1–17 (2012–15). The original superhero Captain Marvel was created by Bill Parker and C. C. Beck for Fawcett Comics in 1939, after which DC sued for copyright infringement. The court battle continued until the early 1950s, when Fawcett closed its comics division. Marvel later trademarked "Captain Marvel" by creating a new character with the same name in *Marvel Superheroes* #12 (December 1967). The supporting character U.S. Air Force Major Carol Danvers was introduced in #13, and, developing her own superpowers, was reintroduced in her own series in *Ms. Marvel* #1 (January 1977). The character underwent a range of changes, until assuming her predecessor's name in *Captain Marvel* #1 (August 2012). Working with a wide range of artists, DeConnick wrote the first series, #1 (January 2014) to #17 and continued through the second series, #1–18 (July 2015). DeConnick is one of the leading writers in contemporary comics; her other recent collaborations include *Pretty Deadly* with Emma Rios, *Bitch Planet* with Valentine De Landro, and *Parisian White* with Bill Sienkiewicz.

Wilson and Alphona's *Ms. Marvel* (2014–15). After Carol Danvers relinquished the name in 2012, the new Ms. Marvel character and series debuted with #1 (February 2014). Kamala Khan, a Muslim teenager living in Jersey City, NJ, is the first Muslim character to lead a superhero series. The concept originated with *Captain Marvel* editor Sana Amanat, who grew up as a Pakistani-American Muslim in a predominantly white, Christian New Jersey suburb. She approached writer G. Willow Wilson, who was born in New Jersey and moved to Cairo after converting to Islam in her early twenties, and artist Adrian Alphona to create the series. Kamala Khan's origin story both reiterates standard superhero tropes, while simultaneously overthrowing them, especially through Kamala's

relationship to her Pakistani parents and community. Alphona's art departs from the comparably naturalistic of style of his 2003–4 *Runaways* in favor of a style that exaggerates human proportions and so offsets Kamala Khan's shapeshifting ability. Alphona was the primary artist for the original run, drawing #1–5, #8–11, and #16–19. Wilson continued as writer of the ongoing All-New All-Different series beginning #1(January 2016), with Alphona appearing sporadically as a co-artist.

Coates and Stelfreeze's *Black Panther* (2016–17). Journalist and senior editor Ta-Nehisi Coates is well known for his articles in *The Atlantic* and *New York Times*. His *Between the World and Me* won the National Book Award for Nonfiction in 2015, the same year the MacArthur Foundation awarded him its renown "genius grant" and Marvel invited him to write an eleven-issue *Black Panther* series. Following an opposite trajectory as Neil Gaiman, who began in superhero comics and established a high-profile literary career afterwards, Coates is the most prestigious author from outside of superhero comics to enter the genre. He partnered with Brian Stelfreeze, a Marvel and DC artist since the early 1990s. #1 (June 2016) premiered as one of the year's top-selling comics, leading to a spin-off series, *World of Wakanda*, to be co-written by Coates, poet Yona Harvey, and fiction writer and essayist Roxane Gay, who is an associate professor of English and literary journal editor. Harvey and Gay are Marvel's first female African-American writers.

GLOSSARY

Abstraction a representational image's reductions in detail and alterations in line contour from real-world subject matter.

Atlas publisher Martin Goodman's 1950s' era comics company, previously named Timely and later renamed Marvel.

Cartoon an image drawn in a style that typically reduces details and exaggerates line contours for non-naturalistic effect.

Charlton comics publisher from 1944–84, known for the 1960s' superhero characters Captain Atom, the Question, and Blue Beetle (a reboot of the 1940s' character originally published by Fox).

Closure undrawn narrative information implied between juxtaposed images.

Colorist an artist who designs or co-designs color or gray tones and adds them to inked pages, sometimes with multiple assistants.

Comic book originally a pulp-paper magazine of newspaper comic strip reprints, i.e., a book of comics, now synonymous with graphic narrative.

Comic strip a syndicated newspaper comic, typically appearing as a single strip of panels if published daily and in multiple strips or full pages if published in Sunday editions.

Comics Code the censorship mandates of the Comics Magazine Association of America, 1954–2011.

Continuity the shared story world of multiple, ongoing characters depicted in multiple titles by multiple creators within a single publishing company.

Dark Horse comics company founded in 1986, currently the third largest independent after Image and IDW.

DC originally Detective Comics, Inc., the umbrella name soon included National Allied and All-American and later through acquisitions Quality, Fawcett, Charlton, and Wildstorm.

Diegesis a story as experienced by the characters within the story's world.

Direct Market the comic book sales system that replaced newsstand distribution with stores that specialize in comics.

Discourse the telling of a story through the specific words and images as experienced by readers.

Eclipse comics company from 1977–94, known for superhero titles *Miracleman*, *The Rocketeer*, and *Zot!*

Frame lines drawn around images to divide their content by evoking physical borders.

Framing rhetoric how the size and shape of a frame relate to the subject matter the frame contains.

Graphic novel a graphic narrative, whether published originally in its complete form or first serialized and then collected in longer book format.

Gutter spaces between panels.

Image largest comics publisher after Marvel and DC, founded in 1992.

Image-text any work that combines words and images, including comics.

Inker an artist who finalizes a comics page by penning over a penciler's sketches.

Inset an image surrounded by another image, as if placed atop it.

Layout rhetoric how the size and shape of an image relate to other images on the same page.

Letterer an artist who draws the scripted words inside speech balloons, thought balloons, and caption boxes.

Marvel Method a creative process associated with Stan Lee, who often gave collaborating artists plot summaries or general ideas and then added words to completed pages afterwards.

Motion line a line drawn to evoke movement, also called a blurgit.

Page sentencing Neil Cohn's visual grammar applied to page layout.

Panel subdivisions of a layout, traditionally framed and divided by gutters.

Penciler an artist who sketches a comics page, typically dividing content into a layout of discreet panels based on a writer's script or summary.

Radiation line a non-naturalistic line drawn to evoke energy, including mental or psychological, that is invisible to the characters themselves, also called emenata.

Reboot the creation of a new continuity based on but separate from a previous continuity.

Retcon the creation of new revelations that alter the interpretation of previous facts, short for "retroactive continuity."

Sound effects letters drawn by a penciler that typically form onomatopoeic words to evoke a sound.

Timely publisher Martin Goodman's first comics company, established in 1939, later renamed Atlas and then Marvel.

Vigilante from the Spanish word for "watchman," a self-appointed law enforcer who acts without legal authority or oversight.

Webcomics comics designed and produced for the Internet.

Writer a creator who conceives a story idea, plots the events, plans the image content and sequence of panels typically through a written script, and/or composes the words that appear in caption boxes and word and thought balloons after the pages have been drawn.

RESOURCES

While significant primary sources could number in the hundreds, I limited the Key Texts to twenty-four, with an emphasis on historical progression. I similarly limit a chronology of useful and historically significant secondary sources here. Since dozens of new and highly accomplished studies appear yearly, this list provides only a starting point for continuing research. See the **Works Cited** for full publication details.

"Don't Laugh at the Comics" (1940). Olive Byrne, writing under the pseudonym Olive Richard, interviewed her Psychology mentor, domestic partner, and future Wonder Woman creator, William Marston, for *The Family Circle*. Marston's comments on Superman are the first analysis of the character and emergent character type.

The Great Comic Book Heroes (1965). Jules Feiffer, a *Village Voice* cartoonist and social critic, published the first significant, albeit brief study of pre-Code superhero comics. His analysis of Superman's Clark Kent disguise was later popularized in Quentin Tarantino's *Kill Bill Vol. 2*.

"Stan Lee: Blinded by the Hype, An Affectionate Character Assassination" (1983). Alan Moore, an emerging British comics writer and future co-creator of *Watchmen*, detailed the genre-redefining significance of Lee and Kirby's 1961 Fantastic Four and the comparative weaknesses of Lee's later 1970s work.

Super Heroes: A Modern Mythology (1995). Richard Reynolds provides the first book-length academic study of the comic book superhero, emphasizing the shaping influence of Superman on the continuing genre.

The Great Women Superheroes (1996). Underground comix artist Trina Robbins began the archival recovery work of identifying

female superheroes and female creators, including Tarpé Mills' 1940s' Sunday strip *Miss Fury*, which Robbins later collected in a separate volume.

Black Superheroes, Milestone Comics, and Their Fans (2001). Anthropology professor Jeffrey A. Brown adapted his dissertation into the first major book-length overview of African-American characters, creators, and fans of superhero comics, with a special emphasis on Milestone Comics of the 1990s.

Comic Book Nation: The Transformation of Youth Culture in America (2001). Bradford W. Wright published one of the most popular, general-interest histories of comics that analyzed superheroes through a sociological lens.

The Myth of the American Superhero (2002). Though their definition of "superhero" is extremely broad and focused more on Western and crime films, John Shelton Lawrence and Robert Jewett's study reveals the underlying pattern of violently redemptive vigilantes in American hero mythology.

Men of Tomorrow: Geeks, Gangsters and the Birth of the Superhero (2004). Gerard Jones' biographical history provides dueling portraits of Superman's creators and the businessmen who transformed the character and genre into an international industry.

Arguing Comics: Literary Masters on a Popular Medium (2004). While collecting texts on the broader form, editors Jet Heer and Kent Worcester provide several pertinent to superheroes, including ones by early social critics Walter J. Ong, Marshall McLuhan, and Gershon Legman, as well as the 1962 "The Myth of Superman" by Italian semiotician Umberto Eco.

Superhero: The Secret Origin of a Genre (2006). Peter Coogan both explores the pre-comics history of the superhero character type and provides a new definition for its twenty-first-century incarnations.

Stan Lee: Conversations (2007). Jeff McLaughlin collects a range of radio and television interview transcripts focused primarily on Stan Lee's 1960s' innovative work at Marvel.

"Secret Skin: An Essay in Unitard Theory" (2008). Michael Chabon, who won the 2001 Pulitzer for his novel *The Amazing Adventures of Kavalier and Clay*, analyzes the significance of the superhero costume in the *New Yorker*.

Critical Approaches to Comics: Theories and Methods (2011).
Editors Matthew J. Smith and Randy Duncan provide nearly
two dozen critical lenses and corresponding case studies.
Marvel Comics: The Untold Story (2012). Sean Howe offers the
most complete and thorough history of the comics company.
The Superhero Reader (2013). Editors Charles Hatfield, Jeet Heer,
and Kent Worcester collect twenty-four of the most historically
significant essays on superhero comics, several of them
included in this list.
What Is a Superhero? (2013). Editors Robin S. Rosenberg and
Peter Coogan provide a collection of new short essays by both
scholars and comics writers.
Superwomen: Gender, Power, and Representation (2016).
Carolyn Cocca approaches the genre from the discipline of
political science and through the critical lens of intersectional
feminism.
Comichron: The Comics Chronicles. John Jackson Miller
maintains an ongoing blog with the most thorough and
up-to-date sales documentation available.

WORKS CITED

Aalsma, Matthew C, Daniel K. Lapsley, and Daniel J. Flannery (2006), "Personal Fables, Narcissism, and Adolescent Adjustment," *Psychology in the Schools* 43 (4): 481–91.

Abel, Jessica and Matt Madden (2008), *Drawing Worlds and Writing Pictures*. New York: First Second.

ACMP Publishers Code (1948), Available online: http://cbldf.org/the-acmp-code/ (accessed September 7, 2016).

Adams, Edward (2011), *Liberal Epic: The Victorian Practice of History from Gibbon to Churchill*. Charlottesville, VA: University of Virginia Press.

Alaniz, José (2014), *Death, Disability, and the Superhero: The Silver Age and Beyond*. Jackson: University Press of Mississippi.

Amann, Peter H. (1983), "Vigilante Fascism: The Black Legion as an American Hybrid," *Comparative Studies in Society and History* 25 (3): 490–524.

Amash, Jim and Eric Nolen-Weathington (eds) (2010), *Carmine Infantino: Penciler, Publisher, Provocateur*. Raleigh, NC: TwoMorrows.

Amash, Jim and Eric Nolen-Weathington (eds) (2012), *Matt Baker: The Art of Glamour*. Raleigh, NC: TwoMorrows.

Anderson, Lars (2004), *Domino Lady: The Complete Collection*. Somerset, NJ: Vanguard.

Andrae, Thomas (1987), "From Menace to Messiah: The History and Historicity of Superman," in Donald Lazere (ed.), *American Media and Mass Culture: Left Perspectives*. Berkeley: University of California Press, 124–38.

Andrews, Travis M. (2016), "The resurgence of comic books: The industry has its best-selling month in nearly two decades," *Washington Post*, July 12. Available online: https://www.washingtonpost.com/news/morning-mix/wp/2016/07/12/the-resurgence-of-comic-books-the-industry-has-its-best-selling-month-in-nearly-two-decades/ (accessed September 22, 2016).

'Are Comics Fascist?' (1945), *Time*, October 22. Available online: http://

content.time.com/time/magazine/article/0,9171,778464,00.html (accessed April 23, 2010).

Arnoudo, Marco (2010), *The Myth of the Superhero*, trans. Jamie Richards. Baltimore: Johns Hopkins University Press.

Ashworth, Laurence, Martin Pyle, and Ethan Pancer (2010), "The Role of Dominance in the Appeal of Violent Media Depictions," *Journal of Advertising* 39 (4): 121–34.

Avery-Natale, Edward (2013), "An Analysis of Embodiment Among Six Superheroes in DC Comics," *Social Thought and Research* 32: 71–106.

Baker, Kaysee and Arthur A. Raney (2007), "Equally Super?: Gender-Role Stereotyping of Superheroes in Children's Animated Programs," *Mass Communication & Society* 10 (1): 25–41.

Ball, Dewi I. (2012), "Mutual Assured Destruction," in James R. Arnold and Roberta Wiener (eds), *Cold War: The Essential Reference Guide*. Santa Barbara: ABC-CLIO, 146–8.

Barrett, Justin L., Emily Burdett, and Tenelle J. Porter (2009), "Counterintuitiveness in Folktales: Finding the Cognitive Optimum," *Journal of Cognition and Culture* 9 (3): 271–87.

Barret, Justin L. and Melanie A. Nyhoff (2001), "Spreading Non-natural Concepts: The Role of Intuitive Conceptual Structures in Memory and Transmission of Cultural Materials," *Journal of Cognition and Culture* 1 (1): 69–100.

Beaty, Bart (2005), *Fredric Wertham and the Critique of Mass Culture*. Jackson: University of Mississippi Press.

Beaty, Bart (2012), *Comics versus Art*. Toronto: University of Toronto Press.

Bendis, Brian Michael (2014), *Words for Pictures: The Art and Business of Writing Comics and Graphic Novels*. Berkeley: Watson-Guptill.

Benton, Mike (1991), *Superhero Comics of the Silver Age: The Illustrated History*. Dallas: Taylor.

Benton, Mike (1992), *Superhero Comics of the Golden Age: The Illustrated History*. Dallas: Taylor.

Berglund, Jeff (1999), "Write, Right, White, Rite: Literacy, Imperialism, Race, and Cannibalism in Edgar Rice Burroughs' *Tarzan of the Apes*," *Studies in American Fiction* 27 (1): 53–76.

Berlatsky, Noah (2013), "The Real Problem with Superman's New Writer Isn't Bigotry, It's Fascism," *The Atlantic*, February 19. Available online: http://www.theatlantic.com/entertainment/ archive/2013/02/the-real-problem-with-supermans-new-writer-isnt-bigotry-its-fascism/273262/ (accessed August 26, 2015).

Biddle, Sam (2015), "Spider-Man Can't Be Gay or Black," *Gawker*, June 19. Available online: http://gawker.com/

spider-man-cant-be-gay-or-black-1712401879 (accessed September 1, 2016).

Bierbaum, Mary, Tom Bierbaum, Keith Giffen, and Jason Pearson (1992), *Legion of Super-Heroes*, #31 (July), DC.

Biersdorfer, J. D. (2012), 'Spinning Their Web', review of *Marvel Comics: The Untold Story*, by Sean Howe, *New York Times*, November 16. Available online: http://www.nytimes.com/2012/11/18/books/review/marvel-comics-the-untold-story-by-sean-howe.html (accessed August 30, 2016).

Binder, Otto and C. C. Beck (1944), "Captain Marvel Presents 'Radar' the International Policeman," *Captain Marvel Adventures* #35 (May), Fawcett.

The Birth of a Nation (1915), [Film] Dir. D. W. Griffiths, USA: David W. Griffiths Corporation.

Black, Edwin (2003), *War Against the Weak: Eugenics and America's Campaign to Create a Master Race*. New York: Four Wall Eight Windows.

Blythe, Hal and Charlie Sweet (1983), "Superhero: The Six Step Progression," in Ray B. Browne and Marshall W. Fishwick (eds), *The Hero in Transition*. Bowling Green: Popular.

Boehmer, Elleke (2005), *Colonial and Postcolonial Literature: Migrant Metaphors*, 2nd edn. Oxford: Oxford University Press.

Bolton, Andrew (2008), *Superheroes: Fashion and Fantasy*. New York: Yale University Press.

Brennan, Donald G. (1971), "Strategic Alternatives I," *New York Times*, May 24, 31.

Broome, John (2014), *DC Showcase Presents: The Great Disaster Featuring the Atomic Knights*. New York: DC.

Brown, Jeffrey A. (2001), *Black Superheroes, Milestone Comics, and Their Fans*. Jackson: University Press of Mississippi.

Brown, Jeffrey A. (2013), "Panthers and Vixens: Black Superheroines, Sexuality, and Stereotypes in Contemporary Comic Books," in Sheena Howard and Ronald Jackson II (eds), *Black Comics: Politics of Race and Representation*. London: Bloomsbury, 133–50.

Brown, Slater (1940), 'The Coming of Superman', *New Republic*, September 2, 301.

Bukatman, Scott (2003), *Matters of Gravity: Special Effects and Supermen in the 20th Century*. Durham: Duke University Press.

Burgos, Carl, et al. (2013), *Marvel Firsts: WWII Superheroes*. New York: Marvel.

Burrage, Alfred S. (1885), *Spring-Heel'd Jack: The Terror of London*, *The Boy's Standard*, July–August. Available online: http://gutenberg.net.au/ebooks06/0602571h.html (accessed 25 August 25, 2010).

Burroughs, Edgar Rice (1983), *A Princess of Mars*. New York: Ballantine.

Burroughs, Edgar Rice (1999), *Tarzan of the Apes*. New York: Tor.

Byrne, John (1984), *Alpha Flight* #7 (February), Marvel.

Cadigan, Glen (2003), *The Legion of Super-Heroes Companion*. Raleigh, NC: TwoMorrows.

Campbell, Joseph (2004), *The Hero with a Thousand Faces*, commemorative edn. Princeton: Princeton University Press.

Capitanio, Adam (2010), "'The Jekyll and Hyde of the Atomic Age': *The Incredible Hulk* as the Ambiguous Embodiment of Nuclear Power," *Journal of Popular Culture* 43 (2): 249–70.

Carlyle, Thomas (1841) *On Heroes, Hero-Worship, and The Heroic in History*. Available online: http://www.gutenberg.org/files/1091/1091-h/1091-h.htm (accessed September 1, 2016).

Carnegie Museum of Art Archives, "Components from RHYTHM MASTR, 1999," Exhibition Catalogue, Carnegie Museum of Art, Pittsburgh.

Carpenter, Stanford W. (2005), "Truth Be Told: Authorship and the Creation of the Black Captain America," in Jeff McLaughlin (ed.), *Comics as Philosophy*. Jackson: University Press of Mississippi.

Carrington, Andre (2015), "Drawn into Dialogue Comic Book Culture and the Scene of Controversy in Milestone Media's Icon," in Frances Gateward and John Jennings (eds), *The Blacker the Ink: Constructions of Black Identity in Comics and Sequential Art*. New Brunswick: Rutgers University Press.

Carter, James Bucky (2004), "'There'll Be Others Converging': Fighting American, The Other, and 'Governing' Bodies," *International Journal of Comic Art* 6 (2): 364–75.

Carissimo, Justin (2016), "Marvel pulls sexualised Riri Williams cover after backlash," *Independent*. Available online: http://www.independent.co.uk/arts-entertainment/books/marvel-pulls-sexualized-riri-williams-cover-after-backlash-a7372911.html (accessed October 21, 2016).

Casey, Jim (2009), "Silver Age Comics," in *The Routledge Companion to Science Fiction*. London: Routledge, 123–33.

Cawalti, John G. (1976), *Adventure, Mystery, and Romance: Formula Stories as Art and Popular Culture*. Chicago: University of Chicago Press.

Chabon, Michael (2008), "Secret Skin: An Essay in Unitard Theory", *New Yorker*, March 10, 64–9.

Chambliss, Julian (2012), "Superhero Comics: Artifacts of the U.S. Experience Dr. Julian C. Chambliss," *Juniata Voices*, vol. 12. Huntingdon, PA: Juniata College.

Chaney, Michael A. (2007), "Superheroes," in Fedwa Malti-Douglas (ed.), *Encyclopedia of Sex and Gender*, vol. 4. Detroit: Macmillan Reference, 1439–41.

Cheyfitz, Eric (1991), *The Poetics of Imperialism: Translation and Colonization from The Tempest to Tarzan*. New York: Oxford University Press.

"Clan of the Fiery Cross" (1946), [Radio program] *The Adventures of Superman*, Mutual Broadcasting System, June 10. Available online: http://www.archive.org/details/adventuresofsupermanradio013 (accessed March 6, 2009).

Claremont, Chris and Frank Miller (2009), *Wolverine by Claremont & Miller*. New York: Marvel.

Cocca, Carolyn (2016), *Superwomen: Gender, Power, and Representation*. London: Bloomsbury.

"Code of the Comics Magazine Association of America, Inc." (1954), October 26. Available online: http://cbldf.org/the-comics-code-of-1954/ (accessed August 6, 2016).

Cohn, Neil (2013), *The Visual Language of Comics*. London: Bloomsbury.

"Comics Code Revision of 1971" (1971). Available online: http://cbldf.org/comics-code-revision-of-1971/ (accessed August 7, 2016).

"Comics Code Revision of 1989" (1989). Available online: http://cbldf.org/comics-code-revision-of-1989/ (accessed August 7, 2016).

Conroy, Mike (2004), *500 Comic Book Villains*. Hauppauge, NY: Collins & Brown.

Coogan, Peter (1995), "Comics Scholars Survey Results, November 1995." Available online: comics.lib.msu.edu/director/survres.htm (accessed January 18, 2015).

Coogan, Peter (2006), *Superhero: The Secret Origin of a Genre*. Austin, TX: MonkeyBrain.

Cook, Roy T. (2011), "Do Comics Require Pictures? Or Why Batman #663 Is a Comic," *Journal of Aesthetics and Art Criticism* 69 (3): 285–96.

Coombes, Annie E. and Avtar Brah (2000), "Introduction: The Conundrum of 'Mixing,'" *Hybridity and its Discontents: Politics, Science, Culture*. London: Routledge.

Costello, Matthew J. (2009), *Secret Identity Crisis: Comic Books and the Unmasking of Cold War America*. New York: Continuum.

Costello, Matthew J. (2015), "U.S. Superpower and Superpowered Americans in Science Fiction and Comic Books," in Gerry Canavan and Eric Carl Link (eds), *The Cambridge Companion to American Science Fiction*. Cambridge: Cambridge University Press, 125–38.

Cuddy, Lois A. and Claire M. Roche (2003), *Evolution and Eugenics in*

American Literature and Culture, 1880–1940: Essays on Ideological Conflict and Complexity. Lewisburg, PA: Bucknell University Press.

D'Amore, Laura Mattoon (2008), "Invisible Girl's Quest for Visibility: Early Second Wave Feminism and the Comic Book Superheroine," *Americana: The Journal of American Popular Culture 1900 to Present* 7 (2). Available online: http://www.americanpopularculture. com/journal/articles/fall_2008/d'amore.htm (accessed November 4, 2013).

Daniels, Les (1991), *Marvel: Five Fabulous Decades of the World's Greatest Comics.* New York: Harry N. Abrams.

Daniels, Les (1998), *Superman: The Complete History, The Life and Times of the Man of Steel.* San Francisco: Chronicle.

Davis, Blair (2015), "Bare Chests, Silver Tiaras, and Removable Afros: The Visual Design of Black Comic Book Superheroes," in Frances Gateward and John Jennings (eds), *The Blacker the Ink: Constructions of Black Identity in Comics and Sequential Art.* New Brunswick: Rutgers University Press.

DeConnick, Kelly Sue, Dexter Soy, and Emma Rios (2016), *Captain Marvel: Earth's Mightiest Hero,* vol. 1. New York: Marvel.

DeGraw, Sharon (2007), *The Subject of Race in American Science Fiction,* New York: Routledge.

De Haven, Tom (2010), *Our Hero: Superman on Earth.* New Haven: Yale University Press.

Dent, Lester (2008), *The Man of Bronze, Doc Savage,* vol. 1. San Antonio: Sanctum Productions.

DiPaolo, Marc (2011), *War, Politics and Superheroes.* Jefferson, NC: McFarland.

Dixon, Thomas, Jr. (1902), *The Leopard's Spots: A Romance of the White Man's Burden—1865–1900.* New York: Doubleday.

Dixon, Thomas, Jr. (2005), *The Clansman: An Historical Romance of the Ku Klux Klan.* Sioux Falls, SD: NuVision Publishing.

Donovan, John (2013), "Cold War in Comics: Clobberin' Commies and Promoting Nationalism in American Comics," in Julian C. Chambliss, William Svitavsky, and Thomas Donaldson (eds), *Ages of Heroes, Eras of Men: Supererheroes and the American Experience.* Newcastle upon Tyne: Cambridge Scholars, 55–91..

Doyle, Arthur Conan (1909), *The Crime of the Congo.* New York: Doubleday.

Dubose, Mike S. (2007), "Holding Out for a Hero: Reaganism, Comic Book Vigilantes, and Captain America," *Journal of Popular Culture* 40 (6): 915–35.

Dumas, Alexander (1997), *The Count of Monte Cristo.* London: Wordsworth.

Duncan, Randy and Matthew J. Smith (2009), *The Power of Comics: History, Form and Culture*. New York: Continuum.

Eaton, Lance (2013), "A Superhero for the Times: Superman's Fight Against Oppression and Injustice in the 1930s," Julian C. Chambliss, William Svitavsky and Thomas Donaldson (eds), *Ages of Heroes, Eras of Men*. Newcastle upon Tyne: Cambridge Scholars, 28–39.

Eco, Umberto (2004), "The Myth of Superman," in Jeet Heer and Kent Worcester (eds), *Arguing Comics: Literary Masters on a Popular Medium*. Jackson: University Press of Mississippi.

Egoff, Sheila (1980), "Precepts, Pleasures, and Portents: Changing Empases in Children's Literature," *Only Connect: Readings on Children's Literature*. Toronto: Oxford University Press.

Eisner, Will (1939), *Wonder Comics* #1, Fox. Available online: http://digitalcomicmuseum.com/index.php?dlid=1797 (accessed October 10, 2016).

Eisner, Will (2000), *The Spirit Archives*, vol. 1. New York: DC.

Eisner, Will (2008), *Comics and Sequential Art: Principles and Practices from the Legendary Artist*. New York: Norton.

Elkind, David (1967), "Egocentrism in Adolescence," *Child Development* 38 (4): 1025–34.

Emerson, Ralph Waldo (1844), *Representative Men*. Available online: http://www.emersoncentral.com/repmen.htm (accessed September 1, 2016).

Ennis, Garth and Darick Robertson (2008), *The Boys, Volume One: The Name of the Game*. Runnemede, NJ: Dynamite.

Eperjesi, John R. (2005), *The Imperialist Imaginary: Visions of Asia and the Pacific in American Culture*. Hanover: Dartmouth College Press.

Erskine, Hazel Gaudet (1963), "The Polls: Atomic Weapons and Nuclear Energy," *Public Opinion Quarterly* 27 (2): 155–90.

Evans, Orrin C. (ed), (1947), *All-Negro Comics* #1, (June). Philadelphia: All-Negro Comics.

"Everybody Has Telepathic Power, Dr. Carrel Says After Research" (1935), *New York Times*, September 18, ProQuest Historical Newspapers *The New York Times* (1881–2005).

Evnine, Simon J. (2015), "'But Is It Science Fiction?': Science Fiction and a Theory of Genre," *Midwest Studies in Philosophy* 39 (1): 1–28.

Falk, Lee and Phil Davis (1934), *Mandrake the Magician*, March 20. Available online: http://comicskingdom.com/mandrake-the-magician?sample=2 (accessed August 6, 2016).

Falk, Lee and Phil Davis (1934a), *Mandrake the Magician*, August 1. Available online: http://comicskingdom.com/mandrake-the-magician?sample=2 (accessed August 6, 2016).

Falk, Lee and Phil Davis (1939), *Mandrake the Magician*, June 11.

Available online: http://comicskingdom.com/blog/2013/09/18/ask-the-archivist-meet-mandrake-the-magician (accessed August 6, 2016).

Fegter, Brian (2012), "Stan Lee Answers Questions from *Comic Book Men* Fans," AMC.com. Available online: http://www.amc.com/talk/2012/12/comic-book-men-stan-lee-fan-interview-part-i (accessed August 27, 2016).

Feiffer, Jules (2003), *The Great Comic Book Heroes*. Seattle: Fantagraphic.

Fermosa, Jose (2015), "The Rise of the Woman Comic Buyer," OZY, September 11. Available online: http://www.ozy.com/acumen/the-rise-of-the-woman-comic-buyer/63314 (accessed September 1, 2016).

Fingeroth, Danny (2004), *Superman on the Couch: What Superheroes Really Tell Us about Ourselves and our Society*. New York: Continuum.

Fingeroth, Danny (2007), *Disguised as Clark Kent: Jews, Comics and the Creation of the Superhero*. New York: Continuum.

Fischer, Craig (2003), "Fantastic Fascism? Jack Kirby, Nazi Aesthetics, and Klaus Theweleit's Male Fantasies," *International Journal of Comic Art* 5 (1): 334–54.

Francis, Conseula (2015), "American Truths: Blackness and the American Superhero," in Frances Gateward and John Jennings (eds), *The Blacker the Ink: Constructions of Black Identity in Comics and Sequential Art*. New Brunswick: Rutgers University Press.

Gabilliet, Jean-Paul (2010), *Of Comics and Men: A Cultural History of American Comic Books*, trans. Bart Beaty and Nick Nguyen. Jackson: University Press of Mississippi.

Gaiman, Neil (2016), *The View from the Cheap Seats*. New York: HarperCollins.

Gaiman, Neil and Andy Kubert (2009), *Marvel 1602*. New York: Marvel.

Galinksy, Ellen, Kerstin Aumann, and James T. Bond (2008), "Times Are Changing: Gender and Generation at Work and Home," *Families and Work Institute*. Available online: http://familiesandwork.org/downloads/TimesAreChanging.pdf (accessed August 14, 2014).

Galton, Francis (1904), "Eugenics: Its Definition, Scope, and Aims," *American Journal of Sociology* 10 (1). Available online: http://galton.org/essays/1900-1911/galton-1904-am-journ-soc-eugenics-scope-aims.htm (accessed September 1, 2016).

Gaslin, Glenn (2001), "The Disappearing Comic Book," *Los Angles Times*, July 1. Available online: http://articles.latimes.com/2001/jul/17/news/cl-23089/2 (accessed August 27, 2016).

Gavaler, Chris (2015), *On the Origin of Superheroes: From the Big Bang to Action Comics No.1*. Iowa City: University of Iowa Press.

Genter, Robert (2007), "'With Great Power Comes Great Responsibility':
 Cold War Culture and the Birth of Marvel Comics," *Journal of
 Popular Culture* 40 (6): 953–78.
Gerber, Steve, Mary Skrenes, Steven Gant, Mark Gruenwald, Jim
 Mooney, Gil Kane, Herb Trimpe, and Ed Hannigan (2005), *Omega
 the Unknown Classic*. New York: Marvel.
Ghee, Kenneth (2013), "Will the Real Black Superheroes Please
 Stand Up?!: A Critical Analysis of the Mythological and Cultural
 Significance of Black Superheroes," in Sheena Howard and Ronald
 Jackson II (eds), *Black Comics: Politics of Race and Representation*.
 London: Bloomsbury, 223–38.
Gibson, Walter B. and Edward Hale Bierstadt (1937), "The Death House
 Rescue," *The Shadow*, [Radio program] Mutual Broadcasting System,
 September 26.
Gill, Ramon (2017), "Trevor Von Eeden speaks out on 40 years in
 the industry," *Comics Creator News*, August 14. Available online:
 http://comicscreatornews.com/trevor-von-eeden-speaks-out/ (accessed
 October 11, 2016).
Gillespie, Michele K. and Randal L. Hall (2006), "Introduction," in
 Thomas Dixon Jr. and the Birth of Modern America. Baton Rouge:
 Louisiana State University Press.
Goldstein, Nancy (2011), *Jackie Ormes: The First African-American
 Woman Cartoonist*, Ann Arbor: University of Michigan Press.
Gonce, Lauren O., M Afzal Upal, D. Jason Slone, and Ryan D. Tweney
 (2006), "Role of Context in the Recall of Counterintuitive Concepts,"
 Journal of Cognition and Culture 6 (3–4): 521–47.
Gordon, Ian (1998), *Comic Strips and Consumer Culture 1890–1945*.
 Washington: Smithsonian Institution Press.
Graeme, Bruce (1925), *Blackshirt*. London: T. Fisher Unwin.
Grant, Donald L. (2001), *The Way It Was in the South: The Black
 Experience in Georgia*. Athens: University of Georgia Press.
The Great Spy System, or, Nick Carter's Promise to the President (1907),
 New Nick Carter Weekly, 563, October 12, New York: Street &
 Smith. Available online: http://www.sul.stanford.edu/depts/dp/pennies/
 texts/carter2_toc.html (accessed March 17, 2009).
Green, Martin (1984), *The Great American Adventure*. Boston:
 Beacon.
Gresh, Lois and Robert Weinberg (2003), *The Science of Superheroes*.
 Hoboken, NJ: Wiley.
Groensteen, Thierry (2007), *The System of Comics*, trans. Bart Beaty and
 Nick Nguyen. Jackson: University Press of Mississippi.
Groensteen, Thierry (2013), *Comics and Narration*, trans. Ann Miller.
 Jackson: University Press of Mississippi.

Groff, Todd and Thomas Jones (2003), *Introduction to Knowledge Management*. Oxford: Butterworth-Heinemann.

Grossman, Lev (2010), "*Watchmen*," *Time*, January 11. Available online: http://entertainment.time.com/2005/10/16/all-time-100-novels/slide/watchmen-1986-by-alan-moore-dave-gibbons/ (accessed September 11, 2016).

Guynes, Sean (2015), "Fatal Attractions: AIDS and American Superhero Comics, 1988–1994," *International Journal of Comic Art* 17 (2): 177–216.

Hack, Brian (2009), "Weakness is a Crime: Captain America and the Eugenic Ideal in Early Twentieth Century America," in Robert Weiner (ed.), *Captain America and the Struggle of the Superhero*. Jefferson, NC: McFarland, 79–89.

Hadju, David (2008), *The Ten-Cent Plague: The Great Comic-Book Scare and How It Changed America*. New York: Farrar, Straus and Giroux.

Hall, Richard A. (2011), "The Captain America Conundrum: Issues of Patriotism, Race, and Gender in Captain America Comic Books, 1941–2001." PhD. diss., Graduate Department of History, Auburn University, Auburn, Alabama.

Hart, Christopher (2007), *Simplified Anatomy for the Comic Book Artist: How to Draw the New Streamlined Look of Action-Adventure Comics!* New York: Watson-Guptill.

Hegel, Georg Wilhelm Friedrich (1953), *Reason in History, a General Introduction to the Philosophy of History*, trans. Robert S. Hartman. Available online: https://www.marxists.org/reference/archive/hegel/works/hi/introduction.htm (accessed September 1, 2016).

Hickey, Walt (2014), "Comic Books Are Still Made By Men, For Mean And About Men," FiveThirtyEight, October 13. Available online: http://fivethirtyeight.com/features/women-in-comic-books/ (accessed September 8, 2016).

Hinckley, David (2013), "PBS announces 'Superheroes: The Never Ending Battle' as comic books continue to take over the world," *New York Daily News*, August 8. Available online: http://www.nydailynews.com/entertainment/tv-movies/pbs-announces-superheroes-ending-battle-article-1.1420911 (accessed September 1, 2016).

Hobsbawm, Eric (1981), *Bandits*. New York: Pantheon.

Hoppenstand, Gary (1982), "Introduction: The Missing Detective," *The Dime Novel Detective*. Bowling Green: Popular.

Hoppenstand, Gary (1983), "Pulp Vigilante Heroes, the Moral Majority and the Apocalypse," in Ray B. Browne and Marshall W. Fishwick (eds), *The Hero in Transition*. Bowling Green: Popular.

Hoppenstand, Gary (2000), "Introduction," in *The Scarlet Pimpernel*, Baroness Orczy. New York: Signet.

Howard, Sheena C. and Ronald L. Jackson II (2013), "Introduction," in Sheena Howard and Ronald Jackson II (eds), *Black Comics: Politics of Race and Representation*. London: Bloomsbury.

Howe, Sean (2012), *Marvel Comics: The Untold Story*. New York: HarperCollins.

Hudson, Laura (2015), "It's Time to Get Real About Racial Diversity in Comics," *Wired*, July 25. Available online: http://www.wired.com/2015/07/diversity-in-comics/ (accessed August 30, 2016).

Hughes, Bob (2005), Introduction, *Superman in the Forties*. New York: DC.

Hunter, George William (1914), *A Civic Biology Presented in Problems*. New York: American Book.

Isabella, Tony (2000), "Black Lightning and Me," Tony's Online Tips. Available online: http://www.proudrobot.com/hembeck/blacklightning.html (accessed November 1, 2016).

"Industry Statistic" (2016), Diamond Comics Distributors. Available online: http://www.diamondcomics.com/Home/1/1/3/237?articleID=173121 (accessed October 14, 2016).

Itkowitz, Mitch and J. Michael Catron (1980), "John Byrne: An X-tra Special, Four-Star, Flag-Waving Talk with the Artist of X-Men and Captain America," *The Comics Journal* 57 (Summer): 57–82.

Jang, Keum-Hee (2007), "Shaw and Galtonian Eugenics in Victorian Britain: Breeding Superman in Bernard Shaw's *Man and Superman*," *Journal of Modern British and American Drama* 20 (3): 225–50.

Jennings, John (2013), "Superheroes by Design," in Robin S. Rosenberg and Peter Coogan (eds), *What is a Superhero?* Oxford: Oxford University Press.

"Jerry Siegel Attacks!" (1940), *Das schwarze Korps*, April 25, trans. Randall Bytwerk. Available online: http://research.calvin.edu/german-propaganda-archive/superman.htm (accessed April 30, 2010).

Johnson, Jeffrey K. (2012), *Super-History: Comic Book Superheroes and American Society, 1938 to the Present*. Jefferson, NC: McFarland.

Jones, Dudley and Tony Watkins (2000), *A Necessary Fantasy? The Heroic Figure in Children's Popular Culture*. New York: Garland.

Jones, Gerard (2004), *Men of Tomorrow: Geeks, Gangsters and the Birth of the Superhero*. New York: Basic.

Kaempffert, Waldemare (1928). "The Superman: Eugenics Sifted," *New York Times*, May 27, ProQuest Historical Newspapers *The New York Times* (1881–2005).

Kaempffert, Waldemare (1932), "Genetic Principles," *New York Times*, September 25, ProQuest Historical Newspapers *The New York Times* (1881–2005).

Kane, Bob and Finger (2006), *The Batman Chronicles*, vol. 1. New York: DC.

Kaplan, Arie (2008), *From Krakow to Krypton: Jews and Comic Books*. Philadelphia: Jewish Publication Society of America.

Kelly, Joe and Ed McGuiness (2016), *Spider-Man/Deadpool* #1 (January). New York: Marvel.

Kennedy, John F. (1963), "Commencement Address at American University, June 10, 1963." Available online: https://www.jfklibrary.org/Asset-Viewer/BWC7I4C9QUmLG9J6I8oy8w.aspx (accessed August 30, 2016).

Kerslake, Patricia (2007), *Science Fiction and Empire*. Liverpool: Liverpool University Press.

Kevles, Daniel J. (1985), *In the Name of Eugenics: Genetics and the Uses of Human Heredity*. Berkeley: University of California Press.

Kipling, Rudyard (1998), *Kim*. Wickford, RI: North Books.

Klock, Geoff (2002), *How to Read Superhero Comics and Why*. New York: Continuum.

Kohlberg, Lawrence (1981), *The Philosophy of Moral Development: Moral Stages and the Idea of Justice*. New York: Harper & Row.

Kountouriotis, Vasileious-Pavlos (2008), "The Appeal of Action Films Containing Violence: *Kill Bill Vol. 1*, A Case Study and a Spectator's Psychophysiological Responses." MA thesis, Trinity Laban Conservatoire of Music and Dance, London.

Kraft, Amy (2013), "ComiXology: The Changing Face of Comic Book Readers," *GeekDad*, October 10. Available online: https://geekdad.com/2013/10/comixology-comic-book-readers/ (accessed August 27, 2016).

Kripal, Jeffrey J (2011), *Mutants and Mystics: Science Fiction, Superhero Comics, and the Paranormal*. Chicago: University of Chicago Press.

Kutzer, M. Daphne (2000), *Empire's Children: Empire and Imperialism in Classic British Children's Books*. New York: Garland.

Lackaff, Derek and Michael Sales (2013), "Black Comics and Social Media Economics: New Media, New Production Models," in Sheena Howard and Ronald Jackson II (eds), *Black Comics: Politics of Race and Representation*. London: Bloomsbury, 65–78.

Lankester, E. Ray (1880), *Degeneration: A Chapter of Darwinism*. London: MacMillan.

Lawrence, John Shelton and Robert Jewett (2002), *The Myth of the American Superhero*. Grand Rapids: Eerdmans.

"THE LEAGUE: Superman!" (1935), *Time*, April 29. Available online: http://content.time.com/time/magazine/article/0,9171,754597,00.html (accessed September 6, 2016).

Lee, Stan (1968), "Stan's Soapbox", *Fantastic Four* #81 (December). New York: Marvel. Available online: bullpenbulletins.blogspot.com/ search/label/1968 (accessed September 6, 2016).

Lee, Stan (2009), "Introduction," *Secret Identity: The Fetish Art of Superman's Co-creator Joe Shuster*, Craig Yoe. New York: Abrams Comic Arts.

Lee, Stan and John Buscema (1984), *How to Draw the Marvel Way*. New York: Simon & Schuster.

Lee, Stan, Gene Colan and John Romita, Sr. (1970), *Captain America*, #126 (June). New York: Marvel.

Lee, Stan and Steve Ditko (2006), *Essential Spider-Man*, vol. 1. New York: Marvel.

Lee, Stan and Steve Ditko (2009), *The Amazing Spider-Man: Marvel Masterworks*. New York: Marvel.

Lee, Stan, Gary Friedrich, and Larry Lieber (2011), *Marvel Firsts: The 1960s*. New York: Marvel.

Lee, Stan and Jack Kirby (2008), *Essential Fantastic Four*, vol. 1. New York: Marvel.

Lee, Stan and Jack Kirby (2011), *Essential Fantastic Four*, vol. 3. New York: Marvel.

Lee, Stan, Jack Kirby, and Steve Ditko (2006), *Essential Hulk*, vol. 1. New York: Marvel.

Lee, Stan, Jack Kirby, and Jim Steranko (2014), *Captain America: Marvel Masterworks*, vol. 3. New York: Marvel.

Lee, Stan, Larry Lieber, Robert Bernstein, N. Korok, Al Hartley, Don Heck, Jack Kirby, and Steve Ditko (2008), *Essential Iron Man*, vol. 1. New York: Marvel.

Lee, Stan and John Romita, Sr. (1967), *The Amazing Spider-Man,* #52, (September). New York: Marvel.

Legman, Gershon (2004), 'From *Love and Death: A Study in Censorship*', in Jet Heer and Kent Worcester (eds), *Arguing Comics: Literary Masters on a Popular Medium*. Jackson: University Press of Mississippi, 112–21.

Lie, Nadia (2001), "Free Trade in Images? Zorro as Cultural Signifier in the Contemporary Global/Local System," *Nepantla: Views from South* 2 (3): 489–508.

Lobdell, Scott and Mark Pacella (1992), *Alpha Flight* #106 (March), Marvel.

Loomba, Ania (2005), *Colonialism/Postcolonialism*, 2nd edn. London: Routledge.

Lopes, Paul (2009), *Demanding Respect: The Evolution of the American Comic Book*. Philadelphia: Temple University Press.

Lupoff, Richard A. (2005), *Master of Adventure: The Worlds of Edgar Rice Burroughs*. Lincoln: University of Nebraska Press.

Mackie, Chris (2007), "Men of Darkness," in Wendy Haslem, Angela Ndaliansis, and Chris Mackie (eds), *Super/Heroes: From Hercules to Superman*. Washington: New Academia, 82–95.

Madrid, Mike (2009), *The Supergirls: Fashion, Feminism, Fantasy, and the History of Comic Book Heroines*. Ashland, OR: Exterminating Angel Press.

The Mark of Zorro (1920), [Film] Dir. Fred Niblo, USA: Douglas Fairbanks Pictures.

Markstein, Donald D. (2010), *Don Markstein's Toonopedia*. Available online: http://toonopedia.com/ (accessed August 20, 2010).

Marston, William Moulton (1943), "Why 100,000,000 Americans Read Comics," *The American Scholar* 13 (1): 34–43.

Marston, William Moulton, et al. (2007), *Wonder Woman: The Greatest Stories Ever Told*. New York: DC.

Marston, William Moulton and Harry G. Peter (2010), *Wonder Woman Chronicles*, vol. 1. New York: DC.

Marston, William Moulton and Harry G. Peter (2011), *Wonder Woman Chronicles*, vol. 2. New York: DC.

McCann, Sean (1997), "Constructing Race Williams: The Klan and the Making of Hard Boiled Crime Fiction," *American Quarterly* 49 (4): 677–716.

McCarthy, Joe (1952), *McCarthyism: The Fight for America*. New York: Devin-Adair.

McCloud, Scott (1993), *Understanding Comics: The Invisible Art*. New York: Kitchen Sink.

McCloud, Scott (2006), *Making Comics: Storytelling Secrets of Comics, Manga and Graphic Novels*. New York: Harper.

McCulley, Johnston (1998), *The Mark of Zorro*. New York: Tor.

McDuffie, Dwayne (2002), "Foreword by the Author, 'Deus Ex Machina' (*Deathlok* issue 5)," in Nat Gertler (ed.), *Panel One: Comic Book Scripts by Top Writers*. Thousand Oaks, CA: About Comics.

McDuffie, Wayne and M. D. Bright (2009), *Icon: A Hero's Welcome*. New York: DC.

McLuhan, Marshall (2004a), "From *The Mechanical Bride: Folklore of Industrial Man*," in Jet Heer and Kent Worcester (eds), *Arguing Comics: Literary Masters on a Popular*

McLuhan, Marshall (2004b), "Superman," in *The Mechanical Bride: Folklore of Industrial Man*, in Jeet Heer and Kent Worcester (eds),

Arguing Comics: Literary Masters on a Popular Medium. Jackson: University Press of Mississippi.

McLaughlin, Jeff, ed. (2007), *Stan Lee: Conversations.* Jackson: University Press of Mississippi.

"Medicine: Puddles of Blood" (1948), *Time,* March 29. Available online: http://content.time.com/time/magazine/article/0,9171,804597,00.html (accessed April 23, 2010).

Mein, Eric (2006), "A Princess of Where? Burroughs's Imaginary Lack of Place," *West Virginia University Philological Papers* 53: 42–7.

Meisler, Stanley (1988), "Reagan Recants 'Evil Empire' Description," *Los Angeles Times,* June 1. Available online: http://articles.latimes.com/1988-06-01/news/mn-3667_1_evil-empire (accessed August 30, 2016).

Memmi, Albert (1957), *The Colonizer and the Colonized.* Boston: Beacon.

Mendel, Gregor (1865), "Experiments on Plant Hybridization," trans. William Bateson and Roger Blumberg, Electronic Scholarly Publishing Project. Available online: http://www.esp.org/foundations/genetics/classical/gm-65.pdf (accessed September 1, 2016).

Messner-Loebs William and Greg LaRocque (1991), *Flash* #53 (August). New York: DC.

Meyerhoff, Howard A. (1954), "Arms and Manpower," *The Bulletin of the Atomic Scientists* 10 (4): 119–22.

Miller, Frank, Klaus Janson, and Lynn Varley (1986), *The Dark Knight Returns.* New York: DC.

Miller, Frank and Bill Sienkiewicz (2012), *Elektra: Assassin.* New York: Marvel.

Miller, John Jackson (2016), "2015 Comic Book Sales Figures," *Comichron: The Comics Chronicles.* Available online: http://www.comichron.com/monthlycomicssales/2015.html (accessed August 27, 2016).

"Miracleman Alias Marvelman" (1985), in *Miracleman* #1 (August). Eclipse.

Moore, Alan (1983), "Stan Lee: Blinded by the Hype, An Affectionate Character Assassination," *The Daredevils* 3/4 (March/April): 44–8.

Moore, Alan and Dave Gibbons (1987), *Watchmen.* New York: DC.

Moore, Alan and John Totleben (1988), *Miracleman* #14 (April). Eclipse.

Morales, Robert and Kyle Baker (2004), *Truth: Red, White & Black.* New York: Marvel.

Moser, John (2009), "Madmen, Morons, and Monocles: The Portrayal of the Nazis in *Captain America,*" in Robert Weiner (ed.), *Captain America and the Struggle of the Superhero.* Jefferson, NC: McFarland, 24–35.

Mosher, Donald and Silvan Tomkins (1988), "Scripting the Macho Man:

Hypermasculine Socialization and Enculturation," *Journal of Sex Research* 25 (1): 60–84.

Murnen, Sarah K. and Donn Byrne (1991), "Hyperfemininity: Measurement and Initial Validation of the Construct," *Journal of Sex Research* 28 (3): 478–89.

Murray, Christopher (2011), *Champions of the Oppressed? Superhero Comics, Popular Culture, and Propaganda in America During World War II*. Cresskill, NJ: Hampton.

Murray, Will (2007), "The Shadowy Origins of Batman," *The Shadow*, vol. 9. Encinitas: Sanctum.

Murray, Will (2008), "Intermission," *Doc Savage*, vol. 14. Encinitas: Nostalgia Ventures.

Nama, Adilifu (2011), *Super Black: American Pop Culture and Black Superheroes*. Austin: University of Texas Press.

Nevins, Jess (n.d.), *Encyclopedia of Golden Age Superheroes*. Available online: http://jessnevins.com/encyclopedia/characterlist.html (accessed May 25, 2016).

Nevins, Jess (n.d.), *Pulp and Adventure Heroes of the Pre War Years*. Available online: geocities.com/jjnevins/pulpsintro.html (accessed March 6, 2009).

Nevins, Jess (2005), "Spring-Heeled Jack," *Encyclopedia of Fantastic Victoriana*. Austin: MonkeyBrain, 820–4.

Newton, Michael and Judy Ann Newton (1991), *The Ku Klux Klan: An Encyclopedia*. New York: Garland.

Nick Carter, Detective: The Solution of a Remarkable Case (1891), *Nick Carter Detective Library* 1. New York: Smith & Street. Available online: http://wwwsul.stanford.edu/depts/dp/pennies/texts/carter1_toc.html (accessed March 17, 2009).

Nordau, Max Simon (1895), *Degeneration*. New York: Appleton.

Norenzayan, Ara, Scott Atran, Jason Faulkner, and Mark Schaller (2006), "Memory and Mystery: The Cultural Selection of Minimally Counterintuitive Narratives," *Cognitive Science* 30 (3): 531–53.

North, Sterling (1941), "The Antidote to Comics," *National Parent Teacher Magazine* (March): 16–17.

Nyberg, Amy Kiste (1998), *Seal of Approval: The History of the Comics Code*. Jackson: University Press of Mississippi.

O'Herir, Andrew (2012), "The Dark Knight Rises: Christopher Nolan's Evil Masterpiece," *Salon*, July 18. Available online: http://www.salon.com/2012/07/18/the_dark_knight_rises_christopher_nolans_evil_masterpiece/ (accessed August 26, 2015).

O'Neil, Dennis (2013), "Superheroes and Power," in Robin S. Rosenberg and Peter Coogan (eds), *What Is a Superhero?* Oxford: Oxford University Press.

O'Neil, Dennis and Neal Adams (2012), *Green Lantern / Green Arrow*. New York: DC.

Orczy, Baroness (2000), *The Scarlet Pimpernel*. New York: Signet.

Packard, Frank L. (2005), *The Adventures of Jimmie Dale*. N.p.: Echo Library.

Page, Norvell (2007), *The Spider: Robot Titans of Gotham*. Riverdale, NY: Baen.

Palmer-Mehta, Valerie and Kellie Hay (2005), "A Superhero for Gays?: Gay Masculinity and Green Lantern," *Journal of American Culture* 28 (4): 390–404.

Panuska, Sarah Margaret (2013), "The Bulge That Dare Not Speak Its Name: Camp, Clones, and the Evolution of the Gay Superhero." MA thesis, Michigan State University, East Lansing, MI.

Payne, Britton (2006), "Superman v. Wonderman: Judge Hand's Side-By-Side Comparison for Superhero Infringement." Available online: brittonpayne.com/Marvel/SupermanWonderman.htm (accessed August 25, 2010).

Pitkethly, Claire, (2013), "Straddling a Boundary: The Superhero and the Incorporation of Difference," in Robin S. Rosenberg and Peter Coogan (eds), *What Is a Superhero?* Oxford: Oxford University Press.

Poole, Shelia (1993), "Black Publishers Launch Superbattle For Comic Book Heroes," *Chicago Tribune*, April 18. Available online: http://articles.chicagotribune.com/1993-04-18/business/9304200048_1_milestone-media-black-superheroes-white-superheroes (accessed August 31, 2016).

Priest, Christopher and ChrisCross (1997), *Xero* #1 (May). New York: DC.

"Priest Warns of Peril of Comic Books" (1946), *New York Times*, August 24. ProQuest Historical Newspapers *The New York Times*.

Proctor, William (2012), "Regeneration and Rebirth: Anatomy of the Franchise Reboot," *Scope: An Online Journal of Film and Television Studies* 22 (February). Available online: https://www.nottingham.ac.uk/scope/documents/2012/february-2012/proctor.pdf (accessed September 1, 2016).

Queenan, Joe (2013), "Man of Steel: Does Hollywood need saving from superheroes?" *Guardian*. Available online: https://www.theguardian.com/film/2013/jun/11/man-steel-hollywood-break-superheroes (accessed June 11, 2013).

Quinn, Ben (2016), "Real-life superhero? Marvel and DC comics back down against Londoner," *Guardian*, May 24. Available online: https://www.theguardian.com/uk-news/2016/may/24/superhero-marvel-dc-comics-graham-jules-court (accessed September 22, 2016).

Raphael, Jordan and Tom Spurgeon (2003), *Stan Lee and the Rise and Fall of the American Comic Book*. Chicago: Chicago Review.

Rathus, Spencer A. (2014), *Childhood and Adolescence: Voyages in Development*. Boston: Cengage Learning.

Rautoiu, Alin (2016), "Theory of superhero comics as two distinct genres," *Medium*, May 9. Available online: https://medium.com/@ Engineeredd/webcomicsdotroeng-385c3693deae#.9dc26cnol (accessed August 30, 2016).

Reagan, Ronald (1983), "Remarks at the Annual Convention of the National Association of Evangelicals in Orlando, Florida, March 8, 1983." Available online: https://reaganlibrary.archives.gov/archives/speeches/1983/30883b.htm (accessed August 30, 2016).

Reed, Douglass (1941), *A Prophet at Home*. Available online: http://douglasreed.co.uk/prophet.pdf (accessed May 30, 2010).

Reichstein, Andreas (1998), "Batman—An American Mr. Hyde?" *Amerikastudien/American Studies* 43 (2): 329–50.

Reitz, Caroline (2004), *Detecting the Nation: Fictions of Detection and the Imperial Venture*. Columbus: Ohio State University Press.

Reynolds, Richard (1992), *Super Heroes: A Modern Mythology*. Jackson: University Press of Mississippi.

Richard, Olive (1940), "Don't Laugh at the Comics," *The Family Circle*, October 25: 10–11, 22.

Richards, Jeffrey (1989), *Imperialism and Juvenile Literature*. Manchester: Manchester University Press.

Rieder, John (2008), *Colonialism and the Emergence of Science Fiction*. Middletown, CT: Wesleyan University Press.

Rifas, Leonard (2010), "Race and Comix," in Frederick Luis Aldama (ed.), *Multicultural Comics: From Zap to Blue Beetle*, Austin: University of Texas Press, 27–38.

Rifas, Leonard (2017), *Korean War Comic Books*. Jefferson, NC: McFarland.

Robbins, Trina (1996), *The Great Women Superheroes*. Northampton, MA: Kitchen Sink.

Roblou, Yann (2012), "Complex Masculinities: The Superhero in Modern American Movies," *Culture, Society and Masculinities* 4 (1): 76–91.

Rollin, Roger B. (2013), "The Epic Hero and Pop Culture," in Charles Hatfield, Jeet Heer, and Kent Worcester (eds), *The Superhero Reader*. Jackson: University Press of Mississippi.

Rowe, John Carlos (2000), *Literary Culture and U.S. Imperialism*. Oxford: Oxford University Press.

Rubinstein, Sharon and Benjamin Caballero (2000), "Is Miss America an Undernourished Role Model?" *Journal of American Medical Association* 283 (12): 1569.

Russell, Bertrand and Albert Einstein (1955), "The Russell-Einstein Manifesto," July 9. Available online: https://pugwash.org/1955/07/09/statement-manifesto/ (accessed August 30, 2016).

Rychlak, Ronald J. (2011), "A War Prevented: Pope John XXIII and the Cuban Missile Crisis," *Crisis Magazine*, November 11. Available online: http://www.crisismagazine.com/2011/preventing-war-pope-john-xxiii-and-the-cuban-missile-crisis (accessed August 30, 2016).

Sadowski, Greg, ed. (2009), *Supermen! The First Wave of Comic Book Heroes 1936–1941*. Seattle: Fantagraphics.

Said, Edward W. (1978), *Orientalism*. New York: Pantheon.

Said, Edward W. (1993), *Culture and Imperialism*. New York: Knopf.

Salter, William MacKintire (1917), *Nietzsche the Thinker: A Study*. New York: Holt.

Santori-Griffith, Matt (2016), "Exclusive Interview: Greg Rucka on Queer Narrative and WONDER WOMAN," *Comicosity*, September 28. Available online: http://www.comicosity.com/exclusive-interview-greg-rucka-on-queer-narrative-and-wonder-woman/ (accessed September 30, 2016).

Schelly, Bill (2010), *Founders of Comic Fandom*. Jefferson, NC: McFarland.

See, Fred G. (1984), "'Writing so as Not to Die': Edgar Rice Burroughs and the West beyond the West," *MELUS* 11 (4): 59–72.

Shaw, Bernard (1928), *Man and Superman: A Comedy and a Philosophy*. New York: Brentano's.

Shooter, Jim, and George Pérez (1978), *The Avengers* #168 (February). New York: Marvel.

Shooter, Jim and Roger Stern (1980), *Hulk Magazine* #23 (October). New York: Marvel.

Shyminsky, Neil (2011), "'Gay' Sidekicks: Queer Anxiety and the Narrative Straightening of the Superhero," *Men and Masculinities* 14 (3): 288–308.

Simone, Gail (1999), *Women in Refrigerators*. Available online: http://lby3.com/wir/index.html (accessed October 11, 2016).

Simonson, Walter, Louise Simonson, Jon J. Muth, and Kent Williams (1988), *Havok & Wolverine: Meltdown* #3 (December). New York: Marvel.

Singer, Marc (2002), "'Black Skins' and White Masks: Comic Books and the Secrets of Race," *African-American Review* 36 (1): 107–19.

Siegel, Jerry (1933), "The Reign of the Superman," *Science Fiction: The Advance Guard of Civilization* 1 (January): 4–14.

Siegel, Jerry (1975), "The Victimization of Superman's Originators, Jerry Siegel and Joe Shuster," October. Available online: http://ohdannyboy.

blogspot.com/2012/07/curse-on-superman-movie-look-back-at. htmlPage (accessed September 1, 2016).

Siegel, Jerry and Joe Shuster (2006), *The Superman Chronicles*, vol. 1. New York: DC.

Siegel, Jerry and Joe Shuster (2007), *The Superman Chronicles*, vol. 2. New York: DC.

Siegel, Jerry and Joe Shuster (2007a), *The Superman Chronicles*, vol. 3. New York: DC.

Simmers, George (2010), "Is Blackshirt a Fascist?" Great War Fiction, June 23. Available online: https://greatwarfiction.wordpress. com/2008/06/23/is-blackshirt-a-fascist/ (accessed May 30, 2010).

Simon, Joe (1990), "The Joe Simon Interview," Garry Groth, *The Comics Journal* 134 (February). Available online: http://www.tcj.com/ the-joe-simon-interview/ (accessed September 10, 2012).

Simon, Joe and Jack Kirby (2011), *Fighting American*. London: Titan.

Slide, Anthony (2004), *American Racist: The Life and Films of Thomas Dixon*. Lexington: University Press of Kentucky.

Slotkin, Richard (1998), *Gunfighter Nation: The Myth of the Frontier in Twentieth-Century America*. Norman: University of Oklahoma Press.

Smith, Andrew A. (2011), "Comics: Neal Adams overview illustrates his lasting impact," *Seattle Times*, June 29. Available online: http://www. seattletimes.com/entertainment/books/comics-neal-adams-overview- illustrates-his-lasting-impact/ (accessed May 13, 2015).

Smith, Jacob (2011), "A Distinguished Burglar: The Cinematic Life of a Criminal Social Type," *Journal of Film and Video* 63 (4): 35–43.

Smith, Zack (2008), "Turning the Clock Back Greg Sadowski on *Supermen!*" Newsarama, December 9. Available online: http://www. newsarama.com/1705-turning-the-clock-back-greg-sadowski-on- supermen.html (accessed April 23, 2010).

Southard, R. (1944), "Parents Must Control the Comics," *Saint Anthony Messenger: A National Catholic Family Magazine* (May): 3–5.

Sparks, Glenn G., John Sherry, and Graig Lubsen (2005), "The Appeal of Media Violence in a Full-length Motion Pictures: An Experimental Investigation," *Communications Reports* 18 (1): 21–30.

Springhall, John (1994), "Disseminating Impure Literature: The 'Penny Dreadful' Publishing Business Since 1860," *The Economic History Review* 47 (3): 567–84.

Stanford, Jacqueline N. and Marita P. McCabe (2002), "Body Image Ideal among Males and Females: Sociocultural Influences and Focus on Different Body Parts," *Journal of Health Psychology* 7 (6): 675–84.

Steranko, Jim (2013), *S.H.I.E.L.D. by Steranko: The Complete Collection*. New York: Marvel.

Stern, Roger and Paolo Rivera (2009), *Young Allies Comics 70th Anniversary Special* #1 (August). New York: Marvel.

Stern, Roger and Mike Zeck (1980), *Peter Parker, The Spectacular Spider-Man* #43 (June). New York: Marvel.

Stringer, Arthur (1916), "The Cave of Despair', *The Iron Claw*, Episode XIX, *Atlanta Constitution Sunday Magazine*, July 2.

Stringer, Arthur (1916a), 'The Triumph of the Laughing Mask," *The Iron Claw*, Episode XX *Atlanta Constitution Sunday Magazine*, July 9.

Stubbersfield, Joseph and Jamshid Tehrani (2013), "Expect the Unexpected? Testing for Minimally Counterintuitive (MCI) Bias in the Transmission of Contemporary Legends: A Computational Phylogenetic Approach," *Social Science Computer Review* 31 (1): 90–102.

Superman in the Fifties (2002). New York: DC.

Superman in the Forties (2005). New York: DC.

Svitavsky, William (2013), "Race, Superheroes, and Identity: 'Did you know he was black?'," in Julian Chambliss, William Svitavsky, and Thomas Donaldson (eds), *Ages of Heroes, Eras of Men: Superheroes and the American Experience*. Newcastle: Cambridge Scholars Publishing, 153–62.

Szasz, Ference Morton (2012), *Atomic Comics*. Reno: University of Nevada Press.

Taliaferro, John (1999), *Tarzan Forever: The Life of Edgar Rice Burroughs, Creator of Tarzan*. New York: Scribner.

Terman, Lewis M. and Catharine Cox Miles (1936), *Sex and Personality Studies in Masculinity and Femininity*. New York: Mcgraw-Hill. Available online: https://archive.org/stream/sexandpersonalit007952mbp#page/n19/mode/2up (accessed September 1, 2016).

Thomas, Roy, Jack Kirby and Neal Adams (2011) *Marvel Firsts: The 1970s*, vol. 1. New York: Marvel.

Thomas, Roy, Stan Lee and Gene Colan (2012) *Marvel Firsts: The 1970s*, vol. 2. New York: Marvel.

Thomas Lester, Avis (2005), "A Senate Apology for History on Lynching," *Washington Post*, June 14. Available online: http://www.washingtonpost.com/wp-dyn/content/article/2005/06/13/AR2005061301720.html (accessed September 1, 2016).

Thorndike, Russell (1915), *Doctor Syn: A Tale of the Romney Marsh*, New York: Doubleday.

Tinsley, Theodore (2007), *Partners of Peril*, *The Shadow*, vol. 9. Encinitas, CA: Nostalgia Ventures.

Toossi, Mitra (2002), "Labor Force Change: 1950–2050," *Monthly*

Labor Review, (May). Available online: http://www.bls.gov/opub/
mlr/2002/05/art2full.pdf (accessed August 14, 2014).

Trexler, Jeff (2006), "Superman's Hidden History: The Other 'First'
Artist," *Newsarama*, August 20. Available online: http://www.
newsarama.com/825-superman-s-hidden-history-the-other-first-artist.
html (accessed April 25, 2010).

Tucker, Richard K. (1991), *The Dragon and the Cross: The Rise
and Fall of the Ku Klux Klan in Middle American*. Hamden, CT:
Archon.

Turner, Frederick Jackson (1920), *The Frontier in American History*.
New York: Holt.

"Two Years of the Superman" (1916), *New York Times*, July 30.
ProQuest Historical Newspapers *The New York Times*.

Upal, M. Afzal (2011), "Memory, Mystery and Coherence: Does the
Presence of 2–3 Counterintuitive Concepts Predict Cultural Success of
a Narrative?" *Journal of Cognition and Culture* 11: 2348.

U.S. Congress, Senate, Subcommittee to Investigate Juvenile Delinquency
(1954), *Juvenile Delinquency (Comic Books): Hearing before the
Subcommittee on Juvenile Delinquency*. 83rd Cong., 2nd sess., April
21, 22, June 4. Available online: http://www.thecomicbooks.com/
frontpage.html (accessed April 23, 2010).

Veitch, Rick (2009), *Brat Pack*. West Townshend, VT: King Hell.

"The Vietnam War: Military Statistics" (n.d.), Gilder Lehram Institute
of American History. Available online: http://www.gilderlehrman.
org/history-by-era/seventies/resources/vietnam-war-military-statistics
(accessed August 30, 2016).

Vlamos, James Frank (1941), "The Sad Case of the Funnies," *American
Mercury* (April): 411–15.

Vogler, Christopher (1985), "A Practical Guide to THE HERO WITH
A THOUSAND FACES by Joseph Campbell," Available online:
http://www.skepticfiles.org/atheist2/hero.htm (accessed August 31,
2016).

Waid, Mark (2005), "The Real Truth about Superman: And the Rest
of Us, Too," in Tom Morris and Mat Morris (eds), *Superheroes and
Philosophy: Truth, Justice, and the Socratic Way*. Chicago: Open
Court.

Waid, Mark and Alex Ross (2008), *Kingdom Come*. New York: DC.

Walbert, David (n.d.), "Living with the bomb," LEARN NC, University
of North Carolina, School of Education. Available online: http://www.
learnnc.org/lp/editions/nchist-postwar/6076 (accessed August 30,
2016).

Walker, Frances Amasa (1896), "Restriction of Immigration," *Atlantic
Magazine*, June. Available online: http://www.theatlantic.com/

magazine/archive/1896/06/restriction-of-immigration/306011/ (accessed September 1, 2016).

Walker, Jesse (2005), "Hooded Progressivism: The secret reformist history of the Ku Klux Klan," *Reason*, December 2. Available online: http://reason.com/archives/2005/12/02/hoodedprogressivism (accessed November 18, 2009).

Walker, Mort (2000), *The Lexicon of Comicana*. Lincoln: iUniverse.

Wallace, Jo-Ann (1994), "De-scribing The Water Babies: 'The Child' in Post-colonial Theory," in Chris Tiffin and Alan Lawson (eds), *De-scribing Empire: Post-colonialism and Textuality*. London: Routledge.

Wanzo, Rebecca (2010), "Black Nationalism, Bunraku and Beyond: Articulating Black Heroism and Cultural Fusion in Comics," in Frederick Luis Aldama (ed.), *Multicultural Comics: From Zap to Blue Beetle*. Austin: University of Texas Press, 93–104.

Wanzo, Rebecca (2015), "It's a Hero? Black Comics and Satirizing Subjection," in Frances Gateward and John Jennings (eds), *The Blacker the Ink: Constructions of Black Identity in Comics and Sequential Art*. New Brunswick: Rutgers University Press.

Wayne, Matt (2015), "What Dwayne McDuffie Meant to Comics and Why There's an Award in His Name," Playboy.com, February 27. Available online: http://www.playboy.com/articles/what-dwayne-mcduffie-meant-to-comics-award (accessed August 31, 2016).

Weart, Spencer R. (2012), *The Rise of Nuclear Fear*. Cambridge, MA: Harvard University Press.

Weaver, Andrew J., Jakob D. Jensen, Nicole Martins, Ryan J. Hurley, and Barbara J. Wilson (2011), "Liking Violence and Action: An Examination of Gender Differences in Children's Processing of Animated Content," *Media Psychology* 14: 49–70.

Weiner, Robert (2005), "'Okay, Axis, here we come!': Captain America and superhero teams from World War II and the Cold War," in B. J. Oropeza (ed.), *The Gospel According to Superheroes: Religion and Popular Culture*. New York: Peter Lang, 83–101.

Weinstein, Simcha (2006), *Up, Up and Oy Vey: How Jewish History, Culture, and Values Shaped the Comic Book Superhero*. Baltimore: Leviathan.

Wells, H. G. (2000), "Zoological Retrogression," in Sally Ledger and Roger Luckhurst (eds), *The Fin De Siecle: A Reader in Cultural History, c. 1880–1900*. Oxford: Oxford University Press.

Wertham, Fredric (1954), *Seduction of the Innocent*. New York: Rinehart.

White, G. Edward (1993), *Justice Oliver Wendell Holmes: Law and the Inner Self*. Oxford: Oxford University Press.

"The White Legion" (1938), *The Shadow*, March 20. Available online: http://pulpsunday.blogspot.com/2008/01/white-legion-mar-20-1938.html (accessed March 6, 2009).

Williamson, Jack and Miles J. Breuer (1998), "The Girl from Mars." Brooklyn: Gryphon.

Williamson, Joel (1984), *Crucible of Race: Black White Relations in the American South Since Emancipation*. New York: Oxford University Press.

Wilson, G. Willow and Adrian Alphona (2015), *Ms. Marvel*, vol. 1. New York: Marvel.

Wister, Owen (1989), *The Virginian: A Horseman of the Plains*. Mattituk, NY: Amereon House.

Witek, Joseph (2012), "Comics Modes: Caricature and Illustration in the Crumb Family's *Dirty Laundry*," Matthew J. Smith and Randy Duncan (eds), *Critical Approaches to Comics*. New York: Routledge.

Wolff, Tamsen (2009), *Mendel's Theatre: Heredity, Eugenics, and Early Twentieth-Century American Drama*. Palgrave Studies in Theatre and Performance History; New York: Palgrave Macmillan.

Wolfman, Marv, Chris Claremont, Tony DeZuniga, and Gene Colan (2004), *Blade the Vampire-Slayer: Black & White*. New York: Marvel.

Wolk, Douglas (2007), *Reading Comics: How Graphic Novels Work and What They Mean*. Cambridge, MA: Da Capo Press.

Woo, Ben (2008), "An Age-Old Problem: Problematics of Comic Book Historiography," *International Journal of Comic Art* 10 (1): 268–79.

Woodall, Lowery Anderson, III (2010), "The Secret Identity of Race: Exploring Ethnic and Racial Portrayals in Superhero Comics." PhD diss., University of Southern Mississippi, Hattiesburg, MS.

Wright, Bradford W. (2001), *Comic Book Nation: The Transformation of Youth Culture in America*. Baltimore: Johns Hopkins University Press.

Wylie, Philip (2004), *Gladiator*. Lincoln: University of Nebraska Press.

York, Rafiel (2012), "*The Fantastic Four*: A Mirror of Cold War America," in Chris York and Rafiel York (eds), *Comic Books and the Cold War, 1946–1962: Essays on Graphic Treatment of Communism, the Code and Social Concerns*. Jefferson NC: McFarland.

Young, Robert J. C. (1995), *Colonial Desire: Hybridity in Theory, Culture and Race*. London: Routledge.

Zillmann, Dolf (1998), The Psychology of the Appeal of Portrayals of Violence," in Jeffrey H. Goldstein (ed.), *Why we Watch: The Attractions of Violent Entertainment*. New York: Oxford University Press, 179–211.

INDEX

The letter *t* after an entry indicates a page that includes a table.

20th International Comic Art Convention, Lucca 241

24th Amendment 161

300 (Varley, Lynn) 6

Abel, Jessica/Madden, Matt: *Drawing Words Writing Pictures* 223

Abomination (character) 192

abstract comics 3

abstraction 230–41

Abstraction Grid 236, 238*t*

ACMP (Association of Comics Magazine Publishers) Code 195

Action Comics (comic book) 7, 109, 274

Action Comics #1 (comic book) 2

Adams, Art 190

Adams, Edward 27, 28–9, 31

Adams, Neal 8, 48, 237, 278, 279

Green Lantern Co-Starring Green Arrow #77 28, 186

grid layouts 214

Adams, Neal/O'Neil, Dennis

Batman 48

Green Arrow (character) 95

Green Lantern Co-Starring Green Arrow 8, 28, 165–6, 167, 278

adolescent egocentrism 29–30

adventure comics face 231, 232, 233, 237

adventure literature 35, 36, 39, 59–63

Adventures of Jimmie Dale, The (Packard, Frank L.) 64–5

Adventures of Superman (TV series) 120

Adventures of Telemachus, The (Fénelon, François) 27

Africa 41–2

Agents of S.H.I.E.L.D. (TV show) 48

Aja, David/Fraction, Matt: *Hawkeye* 285–6

Alaniz, Jose 103

Aleta (character) 196, 197

Alexander, Sam (character) 177

Alias (Bendis, Brian Michael/ Gaydos, Michael) 283–4

Alias, Lee 170

Alicia (character) 142

All-Negro Comics (comic book) 159

All-New All-Different Avengers (comic book) 177

All-New Captain America (comic book) 177

All Star Comics (comic book) 275

Allred, Mike: *iZombie* 239

Allred, Mike/Milligan, Peter: *X-Force* #118 200

Alonso, Axel 5, 284
Alpha Centurion (character) 200
Alpha Flight (Mantlo, Bill) 197–8
Alphona, Adrian 190, 240
Alphona, Adrian/Wilson, G.
 Willow: *Ms. Marvel* 240,
 286–7
Also Spake Zarathustra
 (Nietzsche, Friedrich) 51
Amanat, Sana 5, 286
Amann, Peter H. 89
Amazing Fantasy (comic book)
 277
Amazing Man (character) 8
Amazing Spider-Man, The (comic
 book) 277
Amazing Spider-Man #8 (comic
 book) 123
Amazing Spider-Man #121 (comic
 book) 8
Amazing Woman (character) 200
America
 colonialism 39–44, 47
 eugenics 64, 67–9
 frontier theory 59–60
 Ku Klux Klan (KKK) *see* KKK
 race 77
 sterilization 67–8, 69, 74
 vigilantism 89–90
America, Captain (character) *see*
 Captain America (character)
America, Miss 116, 178
American Breeders' Association
 53, 62
American Law Institute 195
American Psychiatric Association
 195–6
American Visual Language 237–9
"America's Secret Weapon"
 (Cameron, Don) 116
analysis 205
 Elektra: Assassin case study
 251–69
 framing rhetoric 215–22

image-texts 227–30
 juxtapositional closure 222–5
 layout rhetoric 205–15
 page sentencing 225–7
 panel transitions 222
 representational abstraction
 230–41
Anderson, Brent 278
Anderson, Lars 44, 72, 90
Anderson, Murphy 130, 240
Andrade, Filipe 240
Andrae, Thomas 107
Andrews, Archie (character)
 114–15
Andrews, Travis M. 11
Andru, Ross 171
Angel, the (character) 8, 138
"Angel, The" (Gustavon, Paul)
 214
Angela (character) 200, 282
Anglo, Mick: *Marvelman* 4, 6
Ania 175
Ant-Man (character) 47, 133
anti-Semitism 104, 107–8
Anyabwile, Dawud/Sims, Guy A.:
 Brotherman Comics 175
Aparo, Jim 149
Aparo, Jim/Barr, Mike W.:
 Outsiders #1, The 148
Apollo (character) 200
Aqualad (character) 177
Arabian Nights (story collection)
 45
Archie 10, 117
Archie Publications 117
"Are Comics Fascist?" (*Time*
 article) 1–2, 117
*Arguing Comics: Literary Masters
 on a Popular Medium*
 (Heer, Jet/Worcester, Kent)
 294
aristocracy 49–59, 63–7, 71–2
 gentlemen thieves 61–2, 64–5
Arkham Asylum: A Serious

House on Serious Earth
(Morrison, Grant/McKean,
Dave) 281
Arnaudo, Marco 103
arousal 25
Arrow (character) 7
Arrow (TV show) 48
artwork 4
Ashworth, Laurence 25
Association for the Advancement
of Psychotherapy 119
Association of Comics Magazine
Publishers 195
Association of Comics Magazine
Publishers (ACMP) Code
195
associative closure 223
"Astounding Adventures of Olga
Messmer, the Girl with the
X-Ray Eyes, The" (Lovett,
Watt Dell) 7, 184
asymmetrical framing 215–18
Atlas Comics 8, 120, 125, 160
Atom, Captain (character) 46,
125
Atomic Knights (characters)
130–1, 136, 148
atomic war 127 *see also* MAD
audience 29, 96
Authority #29, *The* (Millar, Mark/
Erskine, Gary) 200
Avengers, the (characters) 8
Avengers, The (Marvel Comics)
95
Avery-Natale, Edward 187–8

Bails, Jerry 8, 9
Baker, Kaysee 187
Baker, Kyle/Morales, Robert:
Truth: Red, White & Black
5, 74, 176, 284
Baker, Matt 159–60
"Camilla" 159
gender 185

Journey into Mystery 160
Phantom Lady 159–60, 184
"Sheena, Queen of the Jungle"
159
"Skull Squad" 159
"Sky Girl" 159
"Tiger Girl" 159
"Wambi the Jungle Boy" 159
Ball, Dewi I. 127
Ball, Eustace H. 68
Banks, Darryl 175
Banner, Bruce (character) 131,
133–4, 143, 196 *see also*
Hulk, the (character)
Baron Zemo (character) 192
Barr, Mike W. 148–9
Barr, Mike W./Aparo, Jim:
Outsiders #1, *The* 148
Barra, Mike W./Bolland, Brian:
Camelot 3000 196
Barrett, Justin L. 20, 22–3
"Bat–Man" (Kane, Bob/Finger,
Bill) 7, 17
Bates, Cary/Grell, Mike: Tyroc
(character) 169
Bates, Johnny (character) 196
Batman (character) 1–2, 8, 15,
239, 274–5 *see also* Wayne,
Bruce (character)
colonialism 45
costume 93
degeneration 60, 73
dual identity 49, 51, 60
homosexuality 194–5
origin story 17, 94
romance 194
survival 119
vigilantism 92
villains 118
violence 24, 26, 28
Batman (comic book) 274
Batman (O'Neil, Dennis/Adams,
Neal) 48
Batman (TV series) 28

Batman Begins (Nolan,
 Christopher) 48
Batman: Year One (Miller, Frank/
 Mazzucchelli, David/) 48,
 279–80
Batson, Billy (character) 18, 29
 see also Captain Marvel
 (character)
Batwing (comic book) 177
Batwoman (character) 8, 200,
 285
BDSM 275–6
Beaty, Bart 122
Becattini, Alberto 159
Beck, C. C. 18, 45, 111, 115,
 118, 286
Beecher, Karen (character) 169
Bell, Alexander Graham 67
Belmonde, Raymonde (character)
 197
Bendis, Brian Michael 5, 187,
 283
Bendis, Brian Michael/Gaydos,
 Michael
 Alias 283–4
 Jones, Jessica (character) 1,
 189–90
Benjamin, Ryan 190
Bennett, Arnold 61
Benton, Mike 118, 122, 125
 *Superhero Comics of the
 Golden Age* 113
Beowulf (epic poem) 24
Berg, Terry (character) 96, 200
Berglund, Jeff 41, 43–4
Berlatsky, Noah: "Real Problem
 With Superman's New
 Writer Isn't Bigotry, It's
 Fascism, The" 102
Bernstein, Robert 137
Bierbaum, Mary 199
Bierbaum, Tom 199
Biersdorfer, J. D. 125, 141
Binder, Otto 115, 158, 161

Bird, Brad: *Incredibles, The* 94
Birds of Prey (Simone, Gail) 189,
 284–5
Birth Control Review (magazine)
 66
Birth of a Nation, The (Griffith,
 D. W.) 77–8, 82, 85, 87,
 93–4
bisexuality 193–4
Bishop (character) 175
Black Canary 184, 185, 186
black characters 157 *see also* race
Black Comics (Howard, Sheena
 C./Jackson, Ronald J., III)
 178
Black Goliath (character) 168,
 182
Black Legion 89–90
Black Lightning (character) 177,
 182
Black Lightning (Isabella, Tony/
 Von Eeden, Trevor) 170–1,
 175
Black Panther (character) 47, 95,
 162–3, 167, 178
Black Panther (Coates, Ta-Nahesi/
 Stelfreeze, Brian) 178, 287
Black Panther (Hudlin, Reginald)
 177
Black Panther (McGregor, Don/
 Turner, Dwayne) 175
Black Panther Party for
 Self-Defense 162
Black Racer (character) 165
*Black Superheroes, Milestone
 Comics, and Their Fans*
 (Brown, Jeffrey A.) 294
Black Terror (character) 89
Black Widow (character) 146–7,
 186
Blackhawk (character) 274
Blackshirt (character) 68, 109
Blade the Vampire-Slayer
 (character) 167

Blakeney, Lady Marguerite
 (character) 55, 58
Blakeney, Sir Percy (character)
 see Scarlet Pimpernel
 (character)
Blaxploitation 168
Blob, the (character) 23
Block, Herbert 121
"Blonde Bomber" (Halls,
 Barbara) 184
Blonde Phantom (character)
 117–18, 184
Blood Syndicate (comic book)
 174
Blue Beetle (character) 8
Blue Marvel (character) 176–7,
 178
Blue Snowman (character) 199
blurgits 241
Blythe, Hal 20, 79, 171
Boehmer, Elleke 34, 35
Bogdanove, Jon/Simonson,
 Louise; Steel (character)
 175
bolding 227
Bolland, Brian/Barra, Mike W.:
 Camelot 3000 196
Boltinoff, Murray 168–9
Bolton, Andrew 101
borders 60
Born Again (Miller, Frank) 242
Bowie, David 197
Boyer, Pascal 20
Boys, The (Ennis, Garth/
 Robertson, Darick) 74, 95,
 181
Bozo the Iron Man (character) 7
Bradley, Isiah (character) 285
Brah, Avtar/Coombes, Annie
 E.: *Hybridity and its
 Discontents* 59
Braithwaite, Doug 175
Brat Pack (Veitch, Rick) 198
breakdowns 4

Brennan, Douglas G. 147
Brenner, George E.; Clock, The
 (character) 7
Breuer, Miles J./Williamson, Jack:
 "Girl From Mars, The" 69
Bridwell, E. Nelson/Fradon,
 Ramona; Doctor Mist
 (character) 171
Bright, M. D. 239
Bright, M. D./McDuffie, Dwayne:
 Icon 96, 282
Bright, Mark 173
Bright, Mark/McDuffie, Dwayne;
 Rambeau, Monica
 (character) 173
Bright, Mark/Owsley, Jim
 Falcon 173
 Power Man and Iron Fist 173
Britain 35–9, 41
broken framing 215, 219–20
"Bronze Man" (Hollingsworth,
 Alvin) 159
Bronze Tiger (character) 168
Broome, John 46, 130
Brother Voodoo (character) 167,
 182
Brotherman Comics (Sims,
 Anyabwile, Dawud/Guy A.)
 175
Brown, Charlie (character) 237
Brown, Eliot 240
Brown, Jeffrey A. 96, 167–8, 179
 *Black Superheroes, Milestone
 Comics, and Their Fans* 294
Brown, Slater 113
 "Coming of Superman, The"
 112
Buckler, Rich 146
Bucky (character) 195
Bukatman, Scott 103
*Bulletin of the Atomic Scientists,
 The* 127
Bumblebee (character) 169
Bunker (character) 200

Burgos, Carl: "Human Torch, The" 214
Burrage, Alfred S. 36, 39
Burroughs, Edgar Rice 34, 42, 62–3
 Tarzan of the Apes 40–3, 62–3
 Under the Moons of Mars 39–40
Buscema, Sal 147
Business Zero to Superhero (Jules, Graham) 2
Byrne, Donn 185
Byrne, John 5–6, 187, 197, 198, 239, 278–9
Byrne, John/Claremont, Chris: *Uncanny X-Men, The* 278–9
Byrne, John/Wein, Len/Ostrander, John: *Legends* 172

Cage (comic book) 175
Cage, Luke (character) 175, 177, 182
Camelot 3000 (Barra, Mike W./ Bolland, Brian) 196
Cameron, Ben (character) 78, 82–3, 87–9 *see also* Grand Dragon (character)
Cameron, Don: "America's Secret Weapon" 116
"Camilla" (Baker, Matt) 159
Campbell, J. Scott 191
Campbell, Joseph: *Hero with a Thousand Faces, The* 16–19, 24
Candy (Ormes, Jackie) 159, 184
Capitanio, Adam 131
Capra, Frank: *Lost Horizon* 45
Captain America (character) 74, 113, 120, 123–4, 274
 race 157, 176, 177
Captain America (comic book) 164–5, 177, 277–8

Captain America (Steranko, Jim) 277–8
Captain America and the Falcon (comic book) 165
Captain America Comics 119, 121
Captain Atom (character) 46, 125
Captain Marvel (character) 18, 29, 115, 286 *see also* Batson, Billy (character)
 audience age 29
 Danvers, Carol (character) 178
 race 172, 177
 Rambeau, Monica (character) 172
Captain Marvel (2012 comic book) 240–1
Captain Marvel Adventures (comic book) 118, 119
Captain Marvel: Earth's Mightiest Hero (DeConnick, Kelly Sue) 190, 286
"Captain Power" (Hollingsworth, Alvin) 159
caption boxes 227–8
caption panels 221
Carlyle, Thomas: *On Heroes, Hero-Worship, and The Heroic in History* 31
Carnegie, Andrew 61–2
Carrel, Alexis 69
Carrington, Andre 165
Carter, James Bucky 121, 180–1, 192
Carter, John (character) 39–40, 62
Carter, Nick (character) 82, 84, 86
cartoon comic art 231, 232, 234, 254
cartoon face 231, 237
cartooning 231, 232, 235–7
Cat Man Comics (comic book) 159

Catman (character) 200
Catwoman #1 (Winick, Judd/
 March, Guillem) 194
causal closure 223, 224
Cawalty, John G. 202
centered framing 215, 219
Chabon, Michael 87, 93, 180
 "Secret Skin: An Essay in
 Unitard Theory" 294
Chambliss, Julian 144
Chandler-Jones, Marlo (character)
 200
Chandu the Magician (Earnshaw,
 Harry/Morgan, Raymond)
 44
Chaney, Michael: *Encyclopedia of
 Sex and Gender* 201–2
Charteris, Leslie 68
Chavez, America (character) 178,
 200
Cheyfitz, Eric 42
child psychology 28–32
children's literature 35, 36
Chippy (character) 198
Chivo Man (character) 23
Christman, Bert 280
Chronicle (Trank, Josh) 48
Churchill, Winston 62
*Civic Biology Presented in
 Problems, A* (Hunter,
 George William) 64
Civil Rights Act 161
Civil War (Marvel Comics) 94–5
"Clan of the Fiery Cross" (radio
 episodes) 91
*Clansman: An Historical Romance
 of the Ku Klux Klan, The*
 (Dixon, Thomas, Jr.) 77–8,
 82–5, 87–9, 91–2, 93–4
Claremont, Chris 172, 187, 198,
 278–9, 281
Claremont, Chris/Byrne, John:
 Uncanny X-Men, The
 278–9

Clayface (character) 192
Cloak (character) 172
Clock, The (character) 7
closed sentences 226
closure 222–5
CMAA (Comics Magazine
 Association of America)
 9–10, 195
Coates, Alfred: *Spring-Heeled
 Jack* 34, 36
Coates, Ta-Nahesi/Stelfreeze,
 Brian: *Black Panther* 178,
 287
Cocca, Carolyn 155, 178, 188
 *Superwomen: Gender, Power,
 and Representation* 295
Cockrum, Dave 147, 278
Cockrum, Dave/Wein, Len; Storm
 (character) 168
Coffy (film) 168
coherent counter-intuitive ideas
 21–2, 23
Cohn, Neil 25, 237–9
 *Visual Language of Comics,
 The* 225
Colan, Gene/Lee, Stan; Falcon,
 the (character) 164–5
Colan, Gene/Wein, Len; Brother
 Voodoo (character) 167
Colan, Gene/Wolfman, Marv:
 Tomb of Dracula, The 167
Cold War, the 125–8, 140–51
 1961–2 128–35
 1962–3 135–40
 Cuban missile crisis 135–6,
 137
Colletta, Vince 5
colonialism 33–4, 43–8
 America 39–44, 47
 Britain 35–9, 41
 hybridity 59
 science fiction 46–7
 Tibet 33, 46, 47–8
color 6

colorists 4, 6
Colossus (character) 147
Colt, Denny (character) 275
columns 209–12
Comedian (character) 150, 181
Comet (character) 200
Comic Book Nation: The Transformation of Youth Culture in America (Wright, Bradford, W.) 294
comic books 3, 110 *see also* superhero comics
 layouts 214
 newspaper–driven formatting 214
Comichron: The Comics Chronicles (Miller, John Jackson) 295
comics *see also* superhero comics
 black characters 157
 collecting 9
 definition 3
 Golden Age of 6–7
 production 4–6
comics art 231
Comics Cavalcade (comic book) 275
Comics Code 9–10, 160, 165, 195
Comics Code Authority 198
Comics Magazine Association of America (CMAA) 9–10, 195
"Coming of Superman, The" (Brown, Slater) 112
ComiXology 11
Communism 119, 120–1 *see also* Cuban missile crisis
Conan Doyle, Arthur 42
 Crime of the Congo, The 42
Congo Free State 41–2
Connell, Richard: "Most Dangerous Game, The" 162–3

Connor, Dr. (character) 192
Conroy, Mike 192
conscription 113
Constantine, John (character) 200
contour (line) 234
contour scale 235–6
convergent evolution 23–4
Conway, Gerry 145, 146, 171
Conway, Gerry/Oksner, Bob: Vixen (character) 171
Coogan, Peter 36, 39, 74, 92–3
 eugenics 107
 "F For Fascism: The Fascist Underpinning of Superheroes" 102, 103
 Superhero: The Secret Origin of a Genre 1, 294
Coogan, Peter/Rosenberg, Robert S.: *What is a Superhero?* 295
Cook, Roy T. 3
Cooley, Finn (character) 192
Coolidge, Calvin 67
Coombes, Annie E./Brah, Avtar: *Hybridity and its Discontents* 59
"Cosmo, the Phantom of Disguise" (Elven, Sven) 7
Costello, Matthew J. 126, 143, 144
costume 1, 37, 66, 85, 87, 92–3
 gender 185, 189–90
 homosexuality 197, 198, 199
 Ku Klux Klan 89
 physicality 179–80, 182
 race 164, 167, 168, 169, 170, 172, 175
Count of Monte Cristo (character) 2
Count of Monte Cristo, The (Dumas, Alexander) 31–2
counter-intuitive ideas 20–4
Cowan, Denys 5, 173, 174
creator-owned works 242

Crime of the Congo, The (Conan Doyle, Arthur) 42
Crimson Avenger (character) 7, 177
Crimson Clown, the (character) 68
Crimson Dynamo (character) 137, 138
Crisis on Infinite Earths 8
cropped framing 215, 218–19
Cuban missile crisis 135–6
Cuddy, Lois A./Roche, Claire M.: *Evolution and Eugenics in American Literature and Culture, 1880–1940* 49
Cullins, Paris 173
culture 202
Cunard, Grace/Ford. Francis: *Purple Mask, The* 68
Curse of Capistrano, The (McCulley, Johnston) 66–7
Cyborg (character) 172, 177

Daken (character) 200
Daly, John 115
D'Amore, Laura Mattoon 186
Daniels, Les 118, 122
Danner, Hugo (character) 43
Danvers, Carol (character) 178, 186, 190, 286
Daredevil, the (character) 8, 47, 140
Daredevil: Love and War (Miller, Frank/Sienkiewicz, Bill) 240, 242
Daredevil #1 (Lee, Stan/Everett, Bill) 140
Dark Knight, The (Nolan, Christopher) 48
Dark Knight Returns (Miller, Frank) 8, 94, 124, 149, 215, 242, 279
Dark Knight III #1 (comic book) 11
Darwin, Charles 51

Davis, Alan 148
Davis, Blair 155, 170, 172
Davis, Michael 174
Davis, Phil 156
DC Comics 2–3, 8, 96–7, 125
 Cold War 130
 Comics Code 10
 gender 193
 market dominance 11
 Milestone Media partnership 175–6
 Miller, Frank 241
 race 163–4, 169, 171, 177
De Haven, Tom 104, 111, 116, 119, 122
Deadman (character) 47–8
Deadpool (character) 201
Deadpool (film) 201
Deathlok (McDuffie, Dwayne) 5, 173–4, 177
Deathlok the Demolisher (character) 146
DeConnick, Kelly Sue: *Captain Marvel: Earth's Mightiest Hero* 190, 286
Defenders, the (characters) 186–7
degeneration 50–2, 55–6, 60–1, 63, 64, 73
Degeneration: A Chapter of Darwinism (Lankester, E. Ray) 52
DeGraw, Sharon 40, 62
Delany, Samuel R. 167, 186
demographics 10–11
density (line) 234–5
density-contour grid 236
density scale 234–5
Dent, Lester 44, 72, 107
Desert Song, The (Romberg, Sigmund/Hammerstein, Oscar, II/Harbach, Otto) 68
Destiny (character) 198
Detective Comics (comic book) 274–5

detective fiction 46, 82–3
Dick Tracy (Gould, Chester) 192,
 239
diegesis 230
diegetic frames 221
Dingle, Derek T. 174
DiPaolo, Marc 126
disabled characters 285
discourse 230
disguises 78, 84–5, 87, 92–3
disposition theory 25
Ditko, Steve 4–5, 6, 8
 art 239
 Captain Atom (character) 46,
 125
 Doctor Strange (character) 180
 grid layouts 214
 Hulk, the (character) 132,
 143
 Iron Man (character) 138
 Superman (character) 29
Ditko, Steve/Lee, Stan;
 Spider-Man (character) 180,
 277
diversity 96
Dixon, Thomas, Jr. 80, 85–6, 89
 *Clansman: An Historical
 Romance of the Ku Klux
 Klan, The* 77–8, 82–5,
 87–9, 91–2, 93–4
 *Leopard's Spots: A Romance
 of the White Man's
 Burden—1865–1900, The*
 81–2, 85, 88
 Traitor, The 85
Doc Humo (character) 192
Doc Savage (character) 44, 72,
 107
Doc Savage Magazine (comic
 book) 107
Dr. Connor (character) 192
Doctor Doom (character) 47, 130,
 192
Doctor Droom (character) 47

Doctor Fate (character) 116
Dr. Manhattan 150
Doctor Mist (character) 171
Dr. Occult (character) 180
"Doctor Occult, the Ghost
 Detective" (Siegel, Jerry/
 Shuster, Joe) 214
Doctor Strange 8, 47, 137, 138,
 180
Doctor Strange (Derrickson,
 Scott) 48
Doctor Syn (character) 68
*Doctor Syn: A Tale of the
 Romney Marsh* (Thorndike,
 Russell) 86
Doe, John (character) 68
Doll Man (character) 8, 275
Domino Lady, the (character) 44,
 72, 90
Donenfeld, Harry 7, 184
Donovan, John 128
"Don't Laugh at the Comics"
 (Richard, Olive) 293
Doyle, Arthur Conan *see* Conan
 Doyle, Arthur
Doyle, Thomas F.: "What's
 Wrong with the 'Comics'?"
 115
Drake, Arnold 47
Draut, Bill 146
Drawing Words Writing Pictures
 (Abel, Jessica/Madden,
 Matt) 223
dual-function panels 226
dual identity 1, 37–8, 49–51, 54,
 60–1, 68, 72–4
 *Adventures of Jimmie Dale,
 the* 64–5
 *Clansman: An Historical
 Romance of the Ku Klux
 Klan, The* 84
 Gladiator, The 71–2
 Mark of Zorro, The 66
 pulp literature 72

Scarlet Pimpernel, The 50, 54, 56–7, 84
Tarzan of the Apes 63
DuBois, W. E. B.: *Souls of Black Folk, The* 173–4
Dubose, Mile S. 79
Duffy, Mary Jo 242
Dulles, John Foster 128
Dumas, Alexander: *Count of Monte Cristo, The* 31–2
Duncan, Mal (character) 169
Duncan, Randy/Smith, Matthew J.: *Critical Approaches to Comics: Theories and Methods* 9, 295
Dune (comic book) 242
duo-specific illustrations 229
duo-specific image-texts 230
duplication 235, 237
Dwayne McDuffie Award for Diversity in Comics 173

Eagle (character) 111
Earnshaw, Harry/Morgan, Raymond: *Chandu the Magician* 44
Eaton, Lance 103
Ebbutt, Norman 107
Ebony White (character) 157
Eco, Umberto 124
Egoff, Sheila 36
Eisner, Will 3, 5, 228
 Ebony White (character) 157
 Spirit, The 4, 239, 275
 "Wonderman" 214
 Wonderman (character) 7, 17, 33, 34
 Yarko the Great (character) 45
Eisner, Will/Iger, S. M.: "Sheena: Queen of the Jungle" 7
Electric Company, The (TV show) 239
Elektra: Assassin (Miller, Frank/ Sienkiewicz) 149, 241–2

analysis 251–69
creation of 241
reproduction 243–50
Element Lad (character) 199
Elkind, David 29
Ellis, Warren 200
Elven, Sven: "Cosmo, the Phantom of Disguise" 7
emanata 241
embellishers 4
Emerson, Ralph Waldo: *Representative Men* 31
encapsulation 225
Encyclopedia of Golden Age Superheroes (Nevins, Jess) 16
end stops 226
Engineer (character) 190
England 34
Englehart, Steve 168
Englehart, Steve/Stanton, Joe: *New Guardians, The* 198
Enigma, The (Milligan, Peter/ Fegredo, Duncan) 200
enjambment 226, 227
Ennis, Garth/Robertson, Darick: *Boys, The* 74, 95, 181
Epic Comics 241
epic tradition 26–7, 31
eroticism 194
Erskine, Gary/Millar, Mark: *Authority #29, The* 200
Ervin, Raquel (character) 174
Establisher panels 225
Eternaut, The (newspaper strip) 128
eugenics 49–59, 106–8
 Captain America (character) 124
 hybridity 59–68
 reproduction 69–73
 sterilization 67–75
 Ultra-Humanite, the (character) 111

Eugenics Record Office 53, 69
Evan, George J., Jr.: "Lion Man"
 159
Evan, Orrin Cromwell 159
Everett, Bill 45, 111
 "Sub-Mariner, The" 214
Everett, Bill/Lee, Stan: *Daredevil
 #1* 140
Everyman, Johnny (character)
 115–16
Evnine, Simon J. 2
evolution 50, 51–2 *see also*
 eugenics
*Evolution and Eugenics in
 American Literature and
 Culture, 1880–1940*
 (Cuddy, Lois A./Roche,
 Claire M.) 49
excitation transfer theory 25
expansive framing 215, 217–18
"Experiments on Plant
 Hybridization" (Mendel,
 Gregor) 52–3
Extrano (character) 198

"F For Fascism: The Fascist
 Underpinning of
 Superheroes" (Coogan,
 Peter) 102, 103
Faerie Queen, The (Spenser,
 Edmund) 24
Fairbanks, Douglas 66
Falcon (Bright, Mark/Owsley,
 Jim) 173
Falcon, the (character) 164–5,
 166, 168, 171, 172, 177,
 182
Falk, Lee
 Lothar (character) 156, 161
 Mandrake the Magician 7, 44,
 161
 Phantom, The 7, 44
Famous Funnies 6, 9
Fantastic, Mr. 185

Fantastic Four (characters) 8, 123,
 129–30
 colonialism 46
 identity 1
 Thing, The (character) *see*
 Thing, The (character)
Fantastic Four, The (Lee, Stan/
 Kirby, Jack) 95, 125–6,
 162, 237, 276, 293
fantasy literature 35
fascism 101–6, 115, 124 *see also*
 World War II
 "Brown Scare" 120
 sales decline 119–20
 Superman 107–13, 116, 120,
 122
 superman character type
 106–13, 122
 Wertham, Fredric 122–3
Fate, Doctor (character) 116
Fegredo, Duncan/Milligan, Peter:
 Engima, The 200
Feiffer, Jules: *Great Comic Book
 Heroes, The* 293
femininity 182–4 *see also* gender;
 women
Fénelon, François: *Adventures of
 Telemachus, The* 27
Feuillade, Louis: *Judex* 68
Fighting American (character)
 181, 192
Fighting American (Simon, Joe/
 Kirby, Jack) 120–1
finances 10–11
Finger, Bill 45, 73
 "Girl Who Didn't Believe in
 Superman!, The" 119–20
 Superman (character) 125
Finger, Bill/Kane, Bob
 "Bat-Man" 7, 17
 Batman (character) 94, 194,
 274–5
 Clayface (character) 192
 Joker (character) 192

Penguin (Character) 192
Two-Face (character) 192
Fingeroth, Danny 54, 78, 104
finishers 4
Firestorm (comic book) 177
first Code era 10
 key texts 276–8
 race 160–5
First International Eugenics
 Congress 62
first-person narration 228
Fischer, Craig 102–3
Fitzpatrick, James 195
Flame, the (character) 7, 275
Flash (character) 8, 21, 123, 241
Flash Comics 118
Flattop (character) 192
folktales *see* mythologies
Ford, Francis/Cunard, Grace:
 Purple Mask, The 68
Foster, Bill (character) 168
Four Square Jan (character) 68
fourth Code era 10
 key texts 283–5
 race 176–8
Fox, Gardner 274, 280
Fox, Luke (character) 177
Fox, Victor 7, 33
Fraction, Matt/Aja, David:
 Hawkeye 285–6
Fradon, Ramona/Bridwell, E.
 Nelson: Doctor Mist
 (character) 171
frames 205, 206, 209, 215–22
 foreshortening 221
 orientation 222
 perspective 221–2
framing rhetoric 215–22
Francis, Conseula 155, 164
Frank, Leo 85
Fredericks, Fred 161
Freedom Ring (character) 200
Freeman, August (character) 174
Freeman, R. Austin 61

frontier theory 59–60
Fugitive, The (film) 25
full-page panels 206
full-width panels 209
Fury, Nick (character) 177

Gabilliet, Jean-Paul 241
*Gabriel Tolliver: A Story of
 Reconstruction* (Harris, Joel
 Chandler) 81
Gaiman, Neil 5
 Sandman, The 199, 280–1
Galton, Francis 51, 53
Gardner, Erle Stanley 68
Gargoyle (character) 132, 192
Garrod, Archibald 53
Gay, Roxane 287
gay rights 198
Gaydos, Michael/Bendis, Brian
 Michael
 Alias 283–4
 Jones, Jessica 1, 189–90
gender 179, 240 *see also* women
 costume 185, 189–90
 divisions 191–3
 femininity 182–5, 193
 hostility and female characters
 181, 188–9, 283
 hyper-sexualization 188, 190
 imbalance 190–1
 masculinity 179–82, 192–4
 narrative roles 185–8
 physicality 179–85, 187–8,
 192
 social changes 187
 transgender characters 195,
 196
generalization 235, 237
*Genetic Principles in Medicine
 and Social Science* (Hogben,
 Lancelot) 69
genetics 68–9
genres 2
Genter, Robert 131

gentlemen thieves 61–2, 64–5
Gerber, Steve 147, 196
German Workers' Party 66
Germany 66, 69, 74, 106–9 *see also* fascism; Nazism
Gertler, Nat 9
Gestalt closure 224–5
Gestalt law of closure 224
Ghee, Kenneth 162, 169
Ghidorah, the Three-Headed Monster (film) 142
Gibbons, Dave 215
Powerman 168
Gibbons, Dave/Moore, Alan: *Watchmen* see *Watchmen*
Gibson, Walter 43, 72
Gill, Joe 46, 47
Gillespie, Michele K. 88
Giordano, Dick 171
"Girl From Mars, The" (Williamson, Jack/Breuer, Miles J.) 69
"Girl Who Didn't Believe in Superman!, The" (Finger, Bill) 119–20
Gladiator (Wylie, Phillip) 43, 70–2
Godzilla (character) 142
Golden Girl (character) 184
Goliath (character) 168
Gonce, Lauren O. 20
Good Girl Art 184
Goodman, Martin 8, 160, 276
Goodwin, Archie/Tuska, George *Luke Cage, Hero for Hire* 166
Luke Cage, Power Man 166
Power Man and Iron Fist 166
Gorbachev, Mikhail 148–9
Gordon, Barbara (character) 189, 284
Gordon, Ian 116
Gould, Chester: *Dick Tracy* 192, 239

Graeme, Bruce 109
Graham, Billy 166, 167, 173
Grand Dragon (character) 77, 78, 84, 93
Grant, Madison: *Passing of the Great Race, The* 65–6
Grant, Steven 186
graphic novels 230, 281
Gray, Jean (character) 279
Gray Phantom (character) 68
Gray Seal, the (character) 50, 64–5
Great Comic Book Heroes, The (Feiffer, Jules) 293
Great Man theory 31
Great Women Superheroes, The (Robbins, Trina) 293–4
Green, Martin 39
Green, Samuel 91
Green Arrow (character) 95
Green Lantern, The (comic book) 118, 172
Green Lantern (character) 8, 45, 46, 123, 171, 200
Green Lantern Co-Starring Green Arrow (Adams, Neal/O'Neil, Dennis) 8, 28, 165–6, 167, 186, 278
Green Lantern: Mosaic (comic book) 175
Grell, Mike 168–9
Grell, Mike /Bates, Cary; Tyroc (character) 169
Gresh, Lois 131
grid layouts 206–14
Grier, Pam 168
Griffith, D. W.: *Birth of a Nation, The* 77–8, 85, 87, 93–4
Griffiths, Frederick 68
Grimm, Ben 129, 141–2 *see also* Thing, The (character)
Grimm Brothers 20
Groff, Todd/Jones, Thomas:

Introduction to Knowledge Management 232
Gruenwald, Mark E.: *Squadron Supreme* 124
Guardian (character) 169
Gunhawks (comic book) 166
Gustavson, Paul: "Angel, The" 162, 214
gutters 205, 209, 224–5
Guynes, Sean 198

Hack, Brian 113, 124
Hadju, David 123
Haggard, H. Rider 45
King Solomon's Mines 36
Haines, John Thomas 36
Hall, Randal L. 88
Hall, Richard A. 157
Halls, Barbara: "Blonde Bomber" 184
Hammerstein, Oscar, II/Harbach, Otto/Romberg, Sigmund: *Desert Song, The* 68
Hand, Augustus 7, 33
Hangman, The 114, 116
Hanley, Tim 178
Hannigan, Ed/Mantlo, Bill; Cloak (character) 172
Harbach, Otto/Romberg, Sigmund/Hammerstein, Oscar, II: *Desert Song, The* 68
Hardware (comic book) 174
Harris, Joel Chandler: *Gabriel Tolliver: A Story of Reconstruction* 81
Hart, Christopher 233–4, 240
Harvey, Yona 287
Hastie, William H. 157
Hatfield, Charles/Heer, Jet/Worcester, Kent: *Superhero Reader, The* 295
Havok & Wolverine: Meltdown (Williams, Hank) 29

Hawkeye (Fraction, Matt/Aja, David) 285–6
Hawkgirl (character) 21
Hay, Kellie 96
Heck, Don 47, 137
Heck, Don/Kanigher, Robert; Nubia (character) 167
Heck, Don/Lee, Stan; Foster, Bill (character) 168
Hector (character) 200
Heer, Jet/Worcester, Kent: *Arguing Comics: Literary Masters on a Popular Medium* 294
Heer, Jet/Worcester, Kent/Hatfield, Charles: *Superhero Reader, The* 295
Hegel, Georg Wilhelm Friedrich 30–1
"Henri Duval of France, Famed Soldier of Fortune" (Siegel, Jerry/Shuster, Joe) 214
Henry, O. 61
Hercules (character) 200
heredity 53, 68 *see also* eugenics
Hero with a Thousand Faces, The (Campbell, Joseph) 16–19, 24
heroes 15, 30–1, 36 *see also* superheroes
hybridity 59–61
vigilantism 81–7
heterosexuality 191, 193–4, 197
Hickey, Walt 190
Higgins, John 6, 224
Hilton, James: *Lost Horizon* 45
Hitch, Bryan 190
Hitler, Adolf 66, 74, 106, 107–8, 115
Mein Kampf 67–8
Hobgoblin (character) 196
Hobsbawm, Eric 67
Hogben, Lancelot: *Genetic*

Principles in Medicine and Social Science 69
Hollingsworth, Alvin 159
"Bronze Man" 159
"Captain Power" 159
"Numa" 159
Hollingsworth, Matt: *Wytches* 6
Holmes, Oliver Wendell 68
Homosexual Life (publication) 195
homosexuality 194–6, 197–8, 199–201
Hooded Justice (character) 7–8, 198
Hoover, Herbert 67
Hoppenstand, Gary 54, 82–3, 86–7, 88
horizontal columns 212
Hornblower (character) 169
Hornung, E. W. 61
Houdini, Harry 180
How to Draw the Marvel Way (Lee, Stan) 183
Howard, Sheena C./Jackson, Ronald J., III: *Black Comics* 178
Howard, Wayne 167, 173
Howe, Sean 15, 132
Marvel Comics: The Untold Story 295
Hudlin, Reginald: *Black Panther* 177
Hudson, Laura 178
Hughes, Bob 109–10
Hulk, the (character) 8, 47, 141, 142–4
art 239
atomic anxieties and 131–2, 133–4, 137
Hulk Magazine #2 (Stern, Roger/Shooter, Jim) 196
Hulking (character) 200
"Human Torch, The" (Burgos, Carl) 214

Human Torch, the (character) 8, 185
Human Torch, The (comic book) 118
Humo, Doc (character) 192
Hunter, George William: *Civic Biology Presented in Problems, A* 64
Hybridity and its Discontents (Coombes, Annie E./Brah, Avtar) 59
hybridization 50, 52–3, 54, 57, 59–68 see also eugenics
hyper-feminity 185
hyper sexualization 164, 188, 190 see also sexualization
hyperbole 236, 237

Iceman (character) 200
Icon (character) 96, 239
Icon (McDuffie, Dwayne/Bright, M. D.) 96, 282
iconic abstraction scale 231–3, 234, 237
idealization 235, 236, 237, 238, 239
Iger, Jerry 274
Iger, S. M./Eisner, Will: "Sheena: Queen of the Jungle" 7
Iliad, The (Homer) 26, 27
Iliad of Homer, The (Pope, Alexander) 27
illustrations 229
Image Comics 175, 188, 281–2
image-narrators 229–30
image-only visuals 229
image-specific visuals 229, 230
image-text referent 230
image-text tension 229–30
image-texts 227–30
images 205–6
foreshortening 221
frame orientation 222
framing rhetoric 215–22

insets 205
interpenetrating 221, 225
layout rhetoric 205–15
overlapping 205
perspective 221–2
types 228–9
unframed 220–1
immigration 60, 67
implied frames 220–1
implied grids 207
incoherent counter-intuitive ideas
 23
Incredible Hulk, The (comic
 book) 136–7 *see also* Hulk,
 the (character)
Incredibles, The (Bird, Brad) 94
Infantino, Carmine 47, 185, 240
Initial panels 225–6
inkers 4, 5–6
insets 205
integrated image-texts 230
intensification 235–6, 239–40
interdependent visuals 228
International Comic Art
 Convention, Lucca 241
interpenetrating closure 225
interrupted sentences 226
intersecting visuals 228–9
*Introduction to Knowledge
 Management* (Groff, Todd/
 Jones, Thomas) 232
Invisible Girl (character) 21,
 185–6
Invisible Scarlet O'Neil (Stamm,
 Russell) 184
Invisible Woman (character) 187
irregular column grids 210, 211
irregular grids 207
irregular panels 209
irregular rows 208, 209
Iron Claw, The (José, Edward/
 Seitz, George B.) 68, 86
Iron Fist (character) 48
Iron Fist (TV show) 48

Iron Man (character) 8, 135,
 137–8, 144, 172
Iron Man (O'Neil, Dennis) 172
Iron Man 3 (Black, Shane) 48
Ironheart (character) 178
Isabella, Tony/Jones, Arvell; Misty
 Knight (character) 168
Isabella, Tony/Tuska, George;
 Black Goliath (character)
 168
Isabella, Tony/Von Eeden, Trevor:
 Black Lightning 170–1, 175
Island of Dr. Moreau, The (Wells,
 H. G.) 60–1
isolated columns 212
isolated panels 209
Ivy, Poison (character) 200
iZombie (Allred, Mike) 239

Jackson, Ronald J., III/Howard,
 Sheena C.: *Black Comics*
 178
Jackson, Samuel L. 177
Jang, Keum-Hee 53
Japan 108
Jeffries, Graham Montague 68
Jemas, Bill 284
Jennings, John 179, 180
Jewett, Robert/Lawrence, John
 Shelton: *Myth of the
 American Superhero, The*
 81–2, 104, 294
John XXIII (pope) 136
Johnny Everyman (character)
 see Everyman, Johnny
 (character)
Johnson, Jeffrey K. 141
Johnson–Reed Immigration Act
 67
Joker, the (character) 48, 192
Jones, Arvell 167, 173
Jones, Arvell/Isabella, Tony; Misty
 Knight (character) 168
Jones, Dudley 36

Jones, Gabriel (character) 160–1
Jones, Gerard 101, 113, 123
 *Men of Tomorrow: Geeks,
 Gangsters and the Birth of
 the Superhero* 294
Jones, Jessica (character) 1–2
Jones, Malcolm 173, 175
Jones, Reno (character) 166
Jones, Thomas/Groff, Todd:
 *Introduction to Knowledge
 Management* 232
Jones, Whitewash (character) 158,
 161, 177
José, Edward/Seitz, George B.:
 Iron Claw, The 68, 86
Journey into Mystery (comic
 book) 160
Judex (Feuillade, Louis) 68
Judomaster (character) 47
Jules, Graham: *Business Zero to
 Superhero* 2
Jungle Action (McGregor, Don)
 95, 167
Jungle Book, The (Kipling,
 Rudyard) 41
Jungle Tales (comic book) 160
Justice League of America
 (characters) 8, 123, 171
juvenile fiction 31–2
juxtapositional closure 222–5

Kaempffert, Waldemare 51, 68–9
Kahn, Jeanette 169
Kaiser Wilhelm Institute of
 Anthropology, Human
 Genetics, and Eugenics 68
Kane, Bob/Finger, Bill
 "Bat-Man" 7, 17, 28
 Batman (character) 49, 93, 94,
 194, 239, 274–5
 Clayface (character) 192
 Joker (character) 192
 Penguin (Character) 192
 Robin (character) 195

 Two-Face (character) 192
Kane, Gil 46, 48, 73
 Captain Atom (character) 125
Kane, Kate (character) 200
Kane, Tinymite (character) 195
Kanigher, Robert 185, 276
Kanigher, Robert/Heck, Don;
 Nubia (character) 167
Kaplan, Arie 106
Karolina (character) 200
Kato (character) 157
Kellogg, John Harvey 62
Kelly, Joe/McGuiness, Ed:
 Spider-Man/Deadpool #1
 201
Kennedy, John F. 128, 136, 138
Kennedy, Stetson 91
Kent, Clark (character) 17, 19,
 108, 114, 293 *see also*
 Superman (character)
Kerkslake, Patricia 36, 38
key texts 271
 first Code era 276–8
 fourth Code era 283–5
 post-Code era 285–7
 pre-Code era 274–6
 second Code era 278–81
 third Code era 281–3
Khan, Kamala (character) 177,
 190, 286–7
Kid Miracleman (character) 196
Kill Bill Vol. 2 (Tarantino,
 Quentin) 293
Kim (Kipling, Rudyard) 38
King, Martin Luther, Jr. 161
King Solomon's Mines (Haggard,
 H. Rider) 36
Kingdom Come (Waid, Mark/
 Ross, Alex) 26–7, 124,
 282–3
Kingpin (character) 192
Kingsley, Roderick (character)
 196, 197
Kipling, Rudyard

Jungle Book, The 41
Kim 38
Kirby, Jack 4–5, 8, 46
 Black Panther (character) 47
 Captain America (character)
 113, 276
 character physicality 185
 Doctor Droom (character) 47
 Fantastic Four (characters) 1,
 21, 129
 Fantastic Four #1, The 237
 grid layouts 214
 Hulk, the (character) 131, 143
 Jones, Whitewash (character)
 158
 New Gods 165
 Norman, Shiloh (character) 167
 Spider-Man (character) 277
 Superman (character) 240
 Thor (character) 133
Kirby, Jack/Lee, Stan
 Black Panther (character)
 162–3
 Fantastic Four, The 95, 162,
 276, 293
 Medusa (character) 185
 *Sgt. Fury and his Howling
 Commandos* 160–1
 X-Man, The 95
 X Men #1, The 10, 138–9
Kirby Jack/Simon, Joe: *Fighting
 American* 120–1, 181
Kirbyan style 237
KKK (Ku Klux Klan) 77–87,
 89–91, 95–6
 Birth of a Nation, The 93
 name 93
 vigilantism 87–8
Klock, Geoff 79, 102, 103
Knight, Milton 173
Knight, Misty (character) 186
Knights of Mary Phagan 85
Kohlberg, Lawrence 30
Kountouriotis, Vasileios-Pavlos 25

Kraft, David 186
Kripal, Jeffrey J. 46–7, 103, 118
Ku Klux Klan (KKK) *see* KKK
Ku Klux Klan Act 95
Kubert, Andy 5
Kupperberg, Paul 147, 169
Kutzer, Daphne 35

Lackoff, Derek 163, 179
Lady Luck (comic book) 117,
 184
Lafayette, Lunella (character) 178
Landon, Herman 68
Lane, Lois (character) 73, 119,
 183
Langkowski, Walter (character)
 197
Langkowski, Wanda (character)
 197
Lankester, E. Ray 55
 *Degeneration: A Chapter of
 Darwinism* 52
Larry the Bat (character) 65
Laughing Mask, the (character)
 86
Law for the Prevention of
 Offspring with Hereditary
 Diseases in Future
 Generations 69
Lawrence, John Shelton/Jewett,
 Robert: *Myth of the
 American Superhero, The*
 81–2, 104, 294
layout rhetoric 205–15
layouts 4
Layton, Bob 5
Leach, Garry/Moore, Alan:
 Marvelman 6
*League of Extraordinary
 Gentlemen, The* (O'Neil,
 Kevin) 240
Lee, Jim 188, 239, 282
Lee, Jim/Portacio, Whilce: Bishop
 (character) 175

Lee, Stan 8, 46, 293
 Amazing Spider-Man #8 123
 Black Panther (character) 47
 Captain America (character)
 124
 character physicality 185
 comic books 3
 Communism 120
 Doctor Droom (character) 47
 Doctor Strange (character) 47
 Fantastic Four (characters) 1,
 21
 How to Draw the Marvel Way
 183
 Hulk, the 142–3
 Iron Man (character) 137
 Man-Thing (character) 145
 Marvel Method 4–5, 20–1
 Robertson, Robbie (character)
 163
 "Stan's Soapbox" 163
 Steranko, Jim 277–8
 superhero formula 20–1
 Superman (character) 29, 87
 see also Superman
 Thing, The (character) 128–9,
 131, 141
 Thor (character) 133
Lee, Stan/Colan, Gene; Falcon,
 the (character) 164–5, 166
Lee, Stan/Ditko, Steve;
 Spider-Man (character) 277
Lee, Stan/Everett, Bill: *Daredevil*
 #1 140
Lee, Stan/Heck, Don; Foster, Bill
 (character) 168
Lee, Stan/Kirby, Jack
 Black Panther (character)
 162–3
 Fantastic Four, The 95, 162,
 276, 293
 Medusa (character) 185
 *Sgt. Fury and his Howling
 Commandos* 160–1

 X-Man, The 95
 X Men #1, *The* 10, 138–1
Legends (Ostrander, John/Wein,
 Len/Byrne, John) 172
Legion of Super-Heroes (Levitz,
 Paul) 198
Legman, Gershon 90–2, 119
*Leopard's Spots: A Romance of
 the White Man's Burden—
 1865–1900, The* (Dixon,
 Thomas, Jr.) 81–2, 85, 88
Leopold III (king of Belgium) 41–2
letterers 4, 227
lettering 227
Levitz, Paul: *Legion of Super-
 Heroes* 198
LGBTQ characters 194–202, 285
liberal epics 27
Lie, Nadia 67
Liefeld, Rob 188, 239–40, 282
Lightning (character) 177
Lightning Lass (character) 198
Limited Test Ban Treaty 136, 137,
 138
line styles 233–6, 240
"Lion Man" (Evan, George J.,
 Jr.) 159
literature
 adventure 35, 36, 39, 59–63
 animals 60–1
 children's 35, 36
 colonial 35
 detective fiction 46, 82–3
 dime novels 82
 fantasy 35
 lost world motif 44–5
 pulp 72
 science fiction 35–6, 46–7, 69
 westerns 60, 82
Lizard (character) 192
Lobdell, Scott 199
Lobo (comic book) 162
Loki (character) 200
Loomba, Ania 33–4, 35

Lopes, Paul 9
Lost Horizon (Capra, Frank) 45
Lost Horizon (Hilton, James) 45
lost world motif 44–5
Lothar (character) 44, 156, 161, 182
Louis, Joe 157
Lovett, Watt Dell: "Astounding Adventures of Olga Messmer, the Girl with the X-Ray Eyes, The" 7, 184
Lucas, George: *Star Wars* 16
Luke Cage, Hero for Hire (Goodwin, Archie/Tuska, George) 166
Luke Cage, Power Man (Goodwin, Archie/Tuska, George) 166
Lupoff, Richard A.: "Re-Birth" 6
Luther, Hans 113
Luthor, Lex (character) 112–13, 193, 274

M-F Personality Test 192
M. O. D. O. K. (character) 192
McCabe, Marita P, 181, 182
McCann, Sean 79
McCarthy, Joseph 121
McCarthyism: The Fight for America 121
McCarthyism: The Fight for America (McCarthy, Joseph) 121
McCloud, Scott 110
iconic abstraction scale 231–3, 234, 237
Understanding Comics 3, 222–3
word/picture categories 228–9
McCulley, Johnston 68
Curse of Capistrano, The 66–7
McDuffie, Dwayne 174, 175
Deathlok 5, 173–4
gender 189

Souls of Cyber-Folk, The 174
Static (character) 175
McDuffie, Dwayne/Bright, M. D.: *Icon* 96, 282
McDuffie, Dwayne/Bright, Mark; Rambeau, Monica (character) 173
McDuffie, Dwayne/Velez, Ivan, Jr.; Masquerade (character) 199–200
McFarlane, Todd 188
Spawn 175, 281–2
McGregor, Don: *Jungle Action* 95, 167
McGregor, Don/Turner, Dwayne: *Black Panther* 175
McGuinness, Ed 190
McGuiness, Ed/Kelly, Joe: *Spider-Man/Deadpool* #1 199
machismo 181
McKean, Dave 240, 280, 281
McKean, Dave/Morrison, Grant: *Arkham Asylum: A Serious House on Serious Earth* 281
Mackie, Chris 15
McLaughlin, Frank 47
McLaughlin, Jeff: *Stan Lee: Conversations* 294
McLuhan, Marshall 90, 119
McManus, Shawn 199
MAD (mutually assured destruction) 127–8, 140, 144, 147–8, 150
Madden, Matt/Abel, Jessica: *Drawing Words Writing Pictures* 223
Madrid, Mike 185
Magneto (character) 139
Major Ryker (character) 146
Malcolm X 161
Man and Superman (Shaw, George Bernard) 53, 54–8, 62

Man in Purple, the (character) 68
Man-Thing (character) 145
Mandarin, the (character) 137
Mandingo (film) 168
Mandrake the Magician (Falk,
	Lee) 7, 44, 156–7, 161
Manhattan, Dr 150
Manning, Luther (character) *see*
	Deathlock the Demolisher
	(character)
Mantlo, Bill 196–7
	Alpha Flight 197–8
Mantlo, Bill/Hannigan, Ed; Cloak
	(character) 172
March, Guillem/Winick, Judd:
	Catwoman #1 194
Mark of Zorro, The (Niblo, Fred)
	66
Markstein, Donald 45
Marshall, Kerry James: *Rhythm
	Mastr* 176
Marshall, Thurgood 163
Marston, William Moulton 45,
	105, 108–9, 111, 113, 293
	race 157
Marston, William Moulton/Peter,
	Harry G.; Wonder Woman
	(character) 275–6
Martian Manhunter (character) 8
Marvel, Captain (character) *see*
	Captain Marvel (character)
Marvel, Ms. (character) 177
Marvel Boy (character) 119
Marvel Comics 2–3, 8, 123, 125
	art 240
	bankruptcy 10–11
	Comics Code 9–10
	Epic Comics 241
	female-led titles 190–1
	gender 186–7, 190–1
	homosexuality 197–8
	Iron Man (character) 138
	market dominance 11
	MAX imprint 283–4

X Men #1, *The* 138
Marvel Comics: The Untold Story
	(Howe, Sean) 295
Marvel Fanfare #40 (Milgorm,
	Al) 198
Marvel Girl 185
Marvel Method 4
Marvel Mystery Comics 119
Marvelman (Anglo, Mick) 4, 6
Marvelman (Moore, Alan/Leach,
	Garry) 6, 124
Marz, Ron 189
masculinity 179–82, 192–4 *see
	also* gender
Mason, Hollis 198
Masque, Miss (character) 200
Masquerade (character) 199–200
Mazzucchelli, David/Miller,
	Frank: *Batman: Year One*
	279–80
MCI (minimal counter–intuitive)
	20–4
Medusa (character) 185
Mein Kampf (Hitler, Adolf) 67–8
Memmi, Albert 33, 40
memory processing 19–24
*Men of Tomorrow: Geeks,
	Gangsters and the Birth
	of the Superhero* (Jones,
	Gerard) 294
Mendel, Gregor 50, 54, 57
	"Experiments on Plant
	Hybridization" 52–3
Mendel's Theatre (Wolff, Tamsen)
	53
Mesmer, Olga (character) 184
Messner-Loebs, William 199
Midnight Mink (character) 198
Midnighter (character) 200
Miles, Catharine Cox/Terman,
	Lewis M.: *Sex and
	Personality: Studies in
	Masculinity and Femininity*
	191–2, 193

Milestone Comics 282, 294
Milestone Media 174, 175–6
Milgorm, Al: *Marvel Fanfare* #40
 198
Millar, Mark/Erskine, Gary:
 Authority #29, *The* 200
Miller, Frank 242, 278–9
 Batman: The Dark Knight
 Returns, The 8, 94, 124,
 149, 215, 241, 279
 Batman: Year One 48
 Born Again 242
 Ronin 242
 Wolverine #4 28
Miller, Frank/Mazzucchelli,
 David: *Batman: Year One*
 48, 279–80
Miller, Frank/Sienkiewicz, Bill
 Daredevil: Love and War 242
 Elektra: Assassin see *Elektra:*
 Assassin
Miller, John Jackson: *Comichron:*
 The Comics Chronicles 295
Milligan, Peter/Allred, Mike:
 X-Force #118 200
Milligan, Peter/Fegredo, Duncan:
 Engima, The 200
Mills, Tarpé: *Miss Fury* 184, 294
minimal counter-intuitive (MCI)
 20–4
Miracle Man (character) 130
Miracleman #1 (comic book) 6
Miracleman #14 (Moore, Alan/
 Totleben, John) 196
Miss America (character) 116,
 178
Miss America (comic book) 184
Miss Fury (Mills, Tarpé) 184, 293
Miss Masque (character) 200
Mist, Doctor (character) 171
Mr. Fantastic 185
Misty Knight (character) 168
mixed row-column layouts 211
Moench, Doug 146

Moleman (character) 126, 130
monomyths 16–19
montage visuals 227, 228
Montana, Bob 114
Montoya, Renee (character) 200
Moon Girl (comic book) 184
Moon Knight (comic book) 242
Moondragon (character) 200
Moore, Alan 141, 150, 186,
 194–5, 200, 230
 "Stan Lee: Blinded by the
 Hype, An Affectionate
 Character Assassination"
 293
Moore, Alan/Gibbons, Dave:
 Watchmen see *Watchmen*
Moore, Alan/Leach, Garry:
 Marvelman 6, 124
Moore, Alan/ Totleben, John:
 Miracleman #14 196
moral development theory 30
Morales, Mike 177
Morales, Robert/Baker, Kyle:
 Truth: Red, White & Black
 5, 74, 284
Morisi, Peter 47
Morphology of the Folktale
 (Propp, Vladimir) 16
Morrison, Grant/McKean, Dave:
 Arkham Asylum: A Serious
 House on Serious Earth
 281
Morrison, Grant/Yeowell, Steve:
 Sebastian O 200
Morrow, Gray 145
Moser, John 105, 120
Mosher, Donald 181, 182
"Most Dangerous Game, The"
 Connell, Richard 162–3
motion lines 241
Ms. Marvel (Alphona, Adrian/
 Wilson, G. Willow) 240,
 286–7
Ms. Marvel (character) 177

Ms. Marvel (comic book) 5
Mugambi (character) 168
multi-page sentences 226
multiple authors 4
Multiple Man (character) 23
Murdock, Matt (character)
 140 *see also* Daredevil
 (character)
Murnen, Sarah K. 185
Murray, Christopher 104
Murrow, Edward R. 121
Muslim characters 286
mutually assured destruction
 (MAD) *see* MAD
Mystique (character) 198
Myth of the American Superhero,
 The (Laurence, John
 Shelton/Jewett, Robert)
 81–2, 104, 294
mythology 15, 29, 32
 memory processing 19–24
 monomyths 16–19
 part-animal, part-human
 creatures 23
 violence 24–8

Nama, Adilifu 166, 171
Namora (comic book) 117, 184
narration 227–30
narrative panel types 225–6
naturalism 21, 231, 232, 239
Nazism 69, 74, 102–5, 122 *see*
 also fascism
Negative Woman (character) 147
Neumann, John von 127
neutral framing style 216
Nevins, Jess 36: *Encyclopedia of*
 Golden Age Superheroes
 16
New Gods (Kirby, Jack) 165
New Guardians, The (Englehart,
 Steve/Stanton, Joe) 198
New Mutants (comic book) 242
"Nick Fury, Agent of

 S.H.I.E.L.D." (Kirby, Jack/
 Lee, Stan) 214–15
Nick Fury, Agent of S.H.I.E.L.D.
 (Steranko, Nick) 277–8
Nietzsche, Friedrich 106, 112
 Also Spake Zarathustra 51
Nigeria 168
Night Hawks (characters) 85, 87,
 93
Night Thrasher (comic book) 175
Nixon, Richard 149
Nodell, Martin 45
Nolan, Christopher
 Batman Begins 48
 Dark Knight, The 48
non-fiction 230
non-rectangular layouts 213
Nordau, Max Simon 52
Norenzayan, Ara 20
Norman, Shiloh (character) 167,
 174
North, Sterling 113
Northstar (character) 197–8, 199,
 200
Nova (character) 177
Novak, Jim 242
Novick, Irv/Shorten, Harry:
 Shield, The (character) 111
Nubia (character) 167
nuclear threat 128–9, 131,
 139–40, 149–50 *see also*
 Cold War, the
"Numa" (Hollingsworth, Alvin)
 159
Nyberg, Amy Kiste 122
Nyhof, Melanie A. 20, 22–3

Occult, Dr. (character) 180
off-centered framing 215, 219
O'Herir, Andrew 102, 103
Oksner, Bob/Conway, Gerry:
 Vixen (character) 171
Oliff, Steve 6
Olsen, Jimmy 195

*On Heroes, Hero-Worship, and
The Heroic in History*
(Carlyle, Thomas) 31
one-panel sentences 226
O'Neil, Dennis 22, 48, 173, 278
Bronze Tiger (character) 168
Iron Man 172
Wonder Woman (character)
186, 278
O'Neil, Dennis/Adams, Neal
Batman 48
Green Arrow (character) 95
*Green Lantern Co-Starring
Green Arrow* 8, 28, 165–6,
167, 278
O'Neil, Kevin: *League of
Extraordinary Gentlemen,
The* 240
Ong, Walter J. 117
opacity 235, 237, 240
Oracle (character) 284–5
Orczy, Baroness 53–4, 72
Scarlet Pimpernel, The 39, 50,
53–9, 62, 84
Ord (character) 193
Orientalism (Said, Edward) 48
Orienter panels 225
Orlando, Joe 140
Ormes, Jackie 158–9
Candy 159, 184
Patty-Jo 'n' Ginger 159
Orpheus (character) 177
Ostrander, John/Wein, Len/Byrne,
John: *Legends* 172
Outsiders #1, *The* (Barr, Mike W./
Aparo, Jim) 148
overlapping layouts 213
overlapping sentences 226, 227
*Overstreet Comic Book Price
Guide* 9
Owens, Jesse 157
Owsley, Jim 174, 176
Xero (character) 176
Owsley, Jim/Bright, Mark

Falcon 173
Power Man and Iron Fist 173
Pacella, Mark 199
Packard, Frank L. 50
*Adventures of Jimmie Dale,
The* 64–5
Page, Norvell 72
page panels 205–6 *see also* grid
layouts
page scenes 228
page schemes 213–14
page sentences 226
page sentencing 225–7
paired sub-columns 212
Palmer-Mehta, Valerie 96
panel transitions 222
panels 205–6, 209
dual-function panels 226
narrative panel types 225–6
Panuska, Sarah 191, 201
paper shortages 113
parallel visuals 229, 230
Parker, Bill 18, 45, 111, 286
Parker, Peter (character) 29,
132–3, 144 *see also*
Spider-Man (character)
sexuality 201
as villain 134–5
part-animal, part-human creatures
23
Passing of the Great Race, The
(Grant, Madison) 65–6
Patriot, the (character) 284
Patton, Chuck 173
Patty-Jo 'n' Ginger (Ormes,
Jackie) 159
Peak panels 225, 226
Peanuts (Shultz, Charles) 222,
237
Pearson, Karl 53
pencilers 4–6
Penguin (Character) 192
Pep Comics (comic book) 114–15

Pep Comics #1 (comic book) 111
Pérez, George/Wolfman, Marv;
 Cyborg (character) 172
Peter, David 200
Peter, Harry G. 45, 113, 157,
 184, 239
Peter, Harry G./Marston, William
 Moulton; Wonder Woman
 (character) 275–6
Phagan, Mary 85
Phantom, the (character) 93
Phantom, The (Falk, Lee) 7, 44
Phantom Crook (character) 68
Phantom Lady (Baker, Matt)
 159–60, 184
Phillips, Joe 173
Phoenix (character) 187
photorealism 283
Picaroon, the (character) 68
Pichelli, Sara: *Ultimate*
 Spider-Man 180
Pied Piper, the (character) 199
Pinky Whizz Kid (character) 195
Pitcairn, John Jones 61
Pitkethly, Claire 48
Plastic Man (character) 21, 119
pointers 228
Poison Ivy (character) 200
politics *see also* fascism
 Superman 109–10
Pollard, Keith 167, 173, 175
Poole, Charles 89
Pope, Alexander: *Iliad of Homer,*
 The 27
Portacio, Whilce/Lee, Jim; Bishop
 (character) 175
post-Code era 10
 key texts 285–7
 race 176–8
Power Man and Iron Fist (Bright,
 Mark/Owsley, Jim) 173
Power Man and Iron Fist
 (Goodwin, Archie/Tuska,
 George) 166

Powerman (Gibbons, Dave) 168
pre-Code era 9
 key texts 274–6
 race 156–60
Priest, Christopher 176 *see also*
 Owsley, Jim
Prince, Diana (character) 186
 see also Wonder Woman
 (character)
Pringle, Romney (character) 61
Professor X (character) 21, 139
Prolongation panels 226, 262
proportionate framing 215, 216
Propp, Vladimir: *Morphology of*
 the Folktale 16
Pruneface (character) 192
Pryde, Kitty (character) 23
psychology 28–32
"Psychopathology of Comic Books,
 The" (symposium) 119
puberty metaphor 29–30
pulp literature 72
Punisher (character) 146
Puppet Masters (characters) 130
Purple Man (character) 140
Purple Mask, The (Cunard,
 Grace/Ford, Francis) 68
Pym, Henry (character) 133 *see*
 also Ant-Man (character)

Queenan, Joe 102
Quinn, Harley (character) 190,
 200

race 60, 62, 64, 67, 95, 155–6 *see*
 also diversity; KKK
 first Code era 160–5
 fourth Code and post-Code
 eras 176–8
 pre-Code era 156–60
 second Code era 165–73
 third Code era 173–6, 281
 Tuskegee Syphilis experiments
 176, 284

Race, Blue Jean Billy Race (character) 68
Race Betterment Foundation 62, 64
Radar (character) 115
radiation lines 241
Raffles, A. J. (character) 61
Rambeau, Monica (Captain Marvel) (character) 172, 173, 178
Raney, Arthur A. 187
rape 181, 196
Raphael, Jordan 118, 120–1
Ra's al Ghul (character) 48
Rautoiu, Alin 151
Rawhide Kid (character) 200
Reading Comics (Wolk, Douglas) 233
Reagan, Ronald 147–8, 150
"Real Problem With Superman's New Writer Isn't Bigotry, It's Fascism, The" (Berlatsky, Noah) 102
realism 231, 232
realist comic art 231
Red Barbarian (character) 137
Red Guardian (character) 147, 186
regular column grid 210, 211
regular grids 206–7
regular panels 209
regular rows 208
Reichstein, Andreas 51, 60
"Reign of the Superman, The" (Siegel, Jerry) 106–7, 113
Reitz, Caroline 35
Release panels 225
representational abstraction 230–41
Representative Men (Emerson, Ralph Waldo) 31
reproduction 69–73
retroactive continuity (retcon) 176–7
Reynolds, Richard 15, 37, 87–9

Super Heroes: A Modern Mythology 293
Rhodes, Jim (character) 172 see also Iron Man (character)
Rhythm Mastr (Marshall, Kerry James) 176
Richard, Olive: "Don't Laugh at the Comics" 293
Richards, Jeffrey 35
Rico, Don 160
Rieder, John 35, 40, 41
Rifas, Leonard 102, 121, 156
Rios, Emma 240
Robbins, Trina 186
Great Women Superheroes, The 293–4
Robertson, Darick/Ennis, Garth: Boys, The 74, 95, 181
Robertson, Robbie (character) 163
Robin (character) 178, 194–5
Robinson, James: Starman #48 200
Robinson, Jimmie 176
Roblou, Yann 192
Roche, Claire M./Cuddy, Lois A.: Evolution and Eugenics in American Literature and Culture, 1880–1940 49
Rockefeller Foundation 68, 69
Rocket (character) 174, 282
Rogers, Steve (character) 284
Rollin, Roger B. 24, 32
romance 194
Romberg, Sigmund/Hammerstein, Oscar, II/Harbach, Otto: Desert Song, The 68
Romita, John, Jr./Stern, Roger; Rambeau, Monica (Captain Marvel) (character) 172
Romita, John, Sr. 140, 146
Ronin (Miller, Frank) 242
Roosevelt, Theodore 66
Rosenberg, Robert S./Coogan,

Peter: *What is a Superhero?* 295

Ross, Alex 6, 240

Ross, Alex/Waid, Mark: *Kingdom Come* 26–7, 124, 282–3

row-column grids 211

row grids 206–9

row sentences 227

Rowe, John Carlos 44

Rucka, Greg 201

Rucka, Greg/Williams, J. H., III; Batwoman (character) 285

Russell-Einstein Manifesto 127

Ryker, Major (character) 146

Sadowski, Greg: *Supermen! The First Wave of Comic Book Heroes 1936–1941* 114

Said, Edward 34, 41, 44, 46, 48
 fantasy 35
 Kim 38
 lost world motif 45
 Orientalism 48

Saint, The (character) 68

Saladino, Gaspar 242

sales 10, 155
 decline 117–23
 World War II 114, 116, 117

Sales, Michael 163, 179

Sallis, Ted (character) *see* Man-Thing (character)

Sam Wilson: Captain America (comic book) 177

Sandman, the (character) 7, 137, 280

Sandman, The (Gaiman, Neil) 199, 280–1

Sandow, Eugen 180

Sandy (character) 195

Sanger, Margaret 65

Sasquatch (character) 197

Satana (character) 186

Savage, Doc (character) 44, 72, 107

Sawyer, Maggie (character) 198, 200, 285

Scarlet Fox (character) 68

Scarlet Pimpernel (character) 2, 50, 54–7, 62, 84–5

Scarlet Pimpernel, The (Orczy, Baroness) 39, 50, 53–9, 62, 84–5

Scarlet Witch (character) 187

Scarlet Witch (comic book) 241

scenes 227

Schiff, Jack 115

Schwartz, Julius 123

Schwarze Korps, Das (newspaper) 112

Scott, Alan (character) 200

Scott, Nicola 285

SDI (Strategic Defense Initiative Organization) 147–8

Sebastian O (Morrison, Grant/ Yeowell, Steve) 200

second Code era 9
 key texts 278–81
 race 165–73

Second National Conference on Race Betterment 65

Secret Wars #1 (comic book) 11

Seduction of the Innocent (Wertham, Fredric) 122, 159

segregation 64, 160–1

Seitz, George B./José, Edward *Iron Claw, The* 68, 86

semi-translucency 235, 240

semi-transparency 235, 239

Sensation Comics (comic book) 275

sentence layouts 226

Sentinels, the (characters) 95

School of Eugenics 53

science fiction 35–6, 46–7, 69

Second International Eugenics Congress 67

"Secret Skin: An Essay in Unitard

Theory" (Chabon, Michael)
294
Seduction of the Innocent
(Wertham, Fredric) 122
See, Fred G. 40
Senate Subcommittee on Juvenile
Delinquency 160, 195
Sera (character) 200
*Sex and Personality: Studies in
Masculinity and Femininity*
(Terman, Lewis M./Miles,
Catharine Cox) 191–2
sexuality 191–3
BDSM 275–6
bisexuality 193–4
comic codes and 195, 198
heterosexuality 191, 193–4,
197
homosexuality 194–6, 197–8,
199–201, 285
LGBTQ 194–202, 285
transgender characters 195,
196–7, 199
sexualization 159–60, 171 *see
also* hypersexuality
*Sgt. Fury and his Howling
Commandos* (Lee, Stan/
Kirby, Jack) 160–1
Shadow, the (character) 2, 43–4,
72, 86, 93
Shadow, The (radio show) 90
Shaft (film) 165
Shangri-La 45
Shanower, Eric 5
Shaw, George Bernard 50, 52
Man and Superman 53, 54–8,
62
Shazam (character), colonialism
45
"Shazam" acronym 29, 45
"Sheena, Queen of the Jungle"
(Baker, Matt) 159
"Sheena: Queen of the Jungle"
(Eisner, Will/Iger, S. M.) 7

Shepard, William 89
Shield, The (character) 111,
114–15
Shooter, Jim 163–4, 169, 187,
196, 197
Shooter, Jim/Stern, Roger: *Hulk
Magazine* #2 196
Shorten, Harry/Novick, Irv;
Shield, The (character) 111
Shrinking Violet (character) 198
Shultz, Charles: *Peanuts* 222, 237
Shuster, Joe 32, 44
Dr. Occult (character) 180
"Doctor Occult, the Ghost
Detective" 214
fascism 111, 112
gender 185, 193
grid layouts 214
"Henri Duval of France, Famed
Soldier of Fortune" 214
Lane, Lois (character) 183
race 157
style 110
Superman (character) 1, 2,
16, 17, 27–8, 93, 108–9,
179–80, 239, 274 *see also*
Superman (character)
vigilantism 78, 90
Shyminsky, Neil 191
Siegel, Jerry 32, 44
anti-Semitism 104
"Doctor Occult, the Ghost
Detective" 214
eugenics 72–3, 105, 108
fascism 111–13
gender 193
"Henri Duval of France, Famed
Soldier of Fortune" 214
Lane, Lois (character) 183
"Reign of the Superman, The"
106–7, 113
Superman (character) 1, 2, 16,
17, 43, 73, 108–9, 274 *see
also* Superman (character)

vigilantism 78, 90
Sienkiewicz, Bill 240, 242, 280
 Dune 242
 Moon Knight 242
 New Mutants 242
Sienkiewicz, Bill/Miller, Frank
 Daredevil: Love and War 240,
 242
 Elektra: Assassin see *Elektra:
 Assassin*
Silhouette, the (character) 198
Silver Surfer (character) 276
Simmons, Alex/Turner, Dwayne;
 Orpheus (character) 177
Simon, Joe 113, 121, 158, 276
Simon, Joe/Kirby, Jack: *Fighting
 American* 120–1, 181
Simone, Gail 188–9
 Birds of Prey 189, 284–5
 Wonder Woman 189
Simonson, Louise/Bogdanove,
 Jon; Steel (character) 175
simplification 232–3, 234
Sims, Guy A./Anyabwile, Dawud:
 Brotherman Comics 175
Singer, Marc 38, 176
Singh, Ram (character) 157
Sir Tristan 196, 197
Skrulls (characters) 126, 130
"Skull Squad" (Baker, Matt) 159
"Sky Girl" (Baker, Matt) 159
Slide, Anthony 77, 85
Slotkin, Richard 60, 109
Smith, Jacob 61
Smith, Matthew J./Duncan,
 Randy: *Critical Approaches
 to Comics: Theories and
 Methods* 9, 295
Soljer (character) 169
Souls of Black Folk, The (DuBois,
 W. E. B.) 173–4
Souls of Cyber-Folk, The
 (McDuffie, Dwayne) 174
sound effects 227

Southard, Robert 115, 117
Soviet Union 126–8, 146–8, 150
 see also Cuban missile crisis
Soy, Dexter 190, 240
Space Adventures #33 (comic
 book) 125
Sparkes, Glenn G. 25
spatial closure 222, 224
Spawn (McFarlane, Todd) 175,
 281–2
Spectre, the 116
Spicy Mystery (magazine) 184
Spider, the (character) 72
Spider-Man (character) 8, 47,
 277 see also Parker, Peter
 (character); Morales, Mike
 (character)
 art 241
 origins 132
 physicality 180
 race 177
 sexuality 201
 super power 21
 as villain 134–5
 violence 24–5, 26
Spider-Man/Deadpool #1 (Kelly,
 Joe/McGuiness, Ed) 201
Spidey Super Stories (comic) 239
Spirit, The (Eisner, Will) 4, 239,
 275
Spring-Heel'd Jack (Coates,
 Alfred) 34, 36
Spring-Heeled Jack (character) 2,
 36–9
Springhall, John 36
Spurgeon, Tim 118, 120–1
spurls 255
Spy Smasher (character) 111
Squadron Supreme (Gruenwald,
 Mark E.) 124
squeans 255
Stacy, Gwen (character) 8
Stamm, Russell: *Invisible Scarlet
 O'Neil* 184

"Stan Lee: Blinded by the Hype,
An Affectionate Character
Assassination" (Moore,
Alan) 293
Stan Lee: Conversations
(McLaughlin, Jeff) 294
Stanford, Jacqueline N. 181, 182
"Stan's Soapbox" (Lee, Stan) 163
Stanton, Joe/Englehart, Steve:
New Guardians, The 198
Star Wars (Lucas, George) 16
Starfire (character) 146
Starhawk (character) 196, 197
Starman #48 (Robinson, James)
200
Stark, Tony (character) 47,
135 *see also* Iron Man
(character)
Static (character) 175
Static (comic book) 174
Static Shock (TV cartoon) 175
Station for Experimental
Evolution 53
Staton, Joe 147, 170
Steel (character) 175
Steinman, Gloria 186
Stelfreeze, Brian 173
Stelfreeze, Brian/Coates,
Ta-Nahesi: *Black Panther*
178, 287
Steranko, Jim 8, 214–15, 277–8
Captain America 277
*Nick Fury: Agent of
S.H.I.E.L.D.* 277
Strange Tales 277
sterilization 67–75
Sterling, Steel 116
Stern, Roger 196
Stern, Roger/Romita, John, Jr.;
Rambeau, Monica (Captain
Marvel) (character) 172
Stern, Roger/Shooter, Jim: *Hulk
Magazine* #2 196
Stevenson, Robert Louis: *Strange

*Case of Dr. Jekyll and Mr.
Hyde, The* 37–8, 60–1
Stewart, John (character) 166,
172, 175 *see also* Green
Lantern (character)
Storm (character) 168, 172, 177,
178, 186
Storn, Eric (character) 200
Stowe, Harriet Beecher: *Uncle
Tom's Cabin* 81
Strange, Doctor (character) 8, 47,
137, 138, 180
Strange Adventures (comic book)
130
*Strange Case of Dr. Jekyll and
Mr. Hyde, The* (Stevenson,
Robert Louis) 37–8, 60–1
Strange Tales (Steranko, Jim) 277
Strategic Defense Initiative
Organization (SDI) 147–8
Stroman, Larry 173
Stubbersfield, Joseph 20
sub-columns 212
Sub-Mariner, the (character) 7,
120
colonialism 45
as villain 130
war 111
Sub-Mariner (comic book) 118
"Sub-Mariner, The" (Everett, Bill)
214
sub-page sentences 226
sub-row sentences 226
Sullivan, Vin 108–9
Sun Girl (character) 184
Sun Girl (comic book) 117
Super Fly (film) 168
*Super Heroes: A Modern
Mythology* (Reynolds,
Richard) 15, 292
super powers 21–3
Superboy (character) 119
Superboy (comic book) 118
Superboy Starring the Legion of

Super-Heroes (comic book) 169

superhero comics *see also* comics *and* superheroes
 analysis *see* analysis
 Atomic Age 8
 Bronze Age 8
 collecting 9
 Comics Code 9–10
 Dark/Iron/Copper/Modern Age 9
 definition 1
 demographics 10–11
 finances 10–11
 Golden Age 7–8, 10
 Modern/New Age 9
 New/Millennial Age 9
 production 4–6
 representational tensions 230
 sales *see* sales
 sales decline 117–23
 schema 9–10
 Silver Age 8
Superhero Comics of the Golden Age (Benton, Mike) 113
Superhero Reader, The (Hatfield, Charles/Heer, Jet/Worcester, Kent) 294
Superhero: The Secret Origin of a Genre (Coogan, Peter) 1, 294
superheroes 7–8 *see also* superhero comics
 anxiety-causing *see* Cold War
 black superheroes *see* race
 cancellations 116
 character traits 1–2, 15–32
 child psychology 28–32
 colonialism *see* colonialism
 costume *see* costume
 definitions 1–2, 22, 92–3
 disguises 78, 84–5, 87, 92–3
 diversity 96
 dual identity *see* dual identity

Eco, Umberto 124
 as enemies 129–30 *see also* villains
 eugenics *see* eugenics
 fascism *see* fascism
 gender *see* gender
 minimal counter-intuitiveness 20–3
 monomyths 16–19
 morality 30
 mythology *see* mythology
 origin stories 17
 patriotism 120–1
 physicality 179–85, 187–8, 192
 race *see* race
 romance 194
 satire 121
 sexuality *see* sexuality
 Spring-Heeled Jack 36–9
 trademarks 2–3
 transformations 18–19, 29
 vigilantism *see* vigilantism
 violence 24–8
 World War II 114
Superman (character) 8, 15, 16, 44–5, 87–92, 239, 274 *see also* Kent, Clark (character)
 art 240
 colonialism 44, 46
 costume 93, 179–80
 criticism 119
 eugenics 73, 106–7
 fascism 103, 105–13, 116, 119, 120, 122
 identity 1
 imitations 7, 17, 111
 monomyths 18–19
 morality 30
 name 91, 106
 nuclear threat 149
 origins 33, 97, 125
 politics 109–10

popularity 111
puberty metaphor 29
radio 91
romance 119
super powers 21, 23
survival 119
vigilantism 87–92
violence 26, 27–8, 119–20
World War II 116
Superman (comic book) 274
superman (eugenics) 50–2, 55–7,
 62–7, 69–75, 91
 Germany 106–7
 Wertham, Fredric 122
Superman and the Mole Men
 (film) 120
Superman Birthright (Waid,
 Mark) 97
Superman complex 30
*Supermen! The First Wave
 of Comic Book Heroes
 1936–1941* (Sadowski,
 Greg) 114
SuperMutant Magic Academy
 (Tamaki, Jillian) 222
supervillains *see* villains
*Superwomen: Gender, Power,
 and Representation* (Cocca,
 Carolyn) 295
Svitavsky, William L. 164, 168,
 175
Sweet, Charlie 20, 79, 171
symmetrical framing 215, 217,
 218
Syn, Doctor (character) 68
Szasz, Ferenc Morton 128

Taliaferro, John 62–3
talk balloons 227, 228
Tamaki, Jillian: *SuperMutant
 Magic Academy* 222
Tanner, John (Jack) (character)
 54–6
Tarzan (character) 50, 62–3

Tarzan of the Apes (Burroughs,
 Edgar Rice) 40–3, 62–3
Teen Titans 169
Teen Titans (characters) 172
Tehrani, Jamshid 20
Tempest (character) 170
temporal closure 223, 224–5
Terman, Lewis M. 66
Terman, Lewis M./Miles,
 Catharine Cox: *Sex and
 Personality: Studies in
 Masculinity and Femininity*
 191–2, 193
text 228–31
text-narrators 230–1
The Mary Sue (comics site) 191
Thing, The (character) 129, 130,
 131, 141–2, 185, 186
third Code era 9–10
 key texts 280–2
 race 173–6
Third International Congress of
 Eugenics 69
Thomas, Duke (character) 178
Thomas, Roy 48, 145, 146, 166,
 171, 187
Thompson, Flash (character) 145
Thor (character) 8, 15, 47, 133
Thorndike, Russell 68
 *Doctor Syn: A Tale of the
 Romney Marsh* 86
Thorold, Cecil (character) 61
thought balloons 227
three-dimensional effects 221–2
Thunder (character) 177
Thunderbolt (character) 47, 68,
 170
Tibet 33, 46, 47–8
"Tiger Girl" (Baker, Matt) 159
Tigra (character) 186
Till, Emmett 160
Tim (character) 195
Timely (publishers) 8, 118, 119,
 120

Tomb of Dracula, The (Colan, Gene/Wolfman, Marv) 167
Tomkins, Silvan 181, 182
Tonto (character) 157, 168
Torchy (Ward, Bill) 184
Toro (character) 195
Totleben, John/Moore, Alan: *Miracleman* #14 196
Traitor, The (Dixon, Thomas, Jr.) 85
transformations 18–19, 29
transgender characters 195, 196–7, 199
translucency 235, 237
transparency 235, 237
Triem, Paul Ellsworth 68
Tristan, Sir 196, 197
Truth: Red, White & Black (Morales, Robert/Baker, Kyle) 5, 74, 176, 284
Tucker, Richard K. 79–80
Turner, Dwayne/McGregor, Don: *Black Panther* 175
Turner, Dwayne/Simmons, Alex; Orpheus (character) 177
Turner, Frederick Jackson 39, 60
Tuska, George/Goodwin, Archie
Luke Cage, Hero for Hire 166
Luke Cage, Power Man 166
Power Man and Iron Fist 166
Tuska, George/Isabella, Tony; Black Goliath (character) 168
Tuskegee Syphilis experiments 176, 284
Two-Face (character) 192
two-page panels 206
Tyler, Charles W. 68
Tyroc (character) 169, 182

Ubermensch 51, 106, 107
Ultimate Spider-Man (Pichelli, Sara) 180
Ultimates (comic book) 178, 191

Ultra-Humanite, the (character) 110–11, 192, 193, 194, 274
Ultra-Man (character) 8
Uncanny X-Men, The (Byrne, John/Claremont, Chris) 278–9
Uncanny X-Men #381(comic book) 11
Uncle Tom's Cabin (Stowe, Harriet Beecher) 81
Under the Moons of Mars (Burroughs, Edgar Rice) 39–40
Understanding Comics (McCloud, Scott) 3, 222–3, 224
unintegrated image-texts 230
Upal, M. Afzal 20, 21–2, 23
Uslan, Michael 8

Vabedoncoeur, Jim, Jr. 159
Valentine, Jimmy (character) 61
Valkyrie (character) 186
Varley, Lynn: *300* 6
Veitch, Rick: *Brat Pack* 198
Velez, Ivan, Jr./McDuffie, Dwayne; Masquerade (character) 199–200
Venus (comic book) 184
Vietnam conflict 135, 144–5
vigilantism 59, 77–81, 92–7
heroes 81–7
Superman 87–92
villains 110, 118, 126
atomic fears 130
Cold War 137
homosexuality 196
Hulk, the (character) 134, 141
physicality 192
violence 24–8, 181, 188–9, 196, 198
Virginia Sterilization Act 67–8
Virginian, The (Wister, Owen) 59–60, 81–2

Vision (character) 23
visual analysis *see* analysis
Visual Language of Comics, The (Cohn, Neil) 225
visual sentences 225–6
visuals 228
Vixen (character) 171
Vlamos, James Frank 78–9, 112
Vogler, Christopher 16
Von Eeden, Trevor 170–1
Von Eeden, Trevor/Isabella, Tony: *Black Lightning* 170–1
von Neumann, John 127
Voodoo, Brother (character) 167, 182

Waid, Mark: *Superman Birthright* 97
Waid, Mark/Ross, Alex: *Kingdom Come* 26–7, 124, 282–3
Waku (character) 160
Walbert, David 140
Walker, Frances Amasa 60
Walker, Jesse 80
Walker, Mort 241, 255
Wallace, Edgar 68
Wallace, Jo-Ann 36
Waller, Amanda (character) 172
Walt Disney Comics 118
"Wambi the Jungle Boy" (Baker, Matt) 159
Wanda (character) 199
Wanzo, Rebecca 155
Ward, Bill: *Torchy* 184
Wasp, the (character) 21, 47, 185, 187
Watcher, the (character) 23
Watchmen (Moore, Alan/ Gibbons, Dave) 6, 8, 26, 279
 closure analysis 224–5
 colonialism 47
 fascism 124
 grid layout 215

narrative panel type analysis 225–6
nuclear fears 149, 150
vigilantism 94
violence 26, 181
Watkins, Tony 36
Wayne, Bruce (character) 17, 26, 49, 94 *see also* Batman (character)
Wayne, Matt 173
Weart, Spencer R. 136, 139
Weaver, Andrew J. 25
webcomics 4
Wein, Len 146, 147, 171, 278
 "Day After Doomsday, The" 145
Wein, Len/Cockrum, Dave; Storm (character) 168
Wein, Len/Colan, Gene; Brother Voodoo (character) 167
Wein, Len/Ostrander, John/Byrne, John: *Legends* 172
Weinberg, Robert 131
Weiner, Robert 105
Weinstein, Simcha 108
Weisinger, Mort 164
Wells, H. G. 51: *Island of Dr. Moreau, The* 60–1
Wertham, Fredric 30, 119, 182, 194–5
 Seduction of the Innocent 122, 159
western genre 60, 82
What is a Superhero? (Coogan, Peter/Rosenberg, Robert S.) 295
"What's Wrong with the 'Comics'?" (Doyle, Thomas F.) 115
White, Ebony (character) 157
White Legion (characters) 90
"White Legion, The" (radio episode) 90
Whitney, Ogden 160

Wiccan (character) 200
Williams, Hank: *Havok &*
 Wolverine: Meltdown 29
Williams, J. H., III/Rucka, Greg;
 Batwoman (character) 285
Williams, Riri (character) 178, 191
Williamson, Joel 82, 85
Williamson, Jack/Breuer, Miles J.:
 "Girl From Mars, The" 69
Wilson, G. Willow 190
Wilson, G. Willow/Alphona,
 Adrian: *Ms. Marvel* 286–7
Wilson, Ron 166, 173
Wilson, Sam (character) 164–5,
 177 *see also* Falcon, the
 (character)
Wing, Colleen (character) 186
Winick, Judd 96, 200
Winick, Judd/March, Guillem:
 Catwoman #1 194
Wister, Owen: *Virginian, The*
 59–60, 81–2
Witek, Joseph 21, 231–2, 234, 254
Witty, Paul D. 122
Wojtkoski, Charles Nicholas
 157–8, 161
Wolfenden Commission 195
Wolff, Tamsen: *Mendel's Theatre*
 53
Wolfman, Marv 146
Wolfman, Marv/Colan, Gene:
 Tomb of Dracula, The 167
Wolfman, Marv/Pérez, George;
 Cyborg (character) 172
Wolk, Douglas 27: *Reading
 Comics* 233
Wolverine (character) 146, 200
 super powers 21, 23
 violence 28, 29
Wolverine #4 (Miller, Frank) 28
women 159, 171, 182–4, 194,
 284 *see also* gender
Women in Refrigerators trope
 188, 284

Wonder Comics #2 (comic book)
 45
Wonder Woman (character) 8,
 113–14, 239, 275–8
 gender 182, 184, 186
 race 157, 167
 sexuality 201
 survival 119
Wonder Woman (comic book)
 275
Wonder Woman (Simone, Gail)
 189
Wonderman (character) 7, 17, 33,
 34, 45, 275
 colonialism 37, 45, 46
"Wonderman" (Eisner, Will) 214,
 275
Woo, Ben 9
Wood, Wally 140
Woodhall, Lowery 162
Woolfork, William 119
Worcester, Kent/Heer, Jet: *Arguing
 Comics: Literary Masters
 on a Popular Medium* 294
Worcester, Kent/Heer, Jet/Hatfield,
 Charles: *Superhero Reader,
 The* 295
word containers 227–8
word-only texts 229
word-specific illustrations 228–30
words 227–30
World War I (The Great War)
 106
World War II 101–2, 108, 109,
 112, 113–16 *see also*
 fascism
 atomic bombing 127
 sales decline 117–20
 Superman 116
World's Collide (comic book) 174
World's Finest Comics 115
Wright, Bradford, W. 78, 95, 110,
 117, 123
 Comic Book Nation: The

Transformation of Youth Culture in America 294
writers 4–5
Wylie, Phillip: *Gladiator* 43, 70–2
Wytches (Hollingsworth, Matt) 6

X-Force #118 (Milligan, Peter/ Allred, Mike) 200
X-Man, The (Lee, Stan/Kirby, Jack) 95
X-Men, the (characters) 8, 47, 139
X -Men: Days of Future Past (Singer, Bryan) 48
X-Men #1 (Lee, Stan/Kirby, Jack) 10, 138–9
Xavin (character) 200
Xero (character) 176

Yarko the Great (character) 45
Yellow Kid Award 241
Yeoh, Alysia (character) 200
Yeowell, Steve/Morrison, Grant: *Sebastian O* 200
York, Rafiel 125
Young, Robert 34, 37
Young Allies (comic book) 158
"Young Miracleman" (comic book story) 227

Zavimbe, David (character) 177
Zeck, Mike 197
Zemo, Baron (character) 192
Zillman, Dolf 25
Zorro (character) 2, 8, 50, 66–7, 93